AMERICA'S
MEDICIS

ALSO BY SUZANNE LOEBL

America's Art Museums: A Traveler's Guide to Great Collections Large and Small

The Mothers' Group: Of Love Loss and AIDS.

At the Mercy of Strangers: Growing up on the Edge of the Holocaust

The Nurses Drug Handbook

AMERICA'S MEDICIS

THE ROCKEFELLERS AND THEIR ASTONISHING CULTURAL LEGACY

Suzanne Loebl

HARPER

An Imprint of HarperCollins*Publishers*
www.harpercollins.com

HarperCollins books may be purchased for educational, business, or sales promotional use. For information, please write: Special Markets Department, Harper-Collins Publishers, 10 East 53rd Street, New York, NY 10022.

FIRST EDITION

Designed by Cassandra J. Pappas

Library of Congress Cataloging-in-Publication Data has been applied for.

ISBN: 978-0-06-123722-5

10 11 12 13 14 ID/RRD 10 9 8 7 6 5 4 3 2 1

To Judy H. Loebl and John C. Gordon, whose love nourishes me;

and to David, always.

Contents

 The Asia Society and Lincoln Center

11 The Rockefeller Collection at the Fine Arts 258
 Museums of San Francisco

12 The Nelson A. Rockefeller Empire State Mall 271

13 David Rockefeller: The Museum of Modern Art 287
 and the JPMorgan–Chase Corporate Art Collection

14 In Memoriam: The Michael C. Rockefeller Wing, 307
 and the Nelson A. Rockefeller Center in San Antonio,
 Texas

15 Smaller Gifts 328

16 Kykuit: On a Clear Day You Can See Forever 347

 Acknowledgments 363
 Bibliography 367
 Abbreviations 373
 Notes 375
 Index 401

Introduction

AMERICA'S ARTISTIC LANDSCAPE would be totally different were it not for the Rockefellers. Nowhere is this legacy as evident as it is in Manhattan, where it hop-skips from the glass towers of downtown's Chase Manhattan Bank, to midtown's United Nations— the latter built on Rockefeller-donated land—to Rockefeller Center, the Museum of Modern Art, Rockefeller University, Lincoln Center, the Asia Society on Park Avenue, and Riverside Church, to the medieval tower of The Cloisters, at the island's northern end. Farther afield there is Kykuit, the Rockefellers' summer home; the Nelson A. Rockefeller Empire State Mall in Albany; and museums founded, or contributed to, by the family in California, Rhode Island, Texas, Vermont, Virginia, and elsewhere, including Jerusalem.

Even though more than two hundred books have been written about the family, none so far has looked at their artistic contribution as a whole. *America's Medicis* celebrates thirty institutions that bear the imprint of this legendary family. This by itself might make the Rockefellers America's greatest art patrons. In spite of this wealth of material gifts, the Rockefellers' most important contribution was to teach America that art and its enjoyment, message, and healing power did

not belong to a rarefied elite, but could be loved, understood, and even owned by all.

Almost a century and a half after John D. Rockefeller, Sr. (Senior), started to refine oil in Ohio, the family remains a puzzle, which is why it continues to fascinate. The unscrupulous development of a highly profitable oil monopoly mesmerized Senior, and he relished being America's wealthiest man. However, as Ron Chernow[1] wrote, the Bible-thumping aspect of his personality was as real as his robber baron side, and his greatest pleasure was found in singing hymns in a working-class Baptist church. From early on he wanted to use some of his money for the good of humanity. His descendants absorbed his god-fearing nature, though they translated it into social consciousness, and their goal was to be remembered as responsible American citizens. Education and civil rights remained important causes to these scions of teachers and abolitionists.

A love of art entered the family via Senior's daughter-in-law Abby Greene Aldrich. She, too, had been chastened as a child by the reputation of her beloved father, whom muckraking journalists branded a money-grubbing politician. Abby was passionate about art. As she wrote in 1928, "To me art is one of the great resources of my life. I believe that it not only enriches the spiritual life, but that it makes one more sane and sympathetic, more observant and understanding, regardless of whatever age it springs from ör whatever subject it represents." Abby Rockefeller, like her son Nelson, loved to shop. She bought furniture, dinnerware, clothes, knickknacks, and art. Most of these goodies were paid for with Rockefeller money, but since her husband hated modern art, she used Aldrich money to acquire prints, and out-of-favor and contemporary art. Her top price usually was $1,000, which paid for few masterworks but enabled her to support many artists at the beginning of their careers. Abby Rockefeller eventually owned more than sixteen hundred works on paper.

Collecting art for her own pleasure was not enough for Abby. With some friends and collaborators she founded the Museum of Modern Art (MoMA), in the words of art critic Aline Saarinen, "the most important taste making institution in the world."[2] MoMA was an entirely new type

of museum, one that sent some of its cutting-edge exhibitions to all parts of America and examined the artistic merits of photography, film, architecture, and design. The museum championed what Abby Rockefeller called "The Art in Our Time." In practice, this meant art of the late nineteenth and twentieth centuries.

It was not long before Abby Aldrich Rockefeller's collection attracted attention, and because of her prominent social position, she became a major force in the popularization of contemporary American art. This required courage then, because, as Alfred Barr, MoMA's founding director, wrote, "not only is modern art artistically radical but it is often assumed to be radical morally and politically, and sometimes it indeed is."[3]

John D. Rockefeller, Jr. (Junior), was less adventurous than his wife. During the first forty years of his life he struggled to fulfill what he considered his mandate: conscientiously and wisely to distribute some of his father's oil money. Gradually he allowed himself to enjoy what he called "Beauty in the Well-Rounded Life." He built great—though, in view of his enormous wealth, rather modest—houses, and bought himself expensive Chinese porcelains, medieval tapestries, and other artifacts, always figuring that they might one day belong to the public. Much of Junior's artistic legacy—the term must be interpreted broadly, as it includes his vast building projects—came about accidentally. The Great Depression led to his being the sole sponsor of Rockefeller Center, one of America's architectural gems, and in the process, commissioning much art at a time when artists were "begging." His commissions were what led Frank Crowninshield to call him the Lorenzo de' Medici of the twentieth century.[4] Since Junior felt that the craftsmanship of "the art of his own time" was inferior, his museums taught his contemporaries about the great civilizations of the past. The Cloisters, considered one of America's best museums, celebrates medieval Europe; Williamsburg highlights Colonial America; the Oriental Institute and the Rockefeller Archaeological Museum in Jerusalem explore the ancient Near East.

The family's artistic advisors included some of the twentieth century's greatest experts, who became the shy and retiring John D. Rockefeller, Jr.'s,

closest friends, and their dedication and loyalty are a testimonial to the reciprocity of the relationship. Abby A. Rockefeller, too, established strong bonds with her advisors, and they responded with friendship and admiration for her uncanny artistic eye. For many years Abby's maternal warmth and understanding enabled frail Alfred Barr, modern art's American crusader, to achieve his mission.

Art was such an important part of the Rockefellers' life that the children incorporated it into their existence. John D. 3rd and Nelson Rockefeller, respectively, used art to promote U.S. relations with Southeast Asia and Latin America, and it is the art of these regions that became part of their legacy. As governor of New York, Nelson established the country's first Endowment for the Arts, which served as the model for the National Endowment for the Arts. David Rockefeller interpreted his mother's philosophy as a mandate to introduce art into the workplace.

By establishing the Museum of Primitive Art in 1957, Nelson pioneered the view that non-Western was art, rather than just interesting ethnic objects. Twenty years later, approximately thirty-five hundred pieces of art migrated to the Metropolitan Museum of Art.

At heart, the Rockefellers were builders. Shy John D. Rockefeller 3rd was roped into assuming the chairmanship of Lincoln Center while it was being built some fifty years ago. His ebullient brother Nelson used all the resources at his disposal to turn New York State's administrative seat into the most glorious in the nation. David Rockefeller helped revamp downtown Manhattan. Art was an important part of each of these Rockefeller projects. The Rockefeller legacies vary both in importance and in their success, but the sum total of their achievements earned the family a place among the great art patrons of the world.

AMERICA'S
MEDICIS

Preamble: An Imperial Nest

I N 1938 A wrecker's ball reduced numbers 4 and 10 West Fifty-fourth Street to rubble. Gone was the yard that had been flooded in winter for ice-skating. Gone were the kitchens with their immense cooking ranges, the butler's pantries, the house organ, the dining rooms, and the master bedrooms. Gone was a piece of Manhattan history.

In 1877, Arabella Worsham[1] had remodeled a brownstone at 4 West Fifty-fourth Street into a fashionable residence. The stairs were of solid carved mahogany. Ceilings were elaborately painted, floors were intricately inlaid with costly wood, the windows were of stained glass, and the baths were lined with marble. The atmosphere was both opulent and gloomy, and very Gilded Age.

A few years later, John D. Rockefeller, Sr., the founder of the Standard Oil Company, was looking for a permanent New York abode. Until then the family had lived in Cleveland, but as affairs of the company shifted to the East Coast, they had started to spend winters in various New York residential hotels. After Mrs. Worsham married Collis P. Huntington, the railroad magnate, she moved to even grander quarters, and put her house up for sale. In 1885, Senior bought it and all its furnishings for the then very tidy sum of $600,000. The oil tycoon and his wife were quite indifferent to the interior decoration of their homes and were content to leave

this task to others. The same would not be true of their son and future daughter-in-law.

At the time Senior bought the house from Mrs. Worsham Huntington, midtown Manhattan was still sparsely populated, but the character of the neighborhood was changing. St. Luke's Hospital, Manhattan's leading Protestant Episcopal medical institution, across the street from the house, sat on a large grassy plot stretching all the way to Fifth Avenue. In 1893 the hospital moved uptown, and its original painted brick building was demolished in 1896 and replaced by the University Club, an Italian Renaissance revival palazzo designed by Charles Follen McKim, and new St. Patrick's Cathedral had been completed four blocks to the south. To the north, Central Park, stretching from 59th to 110th Street, had become an urban oasis, and the mansions of New York's Millionaires' Row were rising along Fifth Avenue.

John D. Rockefeller, Jr., was ten when the family moved into the Worsham mansion. He would live on that same block for forty-nine years. In 1901, when he was twenty-seven, he married Abby Greene Aldrich, and after a prolonged honeymoon, the young couple moved into 13 West Fifty-fourth Street, across the street from his parents. After another ten years, Junior purchased a plot at 10 West Fifty-fourth Street for $200,000.[2] As he wrote his father, he and Abby planned to build a simple brownstone instead of the fanciful castles or turreted palaces favored by other multimillionaires.

Junior hired William Welles Bosworth, an American architect who had completed his training at the École des Beaux-Arts in Paris. Just then he was in the process of revamping Kykuit, Senior's Westchester residence, and designing its gardens. Bosworth was a great admirer of Greek art, and all his creations were characterized by restrained elegance. As many of those who worked for the Rockefellers, he became a friend and advisor. He would later oversee the Rockefeller-sponsored rehabilitation of Versailles and design the Cairo Museum, which was never built.

The house at 10 West Fifty-fourth Street turned out to be far from ordinary. For a while it was the largest brownstone in Manhattan. Its nine

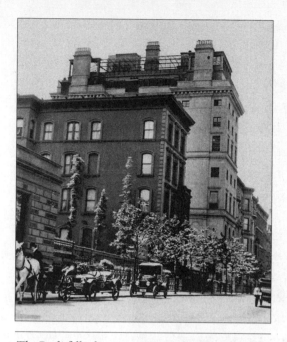

The Rockefeller houses on West Fifty-fourth Street in Manhattan. Even though automobiles would magnify their oil fortune, Junior preferred a horse and buggy. (Courtesy of The Rockefeller Archive Center)

floors included sumptuous living quarters, a ground-floor sitting room for Abby, a study for Junior, umpteen bedrooms, a nursery, playrooms, a gymnasium, a "sick bay," servants' quarters, and a roof garden.

Once completed, the home had to be decorated, which was mostly Abby's job, but Junior took a major interest. Most collectors start out by buying art to decorate their houses, and the Rockefellers were no exception. From the time she was a young child, Abby Aldrich Rockefeller had been passionately interested in art. Her taste was broad and all-encompassing. Looking at and learning about art was her greatest pleasure, and she relished creating tasteful environments for her family. She was an adventurous, impulsive buyer.

For her husband, buying art was quite a different matter. He enjoyed objects that reflected superior craftsmanship, but he had no great liking

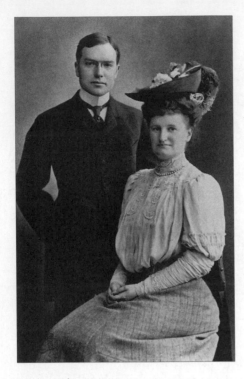

*John D. Rockefeller and Abby Aldrich
Rockefeller during the early years
of their marriage.* (Courtesy of the
Rockefeller Archive Center)

for pictures. Also, since he believed that his excess money was earmarked
for the benefit of mankind, he felt guilty spending millions of dollars on
artworks. But, as he told Raymond Fosdick, his sympathetic biographer,
"In the end I came to the conclusion that a man could buy things for him-
self without jeopardizing other causes, particularly when they would in
time probably come into public possession through their ownership by
museums."[3]

A reluctant Junior participated in the selection of European master-
pieces. His father had taught him to keep accurate financial accounts, and
he kept a watchful eye on all expenditures. Copies of bills and letters deal-
ing with the building, decoration, and upkeep of all Rockefeller residences
are now at the Rockefeller Archives, located in the family compound in
Pocantico Hills, New York. The correspondence is so voluminous that one
wonders how Junior ever had time to do anything else.

Money alone cannot buy great art, and it took time and effort to fill

the house with treasures. With the help of advisors and art dealers, who vigorously zero in on the wealthy, the Rockefellers succeeded in acquiring a stunning personal art and artifact collection. The showrooms of Joseph Duveen,[4] an art dealer par excellence who catered to a few wealthy clients, were conveniently located on Fifty-sixth Street, near the Rockefeller residence. Duveen's American headquarters had been modeled on the Ministry of the Marine, originally built by Louis XV's court architect, on the Place de la Concorde in Paris. The New York version, built of imported French stone, had cost $1 million.

Duveen, an excellent judge of people, realized that it was not easy for Mr. Rockefeller to spend the large sums of money necessary to acquire masterpieces. One of his strategies was to let his clients take art home for a year-long approval, reasoning that by the time they had to return the art, they would have become so attached to the objects that they would pay his exorbitant prices. Always partial to sculpture, Junior bought Verrocchio's bust of the *Daughter of Corleone*, Laurana's head of *Beatrice of Aragon*, and a work by Desiderio da Settignano. These had been part of the Dreyfus Collection, and Duveen now offered them to John D. Rockefeller, Jr., for a hefty $1.5 million. Junior balked at the price, but finally bought them on December 31, 1934, the day his approval period was to expire.[5]

As she was selecting paintings for her new home, Abby Rockefeller fell in love with art of the Italian Renaissance. These works had been mostly ignored in America until the charismatic Charles Eliot Norton, America's first professor of art history, popularized them toward the end of the nineteenth century. In time, the Rockefellers bought *The Raising of Lazarus* and *Christ and the Woman of Samaria*, painted by Duccio between 1308 and 1311. These tempera-on-gold panels once graced the predella of the historic Maestà altar in the cathedral of Siena, the very church that had so inspired Norton. Today *The Raising of Lazarus* is at the Kimbell Museum in Houston, and *Woman of Samaria* is at the Thyssen-Bornemisza Museum in Madrid. Even though the Rockefellers had a preference for Italian Renaissance works, they also bought later Dutch, Spanish, French, and English paintings. Junior was particularly fond of Sir Thomas Lawrence's

Lady Dysart. They did not own any works of the Dutch golden age so be-
loved by the previous generation of American tycoons.

THE DECORATION OF his new house provided John D. Rockefeller with
a life-long passion. One day, as he was searching for objects with which to
decorate a large mantelpiece, he was offered two tall Black Hawthorn vases,
created in China during the K'ang-hsi period, between the sixteenth and
seventeenth centuries. Rockefeller was not the first American millionaire
to fall in love with these exquisite objects. Benjamin Altman, Horace O.
Havemeyer, and J. P. Morgan, all future benefactors of the Metropolitan
Museum of Art, collected them, too. Morgan died in 1913, and two years
later his porcelains were up for sale by none other than the ubiquitous
Joseph Duveen. Junior, accompanied by Theodore Y. Hobby, keeper of the
Altman Collection of Chinese porcelains at the Metropolitan Museum of
Art, went to view the porcelains and was entranced by their beauty. At
the time, Junior did not have the more than $1.5 million it would take to
secure the porcelains. Fearful of losing his heart's desire, he asked his dad
for a loan. The elder Rockefeller was quite shocked by the idea of spending
so much money on such completely nonessential objects and refused. His
son did not give up. In an often-quoted letter he wrote:

> I have never squandered money on horses, yachts, automobiles and
> other foolish extravagances. A fondness for these porcelains is my
> only hobby—the only thing on which I have cared to spend money.
> I have found their study a great recreation and diversion, and I have
> become very fond of them. This hobby, while a costly one, is quiet and
> unostentatious and not sensational. I am sure that if I had the actual
> cash on hand, you would encourage rather than discourage my devel-
> opment of so innocent and educative an interest. The money put into
> these porcelains is not lost or squandered. It is all there, and while not
> income-producing, I have every reason to believe that even at a forced
> sale, I could get within ten percent of what these things would cost,

while a sale under ordinary circumstances would certainly realize the full cost value, and, as the years go by, more . . .

Is it unwise for me to gratify a desire for beautiful things, which will be a constant joy to my friends and to my children as they grow to appreciate them, as well as to myself, when it is done in so quiet and unostentatious manner?[6]

As usual, Junior wanted his father's approval:

Much as I want to do this thing—and I think you do not realize how much I should like to do it, for you do not know the beauty and charm of these works of art—I want more to do what you fully approve, so I have ventured to write this long letter, hoping that perhaps this fuller statement of the situation may lead you to see it in a somewhat different light.

Senior was either so touched by his son's reasonable letter or convinced by Junior's monetary arguments that he not only advanced the money, but offered the porcelains as a gift to his son and heir. In April, Junior paid for the porcelains with 4,900 shares of Pennsylvania Railroad Company capital stock, making sure that Duveen would provide stands for the porcelains and carry out all necessary repairs. On April 13, 1913, Junior once more thanked his father: "I have already written you in expression of my appreciation of this gift, but shall never be able to make you understand how deeply grateful I am."[7]

The Morgan porcelains were only the beginning. During the next fifty years, Rockefeller would spend in excess of $10 million, acquiring more than four hundred Chinese porcelains, including covered temple jars, vases, beakers, and statues. With the advice of Theodore Hobby, the collection underwent constant refinement. Better specimens replaced inferior ones. Junior had a keen eye for quality and a passion for detail, and he became an expert at interpreting the symbolism of the figures, flora, and fauna. He took great care in the display of the porcelains in

his house. A generation later his son Nelson would find great joy in the rearrangement of his own art collection.

According to Fong Chow,[8] assistant curator of Far Eastern art at the Metropolitan Museum of Art, Rockefeller assembled "the most important private collection of its kind in the world. Although many [of the porcelains] are from the same period, there are no duplicates: those who know and love such works find they vary as one Rembrandt does from another."

The porcelains filled Rockefeller with delight. Fong notes that these intricate polychrome objects "have to be studied bit by bit . . ." and that Mr. Rockefeller "would place a piece of porcelain on a revolving stand and sit by the hour watching its details unfold before him like a miniature tapestry." Eventually, like so many other Rockefeller possessions, seventy-four pieces of the Chinese porcelain were donated to the Metropolitan Museum of Art.

The Chinese porcelains demanded grand surroundings. To begin with, the Rockefellers bought rugs. Junior himself attended an auction

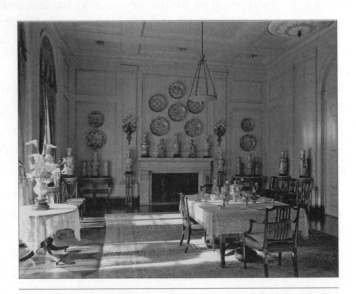

The dining room at 10 West Fifty-fourth Street, overdecorated with Junior's Chinese porcelains. (Courtesy of The Rockefeller Archive Center)

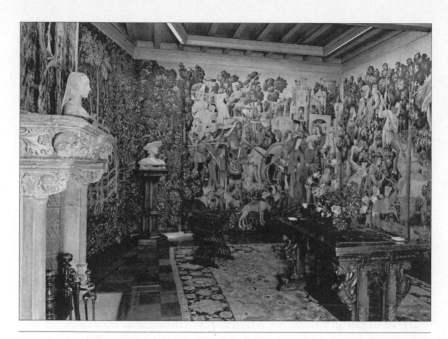

Junior acquired The Hunt of the Unicorn *series of tapestries in 1923 and displayed them in a special room at newly acquired 12 West Fifty-fourth Street. Also note the sculptures acquired from Joseph Duveen. Today the tapestries are in* The Cloisters, *and the sculptures are in the Frick Collection.* (Courtesy of The Rockefeller Archive Center)

and paid $15,400 for a Chinese blue rug that Duveen estimated should have cost only $2,500. After that, Duveen saw to it that his client got his money's worth.[9] Over the course of the next decades the Rockefellers acquired a number of magnificent Oriental rugs. Some of these went by the strange name Polonaise, or Polish, rugs because they had been made (albeit in Persia) for certain European rulers. "In the spring of 1601 the Polish king Sigismund III Vasa sent the merchant Muratowicz to Persia with instructions to order rugs for the king and to supervise their weaving personally."[10] The rugs were loomed of silk and gold, and their decorations were typical for Isfahan rugs, "mainly floral, consisting of scrolling stems, with large palmettes, blossoms and lanceolate leaves."

Gobelin tapestries, intended to keep out cold winter drafts, are closely related to sumptuous rugs. In 1920, Duveen told Junior that a set called *The*

Months of Lucas had come on the market. They were woven during the seventeenth century for the Comte de Toulouse, a son of Louis XIV. Originally there were twelve tapestry panels representing the months, but February and June had been lost. Based on cartoons by Lucas van Leyden, each design illustrates the Zodiac sign of the given month. To match these splendid weavings, the Rockefellers acquired a set of twelve chairs and two sofas covered in Gobelin upholstery fabric. These, too, had an illustrious pedigree, having once belonged to the king of Sweden and, later, to J. P. Morgan. To complete the décor, Duveen supplied authentic Louis XV side tables, additional chairs, and other appropriate items to the tune of $45,000.[11]

AROUND 1500, AN unknown patron celebrating an unknown event ordered a set of tapestries from a Brussels atelier. The subject was the hunt of the unicorn. The initials AE that appear throughout the tapestries and those of FR, which appears on only one, add to the mystery of the original commission. By 1680, the "Unicorn Tapestries" belonged to François VI de la Rochefoucauld, a French nobleman, and they'd remained in his family ever since. The tapestries survived the French Revolution, even though it is believed that for decades they were used to shield winter vegetables and fruit trees during frosts.

In 1923 the current count de la Rochefoucauld sold the tapestries to Edouard Larcade, a Parisian dealer. Learning of their availability, architect Welles Bosworth alerted John D. Rockefeller, Jr., who promptly requested and received a set of photographs and a letter explaining that the tapestries from the Château de Verteuil were, according to "three leading curators of the Louvre Museum . . . the most beautiful and rarest tapestries of the 15th century that exist."[12] Larcade, who planned to bring the tapestries to New York and exhibit them at the Anderson Gallery, had prepared an elaborate brochure whose facts were at slight variance with later research.

Gothic tapestries are amongst the greatest glories of mediaeval art
. . . They become rarer and rarer in the world's art market . . . The

famous set of the Unicorn now in the Cluny Museum in Paris [the city's preeminent medieval museum] is generally cited as one of those masterpieces of beauty that may be coveted but never possessed by the modern collector.

If someone were to say that in a remote castle he had discovered a series of tapestries thickly interwoven with gold, more beautiful in design and richer in quality than the Cluny series, everyone would be tempted to smile at him. Yet fairy tales sometimes come true. Another superb set of mediaeval tapestries: "*The Hunt of the Unicorn*," has now actually been brought to America. It had been hidden for centuries in the Castle of Verteuil; in France, the ancestral seat of the de La Rochefoucauld family . . . The de La Rochefoucaulds were extremely jealous of their priceless possession. A few cognoscenti knew of their existence, but the family never allowed any photographs or descriptions to be published, not wishing, for various reasons, to disclose the secret of such a treasure . . . They were acquired by M. Larcade only a few weeks ago, and were immediately brought to this country by their new owner . . .

The mythical unicorn is a symbol of purity and believed to be a stand-in for Christ. Legend has it that only an innocent maiden can capture the majestic animal. The de la Rochefoucauld tapestries were reputed to be even more beautiful than those of the Cluny, and their arrival in New York was awaited with great excitement.

Junior saw the tapestries before they went on public view. After a brief glance he knew that he wanted them, and after some negotiation, they were his. By the time they arrived at 10 West Fifty-fourth Street, however, the brownstone was overflowing with possessions. Fortunately, the house at 12 West Fifty-fourth Street was for sale. Once it was acquired, the two houses were linked and there was additional space for rugs, tapestries, Chinese porcelains, and other spectacular objects. The Unicorn Tapestries were once more sequestered in a room of their own. Here Junior liked to retreat and study the tapestries' myriad details.

Junior's taste was well defined and unwavering, but Abby's was constantly expanding and changing. Just when she had persuaded her husband to accept art that distorted perspective or explored the uglier aspects of life, she fell in love with modern art. Visiting galleries in New York and elsewhere in her travels was a favorite pleasure. Unlike her husband, she was very thrifty in her purchases. Her husband's dislike for some of modern art's emotionally unrestrained, expressionistic spirit was such that the couple agreed that the art she acquired should be kept out of his sight—although he and Abby both developed a taste for South Asian art—which was not much of a problem in such a large house.

While Mr. and Mrs. Rockefeller saw to it that their priceless objects did not overwhelm the atmosphere of the house, the place was nevertheless extremely luxurious. A series of photographs taken during the late 1930s shows an eclectic mix of European paintings, Chinese porcelains, Asian art, medieval carvings, rugs, tapestries, and great furniture. A rare sixth-century bodhisattva statue created during the T'ang period and surrounded by plants welcomed visitors in the front hall. A lionskin rug, head and all, added an incongruous note to the peaceful image. Elsewhere there was another smiling, almost mischievous bodhisattva. Paired with an admiring monk, he sat on a shelf, one leg tucked under his robes. Imposing stairs, hung with small prayer rugs, led up to the parlor floor. The full-length portrait of *Lady Dysart*, by Sir Thomas Lawrence, the largest painting in the house and one of Junior's favorites, dominated the dining room. Most of the other paintings were small and delicate. Mr. Rockefeller's beloved porcelains were everywhere.

BY THE LATE 1930S, the Rockefeller children had left their childhood home, and 10 West Fifty-fourth Street had become too cumbersome. The Rockefellers decided to move to an apartment at 740 Park Avenue, and to do so, they had to divest themselves of some of their possessions. The move was planned like a military operation. Lists were made of the contents of

each room and, in his orderly fashion, Junior penciled in the destination of various objects. Some went to their children, some to the new apartment, some to the Kykuit basement. Some small and large items were sold. John D. Rockefeller, Jr., had already donated his beloved Unicorn Tapestries to The Cloisters, but the *Months of Lucas*, eventually destined for the Metropolitan Museum's main building, were moved to Park Avenue. Some pictures and precious belongings reached their final destinations in museums, schools, and other institutions. Thereafter, the houses at 4 and 10 West Fifty-fourth Street were demolished. The contents of three rooms of Senior's house were moved to the Brooklyn Museum and to the Museum of the City of New York.[14] The land, including the yard that separated the two houses, was given to the Museum of Modern Art, which turned the space into the Abby Aldrich Rockefeller Sculpture Garden, one of Manhattan's best-loved oases.

The neighborhood, which had been so sparsely settled when Senior bought his house in 1885, was now a busy part of midtown. Along with St. Luke's Hospital, the mansions of the other multimillionaires had vanished. Rockefeller Center, which had loomed over the Rockefeller houses from the 1930s on, was now obscured by other high-rises.

Before leaving, Junior sent photographs of the interior of his personal domicile on Fifty-fourth Street, and a complete catalogue of his Chinese porcelains, to Theodore Hobby, who had helped him assemble his stellar collection. On January 29, 1937, Hobby wrote:[15]

Dear Mr. Rockefeller:

I cannot tell you how much I appreciate you sending me the photographs of your rooms. The albums [catalogues] containing your porcelains are one of my most cherished possessions and I shall keep the views of your rooms with the albums.

When I think of you leaving No. 10 a feeling of regret always comes over me because I always associate you and your collections with that beautiful house. At the same time I am looking forward

with much interest to seeing your new apartment. The actual moving will be quite a task but it will be interesting to plan and arrange the rooms.

 Again my grateful appreciation of your kind thought.

 Theodore Hobby

In 2002, when MoMA underwent its $850 million rebuilding and expansion, the ground along Fifty-fourth Street that once supported the Rockefeller houses, other brownstones, and the Dorset Hotel was excavated to a depth of fifteen feet. Mark Dion,[16] an artist specializing in rescue archaeology, sifted through the freshly uncovered debris. He found sections of fireplaces, cornices, a pillar, moldings, crockery shards, wall fragments with and without wallpaper, pieces of marble, buttons, electric condensers, and much more. Dion selected part of these components for display in "treasure chests" and assemblages that link the past to the present. The finished work, entitled *Rescue Archaeology: A Project for the Museum of Modern Art*, brings us close to the time when the Rockefellers were enjoying their treasures and when the houses on Fifty-fourth Street were filled with life, art, and music.

2

To the Glory of God

WILLIAM AVERY ROCKEFELLER (Big Bill), an itinerant ped-
dler, always had a trick up his sleeve. So when he knocked on
the door of the Davison farmhouse in Richford, New York,
he pretended to be deaf and dumb. Even so, he charmed the god-fearing,
good-looking twenty-four-year-old redhead who opened the door. In 1837,
against the advice of her father, she consented to marry him. A year later,
Eliza gave birth to Lucy. John D. Rockefeller (Senior), the second of their
six children, was born on July 8, 1839.

Marriage did not reform Big Bill. He engaged his mistress as a house-
keeper and took months-long business trips, during which he hawked
"snake oil" and posed as a herbal doctor. Every so often he returned home
with dapper horses, fine clothes, plenty of cash, and tall tales. In 1853 he
moved Eliza and their children to the outskirts of Cleveland, then a fast-
growing frontier town. By then he had met a seventeen-year-old maiden,
assumed another name, and was about to engage in bigamy. Two years
later he informed his eldest son that it was up to him to support Eliza and
his siblings. At sixteen, Senior became the effective head of the household.

Senior was as devoted to Eliza as Big Bill had been negligent. He had
hoped to go to college and perhaps become a Baptist minister. Instead,
he attended a short business course and, on September 26, 1855, a date he

would celebrate for the rest of his life, started clerking and bookkeeping for Hewitt and Tuttle. Within a few years, Senior and a partner founded their own commodities commission firm. They were in the right place at the right time. In 1859 the first successful oil well was drilled in Titusville, Pennsylvania. Four years later, Senior invested some of his hard-earned cash in a minuscule oil-refining venture. Soon the plant grew, becoming Cleveland's largest and, within a few years, the largest in the world.[1]

Religion was a dominant factor in Senior's life. At fifteen he joined Cleveland's Erie (later Euclid) Street Baptist Church. He loved its mostly blue-collar congregation, its hymn singing and rousing sermons. He swept floors, lit lamps and fires, kept the church's books, ushered, and, even when he was relatively poor, donated money. Later, when he became rich, he believed that God had chosen him to be a conduit for the distribution of wealth. The church remained the center of Rockefeller's social life. Baptist ministers, missionaries, and temperance advocates would always be welcome at his homes. He set great stock by their wisdom and integrity and hired many as business associates and advisors.

During his short high school attendance, Senior had met Laura Celestia (Cettie) Spelman. Her parents had made their home available as a stop on the Underground Railroad, and they were enthusiastic temperance advocates. Cettie had been valedictorian of her high school class, and her speech, "I Can Paddle My Own Canoe," alluded to her feminist beliefs. While attending junior college in Massachusetts, she did some writing. Ironically, in view of her destiny, her essays derided New York's nouveaux riches and parvenus and deplored the power of the dollar and of Wall Street. Thereafter, she taught in Cleveland, a post she had to resign when she accepted Senior's marriage proposal. The couple was extremely compatible, believing in education, thrift, aiding the poor, and adhering to the dictates of the Northern Baptist convention.[2]

On January 29, 1874, after the birth of four daughters, Cettie finally delivered the hoped-for male heir. By the time John D. Rockefeller, Jr., was born, the family was living on Euclid Avenue, Cleveland's most elegant thoroughfare, and also owned Forest Hill, a rambling old hotel located

on the outskirts of town. Eventually that property would encompass over seven hundred acres.

His mother and sisters dominated Junior's childhood. He was extremely timid and had few male companions. An austere spirit, with emphasis on service to God and humanity, dominated the parsimoniously run household. Junior wore his sisters' refashioned old clothes. He learned to cook, sew, and iron, skills that would amuse his classmates when he practiced them later at Brown University.

Senior ruled Standard Oil, but Cettie ruled the house. As she aged, her religiosity grew, and she fanatically adhered to her interpretation of a strict Baptist lifestyle. The Sabbath, devoted to the worship of God, was the highlight of the week. On that day, recreational reading, games, sports, and secular music were prohibited; Sunday supper was cold, so that the help avoided violating the sanctity of the day. In the evening, Cettie delivered a "home talk," in the course of which she and the children reviewed their week and examined ways in which they had sinned against God.[3]

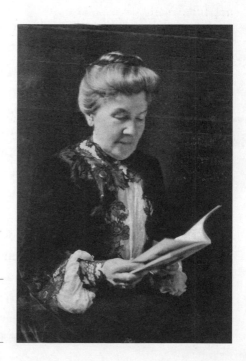

Laura Celestia (Cettie) Spelman Rockefeller. (Courtesy of The Rockefeller Archive Center)

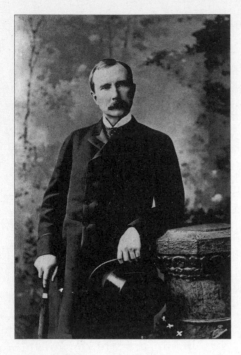

John D. Rockefeller, Sr. (Courtesy of
The Rockefeller Archive Center)

Junior never rebelled against his mother's stern dictates, and he absorbed her faith. Religion would sustain him for the rest of his life. Early on he realized how much his parents expected of him, the only male heir. No wonder he turned out to be an over-conscientious perfectionist.

Fortunately Junior knew that he was immensely cherished. His parents accepted his psychosomatic ills, headaches, and stomach upsets, never wavering in their love for their only son, and letting him find his own way of handling the family fortune and the responsibilities it entailed. From childhood on, Junior exhibited a strange combination of self-doubt and self-assurance. Father and son formed a special bond. As Junior recalled years later, "To my father I owe a great debt in that he himself trained me in practical ways." The two discussed business, and Senior taught him to be circumspect and competent.[4] It was a given that Junior would join his father's business, and even after he married he continued to live next door to his father both during the week in Manhattan and during weekends on a tightly guarded estate in Westchester. Even when they saw each other

daily, the two corresponded. The habit of putting important thoughts in writing became a Rockefeller hallmark. Later, when his own sons were grown, Junior asked them to put their requests on paper, and to schedule "conferences" to discuss important matters face-to-face. The practice reinforced the emotional distance between him and his children. Even Abby wrote to her husband when she wanted to make a point. Both she and Junior employed full-time secretaries and constantly dictated letters addressed to family, friends, associates, and others. Abby's letters to her children, written from the time they were very young, were full of maternal concern. She condoled with a young Nelson about the death of a litter of rabbits, and later, when he was in college, she reminded him to drink milk and sleep as much as he could.[5]

Even after the senior Rockefellers moved to New York, they never joined high society. Their residence on Fifty-fourth Street was north of Manhattan's most fashionable neighborhood,[6] and they worshiped at the nearby Fifth Avenue Baptist Church, where Cettie, daughter Alta, and eventually Junior taught Bible classes.

In Cleveland, Junior was tutored, but in New York he attended a series of small private schools. He was a good student, sometimes overexerting himself to achieve a 98 percent average. In 1891, whether from overwork or other stresses, he had the first of several nervous collapses. He and his mother spent the winter at Forest Hill, the family estate in Ohio, where Junior cut wood, built roads, and collected maple syrup.[7] Looking back on those years half a century later, he characterized himself as a "shy, ill-adjusted, not very robust" young man. After his solitary winter in Cleveland, he enrolled in the nearby Browning School, on Sixty-second Street, and grew extremely fond of the school's director, describing him as a "gifted teacher, who inspired interest in learning." Junior had a definite knack for finding a series of inspiring mentors and, later in life, loyal and capable collaborators.

Junior searched for an appropriate college in his usual systematic, tortured manner. He consulted William Rainey Harper, president of the University of Chicago and his father's protégé, telling him that he did "not

make friends readily," and feared that if he went to a larger university such as Yale he would be "lost in the crowd . . . and remain much by myself, instead of getting into the social contact I so badly need."[8]

In the end, Junior wisely selected Brown University. Elisha Benjamin Andrews, the Baptist minister who headed Brown, became an inspiring mentor. For Junior, college proved to be a liberating, normalizing experience. Much to his mother's chagrin, he learned to dance, and though he himself did not smoke or drink, he tolerated these "vices" in others. Junior made some life-long friends at Brown. His classmates, who affectionately called him Johnny Rock, accepted his peculiarities, including the lengthy auditing of dinner checks, or small economies such as fixing frayed shirt cuffs, salvaging postage stamps, and pressing his pants by sleeping on them. Well aware of his awkwardness and social isolation, Junior joined a fraternity, a glee club, a mandolin club, and a string quartet, and managed the football team. He mastered his fear of public speaking by accepting every opportunity to do so, even appearing in a college operetta and teaching a Sunday school class in Providence.[9] During his junior year, his class elected him president and he made Phi Beta Kappa. Most important, he met Abby Greene Aldrich, the bubbly, popular daughter of Rhode Island's senior senator.

Brown broadened Junior's outlook. He took more than a dozen social science courses in which he examined America's increasingly complex labor relations and studied Thomas Malthus's essay on "unprecedented" population growth. A generation later, a third John D. Rockefeller would also study Malthus, at Princeton, and, during the 1960s, become America's "Mr. Population." Another of Junior's courses dealt with Karl Marx's *Das Kapital.* Brown president Andrews, and his views on how to solve the world's social and economic problems, impressed Junior deeply. Brown University's governing board, however, questioned their president's liberal ideas, and Andrews resigned in 1898.[10] However, as far as Junior was concerned, the older man's ideas had fallen on fertile soil, and would influence Junior in the years to come.

After college, Junior took up his duties in the Standard Oil Building at 26 Broadway. From the very first, he did not work for the oil com-

John D. Rockefeller, Jr. (Courtesy of The Rockefeller
Archive Center)

pany proper, but for his father, in a separate three-room suite devoted to
the management of Senior's large fortune and manifold philanthropic
enterprises.

During the last decades of the nineteenth century, America's laissez-
faire attitude was changing. The public, aided by the press, became infu-
riated by the ruthless business practices of the "robber barons," and the
hands-off policy of the government with regard to them. Labor started
to organize. On October 5, 1882, one hundred thousand workers marched
from New York's City Hall to Union Square. Four years later, a rally in
support of striking workers at Chicago's McCormick Harvesting Machine
Company ended in the bloody Haymarket Riot. That same year marks
the founding of the American Federation of Labor. Ten years later, the
country entered a major economic slump. The stock market crashed, re-
sulting in panic and an economic crisis.[11] The ensuing turmoil enabled
Standard Oil to consolidate its oil monopoly, and Senior became the epit-
ome of the bad guy.[12]

"The History of the Standard Oil Company," serialized in *McClure's
Magazine* in 1902, fueled much of this antagonism. In nineteen install-
ments, Ida Tarbell, a gifted journalist who partly was avenging the loss

of her father's small oil refinery,[13] detailed Standard Oil's collusion with the railroads, its effective oil price rebates and hikes, and its other devious measures. The public's ire was additionally stoked by Senior's professed piety, unprecedented wealth and parsimony, and by his refusal to defend himself or be interviewed by Tarbell, the last seeming like a tacit admission of guilt. In spite of these charges, truthful or not, Junior revered his father. Early on, he must have resolved to subjugate his own life to Senior's. He was deeply hurt by all the attacks aimed at the Rockefellers, and once in a while he even decided to counterattack.

Senior felt increasingly burdened by the management of his personal wealth, the affairs of the Standard Oil Trust, and the ever-increasing need to give away some of his money. He could not bear donating money unless he was convinced that the cause was justified. Until 1889, his donations had been small, but that year the American Baptist Education Society asked him to underwrite a new Baptist university in Chicago. In the course of these negotiations, Senior met with Frederick T. Gates, another young Baptist clergyman, and offered him the job of personal assistant and almoner. Senior could not have made a better choice. Gates became a gifted architect of Rockefeller philanthropy, and an excellent steward of the family's wealth.

When Junior entered the family business, his father was in the process of retiring, and it was Gates who helped the young man find his way in the complex Rockefeller empire. By then, molded by Brown University and his mother's ethics, Junior was becoming his own man. Brown had taught him a sense of social responsibility that differed from that of his father and Frederick Gates. Almost as soon as he arrived at the family offices, he discovered that he disliked business and decided to devote himself to philanthropy. By the time he was forty, he had resigned from most of the companies in which the Rockefellers had a financial stake. He secularized Rockefeller donations. He was opposed to palliative solutions and, together with Gates, created institutions designed to eradicate some of the evils of modern society. Within a short time, Senior, Gates, and Junior had founded the Rockefeller Institute for Medical Research (1901), the General

Education Board (1903), the Rockefeller Sanitary Commission (1909), and the Rockefeller Foundation (1913).

Unfortunately, Junior had hung on to the Colorado Fuel and Iron Company (CF&I) in which Senior had bought a 40 percent interest in 1902. A decade later, the company was still operating in the red, and Junior hoped to turn it around before selling it at a profit. Working conditions at CF&I were unsafe and exploitative: long hours, low wages, company housing, and company stores. For years the United Mine Workers of America had attempted to unionize the workforce there. Senior and Gates were violently opposed to unions and relied on La Mont M. Bowers, their local Colorado manager, to enforce their stand. Even though unrest prevailed at CF&I, Junior, now in charge, relied on the, as it turned out, untruthful reports of Bowers. The situation escalated, and on September 26, 1913, nine thousand workers went on strike. The CF&I evicted the miners from their homes, and the latter hastily moved to set up tent colonies. Both the Colorado National Guard, charged with restoring order, and the miners carried arms.

The strike was gathering national attention. In April 1914, the House Subcommittee on Mines and Mining summoned Junior to testify about the Colorado strike. He defended his father's anti-union stance. His congressional presentation revealed that the Rockefellers were absentee owners and ill informed about the actual state of affairs in Colorado. Junior's parents, however, were jubilant about their son's unyielding performance, and Senior rewarded his son with a gift of ten thousand shares of CF&I stock. Two weeks after Junior's testimony, gunfire broke out at Ludlow, the site of one of the tent colonies. Thereafter, guardsmen torched the tents, which resulted in the death of two women and eleven children.

The nation, which by then had largely forgotten about the Rockefellers and their rapacious business practices, became incensed. Now pickets surrounded Standard Oil headquarters, the Rockefeller residences in Manhattan, and their country estate at Pocantico Hills. The favorable publicity Junior and Gates had garnered was evaporating.

Junior, encouraged by Abby, started to doubt the veracity of manager

Bowers's reports, and he embarked on his own fact-finding mission. He also contacted W. L. Mackenzie King, a Canadian labor relations expert, who helped him emerge from the Ludlow quagmire. King, who in time became Junior's best friend, also helped him jettison his father's narrow view of capitalism. Junior's next testimony before a congressional committee even included a mea culpa. It took months, however, to bring about a peaceful solution of the CF&I dispute. In September 1915, Junior, accompanied by King, traveled to Colorado on a peace-making mission, which turned into a personal triumph for him. In his letter to Abby, King predicted that the results of the visit would be "epoch-making in his [Junior's] own life. . . . From now on he will be able to devote his time to advancing vast projects . . . without being thwarted at every step by . . . the voice of popular prejudice."[14] Junior was extremely grateful to King, writing him that without him "I would have failed to accomplish much that you have made possible."[15]

Ludlow marked a turning point in Junior's career. From then on, and even though he continued to avail himself of the opinion of many experts, he realized that in the end, he had to rely on his own judgment in matters of business. Junior appears to have had a cordial rapport with his collaborators and advisors, as opposed to the strained relationship he often had with his children. He had very high standards for himself and others. He was an extremely disciplined perfectionist, very appreciative of a job well done. Often, mostly because he was shy, he appeared overbearing and distant. Few, if any, of his adult friendships progressed to a first name basis. He harbored certain inconsistencies. He spent millions but pinched pennies. Ludlow had made him aware of the inequities of the world, and he became a spokesman for new, more equitable industrial relations, yet he stinted on the benefits granted his household staff.[16]

Junior always preferred work to play and befriended those with whom he shared a common interest, such as Dr. William A. R. Goodwin, the moving spirit behind the Colonial Williamsburg reconstruction; James J. Rorimer, with whom he built The Cloisters; Dr. James Breasted, whose archaeological work he funded; and Theodore Hobby, his advisor on Chinese porcelains.

The relationship with his beloved father had been formal, and the rapport with his children, especially Babs and John 3rd, was strained. The major exception was the continuing romance with his wife.

THROUGHOUT HIS LIFE Junior remained devout. For years, much to the merriment of the press, he insisted on teaching the Men's Bible class at the Fifth Avenue Baptist Church. Sometimes he tried to explain that being wealthy was not necessarily a panacea. At an unknown date he drafted a speech entitled "The Difficulty Inherent in the Job of Being the Only Son of a Very Rich Man."[17] The preparation for his Bible classes took up several evenings a week, and delivering the lessons was stressful. Abby, and Gates, suggested that he quit, and he finally did in 1908. He continued his leadership role at the Fifth Avenue Church, however, which in 1922 moved to Park Avenue, adopting the name of that thoroughfare.

During the 1920s the Northern Baptist Convention was torn asunder by a rift between the fundamentalists, who wanted to continue adhering to rigid Baptist rules, including baptism by total immersion, and reformers who advocated liberalization of the Church's practices. Harry Emerson Fosdick, then America's most popular and dynamic preacher (and brother of Junior's later biographer Raymond B. Fosdick), spearheaded this latter faction. Junior was one of Fosdick's ardent disciples, and he became the major financial supporter of the newly formed Interchurch Movement.[18]

When Cornelius Woelfkin, a liberal Baptist minister, was about to retire from the Park Avenue Baptist Church, Junior tried to persuade Harry Fosdick to succeed him. He resisted. In his memoirs, Fosdick recalled that during the wooing period, when he once more refused the pulpit, Junior demanded to know why. Fosdick replied that he "did not want to be known as the pastor of the richest man in the country." Junior countered by asking Fosdick whether he did not think that fewer people would criticize him on account of Junior's wealth than would criticize Rockefeller on account of Fosdick's theology.[19] Harry Emerson Fosdick eventually accepted the job, provided certain conditions were met. These

included liberalization of the baptismal ceremony, enlargement of the congregation, and relocation of the church to a less elitist neighborhood.[20]

With the consent of the congregation, Junior planned the relocation of the church to Manhattan's Upper West Side, adjacent to Columbia University, the Union Theological Seminary, and the International House. The last, another Rockefeller creation, was designed to promote the interaction of American and foreign students.

One can only imagine how much pleasure Junior derived from planning the new church. He assumed the chairmanship of the building committee and, as usual, involved himself in the execution of every minute detail. As a child he had been entranced by the lights that shone through the stained-glass windows of St. Patrick's Cathedral, visible from the hotel suite his parents had rented during the family's initial New York winters. Later, when traveling in Europe during his college years, he had fallen in love with its Gothic cathedrals. The spire of Salisbury and the light streaming through the stained-glass windows at Canterbury and Winchester were among his fondest memories. Though he retained an open mind as to the ultimate design of the future Riverside Church, he was predisposed toward Gothic architecture.[21]

THE FLOWERING OF the cathedrals of Europe during the twelfth century is one of art history's most extraordinary chapters. By that century, architects had discovered that by supporting the exterior of their churches with flying buttresses they could reduce the thickness of the walls and build larger, taller edifices with airy interiors. Rounded Romanesque arches gave way to pointed Gothic ones, and large windows flooding these sanctuaries with light.

Along with the architecture, sculpture also flourished during this period. Statues, draped in sinuously flowing robes, became more realistic, their anonymous creators endowing their faces with deep humanity. Stained glass was the other art form that reached unparalleled heights during the Gothic era. Artists assembled carefully cut pieces of jewel-

toned glass into translucent pictures. Once in place, the windows filtered the sunlight, filling the church with patches of color, their images teaching nonreaders the tales of the Old and New Testaments.

At the time, not everyone was happy with this novel building style, then referred to as *opus modernum*. A few centuries later, Renaissance writers who felt that the style violated the classic standards established by the Greeks and Romans disapprovingly called it "Gothic," a reference to the uncouth Goths who had invaded the Roman Empire from the third to the fifth centuries.[22]

It took Rockefeller some time to assemble the building site for the new church. In the end, however, he controlled two entire blocks between 120th and 122nd Streets, and Riverside Drive and Claremont Avenue. The site, high above the Hudson River, was magnificent. Leading architects were consulted about the design of the new church. Specifications included a large auditorium to seat twenty-five hundred people, a tower rising to a height of three hundred or more feet, several chapels, offices, and rooms for community activities. Above and beyond these essentials, the building and its interior had to have beautiful proportions, dignity, and finesse.

Junior was in a big hurry to start building his cathedral, and he gave the competing architects only about four weeks to come up with a suitable floor plan, rough sketches, and a small model. Charles Collens's team submitted the winning Gothic-style design. Taking the site into consideration, Collens aligned the long axis of the church with Riverside Drive, located the tower at the south end, and pierced its west façade with an imposing portal, which was to be the main entrance. Auxiliary buildings, including a small cloister and its garden, were aligned along Claremont Avenue. A few years later, Collens's ability to visualize a building on its site would earn him the contract to build Junior's Cloisters Museum, located some seventy blocks north of Riverside Church. Junior engaged Marc Eidlitz and Son as general contractor. The firm had previously built the Park Avenue Baptist Church and the International House.

It had taken decades, sometimes centuries, to build the European cathedrals similar in size to Riverside Church. Junior and his team

would do so in fewer than five years. The cornerstone of the new church was laid on November 20, 1927. A major fire on December 21, 1928, which destroyed part of the nave and caused $2 million worth of damage, slowed progress. Still, Riverside Church would open as planned in the fall of 1930.

Like medieval cathedrals, Riverside Church was to be richly ornamented. Its details and overall design were copied from the cathedral at Chartres and other European churches. Rockefeller hired Robert Garrison to do the modeling for "exterior and interior stonework" at a fixed salary of $750 a month. By then Garrison was a well-known award-winning sculptor. Rockefeller also hired the six, now mostly forgotten, Piccirilli brothers. Theirs is a typical immigrant saga. Giuseppe, an accomplished stone carver, came from Massa, a village near Italy's famous Carrara marble quarries. Having trained his six sons, he arrived in New York in 1888 with his family and set up a sculpture studio in the Bronx, which eventually became the biggest such enterprise in America.

Before the Piccirillis' arrival in America, sculptors used to have to send their models, or maquettes, to Europe for enlargement and actual cutting; now sculptors such as Daniel Chester French and Augustus Saint-Gaudens used the Piccirilli studio. French's 150-ton statue of a seated Lincoln, destined for Washington, was actually carved in the Bronx. The Piccirilli brothers, in particular Attilio, a sculptor in his own right, had carved the lions guarding the entrance to the New York Public Library, the USS *Maine* Memorial on Columbus Circle, and the statuary ornamenting the U.S. Customs House in downtown Manhattan.[23] The Piccirilli studio was a social gathering place for Italians and Italian Americans, with Enrico Caruso and Mayor Fiorello La Guardia being frequent visitors. Both Robert Garrison and the Piccirilli brothers were to be part of Junior's next major enterprise: Rockefeller Center.[24]

The stone and wood carvings at Riverside Church are impressive, though they in no way rival the geniality of medieval sculptures. The church's west entrance, based on the royal portal of the cathedral in Chartres, is traditional in concept. Like elsewhere in the church, the carv-

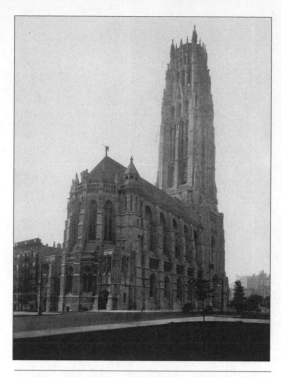

The Riverside Church in Morningside Heights during the 1930s. (Courtesy of The Rockefeller Archive Center)

ings—about 125 individual figures—represent religious, historical, and contemporary figures. Albert Einstein and Charles Darwin, the bête noire of fundamentalists, are among them. Christ in Majesty, surrounded by an angel, a lion, a bull, and an eagle, the symbols of the four evangelists, occupy the top of the tympanum. Elsewhere, gargoyles, monsters, animals, and angels, lurking in unexpected places, relieve the moral seriousness of the edifice. As in Chartres, a large smiling angel stands atop the roof of the nave, trumpeting a message to the world.

The interior is sumptuous. Fifty-one stained-glass windows are its major decoration. Ten windows are actual copies of those in Chartres. Some of these illustrate the crafts of the guilds that paid for their creation way back in the thirteenth century. Rose windows are set above the clere-

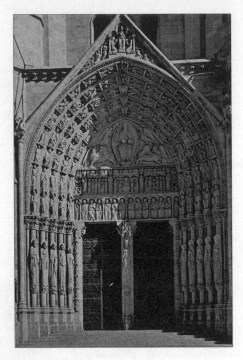

*The design of the west portal of
Riverside Church, like much else, is
based on the entrance of Chartres
Cathedral in France.* (Courtesy of The
Rockefeller Archive Center)

story (upper-level) windows in the nave. Some windows were fabricated in
France; others, in the United States. Junior personally journeyed to Boston
and Philadelphia to check on their execution.[25] A few of the windows,
especially the rose window made by D'Ascenzo of Boston, did not meet
Junior's exacting standards, and required adjustment.[26]

Music, so important to Cettie Rockefeller, is a crucial ingredient of
most religious services held at Riverside Church. Junior commissioned a
magnificent organ—the sixth largest in the world—for the church, the
acoustics of which turned out to be magnificent. Riverside has a single,
squat, 392-foot tower, and twenty-four floors that provide offices for the
congregation's many programs. Junior dedicated the tower, and its caril-
lon, to his mother. The carillon had been built five years earlier, for
the Park Avenue Baptist Church. It was moved from there to Riverside
Drive, most of the bells taking a side trip to Holland for recasting. Later,
the carillon grew to seventy-two bells, the smallest weighing ten pounds,

the largest (the Bourdon Bell) weighing twenty tons. It is the largest bell ever cast, the centerpiece of the world's biggest carillon.

Before the official opening of the church, Junior, wearing his chairman of building committee hat, held a celebratory dinner for those who had helped him realize his dream. Once again the citation illustrates his appreciation of a job well done:[27]

> *To Charles Collens* . . . one of the architects of Riverside Church and its creative genius whose work combines to an unusual degree the practical with the idealistic.
>
> *To Harry C. Pelton* . . . delightful to work with, a man of endless patience; untiring in his efforts to achieve the best results. This reminder of happy years of service together in a great undertaking is given with appreciation and gratitude by his friend.
>
> *To Robert W. Eidlitz:* Builder of the Riverside Church, capable, and experienced, practical, yet keen in his appreciation of beauty.
>
> *To Frederick C. Mayer:* Carillon expert who combines a highly analytical and scientific mind who has made this carillon the greatest and finest instrument of its kind ever conceived or created.
>
> *To Robert Garrison* for his ability as an artist, sculptor and carver.

In February 1931, Riverside Church organized a testimonial dinner for Junior, who, in the words of Harry E. Fosdick: "loved the new edifice into being."[28] Speaking for the Board of Deacons of Riverside Church, Mr. Bestor said:[29]

> Mr. Rockefeller has been a member of this church since 1901. This church therefore has been responsible for his conduct and reputation for more than half of his lifetime. . . . [It] never put any task upon him which he did not carry . . .

Of what Mr. Rockefeller has meant in all his plans for this new enterprise no one person will ever know. Dr. Fosdick, as minister of the Church knows part of the story; the architects and all those concerned with the building will have another story; the Building Committee, associated closely with Mr. Rockefeller all these months, knows something of Mr. Rockefeller's constant attention to every detail and his indispensable wisdom and leadership in connection with the creation of this building. If it were possible to bring all these stories together we should then have a partial record of Mr. Rockefeller's services, which we are attempting to evaluate on this occasion.

I am inclined to think that we should know something of the spirit in which he has given himself to this work if we read the words which he composed and placed in the narthex with respect to the carillon:

In loving memory of my Mother, Laura Spelman Rockefeller 1839–1915, whose gentle kindly spirit and steadfast devotion to Christ and His cause, in association with this Church will ever be an inspiration, this Tower and Carillon are given

John D. Rockefeller, Jr., Anno Domini, 1930

During his lifetime, Junior indeed spent thousands of hours working for Riverside Church and for two of its prior incarnations. His cash donations exceeded $32 million.

FOR THE OPENING services on October 5, 1930, six thousand people crowded into Riverside Church. They entered through the ornate west portal[30] into the large narthex (vestibule) and from there into the opulent 215-foot-long marble and limestone nave. Now as then the solid oak pews are inviting, and the richness of imagery commands reverence. On a sunny day, colored light filters through dozens of stained-glass windows.

Fosdick's pulpit—it alone weighs nine tons—is covered with carv-

ings. These represent prophets—even two women, Anna and Miriam, were included—and small models of ten Old World cathedrals. A wooden canopy, shaped like the lacelike spire of a medieval church, surmounts the pulpit. A large lectern surmounted by an eagle stands in the middle of the chancel. As in Europe, the stall seats are enriched with elaborate carvings. The large reredo (chancel screen) honors eighty men and women who enriched the world. These are subdivided into seven groups highlighting the specific contributions made by physicians, teachers, prophets, humanitarians, missionaries, reformers, and artists.

A labyrinth, adapted from the larger one found in Chartres, is embedded in the floor of the chancel. Some historians believe that it stands for the Via Dolorosa, Christ's route to Calvary; others believe that women and children, excluded from pilgrimages and crusades, followed the tracings of the labyrinth as a substitute journey.[31]

In addition to the large nave, Riverside Church has several small chapels. The most beautiful of these is Christ Chapel, patterned after the eleventh-century church of St. Nazaire in Brittany. The round Romanesque arches contrast beautifully with the Gothic style of the church as a whole. The chapel is lit by its own rose window and reredos, executed in the simpler Romanesque style.

A small, enclosed cloister is located on the east side of the church, which abuts Claremont Avenue. Its most precious inhabitant is Jacob Epstein's *Madonna and Child*, considered one of the artist's greatest works. In Epstein's version of the popular image, the Christ child, about six years old, skinny, and wrapped in a simple shawl, stares with wide-open eyes at the viewer.

Junior took great joy in the beauty of his church, especially in the glow of the stained-glass windows. Before the church was finished he wrote to architect Welles Bosworth:[32]

You will be interested to know that much of the stained glass, both European and American . . . is now in place. . . . We are quite thrilled with the effect which these windows produce, and had not believed

anything so completely in the spirit of Chartres could be done in this country.

Junior was not the only one to admire his church. In 1933 he received a missive from his hardworking contractor Robert Eidlitz:[33]

> It has always been a privilege to be connected with any operation of which you are the head, for you take such a keen interest in everything that it is an inspiration to work under you. . . . To have had a part in erecting the church was an experience such as does not come to everyone, and each time I enter the nave I feel the same thrill—it never seems to get any less. If I can have that sense of ownership for the relatively little that I contributed, what must it mean to you who made it all possible!

UNTIL THE 1920S, buildings in America were inspired by European architecture. Museums, banks, town halls, and other public structures were often copied from Greek and Roman temples, Italian palazzos, or French châteaux. A more contemporary approach to architecture was about to emerge and was already apparent in skyscrapers. In line with this, it is not surprising that the praise for Riverside Church was by no means unanimous.

Walter A. Taylor,[34] professor of the history of architecture at Columbia University, was incensed not only by the church's outmoded style, but by the fact that the builders had used steel beams, which obviated the need for the flying buttresses and other devices that had represented an architectural breakthrough in the thirteenth century. Taylor also chided "Fosdick, Riverside's pastor, who achieved fame by his fearless and aggressive attacks on the conservative and reactionary forces in religion" for preaching in a newly built church that spoke with the voice of the thirteenth century. Taylor also wondered how the sculptors of doorways felt about doing work using medieval techniques and creating "stretched saints" for

the doorways. Lewis Mumford, the powerful architectural critic of *The New Yorker*, who later would give Junior a hard time during the construction of Rockefeller Center, was also unhappy, calling the church a "leaden, dead colossus like the Federal Courthouse in Lower Manhattan." Other critics lauded the simple proportions of the great nave and were impressed by the size of the twenty-two-story tower.

In the July 1931 issue of *The American Architect*, Charles Crane,[35] a member of the architectural firm that designed the church, explained that they'd made it Gothic because the style had proved to be reliably suited for ecclesiastic buildings, whereas new styles, as used in the Empire State, Chrysler, and Daily News buildings, were still considered controversial. He pointed out that, after twenty-five years, New York City office buildings were considered obsolete, whereas the builders of Riverside Church hoped it would last one hundred.

Though it has not achieved the patina and perfection of the Old World cathedrals it tried to emulate, Riverside Church is still beautiful, providing, as Fosdick hoped, beauty and harmony that enhance the experience of the religious service.

A Passion for Asia

LIKE JOHN D. ROCKEFELLER, SR., Nelson Aldrich was a self-made man. Born in Rhode Island, he began clerking for the state's largest wholesale grocer when he was seventeen. Four years later, in 1862, he enlisted in the Rhode Island National Guard and fought in the Civil War. Discharged after contracting typhoid fever, he returned to his job in Providence and prospered. In 1864 he fell deeply in love with nineteen-year-old Abby Pearce Chapman, and the couple married in October 1866.

Nelson Jr. arrived in September 1867; Lucy and Edward followed in rapid succession. Four years later their firstborn died, a tragedy that plunged his father into such deep despair that he started to suffer from a series of ill-defined symptoms and questioned the purpose of his existence. To regain his composure, Nelson Aldrich embarked on a solitary European voyage in November 1872, letting his wife deal with two small children, everyday hardships, and her own misery.

Though the Aldriches' correspondence reveals some stress and discontent, his letters are mostly love-filled, describing his joy at discovering the splendors of London, Paris, and Italy. He delighted in paintings by Turner and Reynolds. In Italy, he feasted on the legacy of the Roman Empire and the Renaissance. For the rest of his life art inspired him, much as it

*Abby Aldrich Rockefeller standing
next to one of her husband's Chinese
vases.* (Courtesy of The Rockefeller
Archive Center)

would his daughter Abby. He was "quite untutored" to begin with, but
studied paintings assiduously and developed an excellent eye.[1] "His sons
and daughters learned first from him those powers of evaluation and dis-
crimination, which later would mean much not only to themselves but to
others."[2] Nelson Aldrich's taste and judgment were infallible, and beauti-
ful objects—paintings, Persian rugs, and antiques—would fill his homes
in Providence and at Warwick.

Six months after he departed, Nelson Aldrich returned from Europe.
For her parents, Abby Greene Aldrich's birth, on October 26, 1874, marked
a return to peace and harmony. Nelson's voyage had emboldened him to
abandon his lucrative business career and enter politics. After serving in
the Rhode Island legislature, he joined Congress as a representative and
was elected to the U.S. Senate in 1881, where he remained until his retire-
ment in 1912.

During the early 1880s, Miss Asenath Tetlow, succeeded by her sister Fanny, was engaged as governess to teach Abby and her siblings at home and to accompany the family to Washington during the legislative session. The children received a firm grounding in English grammar, American history, German, and the Bible. The Tetlow sisters were Quakers, and their tolerant views would have a deep and lasting influence on Abby.[3]

While the Aldriches were in Washington, Nelson's career dominated family life. In her sporadically kept diary, young Abby wrote, "April 8, 1892: After lunch went into the Capitol and into the Senate. April 11: In the morning went up to the Capitol and saw all the Senators shake hands with Papa to congratulate him. . . . May 6: After lunch we all went up to the Capitol."[4]

These were important years in the history of America. From a backward agrarian country, the United States developed into an industrialized world power. The Civil War had ended slavery, but discrimination against African Americans persisted, as did extreme poverty. The Washington slums were particularly notorious. There is no indication that the squalor she witnessed affected Abby, but in 1923 she wrote this remarkable letter to her three older sons:

> For a long time I have had very much on my mind and heart a certain subject. . . . Out of my experience and observation has grown the . . . conviction that one of the greatest causes of evil in the world is race hatred or race prejudice. . . . The two peoples . . . who suffer most in the country from this kind of treatment are the Jews and the Negroes.
>
> You boys are still young. No group of people have done you personal injury . . . I want to make and appeal to your sense of fair play.[5]

Politics, however, was not Abby's only distraction. There were parties, luncheons, skating, boating expeditions on the Potomac, theater performances, visits to the Corcoran Gallery and the Smithsonian, and there was Nelson Aldrich's social life, which included poker and other card games. Still, the cheerful atmosphere in the Aldrich house was punctu-

ated by sadness. Two more of the couple's eleven children died during childhood. Abby's mother bequeathed her anxiety about illnesses to her daughter, who would ceaselessly fret about her own six children's fevers, paleness, and discomforts. From childhood on, Lucy Aldrich, her older sister, was Abby's closest friend and confidante. Lucy's congenital hearing problem was most likely the reason why young Abby assumed uncommon responsibilities in the Aldrich home. At thirteen, while her parents traveled, Abby looked after her siblings, including eighteen-month-old Winthrop. Since her mother was frail, and disliked the obligatory social life incumbent upon politicians, Abby often served as her father's Washington hostess.

At seventeen, Abby entered Miss Abbott's School for Young Ladies in Providence, studying science, literature, and art history. She did not go to college, but became a voracious, almost compulsive reader. Art books filled her growing library. These, like many of her other possessions, were eventually donated to the Museum of Modern Art.[6]

Senator Aldrich's political career prospered. He assumed the chairmanship of the powerful Senate Finance Committee. Nicknamed "the general manager of the nation," he introduced and championed many long-lasting financial measures, including tariffs that protected U.S. factories and farms, and the levying of income tax. He laid the groundwork for what would become the Federal Reserve Bank. Closer to the topic at hand, he also sponsored the Payne-Aldrich Tariff Act, which exempted older art objects from import duty. Initially the bill profited the rich, but in the end it contributed to the wealth of America's art museums.

Nelson Aldrich favored the interests of big business and grew rich investing in railroads, steel, rubber, and banking. In 1891 he bought an imposing house at 110 Benevolent Street in Providence, and soon thereafter built a lavish 99-room castle on 250 waterfront acres in Warwick, Rhode Island. The press, especially Lincoln Steffens and other contemporary muckraking journalists, criticized Aldrich widely, calling him the "Boss of the U.S." or the "chief exploiter of the American people," and labeling Warwick "the house that sugar built." His daughters were hurt by such

attacks. As a consequence, the sisters avoided displays of wealth, and were prone to buy inexpensive art, such as Japanese prints.[7]

Nelson Aldrich loved to spoil his daughters. As Lucy would recall, "There was nothing that Papa liked so much as to have Abby and me ask him for money for our one best dress each year.... We never chose brown, a color he couldn't tolerate."[8] Clothes, including extravagant, excessively trimmed hats, remained Abby Rockefeller's weakness.

From 1894 on, Lucy and Abby frequently journeyed to Europe. Their art-struck father piloted his family through the galleries of London, Paris, Munich, Florence, and Antwerp. The Aldrich girls were high-spirited and mischievous. Lucy, who never married, remained witty and sharp-tongued, but after Abby married, she became more restrained. Even so, Junior was always somewhat embarrassed by his wife's ebullience. Once, when they were on a trip, Abby reported to her children, "Your father is afraid that I shall become intimate with too many people, and will want to talk to them, so generally we eat in what I call the old people's dining-room, where he feels I am safer."[9]

From 1894, when he met Abby at a dance, Junior became a regular guest at the Aldrich Sunday night soirees, at which the sisters hosted students from nearby Brown University. From then on, the notation "flowers, Abby" appears almost weekly as an expense in Junior's account ledger. "Miss Aldrich" had immediately entranced Junior, but his perfectionism and shyness initially kept him from asking her to dance. He took dancing lessons so that he could partner her elegantly, and dancing soon became one of his favorite pastimes. Later, when the Rockefellers were ensconced in their opulent, enormous homes, they often retired to the privacy of their bedroom to practice new dance steps and indulge in hot chocolate.

After their lavish wedding, Junior and Abby settled into a comfortable married routine. Abby remained Junior's one deep passion. He apparently wrote her fiery love letters, but even though he carefully kept all signifi-cant and trivial papers, he insisted on burning these, judging them to be too intimate. Abby, too, was extremely devoted to her husband. Regard-less of whatever else was going on in her life, she'd drop everything to ac-

company him on his travels. In her numerous letters to her children, she reasserts her love for their sometimes autocratic father. On the occasion of her thirtieth wedding anniversary, she wrote to John 3rd:[10]

> The time has gone by very rapidly because I have been very happy with dear Papa and you children, my heart is overflowing with gratitude for all my many blessings, not least among them is you dear boy.

Junior and Abby had opposite temperaments. He was reclusive, reticent, and exacting. She was ebullient and spontaneous. He was formal and reserved. Abby easily related to others, be they her staff; her children; heads of state; the women living at Bayway, the model community she created near the Standard Oil refinery in New Jersey; Alfred Barr, MoMA's fragile founding director; or her burdened husband. He preferred quiet times; she loved bustle and parties. She relied on intuition; he, on thorough knowledge and expertise.

Though their personalities differed, Junior and Abby's family background, attitude, and life experience were remarkably alike. Both had grown up with powerful, self-made fathers whose exploits were defamed by the press. Both shunned publicity and ostentation. Given the times, both were rather liberal, strongly believing in the rights of women, birth control, universal education, and racial equality. They generously shared part of their wealth with others, and since they felt that giving money was not enough, they worked hard at their chosen projects.

At a time when women were often invisible, Abby would play an important role in all of Junior's undertakings. Four months after they were married, she attended a Rockefeller-sponsored meeting of the future General Education Board, concerned with the education of African Americans in the southern United States. (She was the only woman present.) She kept up her philanthropic involvements even after she began giving birth to a Rockefeller dynasty. Abby (Babs) Rockefeller, Junior and Abby's first child and only daughter, arrived in 1903. Five boys—John D. 3rd, Nelson, Laurance, Winthrop, and David—followed, roughly spaced at two-year

intervals. It would not be an easy task to bring up this third generation of Rockefellers with some sense of normalcy amid unprecedented wealth and the glare of the tabloids.

Thrift had dominated Junior's childhood, and he adopted a similar attitude toward his children. There was always a major dichotomy between the Rockefellers' immense wealth and their attitude toward daily expenditures. The children had comparatively small allowances. Keeping expense ledgers like their grandfather and father was an inviolate requirement, as was earning money performing menial tasks such as catching flies (ten cents a hundred) or mice (five cents each). Junior audited the ledgers weekly.

In relating to their children, the parents adopted opposing roles. Junior was a strict, distant father who, for decades, kept a firm grip on the family purse strings. He also had such high expectations of his six children that they never gained his full approval. All of them were subjected to his rigidity, but it was hardest for the two eldest. Babs rebelled openly, but the boys toed the line. The fact that they had to live by their father's rules led to a special cohesion among the brothers.

Abby's approach was different. She was loving and understanding, and her psychological insight enabled her to tune in to each child's personality. In raising her children, she looked to her own childhood, which had been joyful and fun-filled. During her entire life, she would mediate between her husband and their children. While they were small, she would help them meet their father's demands, whether it was keeping accurate account ledgers or learning new Bible verses. When they were grown, she continued to champion their causes, eventually even reconciling Junior to their daughter's divorce.

DURING THE FIRST two decades of their marriage, Abby was engulfed in motherhood, social and philanthropic obligations, the couple's aging parents, and the running and decorating of the Rockefellers' many homes. In 1911 they had added the sixty-six-room Eyrie, an oversize "cottage" on

Abby, Junior, and their six children standing in front of the Eyrie in Maine. (Courtesy of The Rockefeller Archive Center)

Mount Desert Island, Maine. Duncan Candler, a Paris-trained architect with offices in New York, was engaged to remodel it. He had an impressive Maine clientele and built the Bar Harbor Club and, in Seal Harbor, the "cottages" Sea Bench, East Point, and Skylands (the last, for Edsel Ford, now owned by Martha Stewart).

For the Eyrie, Duncan Candler adhered to a Norman French style. The outside of the principal building consisted of stucco and heavy wooden beams; the inside was accented by dark wooden paneling. He worked closely with Mrs. Rockefeller and became her favorite architect, building the famous Rockefeller playhouse on the Pocantico estate in 1925.

Abby and Candler designed the Eyrie for growing children and summer living. There was a ballroom in which Junior hosted regular tea dances. There were several outbuildings, including a five-room "rest house" decorated with American Indian artifacts, where Abby and Junior napped; and a playhouse with a fully equipped kitchen where, once a week, the children cooked dinner for their parents. There were children's

parties, at one of which Abby was voted the most popular mother.[11] Still, even in Maine, life was never quite informal. It took a staff of twenty-two to run the house. There were governesses, tutors, companions, chaperones, and sports instructors. Every entertainment and sport was so readily available that, as David Rockefeller reported, it was unnecessary to leave the premises, and as a youngster he felt quite isolated from the rest of the world during the summer months.

A large terrace—the only part of the house surviving its 1962 demolition—fronted the Eyrie. From it one can glimpse Mount Desert's wondrous landscape: a silvery pond, the rocky coast, craggy mountains, dense forests, and small islands strewn in the ocean. In the 1850s this extraordinary landscape attracted Frederic Church, Thomas Cole, and other painters of the Hudson River School, and in the course of the following decades, tourists and "summer people" followed them.[12] For a while, Bar Harbor rivaled Newport in elegance and sophistication. The island also attracted nature-loving visitors such as Charles W. Eliot, the president of Harvard; the Fords; and, of course, the Rockefellers, who were more interested in the natural beauty of the place than in a glittering social life. These folks drifted to Northeast Harbor and Seal Harbor, located on the shores of Somes Sound.

Upon first seeing it, Mount Desert Island had filled Junior's heart with delight. He loved being outdoors, riding his horses or driving his fancy carriages. Soon after he decided to summer in Maine, he started to buy vast tracts of land surrounding his summer home. He also joined the efforts of his friends and neighbors, Charles Eliot and George Dorr, who had become concerned about preserving the island's beauty. The three "fathers of the park" assembled the scenic portions of the island, lobbied the legislature, and succeeded in having the government establish Acadia National Park, the first National Park on America's East Coat.[13] Maine provided Junior with another one of his favorite activities, felling trees, cutting wood, and building roads with spectacular vistas. Today, fifty-five miles of carriage roads passing over twenty-seven granite bridges crisscross the park, providing delight to hikers, cyclists, and equestrians.

THE ROCKEFELLERS, LIKE much of the rest of America in the nine-
teenth century, had become enamored of Buddhism and Asian art. The
appreciation for both had started in Boston. Ernest Francisco Fenollosa,
a native of Salem, Massachusetts, initially forged an intellectual relation-
ship between the United States and Japan. Fenollosa graduated from Har-
vard College in 1874, and then continued to study philosophy and divinity
in Cambridge, England. In 1878 he went to the Imperial University in
Tokyo to teach philosophy and political economy. There, ancient temples,
shrines, and other art treasures captured his imagination. He established
close bonds with the emperor, converted to Buddhism, and became a cura-
tor of Oriental art in the Imperial Museum of Japan, where he inventoried
the country's national treasures. Later he participated in the founding of
Tokyo's Academy of Fine Arts.

Fenollosa returned to Boston in 1890 and became the Museum of Fine
Arts' (MFA) first curator of Oriental art. A forceful writer, he promoted
Chinese and Japanese art throughout the United States. He selected Jap-
anese art for the 1893 World Columbian Exhibition, whose Japanese pa-
vilion introduced many Americans to Oriental art.[14] He also organized
Boston's first exhibition of Chinese paintings, in 1894, followed two years
later by a New York exhibition of Japanese paintings and color prints. His
posthumously published *Epochs of Chinese and Japanese Art* pioneered the
appreciation of Asian art in the English-speaking world.

America's interest in Buddhism also originated at the Museum of Fine
Arts in Boston. Ananda K. Coomaraswamy, born in 1877 in Ceylon to an
English mother and Hindu father, sparked it. The elder Coomaraswamy
died before his son was two. Ananda returned to England with his mother
and studied geology and natural science. He went back to India in 1909,
working as a mines research officer in Ceylon. Once in India, he fell in
love with Hindu culture and art. Realizing that Indian art was misunder-
stood in the West, Coomaraswamy wrote a series of widely popular books,
including *The Origins of the Buddha Image* and *The Arts and Crafts of India*

and Ceylon. In 1917 the MFA invited him to become research director of Indian, Persian, and Muslim arts. In Boston, Coomaraswamy adhered to his Indian lifestyle, wearing a turban in combination with Western clothes. He was a prolific writer, and his books taught Westerners to appreciate Hindu gods and goddesses and their symbolism.[15]

Boston's expertise in Asian art quite naturally spread to neighboring Providence's Museum of Art of the Rhode Island School of Design (RISD), founded in 1877, when Abby was three years old. By 1898 the museum was holding an exhibition of Japanese prints; later it was the first U.S. museum to have an American wing showcasing what Junior would describe as "old furniture." Coincidentally, both of these museum activities dovetailed with Abby's future interests.[16]

The appetite of American collectors for Asian artifacts resulted in their availability from art dealers. The Rockefellers bought many of their Asian possessions from Yamanaka and Company, then one of the major dealers in Oriental art. Originally based in Osaka, Japan, Yamanaka Sadajiro, the founder of the enterprise, opened a branch in New York in 1895. Eventually there were also branches in Boston, Chicago, London, and even Bar Harbor.

Nobody quite knows when and why Abby Rockefeller started to collect Japanese prints. Perhaps her interest was aroused when she traveled to Paris with her father and discovered that these images had influenced Claude Monet and Toulouse-Lautrec, two painters she was especially fond of. However, once she developed an interest, she pursued it quite obsessively. So it is not surprising that, in 1919, she asked her sister Lucy, who was about to visit Japan, for help in enlarging her collection. Both Aldrich daughters had inherited their father's acquisitiveness. After Abby got married, Lucy did some of her sister's high-end shopping, and the subject was endlessly discussed in their frequent letters. From 1924 on, Lucy would select Abby's dresses, hats, and other garments from Worth and other Parisian couturiers. Abby was pleased with her sister's choices, writing that without Lucy she "would look like a frump."[17]

After her parents' deaths, Lucy became restless, for, as she said, "there was not much excitement in Providence for a deaf person." International

Katsushika Hokusai's Cranes and
Pines in Snow, *one of 720 Japanese
prints that Abby Aldrich Rockefeller
donated to the museum of the Rhode
Island School of Design.* (Eric Gould,
Courtesy of the Museum of Art, Rhode
Island School of Design, Providence RI)

travel had been curtailed during World War I. Once it was over, Lucy, ac-
companied by Minnie E. MacFadden, her faithful companion, would cir-
cumnavigate the globe three times. In April 1919 they embarked on their
initial trip to the Far East. Lucy fell in love with Japan. Her letters home
overflowed with enthusiasm: "The more I see of Japan, the better I like it."
She admired the "curious and beautiful things," and declared that she'd
"much rather be a Buddhist than a Baptist anyway."[18]

Lucy was nervous about the money Abby had entrusted to her to pur-
chase art because, as she wrote, "she knew absolutely nothing about Oriental
things." She describes the visit of a merchant who had come to see her at her

hotel, offering three beautiful bird prints for a sum Lucy considered excessive. She told him that "she could not pay the asked for 15,000 yen without consulting her sister." The merchant mocked Lucy's counteroffer of $250 a print, declaring that for that price she would not get anything. Lucy reported "that the man was an awful liar . . . He is awfully cheap, even if his prints are not. He made insolent remarks about the rich in an insolent manner and I had to hold on to my chair hard to keep from flying at him and chewing him up."[19]

From Yokohama, Lucy wrote:

> I have just been to Mr. Keane's and bought you six prints by Hiroshige. They cost a great deal but they are so hard to get . . . that I thought I better get them . . . They are two prints of peonies, one of morning glories, one peacock and peonies, one pheasant and pheasant and small flowers, one small parrot on a pine tree . . . I hope that you will not think it is too much. I think [now] there are 21 prints in all and if you don't want them I will keep some . . .
>
> I plunged because I know you have just gotten more money from the sale of Mamma's buildings in Providence and I know you want them . . . I am going to buy you the Mandarin Coat etc. just the same in China and anything else I see that I know you would like and you can pay me when I get home. . . . If you are hard up cable me by the Standard Oil to stop buying . . . I am really quite frightened at buying such expensive things—a thousand dollars is an awful lot. Do write and reassure me.[20]

By then Lucy had embarked on forming an Asian textile collection. The economic conditions in China, Japan, and India were so depressed then that, for Americans, textiles and other objects were extremely inexpensive, and Lucy's modest funds would yield a superior collection. She bought priest and court robes, cushions, hangings, Japanese Nō costumes, Indian garments, imperial robes, jade, and furniture.

BY THE 1920S, Junior and Abby had a well-established routine. During the school year they resided mostly in Manhattan and Pocantico Hills. On July 8, the day after Senior's birthday, they would migrate to Maine, which at the time required an overnight trip by train and boat. Every so often the family also would undertake an educational trip out west, or the parents would travel to Europe or take a rest cure. This pattern was interrupted in 1921, when the Rockefellers were asked to participate in the dedication of the new quarters of the Peking Union Medical College, a grantee of the Rockefeller Foundation.

Until then, Junior and Abby had never left their growing children for any length of time. Now Junior wanted to attend the ceremonies in China and was adamant about Abby accompanying him. After much soul-searching, she agreed to come, even though John 3rd, who, at his father's insistence, was attending boarding school, vehemently protested about the forthcoming parentless summer. Abby wrote him that she, too, minded the separation but felt that "Papa needs the change and rest very badly, and he is not willing to go alone."[21]

Since China was so distant, the Rockefellers decided to visit Japan, Korea, Manchuria, Hong Kong, and Manila as well. Seventeen-year-old Babs was to accompany them, but the boys, including six-year-old David, stayed home. Eighty-five years later he recalled:

> There was great excitement as they prepared for the trip, which would take them first to Japan . . . then through Korea by train to China . . . I did not share their enthusiasm. I was the youngest of six children, and although interesting summers had been planned for all my brothers, I was left languishing alone and forgotten at home.[22]

The Rockefeller trip to Asia turned out to be immensely satisfying and would kindle a multigenerational passion for Asian art. In China, Junior immersed himself in viewing and buying more porcelain. The party visited the Ming tombs, whose majestic Spirit Path was in disrepair. Upon his return to the United States, Junior contributed funds for

its restoration. The Rockefellers stayed in Japan for three weeks and were enchanted by the shrines, temples, and especially the gardens. Abby's letters from Japan were enthusiastic. From the Miyako Hotel in Kyoto she wrote on October 24, 1921:

> Dearest Johnnie-boy,
> There is much to see in the way of palaces, temples and gardens
> . . . [They are] much the loveliest gardens I have ever seen . . .
> Grandfather's Japanese teahouse gives you an idea . . . [one] garden is
> three-hundred years old and you can imagine the size of the trees.

Abby loved Japan and its culture, reporting that if she did not have trouble sitting on her feet, she would rather stay in Japanese hotels than in European ones.[23]

David Rockefeller remembers his parents returning from the Far East with:

> . . . a wonderful array of Asian art that completely entranced me . . .
> superb Ming and Kangxi porcelain, much beloved by my father, colorful Nō robes, exquisite furniture, exotic statues and dozens of intricate Japanese prints by Ando Hiroshige.[24]

The trip enhanced the Rockefellers' passion for the Far East. Abby studied Buddhism, and the Eyrie's interior soon reflected her increasing fascination with Asian art and furniture. She hung a set of fourteen Utamaro prints in her little office there, and asked her sister, again on the verge of departing for the Far East, to bring "back some Korean things, which would make this room very attractive."[25] Korean chests migrated to the living room, and parts of Abby's brass temple set moved to the dining room mantel. Dinner was served every night on her precious antique Oriental porcelain. "We all enjoy [it] even the children . . ." she wrote to Lucy; "it looks much better being used than when it was all stacked round the fourth floor room at No 12 [West Fifty-fourth Street]."[26]

These dishes, too, came from Yamanaka. As David Rockefeller explained:

> The fact that Mother had so much Japanese porcelain in Seal Harbor came about in part because Yamanaka & Company, the prominent Japanese art firm, had a branch in Bar Harbor. Mother greatly admired Imari and other styles of Arita ware Yamanaka carried and felt that they fitted in well with other Oriental objects at the Eyrie.[27]

It was from Yamanaka that the Rockefellers acquired the graceful headless and armless seventh-century Tang-period bodhisattva now at Kykuit. Junior could not help arguing about its cost and wrote, "I never enjoyed a mutilated statue, and therefore find it difficult to reconcile myself to the asking price." He persuaded the dealer to reduce the price by about two thirds.[28]

Notwithstanding Junior's initial judgment, the statue is stunning. For the period 1935–36, Abby lent it to the Royal Academy's International Exhibition of Chinese Art in London. Of it, collector Sir Percival David wrote:

> [It is] full of grace and movement, [and] owes much to the artistic heritage left by Greece and India to the Far East. It is from Greece that it derives the clinging folds of its drapery; it is India which has inspired the swaying poise of the body and its sensuous modeling. But it is the genius of China which has breathed into the figure its vitalizing spirit.[29]

The statue was a favorite of Nelson's. He inherited it, and eventually moved it to Kykuit. It, however, was only one of dozens of fine Asian artworks the Rockefellers acquired from various dealers. In 1935, when they moved from their large "Imperial Nest" at 10 West Fifty-fourth Street to 740 Park Avenue, Abby donated twenty-one Far Eastern sculptures to the Metropolitan Museum of Art.[30]

Young David often accompanied his mother to Yamanaka's Manhattan shop, conveniently located near the Rockefellers' Fifty-fourth Street home, and was entranced "by the beautiful and, to my mind, mysterious artifacts from China, Japan and Korea. In a certain sense, I began my own career as a collector at Yamanaka when I started to assemble, with Mother's advice and encouragement, a number of small and delicately carved ivory animals."[31]

IN 1926, ABBY ROCKEFELLER decided to re-create in Maine the serenity and spiritual nature of the gardens she had seen during her Oriental trip. By then, she and Junior were experienced, since they had lavished infinite care on landscaping the grounds surrounding Kykuit, Senior's country seat, which included a Japanese garden. For their Maine garden, the Rockefellers contacted Beatrix Farrand, the first female member of the American Society of Landscape Architects. Farrand, a leading landscape architect, happened to summer and practice on Mount Desert Island. Today she is best remembered for the exquisite gardens she created at Dumbarton Oaks, in Washington, D.C., now owned by Harvard University. Farrand became the Rockefellers' life-long friend, assisting Junior in landscaping the carriage and motor roads he built on Mount Desert Island.

Since the Eyrie garden was to provide respite from life in the overly busy mansion, it was located at some distance from the house. Farrand had never been in the Orient, but she had visited the Japanese garden at the World's Columbian Exhibition in Chicago in 1893. The Eyrie garden was to merge the restraint of the East with the colorful flowers of the West. Like other Farrand creations, it would combine a strong overall design with distinct, individual garden rooms.[32] While her garden took shape, Abby shared her pleasure with Lucy:

> I am having great fun with the new garden. Mrs. Farrand is helping
> me, and fortunately she likes Chinese sculpture. We are going to put

the Korean (Ming tomb sort of) figures along one side making a walk
by the garden into the woods beyond.[33]

Mount Desert Island is extremely rocky, so it was a major challenge to
insert a garden amid the granite ledges and woodlands that surrounded
the Eyrie. Moreover, the soil is poor and the growing season is extremely
brief. Felling trees, removing rocks and roots, leveling the terrain, and
bringing in tons of topsoil were the first tasks.

The preliminary plans for the garden show the Spirit Path; the Sunken
Garden, a large central portion to be planted with flowers; and the Sun, or
Oval, Garden, in which a small pool is to be surrounded by an oval lawn.
There would be sculptures, gates, and small enclaves along the way. Though
the garden evolved during its construction, its basic design was not changed.

By 1928 most of the garden was in place. That fall, however, it was
rumored that yellow coping tiles from a demolished section of the For-
bidden City's enclosure might be for sale in China and it was decided to
surround the garden with a tile-covered wall.[34]

Yamanaka offered to handle the transaction, and eventually supplied
a total of six thousand unbroken tiles at eighty-five cents apiece. The walls
were laid out with great care. In her letter of October 26, 1928, Farrand
wrote, "The wall lines were tentatively staked out yesterday with much
fussing and refussing and changes of curves here and there." Equal care
was expended on the gates, copied from existing Chinese architectural
books. The correct shade of pink for the walls, which had to harmonize
with the coping tiles, was also of great concern.[35]

The garden survived the demolition of the Eyrie. Today it is hard to
imagine how it—now called the Abby Aldrich Rockefeller Garden—
would have worked without the walls, because they supply both strong
architectural anchors and an otherworldly feeling. The round Moon Gate,
at the north end of the Sunken Garden, and a Bottle Gate, separating the
Sun Garden from the Spirit Path, add an air of mystery. The more than
thirty sculptures, lanterns, and posts are strategically distributed through-
out the garden, so that they match the varying moods of the visitor. A lush

border of flowers, not used in traditional Oriental gardens, surrounds a large lawn in the Sunken Garden.

It took years to complete the garden. In 1929, when Farrand sent Mr. Rockefeller one of her periodic invoices—she was paid $100 a day—she wrote:

> I am really almost ashamed to have spent so much time at the Eyrie as I did last autumn [1928], and should not have done so had I not really known that you and Mrs. Rockefeller seemed to want the garden to be quite as perfect a product of our united efforts as possible . . . the garden has not been an easy one to design, and if you finally think it successful it will be the result not only of my work but of your own.[36]

The garden turned out to be perfect, and it remained an oasis not only for Junior and Abby but also for their children and grandchildren. As David Rockefeller recalled, "it has been an important part of my life ever since my early childhood . . . It was one of the first places I took Peggy before we were married, when she visited my family in Seal Harbor in the late 1930s. For both of us it represents a living expression of my parents, and especially of my mother's artistic creativity."[37]

He remembered how his mother "used to love to go [to the garden] alone in the late afternoon to sit quietly on one of the teak benches in the Oval Garden looking out at the sunlight on the flowers and listening to the sweet notes of wood thrushes."[38]

After the death of his wife in 1948, the garden remained a poignant touchstone for Junior: "How thoughtful and neighborly of you to greet me on my arrival Saturday morning with your gracious note and the exquisite roses," he wrote Beatrix Farrand:

> . . . I have placed underneath Mrs. Rockefeller's portrait! . . . What wonderful roses they are! . . .
> I am delighted with the garden. It makes me yearn to have Mrs. Rockefeller there to enjoy it with me as formerly. But I am sure, though invisible, she is there.[39]

The garden is one of the few Rockefeller possessions still in private hands, open to the general public only by appointment, for a few days during the summer. After Junior's death it became the property of the David Rockefellers. Peggy, David's wife, cared for it until her death in 1996, every year choosing the annual plants that would provide a slightly different palette the following summer. In 1970, David and Peggy created The Island Foundation, which will care for the garden after their deaths, but for now it is cared for by their daughter Neva Goodwin, and by a devoted staff of gardeners.[40]

The Abby Aldrich Rockefeller Garden is now eighty years old. It wears its age well. Through a pink stucco gate roofed over with the tiles Yamanaka imported from China, one enters an enchanted world, the Spirit Path lined by six pairs of imposing Korean figures, one consisting of military officials, the other five pairs representing civilians. The ground cover of blueberry bushes, bunchberries, and ferns affirm that one is in Maine.

Along the path are self-contained enclaves—one hiding a rock-lined pool filled with limpid water. Thick moss covers a granite outcropping, almost obliterating a fat Japanese stone frog. A few steps farther along, a glistening stream, not even a foot wide, makes its way between thick lips of moss. At the end of the Spirit Path a stele (China, Northern Chi period from 574) marks the only place in the garden from which one overlooks the outside world. A small opening leads from the Spirit Path to the Sunken Garden, where flower borders throb with color provided by a profusion of different lilies, clematis, bluebells, snapdragons, larkspur, delphiniums, zinnias, columbines, and much more. Monarch butterflies buzz around a buddleia bush.

A large pine and the Moon Gate, a perfectly round opening through the wall, anchor the Sunken Garden at its north end. Outside the enclosing wall is a large gilded Buddha (seventeenth-century Ch'ing) sitting on a lotus pedestal. Its twin is found outside the Sun Garden, atop a flight of granite steps. Ancient trees, old canvas chairs, and a stone bench surround it. Here, as elsewhere, nature and art meld into one and fill the surroundings with peace and reverence.

At its southern end, the Sunken Garden adjoins the Sun Garden, Abby Rockefeller's special favorite. A single water lily, embedded in a clay pot, spreads its large leaves on the surface of the small rectangular pool. Everything is well ordered. Even the benches stand on their own granite platforms, surrounded by a sea of lush grass.

The adjoining Shade Garden is filled with ferns, hostas, and other green plants and a number of smaller sculptures, including a rare portrayal of the *Arhat Bhadra with a Tiger Cub* from 1158.[41]

The garden, a synthesis of East and West, is a perfect Rockefeller creation, illustrating the power of money combined with imagination, taste, the judicious choice of collaborators, hard work, and close attention to detail. Its flawlessness is an example of Junior's belief that, to attain perfection, it is the last 5 percent that counts.

BY THE MID-1930S, Lucy Aldrich was starting to be bothered by the clutter in her house on Benevolent Street, which, though it had its own museum room, was much too small for all her possessions. She contemplated auctioning off some of these, but fortunately did not. Her thoughts then turned to the museum of the Rhode Island School of Design. Since she was childless, as she would write to her brother-in-law, donating was one way in which she could perpetuate her name.[42]

Lucy's first major involvement with RISD was to ask her sister to leave the school her collection of Japanese prints. By then Abby was totally immersed in the creation of MoMA and did not mind divesting herself of the bulk of her collection. At the time, she owned thirteen hundred such prints, mostly bought in America.

Large-scale printmaking in Japan dates from the seventeenth century, when well-known artists developed an inexpensive form of color printing. Popular subjects included actresses, teahouse waitresses, landscapes, cartoons, caricatures, and scenes of everyday life. Images of birds and flowers occurred less often. Among the many Japanese artists, Kitagawa Utamaro (1753–1806), Katsushika Hokusai (1760–1849), and Utagawa Hiroshige

(1797–1858) were most revered and prolific; one of Hokusai's series includes thirty-six views of Mount Fuji. When he was in his seventies, the artist created the *Great Wave*, his best-known woodcut.

By the nineteenth century, Japanese woodprints had reached Europe and become so popular that, according to art historian Paul Johnson, 90 percent of the entire output was sold to Western collectors. The works' simplicity is even reflected in the evolution of the style of some Western artists.[43]

Upon Lucy's urging, Abby donated 720 prints to RISD. In addition to these, she gave the museum a simple wooden box filled with cards, each bearing a photograph of a print, with its title, description, provenance, cost, and other details. For example:

Utamaro flower arrangement in poor condition bought during Oriental trip, Aug-Dec 1921.

Utamaro print of a turtle. In poor condition and only valued at $5 by the Mr. Nakagawa. The original cost was $12.[44]

The bulk of Abby's collection consists of bird and flower prints, though there are occasional cats, dragonflies, and even tigers. All prints start with a sketch, and the finished images often retain the lightness of the original drawing. Abby's collection includes some duplicates because, as one of the museum's curators of Asian art, Dr. Deborah Del Gais, explained, Abby sometimes bought several versions of the same print. Del Gais added that it is fascinating to compare the differences between the various states.

A handful of Abby's 720 prints are always on display at RISD. Because of their sensitivity to light, they are rotated every few months. From time to time the museum holds a major retrospective. In 2007, De Gais mounted *Feathers, Flowers, Talons, and Fangs*. The titles of the images are poetic: *Swallow and Peach Blossom Under Full Moon*; *Long-tailed Blue Bird and White Plum*; *Sparrow and Camellia in Snow*; *Cranes and Pines in Snow*; *Cuckoo and Azaleas*. Poems and haikus are inscribed on some images, but one does not need to read Japanese to be transported by the pieces' lyricism.[45]

A good many of Abby Rockefeller's prints went to the Philadelphia

Museum of Art. The museum's bulletin of November 1946 announced that the museum would hold a special exhibition of Japanese prints:[46]

> ... prompted by two important gifts: by Mrs. John D. Rockefeller Jr. of 106 prints and by Mrs. Anne Archbold of 125 prints and 26 woodcut blocks.... Both collections contain prints of exceptional quality and importance. In the Rockefeller group may be cited a rare Pentateuch by Yeishi in marvelous condition; five excellent Harunobus; and extremely rare Utamaros in perfect condition (*Four Famous Beauties Enacting the Ox Cart Scene in the Sugawara Drama*); ... numerous Hiroshiges; and a large group, seldom assembled, of prints after artists not of the Ukiyo-ye School.

These large gifts still did not exhaust Abby's cache. Many Japanese prints were handed on to her children. Nelson, for instance, received at least sixteen, including one of Hokusai's thirty-six views of Fuji described by the artist as *Fair Weather on Fuji*.

Abby's inventory card describes it as follows:[47]

> The red cone of Fuji rises in majestic grandeur in the blue summer sky ... One of the finest and most famous prints in the series. A superlative fine impression, in flawless condition.

> Abby's cost was $230 paid on April 1, 1922.

IN THE 1930S, to Lucy's delight, her textile collection, characterized by many different types of robes, had started to attract national attention. In 1934 the Metropolitan Museum of Art requested the loan of twelve robes. Lucy was surprised by how much they had appreciated in value. She had paid $10,000 for thirty robes; now the twelve she loaned to the museum were appraised at $13,300.[48]

Lucy started lending some of her robes to RISD, too. The museum assigned her two galleries on the top floor of the new wing designed by William Aldrich, the sisters' architect brother. Abby's Japanese prints were displayed in one; the other, equipped with specially designed cabinets, was for Lucy's robes. While Lucy was alive she did not entrust the staff of the museum with the care of her robes. Every month or so, she and her companion, Miss MacFadden, rotated those on exhibit. After Abby's death, Philip Johnson redesigned the print gallery.

The robes and other textiles Lucy Aldrich gave to RISD are, as described in the exhibit's accompanying catalogue, "pure poetry." Many patterns and embroideries are derived from birds and floral motifs. The images on one robe suggest flowerboxes filled with chrysanthemums, camellias, and peonies silhouetted against an orange gold-stenciled background. Egrets fluttering among reeds are the main motif of one robe, while long-tailed swallows frolicking among the roots and trunk of a willow tree can be found on another. It is fitting that these textile masterworks, with their vibrant colors and astounding array of embroidery techniques, ended up in the museum of one of America's top design schools.

After Lucy was through collecting textiles, she turned to European porcelain. Beautiful porcelains enchanted the entire Rockefeller-Aldrich clan. Collecting Chinese porcelains had been Junior's first true indulgence. Abby, in cahoots with Lucy and Yamanaka, amassed dinner dishes by the carload.

"Aunt Lucy and Mother . . . shared many interests, including ceramics," David Rockefeller recalled.

They often compared notes on pieces of porcelain and other objects they had seen or bought on their travels. Aunt Lucy would buy a porcelain dinner or dessert service, which she thought Mother would like and would simply ship it to her sight unseen. Sometimes, if she bought a particularly large service, she would keep a dozen plates for her own use and let Mother have the rest.[49]

Fine porcelain originated in China and was a well-kept secret until Germany's Johann Friedrich Boettger breached it at the very beginning of the eighteenth century. In 1710 his sovereign, August the Strong, elector of Saxony, founded the Meissen factory, which produces fine porcelains to this day. By 1760 there were about fifty porcelain factories in Europe, mostly founded by royal or princely rulers. Their names—Nymphenburg, Fürstenberg, Royal Copenhagen, Mennecy-Villeroy, Bow, Derby, Staffordshire, and Sèvres—are still synonymous with fine antique and new porcelain. In addition to dinnerware, leading porcelain artists created small and large porcelain figures for decoration, display, or centerpieces.

It was these that Lucy collected when she was done with her textiles. Aided by leading porcelain dealers recommended by Sir Joseph Duveen, she assembled a museum-quality porcelain collection in record time,[50] and donated it to RISD during the 1930s. For its proper display, she, Abby, and a friend bought and resized wood paneling from an eighteenth-century English manor house, and a fireplace mantel, antique furniture, and chandeliers. Today the Lucy Truman Aldrich Porcelain Gallery is a quiet oasis that takes the viewer back to a luxurious, leisurely past. Its shelves are filled with porcelain figures of dancers, musicians, children dressed in Moorish clothes, gardeners, clowns, Moors, sleeping shepherdesses, peacocks, swans, squirrels, lambs, goats, and dogs. Many of the figures are stand-alones; others are pairs; and some depict intricate scenes. One prized possession is a group of about twenty fancily dressed monkeys playing musical instruments. It dates from about 1749 and was modeled by J. J. Kaendler, the most famous Meissen sculptor.

Lucy died in 1955, outliving both Miss MacFadden, her faithful companion, and her beloved sister. The Rockefeller children remained devoted to RISD. Babs, who frustrated her father by paying taxes rather than donating money to charity, and her mother by not caring for art, left the museum some money and a few ceramics. In 2007, David Rockefeller pledged $1 million to once more rebuild his mother's and aunt's galleries, and so it is that the Rockefellers left a permanent memorial to the city that played such an important role in their lives.

Bridging the Past and the Present:
The Oriental Institute, the Cairo Museum, the Metropolitan Museum's Assyrian Sculptures, and the Rockefeller Archaeological Museum, Jerusalem

THE ORIENTAL INSTITUTE

I N 1974 THE John D. Rockefeller, Jr., Centenary Exhibition opened at the Oriental Institute Museum of the University of Chicago.[1] The name of the institution reflects the fact that during the eighteenth and nineteenth centuries, when archaeologists started to explore humanity's oldest civilizations, the regions to the east of the Mediterranean were commonly called the Orient and included what we now call the Near and Middle East. Though young as archaeological institutions go, and to begin with insignificant, the Oriental Institute played a major role in unraveling mankind's history. The 1974 exhibition was a tribute to Junior and illustrated the extraordinary friendship between two men: James Henry Breasted, the scholar who did the work, and John D. Rockefeller, Jr., the philanthropist who funded it.

For the exhibition, the museum assembled a very few of the treasures

Gold-covered statuette of a male deity from Megiddo. (Courtesy of The Oriental Institute Museum, University of Chicago.)

that Breasted had uncovered. Prominent among these was a tiny gold-covered statuette of a male Canaanite deity sitting on a throne and holding a scepter. Dating from about 1300 BCE, the piece was excavated at Megiddo, now in modern Israel. The town had been an important administrative center in ancient times, and is also the biblical Armageddon, where, according to the New Testament, the ultimate battle between good and evil will take place.

The University of Chicago, founded in 1890, was the first major beneficiary of Rockefeller largesse. The concept underlying the institution was novel insofar as it combined a liberal American-type undergraduate education with a rigorous, German-style graduate research institution. While visiting his daughter Bessie, Senior had befriended William Rainey Harper, a noted Semitic language scholar at Yale, who often taught Sunday Bible school at nearby Vassar College. Rockefeller was impressed by the young man and persuaded him to become the founding president of the University of Chicago. Even though administrative duties occupied most of Harper's time, he continued to be a dynamic Semitic scholar, specializing in ancient Hebrew texts and teaching at the new university's Depart-

ment of Semitic Languages. It was in this capacity that, in 1896, Harper persuaded philanthropist Caroline Haskell to endow a small museum housing a study collection of Near Eastern artifacts in memory of her husband, a benefactor of the university.[2]

James H. Breasted trained as a pharmacist. After having weathered a serious illness, he switched to divinity and then, once more, to Semitic languages. He studied with Harper at Yale and impressed him with his talent. At the time of his studies, there was a great interest in Egypt, and when Breasted had to select an area of specialization, Harper told him that if he were to study Egyptology in Berlin, he would appoint him America's first professor of Egyptology at the new University of Chicago.

Breasted agreed and returned from Germany with both a doctorate and a wife, Frances Hart. Presaging the nature of their marriage, the Breasteds spent their honeymoon on the Nile, where Breasted started his life's work: copying and translating Egyptian inscriptions from monuments, papyri, and other sources. These were to be included in a mammoth Egyptian dictionary that was being compiled in Berlin. As his work progressed, Breasted realized that many of the previous interpretations and translations of the hieroglyphic inscriptions were inaccurate. Just as important, he resolved to familiarize the West with the evolution of Near Eastern cultures, and to prove that they represented an important link in the development of Western civilization.[3]

By 1900, European and American archaeologists were digging up the ancient Middle East. In 1903, scientists at the University of Chicago received a major grant from Senior to organize their own excavations and epigraphic research (study of inscriptions) in the region. Whenever his teaching schedule allowed, Breasted went off to Egypt, where he continued to study and decipher inscriptions. In 1906, the forty-nine-year-old Harper died unexpectedly, and the Rockefeller grant was not renewed. During the next fifteen years, Breasted was mostly marooned in Chicago.

Fortunately, he was a gifted writer, and Charles Scribner asked him to develop a textbook dealing with the world's ancient history. After some hesitation Breasted agreed. He hoped that the book would do for ancient

history what Charles Eliot Norton, America's first professor of art history, had done for European art. Most important, the text would demonstrate that civilization had not started in Greece or Rome, but in Egypt and in what Breasted called the "Fertile Crescent," an arc roughly starting in Iran, cresting in Mesopotamia and Anatolia, and ending in Palestine.[4]

Breasted's *Ancient Times: A History of the Early World* is a masterful account of ". . . the life of man in all its manifestations—social, industrial, commerce, religion, art and literature." The book emphasizes how one age morphed into the next and how each civilization profited from the ones that preceded it. Breasted writes about the early Europeans, the Egyptians, Babylonians, Assyrians, Chaldeans, the ancient Persian Empire, and the Hebrews. Since he was a linguist, the book explores ancient scripts, in particular the sequential history of pictographs, hieroglyphs, and cuneiform characters.

Breasted succeeded in his mission; his book became extremely popular both as a textbook and for the general reader. At its height it sold 125,000 copies annually. Unfortunately Breasted did not collect royalties, since he had written the book for a flat fee, but in the end it did pay for his life's work. Abby Aldrich Rockefeller read *Ancient Times* to her children at bedtime and was gracious enough to send her compliments to the author. Emboldened, Breasted mentioned this letter in 1919, when he again asked the Rockefellers' General Education Board for funds to continue his Near Eastern studies.

Breasted had also contacted Junior directly, appealing to his sense of history. His request was granted, and Frances Breasted wrote to the General Education Fund expressing the couple's joy and relief, and her deep gratitude for a gift, at first anonymously paid for by Junior himself, which "will bring to my husband the support which he needs, in an undertaking which is demanding all the fortitude which he possesses to carry out."[5]

A deep personal friendship developed between the professor and the donor. From his armchair, Junior enthusiastically shared Breasted's progress, and the funds he supplied were ample enough to found a world-renowned Oriental Institute, build an on-site facility in Luxor, finance numerous archaeological excavations, and acquire a world-class collection for the museum. All in all, Rockefeller's private support of Breasted and

his work amounted to more than $11 million. As in the case of The Cloisters and Colonial Williamsburg, Junior would share the dream of another man. In 1919, Breasted met the Rockefellers in person and typically became one of the family's friend-retainers. He visited them often in New York and even in Maine and kept them informed, with lantern slides, about his research. That same year, he founded the Oriental Institute at the University of Chicago, and it rapidly attained worldwide fame.

In November 1922, three years after Breasted resumed his annual Egyptian expeditions, Howard Carter, a British archaeologist, found the passageways leading to Tutankhamun's tomb. He hastily summoned his patron, Lord Carnarvon, from England. Then, before actually unsealing the tomb, Carter asked his colleague Breasted, who was working nearby, to decipher the seals affixed to various doors.[6]

The discovery of the young pharaoh's tomb was considered to be the most important archaeological event since the finding of Troy. Breasted's participation in the actual opening of the tomb must have been a great moment in his professional career. The world became entranced with Tutankhamun, and his appeal has not diminished over the years. Breasted wished to take the Rockefellers to Egypt so that they could view some of King Tut's fabulous treasures while still in place, but they declined because they did not want to leave their growing children for such a long time. Breasted, however, accidentally encountered Lucy Aldrich in Luxor and offered her a private tour.[7]

In December 1927, Breasted reported to his patron that as a result of five expeditions to the Near East, the Oriental Institute was outgrowing its home in the University of Chicago's Haskell Hall. Junior agreed to fund a new building, which opened in 1931. A large Art Deco–style tympanum surmounts its entrance, showing a traditionally clothed Egyptian scribe handing a hieroglyph text to a muscular, loin-clothed youth, an illustration of the debt contemporary civilization owes to its distant roots. A friendly lion and a good-natured bison, respectively representing the Near East and the West, complete the picture. The tympanum is the work of Ulrich Ellerhusen, who, together with Lee Lawrie, had completed the sculptural work on the University of Chicago's imposing Rockefeller

Chapel. As before, the ground floor of the new building houses an archaeological museum. The year of its official opening, Breasted's work and the publicity for the new museum earned him a *Time* magazine cover.

In September of that same year, on his way to Egypt, Breasted wrote his patron a six-page single-spaced letter from aboard the SS *Lapland*. It details the twelve active research projects—six in Egypt and six in Asia—undertaken by scientists of the Oriental Institute. In it, he reiterated that it was Rockefeller's financial support that had enabled them to bring forth knowledge about humanity's "earliest civilizations."[8]

One of the results of the Oriental Institute's many activities was a dig at Dur-Sharrukin (Khorsabad), the capital that Assyrian king Sargon II built around 710 BCE, when he returned from his eighth campaign. It took only ten years to complete what Karen L. Wilson, recent director of the Oriental Institute, called a Middle Eastern Versailles.[9]

Sargon II enjoyed his palace for only two years; then he was killed, and his son moved the capital back to Nineveh.

The Khorsabad palace was buried by sand, to be rediscovered by pioneer archaeologist Paul-Emile Botta, the French consul at Mosul, in 1843. Before his consular term was over in 1844, Botta sent his finds to the Louvre. Victor Place, his successor, continued the excavation, and also sent his loot back to France, but unfortunately it was lost at sea. Nevertheless, the Louvre owned enough Assyrian remains to erect an impressive section of the palace in its galleries. A label affixed to the display reflects Sargon II's pride in his achievements:

> According to my heart's inclination, I have built a city on the plain of Nineveh at the foot of Mount Musri and I have called it Dur-Sharrukin [Sargon's Fortress]. 16283 full cubits, which is the value of my name. I have established the perimeter of its ramparts and I have settled it on solid rock.[10]

After the French dig, Sargon II's palace remained dormant until the Oriental Institute continued the excavations from 1928 to 1935. The ar-

chaeologists uncovered a forty-ton human-headed bull. These composite sculptures called lamassu, which have an animal body representing strength, a crowned human head representing intelligence, and the wings of an eagle representing power—embodied the supernatural power of the king. Lamassus (they usually occurred in pairs) have five legs, so that they appear to stand firmly when viewed from the front and to stride when viewed from the side. The original function of lamassus was to guard the entrance to the throne room of the gigantic palaces. Breasted's lamassu was carved from a single piece of stone. When discovered by the Oriental Institute it was buried in the sand and had broken into twelve pieces. Rockefeller paid for its transport to Chicago by flatbed truck and boat.[11]

Archaeologists from the Oriental Institute also unearthed spectacular low stone reliefs. One set commemorates a procession led by the crown prince Sennacherib; another depicts the king himself leading two horses. Almost three thousand years later the strength of the carvings remains awe-inspiring. During the 1990s the French made a plaster cast of the Chicago lamassu and added it to their impressive display at the Louvre.

THE ORGANIZATION OF the Chicago museum is echoed by that of the Archaeological Museum in Jerusalem, another Rockefeller gift. In both museums there are finds from the overlapping and sequential dominance of the Near East by Sumer, Babylonia, neo-Babylonia, Assyria, Egypt, Megiddo, and Persia. Each gallery follows its own timeline.

At any one time only 5 to 10 percent of the Oriental Institute's possessions are on view. The objects range from the monumental to the minuscule, and many are very, very old.

In the Mesopotamian Gallery, exhibits progress from Paleolithic times to the fifth-century CE Sasanian period. An axe with traces of human blood confirms that over the millennia humankind has not changed that much. Mesopotamia gave birth to the world's first cities, among them Uruk, Ur, Babylon, Nimrud, Khorsabad, and Nineveh.

"Red tape" and writing were invented in Mesopotamia. At first writing

was used only for trade and commerce; merchants identified their possessions or transactions through the use of small cylindrical seals, which were rolled in wet clay. Their use doubtlessly gave rise to the expression "signed and sealed." Writing expanded rapidly and was used to record history, epic tales, and, most of all, legal codes. Numbers were invented, and mathematical principles started to evolve. The famous Hammurabi legal code, which enumerates crimes ranging from murder and adultery to cutting down a neighbor's tree, meted out often harsh punishments and established lines of inheritance. It was written in Babylonia during the second millennium BCE.

The lamassu is the obvious showpiece of the museum, but there are other treasures. Breasted, who started out as a scholar of Hebrew and the Bible, initiated excavations at Megiddo, a site, which as he explained to Raymond Fosdick when proposing this new dig, "guarded the gateway between Asia and Africa . . . for thousands of years" and, moreover, was so close to Jesus' boyhood village of Nazareth that "He must have looked down upon it every day of His life there."[12]

Megiddo is mentioned in both the Old and the New Testament and in Egyptian, Assyrian, and Hittite sources. Being located on the ancient road connecting Egypt and Mesopotamia, the city was destroyed and rebuilt numerous times. During its excavation, archaeologists found altars used by the Canaanites. According to the Oriental Institute "the most spectacular portion of the Megiddo [find] are the Megiddo ivories, . . . exquisitely carved pieces of elephant tusks [that] were inlays for furniture," and a carefully carved gaming board. The other half of this ivory hoard is in the Rockefeller Museum in Jerusalem. The various objects found at Megiddo demonstrate that even during the Bronze Age the local Canaanites traded with Egypt as well as Mycenae.

In another layer dating from 975 BCE, archaeologists found biblical texts and an ossuary inscribed in Hebrew. Other remarkable finds include a group of small statuettes from Tell Asmar whose enormous inlaid eyes consisted of shells and black limestone. They date from around 2700 to 2600 BCE. A statue of Tutankhamun weighing an estimated six tons

dominates the Egyptian Gallery, and a colossal bull's head made of polished black stone inhabits the Persian Gallery.

BREASTED WAS EAGER for the Rockefellers to accompany him to the Near East, and in 1929 Junior finally consented. David Rockefeller, then fourteen, came with his parents, as did Mary Todhunter Clark, whom Nelson was courting. Perhaps Junior and Abby wanted to get to know Tod, as she was called by family and friends, to decide whether she would be a suitable daughter-in-law. In addition to the principals, the Rockefeller party included a maid for Abby, a valet and secretary for Junior, and a tutor so David would be able to keep up with his classes at the Lincoln School. Preparations for the trip were lengthy, and compared to our current informal lifestyle, seem cumbersome. The Rockefeller party discussed the type of clothes they should take, such as cutaways and top hats.

Since childhood, Junior had been immersed in the study of history and the Bible, and the trip evoked strong emotions in him. His detailed letters to his father and children attest to his enthusiasm. According to his February 6, 1929, letter,[13] everyone had loved their two-week stay in Cairo, where, even though they visited the museum at least half a dozen times, "they only touched the high spots, which included the Tutankhamun things, rich and beautiful beyond our slightest dreams." The party had visited mosques, pyramids, and the newly excavated temple at the pyramids of Sakkara, "which contain paintings and bas reliefs . . . of great beauty and delicacy."

> Dr. Breasted has made all of these things live for us with his intelligent lantern slide talks night after night. Friends whom we met and invited to these lectures . . . have uniformly been thrilled by what they saw and heard. How I wish you could all be enjoying . . . the privilege . . . of learning from the lips of perhaps the greatest living archaeologist, the relation of all these things to the development of history and the progress of civilization.

In addition to sightseeing, the party indulged in visits to bazaars, where Junior and Abby acquired exquisite rugs for their Pocantico play-house and where David turned out to be the "best bargainer and delights in the wonderful things he bought." Junior had an audience with the king, who filled him in on his grand plans for Egypt, while Abby saw the queen, who "was more interested in movie stars than affairs of the state." There were dances, dinners, teas, and Arabian horse rides, at which David ex-celled. After Cairo the Rockefellers boarded the SS *Serapis*, a *dahabiyeh* (launch) they had chartered for a four-week-long trip up the Nile.

> . . . The first two days of our trip on the River were made with almost
> unprecedented wind which brought with it a violent sand storm . . .
> The storm was so dense . . . that it was just like fog . . . To be on the
> water and to have sand constantly blowing in the windows seems in-
> congruous.

The party sailed up the Nile to Luxor, where they tied up for four days. Ten days later Junior wrote from Luxor:[14]

> We found Luxor a fascinating place. Two miles out of Luxor . . . is the
> great temple enclosure of Karnak . . . one sees the most colossal struc-
> tures ever built by man. On [our last afternoon there] we had tea on
> the top of one of the pylons . . . and watched the sun set and the moon
> and stars come out. We sat . . . on an oasis, green and fertile, with the
> native mud-huts nestling among the palm trees in the foreground—
> the river threading its quiet way through the fields, and on both sides,
> as far as the eye could see, stretched the rocky cliffs, . . . rising out of
> the barren desert. It was a scene of thrilling and awful beauty—never
> to be forgotten.

In Luxor the party visited King Tut's tomb. By then most of the trea-sures had been transferred to the Cairo Museum, but, as Junior writes, "the completely gold covered sarcophagus in which the body of the king

still lies in a beautifully carved granite tomb with the lid off, was a dazzling sight."

The group also visited Chicago House, "where Dr. Breasted and his staff . . . are working on copying and describing the records on the walls of the temples." Junior reported that the inscriptions on the temple of Ramses III, on which the group had been working for several years, was to him the most interesting he had ever seen.

On February 26, Junior described to his father the great dam at Assouan and noted that the resulting ninety-foot difference in the level of the river required the insertion of a series of six locks. The Rockefeller party then traveled to the second cataract in Nubia. By then they had covered a distance of eight hundred miles from Cairo.[15] After Egypt they visited the Holy Land and the sites associated with the Bible.

During the long trip, Junior must have grown even fonder of the erudite professor of Egyptology and Semitic languages. Before returning to

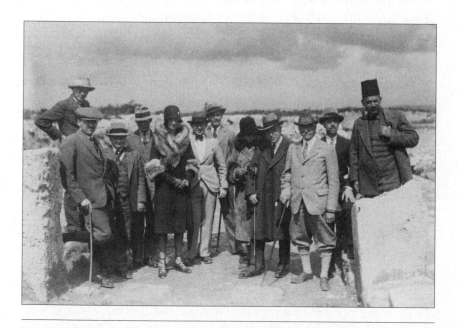

The Rockefeller party and Professor James Henry Breasted at Megiddo in 1929.
(Courtesy of The Oriental Institute Museum, University of Chicago.)

New York he gave Breasted a personal gift of $100,000 so that from then on he and his family would be free of monetary concerns.

There was another major consequence of the trip. In Egypt, Abby had met up with her good friend Lillie Bliss, also a collector, and the two women talked about founding a museum for modern art in New York. On her trip back across the Atlantic, Abby met dealer and collector Mary Sullivan, who would become the third partner in that enterprise.

THE CAIRO MUSEUM

The Cairo Museum was a Rockefeller failure. James Breasted was first and foremost an Egyptologist. Though he was a great teacher and the moving force behind the Oriental Institute at the University of Chicago, he was happiest when he was reading and deciphering hieroglyphs in Egypt.

During his frequent sojourns in Egypt, Breasted was shocked by the state of the Cairo Museum, the custodian of many of the remains of one of the world's earliest and greatest civilizations. Furthermore, he was concerned about the fate and care of the treasures from the newly discovered grave of King Tutankhamun that were to be housed there. Breasted discussed the funding of a new museum with John D. Rockefeller, Jr., who assumed the cost of developing preliminary plans designed by Welles Bosworth, his favorite architect.[16]

Egypt was in political turmoil then. During World War I, Britain had freed it from the Turks, and thereafter, Lord Allenby, a British high commissioner, governed it, as well as Palestine. In 1922 the British made Sultan Fuad king of Egypt, and handed him the reins of the entire government. The new monarch was under enormous pressure to assert modern Egypt's independence. It was during these unsettled political times that Breasted approached Egypt with his proposal for a new museum.

Breasted, Lord Allenby, Welles Bosworth, and Raymond Fosdick handled the project.[17] Breasted presented detailed sketches for a new state-of-the-art institution to Lord Allenby, who was duly impressed and agreed to transmit the plans to the king and to the British Foreign Office.

The sticking point in the $10 million project was that during the initial thirty years, the rejuvenated museum would remain under Western control. Breasted proposed that this period be reduced to twenty-five or even twenty years, but in the end this condition was not altered.

The documents that were finally submitted to the king consisted of a carefully prepared illustrated brochure of the future Cairo Museum. In the unctuous introductory letter, Breasted stressed the pivotal role the culture of ancient Egypt had played in the development of civilization, and he exalted the splendor of the proposed museum. Facing the Nile, like the great temple of Karnak, it might possibly be, he suggested, "the most magnificent museum building in the world." It would house a research building, a laboratory, a workshop for the production of facsimiles and casts, photographic facilities, and rooms for visiting scholars. In spite of the layers of flattery, the king turned down the generous offer. Egypt's loss most likely was Chicago's gain. There is no doubt in the mind of John A. Larson, current archivist of the Oriental Institute at the University of Chicago, that Breasted would have left America to be the founding director of the Cairo Museum.

THE ASSYRIAN SCULPTURES

In 1845, Austen Henry Layard, a British amateur archaeologist, had discovered the Palace of Ashurnasirpal II in Nimrud. Among his many finds were gigantic winged guardian paired lamassus, said to be endowed with magical powers, and stone slabs covered with bas-reliefs and cuneiform texts extolling the ruler's exploits.

Ultimately most of Layard's finds ended up at the British Museum. The archaeologist, however, donated a pair of lamassus and twenty-six Assyrian bas-reliefs to his cousin Lady Charlotte Guest, whose husband, Lord Wimborne, had funded his expeditions. Lady Charlotte asked Charles Barry, the architect of the Houses of Parliament, to build her, in Canford, her husband's Dorset estate, a garden pavilion to house her collection. The so-called "Magic Nineveh Porch" was a charming composite of a human-headed winged bull, a human-headed winged lion, Assyrian bas-

reliefs, Gothic arches, and stained-glass windows.[18] Some of Layard's booty reached the United States. J. P. Morgan acquired six bas-reliefs, which he donated to the Metropolitan Museum of Art. American missionaries, who felt that these bas-reliefs were tangible tokens of the actual historical past of the Bible, bought a great number of them, which ended up in the art collections of the small colleges emerging all over New England.

During the 1920s one of Lord Wimborne's heirs sold the Magic Porch for a song to Dikran Kelekian, an antiques dealer, who in turn, in 1932, sold it to John D. Rockefeller, Jr., for an inflated price. Before deciding on the ultimate recipient of this extraordinary treasure, Junior loaned it to the University of Pennsylvania, which had one of the best Near Eastern art collections in America.

Junior discussed the ultimate recipient of the lamassu statues with Breasted, who conceded that the Metropolitan Museum of Art, "the greatest art museum in America, would be a fitting recipient." However, he added, that since the staff of the New York museum could not read the cuneiform inscriptions, he hoped that Rockefeller would end up donating the lamassus to his Oriental Institute, which was considered to be America's leading center for Oriental studies.

Nevertheless, Abby was in favor of giving the winged beasts to the Metropolitan, which at the time was once more rebuilding itself. Before finalizing his gift, Junior scrutinized the architectural plans for the museum's new Near Eastern galleries and was satisfied. He wanted to pair his winged beasts with some of the fifty-five fragments from the palace that had been acquired by sixteen different East Coast institutions and one private collector. The New-York Historical Society owned thirteen, the largest number. Several colleges owned six or fewer.[19] In the end, Junior's gift to the Metropolitan included seventeen bas-reliefs.

For about twenty-five years the colossi resided in the museum's Great Hall. Then they were moved to new galleries on the first floor, where[20]

The great winged human-headed animals placed on either side of the entrance archway [to the Near Eastern galleries] can be seen from a

distance; together with the surrounding reliefs they give an impression of the boldness and massiveness of the great gate at Nimrud with continuing wall decorations carved in alabaster.

THE ROCKEFELLER ARCHAEOLOGICAL MUSEUM, JERUSALEM

Palestine, the corridor extending between Egypt to the southwest and the Fertile Crescent to the north, has always been of extreme importance, both culturally and geographically. It separated the land of the pharaohs from the great Mesopotamian empires built by the Assyrians, Babylonians, and Sumerians. By sea it was within easy reach of the Persians, Phoenicians, Greeks, Macedonians, Romans, and the other maritime powers ruling the Mediterranean and Asia Minor. The people who inhabited the strip of land were—as we would say today—highly civilized. They knew how to write, grow grain, and husband animals. Unlike the fortified cities of the Fertile Crescent or the pyramids of Egypt, their edifices were small.

Palestine was a major trade route of the ancient world. As such, it suffered frequent invasions from its neighbors, especially those in the cities along the coast of the Mediterranean. Its soil is still scarred by ancient battles, and it became a fertile terrain for archaeologists. The cradle of three major world religions, the land is also of major interest to Jews, Christians, and Muslims.

In ancient times, the lives of most of the people inhabiting Palestine, like those of their neighbors, were governed by a panoply of gods. Of special historical interest was a small tribe who worshipped a single god. The Ivriim (Hebrews)—the word means "from across the river"—emerged about four thousand years ago. They may have descended from a man named Abraham, who, with his family, migrated from the city of Ur in Assyria to Canaan, part of present-day Israel. Abraham initiated a dialogue with God that his descendants still carry on.

The Hebrews lived in Palestine, but during a severe famine, part of the tribe migrated to Egypt, where they were at first well received. After several centuries, as a result of political changes, the foreign Hebrews were

enslaved. About 1200 BCE another man, named Moses, led a relatively small group of these slaves out of Egypt. Moses and his followers, whom he had converted to monotheism, wandered in the desert for a number of years, before migrating to Canaan. They settled in their "Promised Land" and eventually established two kingdoms. With interruptions, the Kingdom of Judah occupied a large portion of the area from the eleventh century BCE until 73 CE, when the Romans exiled its citizens, the Jews.

The fact that distinguished the Hebrews (later Israelites, or Jews) from the other ancient civilizations is that some three thousand years ago they recorded their history in a book, or rather on a scroll, called the Torah. It consists of five books whose content God is said to have communicated to Moses. These books, which include the Ten Commandments, provided the Hebrews with a code of law that in essence still governs the ethical behavior of the entire world. The Torah became the most precious possession of the Jewish people, who, because of it, are sometimes referred to as the People of the Book.

Prophets, judges, poets, teachers, and scholars commented on the Torah, and their writings, together with the five books of Moses, were assembled in the Old Testament, parts of which describe actual historical events.

Jesus was born in Nazareth about two thousand years ago, and his disciples recounted his life and teachings in the four Gospels of the New Testament. Scholars have found certain links between Christian practices and those of the Essenes, a Jewish sect that existed during Jesus' lifetime. Part of the library of the Essenes, referred to as the Dead Sea Scrolls, was discovered at Qumran during the 1940s, on the eve of Israel's War of Independence.

Muslims also regard Jerusalem as a Holy City, since legend has it that Mohammad, seated on his steed, ascended to heaven from a rock in Jerusalem.

Consequently, even after the center of the civilized world had shifted from the Near East to Europe, Palestine and Jerusalem remained important to three of the world's major religions.[21]

According to Israeli archaeologist Ornit Ilan, the period between the

two world wars was the golden age of biblical archaeology. British, American, French, and German expeditions started excavating important sites, hoping to substantiate both the Bible and the history of the land that had played such an important role during ancient times. The explorers were richly rewarded with important finds.[22]

After World War I, Britain took over the rule of Palestine from the Ottoman Empire. Given the enthusiasm of archaeologists, the British Mandatory government became keenly aware of the need for a proper museum to house the newly uncovered treasures. Preliminary plans had been developed, but were abandoned because of lack of funds.

In 1925, when the plans for the Cairo Museum foundered, Breasted journeyed to Palestine to check on the University of Chicago's excavation at Megiddo. In Jerusalem he visited the building of the antiquities department and was shocked to find that only three small rooms had been devoted to the display of various antiquities. During his visit, he explored the idea of a proper museum with an enthusiastic Lord Plummer, the British High Commissioner for Palestine. The latter revealed that an ideal site had already been located, but he feared that someone else might snap it up because land in the rapidly expanding Jerusalem was at a premium. Breasted promised to raise the matter with his good friend John D. Rockefeller, Jr.

Described in 1906 as being "a five minute walk from the Damascus Gate . . . located on a small hilltop next to the route to the Mount of Olives, . . . nearly at [the height] of the Old City" with a view of the "Holy Places," the eight-acre Karm el-Sheikh site seemed to be ideal.[23] The property had a colorful history. It had served as a cemetery during the Hellenistic, Roman, and Byzantine periods. It was also here that the First Crusade, under the guidance of Godfrey de Bouillon, assembled and, on July 15, 1099, victoriously attacked the Muslim-occupied city.

In 1711 the Muslim al-Kalil family bought Karm el-Sheikh and built a two-story summer home, whose ruins survived into the 1920s. The former orchard of olive, fig, and date trees had vanished, but a magnificent old pine, brought as a seedling by Muhammad al-Kalil from Hebron centuries before, survived until 1988. After the house fell into ruin, various dignitar-

ies, including Britain's future king Edward VII, camped on the site while visiting the Holy City.

As promised, upon his return to New York, during his visit on December 15, 1926, Breasted broached with Rockefeller the question of building a museum in Jerusalem. Breasted believed that Junior would take an interest in the venture, since it bridged his fascination with archaeology and religion. The latter, however, might have been tired of his involvement in the Middle East, for the next day he wrote to Raymond Fosdick:

> I suggested to Dr. Breasted that while . . . there was not one chance in a thousand that I would care to make the contribution, I might be willing to pay the cost of a careful study of the situation, including the drawing of plans and the working up of a program to cover the whole matter. With such data before me I could more easily decide whether or not it was wise to make the contribution proposed.[24]

A week later Junior formally offered Breasted $10,000 to pay for an in-depth study of the project, preliminary architectural drawings, and to secure an option on the Karm el-Sheikh property. He added:

> You understand, of course that I have come to no conclusion in regard to any future participation on my part in this project, and I trust that you will make this point clear to the group in Palestine. I am merely making it possible for the matter to be developed in such a way that the facts may be brought to the attention of those who may conceivably be interested in the project here in the United States.[25]

An option was put on the Karm el-Sheikh property, and architect Austen St. Barbe Harrison was asked to prepare some preliminary plans.[26] English by birth, this Harrison (no relation to architect Wallace K.) had studied architecture in Canada, followed by a course in urban planning in London. In 1919 he accepted a job in sunny Greece, and thereafter spent as little time as possible in Northern Europe.

Harrison felt that the future building should combine the architectural heritage of East and West. For inspiration he visited Europe's new museums, and was particularly impressed by the use of different wings united by a continuous roof. Harrison lingered in Spain where he absorbed the beauty of the Alhambra in Granada, by all accounts one of the world's most spectacular palaces. He studied the Jerusalem site and felt that given the skyline of the Old City, the new museum should incorporate units of varying heights. His design included a tower, which, together with the proposed massive walls, was to be built from enormous blocks of stone pierced by small windows. The overall effect would be that of a medieval fortress.

Junior was so pleased by the proposal that on October 11, 1927, he sent Lord Plummer a letter committing $2 million to the project, provided "That the collections in the new museum will include all material throwing light on the past of man in Palestine; that natural resources and materials pertaining to natural science would therefore be included only in so far as they concern the human career in the past; in short that the Museum is to be an archaeological institution, not a museum of natural science."[27] The agreement also specified that the government of Palestine should pay for the site and the maintenance of the completed museum.

The Karm el-Sheikh property was bought for $140,000, and Harrison was awarded the project. Almost as soon as the ground was broken, the builders came across ancient, almost two-thousand-year-old graves. Archaeologists went to work and unearthed ceramic and glass vessels, coins, jewelry, and a stone sarcophagus, now safely inside the Rockefeller museum.

After a prolonged delay, construction proceeded. The completed building is a stunning combination of East and West. It does have a fortress-like appearance, but this impression is mitigated by the smoothness and golden hue of the Jerusalem stone used for the exterior. The sparsely used decorations endow the structure with a clean, contemporary look.

A large rectangular atrium, whose oblong pool is reminiscent of the Alhambra, occupies the center of the building. A gargoyle spouts water at

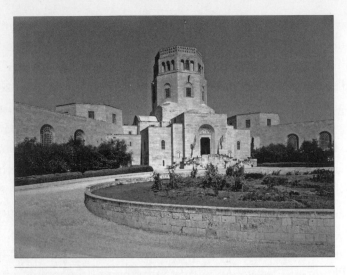

The Rockefeller Archaeological Museum in Jerusalem. (Photo ©
The Israel Museum, Jerusalem, Israel)

one end, and an ancient stone lion watches over the other. Potted plants
sit in the middle of the arcade-ringed pool, surrounded by a carefully
trimmed boxwood hedge. Unlike the thin medieval columns that ring
the inner gardens of Rockefeller's Cloisters, thick square arches surround
the Jerusalem pool.

The walls of the inner court are enhanced by ten bas-reliefs by Eric
Gill[28] an English sculptor. They represent the major cultures that impacted
Palestine: Canaan, Egypt, Assyria-Babylonia-Persia, Phoenicia, Israel,
Greece, Rome, Byzantium, Islam, and the Crusaders. The witty sculptures
are extremely fine. Three Phoenicians arrive in a little rowboat floating
on decorative waves. Islam is represented by a female-headed sexy-looking
version of a winged beast; Rome, by a thin wolverine suckling two lusty
twin boys; the Crusaders, by a childlike knight bearing a flag and kneel-
ing in front of a quadruple cross; and Greece, by a wistful-looking youth
holding up the world.

David Ohanessian, an Armenian ceramicist, had arrived in Jerusalem
in 1918 to restore the ceramic tiles of the Dome of the Rock. That project
fell through, but fifteen or so years later, Ohanessian was hired to create

tiles for the Rockefeller Museum. The design included a stylized flower surrounded by twelve petals colored in blue, turquoise, and black on a white background. The tiles line the walls of the fountain niche at the head of the central court, adding color to the white walls and emphasizing the Near Eastern character of the museum.

The overall shape of the museum resembles a butterfly. Seven galleries, two large ones and five small ones, and the imposing tower hall that serves as an entrance, surround the Central Court. Three additional open courts surrounded by thick walls suggest the claustrophobic and protective atmosphere of a medieval fortress. Though Junior never saw the museum, he would have approved of the careful workmanship.

TO CELEBRATE ITS sixtieth birthday in 1998, the museum mounted an exhibit entitled *Image and Artifact*, which paired aerial views of the sites in Israel with their finds. The most imposing of these is the excavated city of Caesarea on the Mediterranean coast, built by Herod the Great nine years before the advent of the current era.[29]

Caesarea's largest structure is its Roman amphitheater, now rebuilt and used for outdoor performances. The Roman necropolis yielded a spectacular sarcophagus copiously decorated with a mythological battle between the Greeks and the Amazons. Today the sarcophagus sits in an arched doorway overlooking the museum's inner court.[30]

In olden times, Palestine, also referred to as Canaan, encompassed modern Israel, the West Bank, and part of both the East Bank and Lebanon. Its history can be divided up many different ways. The artifacts displayed at the Rockefeller Museum are arranged chronologically, spanning a period from Paleolithic times to the Ottoman Empire, and include items from the Bronze and Iron ages, and the Persian, Judean, Canaanite, Hellenistic, Roman, Byzantine, Islamic, Crusader, and Mameluke periods.

Date-wise, the brilliant civilizations of Mesopotamia and Egypt started to develop around 4500 BCE and were contemporary. During these millennia peace, trade and prosperity alternated with war and conquest. The

feisty resident population of Palestine participated in all the phases of this turbulent history.

Some of the treasures of the Rockefeller Museum are spectacular; others, such as a group of letters discussing the political tensions that existed in Palestine 600 years BCE, are significant from a historical point of view.[31] There are dozens of small Egyptian bronze figurines representing gods, mortals, and animals. A tomb from the Persian period yielded furniture and a bowl and ladle presumably used during opulent banquets. When J. H. Iliffe, the founding curator of the Rockefeller Museum, examined the furniture pieces, he discovered that they were marked with Phoenician letters intended to facilitate their assembly. A large painted stucco statue of a sumptuously clad caliph standing atop two lions attests to the presence of Muslims during the eighth century. And the helmeted head of a Crusader, which originally decorated a building, recalls the many religious wars fought over Jerusalem.

During the 1937 digging season at Megiddo, archaeologists from the University of Chicago unearthed 382 ivory plaques. Most were of local manufacture, but some may have originated in Egypt, Syria, Turkey, or Greece. One of these, now in the Rockefeller Museum, is incised with two

Ivory plaque depicting a victorious prince returning from a battle; Megiddo, thirteenth to twelfth century BCE. (Photo © The Israel Museum, Jerusalem, Israel)

scenes. In the scene on the right a charioted Canaanite prince returns from a victorious battle. Two circumcised prisoners precede his horse. In the left portion of the plaque the prince is seated on an ornate throne, being attended by a woman, presumably his wife, and by musicians and servants. Flowers, lotus blossoms, and a delicately carved winged sun disc float above and in between the figures.

The possessions of the Rockefeller Museum not only made a major contribution to the understanding of the ancient world but also underscored the fact that Jerusalem is the spiritual home of three major faiths. A wooden panel from the al-Aqsa Mosque dating from the eighth century CE attests to the presence of the Muslims; an inscribed stone panel from an ancient Jerusalem synagogue dating from the first century BCE, to that of the Jews; and a fourth-century CE marble statue of Jesus as the "Good Shepherd," to that of the Christians.

The earliest finds in the museum, uncovered in prehistoric Carmel caves, date from about 12,800 to 10,300 BCE. They consist of carved bones, one of which resembles a gazelle, and necklaces made from shells and bone fragments. Jericho, associated with the biblical tale of its conquest by Joshua, was the site of a pre-pottery Neolithic culture. The Rockefeller Museum owns a plaster-covered human skull dating from the Middle Bronze Age II (1750–1550 BCE) and an abstract-looking drinking vessel.

Major cities were founded in the region around 3000 to 2300 BCE. The outlines of the palaces, temples, and fortifications built at the time can be discerned in aerial photographs. Upon excavation, the temple of the city of Ai yielded fragments of Egyptian alabaster, proof that five thousand years ago Canaan and Egypt traded with each other.

The Rockefeller Museum owns two jewelry hoards. The first was discovered at Tell-el Ejjul, located on the banks of the Nahal Besor River, near its Mediterranean estuary. Ejjul was one of the fortified cities that arose around 1700 to 1600 BCE along the coast. Asiatic tribes, referred to as *hekau khaswt* ("rulers of foreign lands," or Hyksos), who also settled in the Nile Delta, probably founded it. They plied a lively trade in oil and wine between Egypt and Canaan. The city eventually was destroyed around 1550 BCE.

Excavations yielded a cache of earrings, belts, plaques, pendants, brace-
lets, and fibulae, which seem to have been created by Canaanite craftsmen
from Nubian gold. One pair of earrings is even made by the cloisonné
technique and features inlaid Egyptian sun discs and tiny golden gazelles.
Gold plaques bear the image of a Canaanite fertility goddess, and belts are
decorated in an intricate herringbone pattern. According to Ornit Ilan,
the cache "is the most sumptuous ever uncovered in this country."

The second group of ornaments, dating from the late Bronze Age (1550–
1150 BCE), was found at Beth Shemesh in the Judean Hills. During this
period this Canaanite settlement was thriving under Egyptian rule. Four
hundred individual items had been stowed in a single pottery jar hidden
beneath the floor of a private house, presumably by the fleeing owner.
The jewelry, made of gold, silver, bronze, and stone, included earrings and
several necklaces. Some consisted of gold and intricately shaped beads of
red carnelian and dark hematite; others, of rectangular plaques imprinted
with a papyrus pattern. The hoard also included thirty-one small Egyp-
tian scarabs dating from the time of Ramses II and, most important, a
small seal from Mesopotamia. The latter dates from the seventeenth cen-
tury BCE and depicts the storm god Adad, carrying a thunderbolt, in con-
versation with an ordinary mortal. The hoard once more demonstrates the
lively trade that existed among the inhabitants of the Near East some four
thousand years ago.

Of great interest are twenty-one letters dating from 587/6 BCE written
in Hebrew script by a certain Hosha'yahu, presumed to be a military offi-
cer stationed in Lachish prior to the wars with the Babylonians. This par-
ticular conflict ultimately resulted in the destruction of the first temple in
Jerusalem and the exile of the Jews.

FOR SOME REASON, Rockefeller had wanted to keep his involvement
with the museum in Jerusalem a secret, but word leaked out. As usual,
news involving the Rockefellers elicited a reaction from the press. On

November 18, 1927, *The Boston Transcript*[32] registered its disapproval of the urban renewal that was engulfing "the City of David, of the Temple of Gethsemane and the Holy Sepulcher." Nevertheless, the paper felt that Mr. Rockefeller's museum "will fill an important need not only of archaeology but of religion. It will help separate the true from the false in the way of sacred relics and reminders in and about a city which is holy to three religions."

The Rockefeller Museum finally opened on January 18, 1938. Five years earlier, Breasted had retired from the University of Chicago. He had journeyed twice more to Egypt and his beloved Near East. After the second post-retirement trip he was "as keen as a boy" to get back to his desk and begin the revision of his *History of Egypt*. On his return voyage aboard ship he developed a hemolytic streptococcus infection. When he arrived in New York he was immediately transferred to the hospital of the Rockefeller Institute, but in those pre-antibiotic days, the infection took hold, and he died on December 2, 1935. Appropriately his tombstone is a block of rough-hewn granite from the ancient Egyptian quarries in Assouan.[33]

The Near East, to which he had devoted his life, continued to be engulfed in turmoil. The Rockefeller Museum, under the aegis of the British Mandate, became an important presence in the cultural life of Jerusalem. The British Mandate in Palestine ended in 1947. Prior to Britain's departure, its high commander appointed an international board of trustees to oversee the museum. Their administration was brief. In 1949, East Jerusalem fell to the Jordanians during Israel's War of Independence.[34]

In April of that year, John D. Rockefeller 3rd received a letter from his friend James G. McDonald, working for the U.S. Foreign Service in Tel Aviv. Over the weekend he had gone to Jerusalem

> long enough to get a vivid and moving impression of the historic City. In particular I think that your father would be interested to know that the Museum has mercifully escaped all save merely some surface damage to the tower . . . as judged through powerful glasses from the

roof of the Notre Dame de France, which overlooks the walls of the
Old City to the northwest. . . . I wish I could add that I am hopeful
that the Museum would be reopened for the use of the whole City
soon, but that is too much to expect.[35]

The museum finally reopened in 1950.[36] An international board of
trustees ran it until 1966, at which time King Hussein of Jordan national-
ized it. During the Six-Day War, in 1967, the museum once more changed
hands. It is now part of the Israel Museum in Jerusalem.

Rockefeller Center

J OHN D. ROCKEFELLER, JR.'S best-known legacy is Rockefeller Center, a building complex constructed at the height of the Great Depression. The project became entirely his almost by default. For a long time it looked as if this "city within the city" would be an architectural, cultural, and financial disaster.

Now, almost eighty years after the laying of its cornerstone, Rockefeller Center astonishes with its elegance, the clean lines of its buildings, the perfection of its workmanship, and the unifying concept of both the buildings and the more than one hundred pieces of art that adorn its interiors and exteriors.

SEVERAL FACTORS CONTRIBUTED to the birth of Rockefeller Center during the second quarter of the twentieth century, in the midst of an already crowded, always expanding city. The first of these was that the Metropolitan Opera was stifled by its unattractive home located at Thirty-ninth Street and Seventh Avenue. It wanted a spectacular new theater, fronted by an elegant plaza like that of the Place de l'Opéra in Paris. Perhaps, the directors of the Metropolitan Opera dreamed, their new home

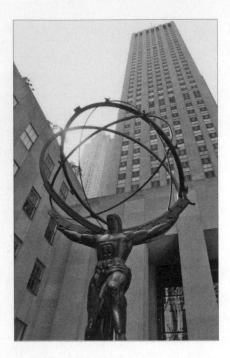

*The 7-ton Atlas in front of
the International Building. Junior
was so impressed by it that he allowed
an overdraft to have it cast in bronze
rather than aluminum.* (Sean
Gordon-Loebl)

could even be paired with a grand concert hall, one that would replace aging Carnegie Hall.

The board of the Opera realized that the construction and maintenance of a new opera house would be costly. They decided to pair it with revenue-producing real estate that would include office buildings, shops, and restaurants. In order to recruit backers, the preliminary plans, developed by the well-respected architect Benjamin Wistar Morris, were presented in 1928 at a festive dinner held at New York's elegant Metropolitan Club. The Opera board hoped to interest John D. Rockefeller, Jr., in their venture.[1]

It was a near-miracle that a single owner controlled a large piece of real estate in midtown Manhattan. Around 1810, when a reluctant New York State legislature awarded it the former Elgin Botanic Garden, Columbia University had come into possession of three entire city blocks. At the time, the rural site was distant from the city's center of activity,

and the university leased it out for a pittance. When the city grew, the university's land—bordered by Fifth and Sixth avenues, and by Forty-eighth and Fifty-first streets—became more valuable. At one time, the university itself had been expected to relocate to this so-called Upper Estate. (The Lower Estate, located near New York's present City Hall, had been given to the trustees of the original King's College, Columbia's predecessor, in 1755.)[2] Columbia University never moved to its three mid-town blocks. During the 1910s it relocated all the way uptown to a Morn-ingside Heights site vacated by the Bloomingdale Asylum. The value of Columbia's midtown real estate kept increasing, especially after the new St. Patrick's Cathedral opened its doors in 1878. Millionaires vied for lots, and the university's revenue from its ground leases soared. By the 1920s there was another turnaround. The land along Fifth Avenue was still desirable, but the side streets became shabby—filling with speakeasies, tenements, and houses of prostitution. The university began looking for new tenants.

Junior did not attend the Metropolitan Club dinner meeting at which the Metropolitan Opera unveiled its plans. But Ivy Lee, his publicist, rep-resented him there, and was favorably impressed. In addition to the phil-anthropic and commercial aspects of the project, Junior was concerned about his own neighborhood. He had lived four blocks north of the Upper Estate since the family moved to New York in 1884, but now midtown was becoming increasingly commercialized. A 1923 change in the zoning law had allowed high-rises to be built along upper Fifth Avenue. This prompted Rockefeller's fellow tycoons to abandon their mansions below Fifty-seventh Street and move into luxurious apartment houses. Midtown thus was losing its residential character. The demolition of the 137-room Cornelius Vanderbilt mansion at Fifth and Fifty-eighth, and its replace-ment by the Bergdorf Goodman store, was a bellwether.[3] Junior tried to protect his immediate surroundings, buying up any available real estate. By 1924 he owned more than forty separate parcels of property along and west of Fifth Avenue, on Fifty-third, Fifty-fourth, and Fifty-fifth streets. He used his economic and political clout to forestall the rezoning of Fifty-

third and Fifty-fourth streets between Fifth and Sixth avenues for commercial use. His office also managed to minimize the real estate taxes on Rockefeller-held properties by carrying them at a figure that was well below then true market value.[4]

Even though he had secured his fiefdom, Junior remained worried. So he was favorably disposed when asked to participate in the development of a more or less self-sustaining opera house paired with mixed-use commercial real estate. Nevertheless, before committing himself to the venture, he consulted five different real estate agents about the financial soundness of the project. The responses were unanimously positive.[5]

Junior began negotiating with Columbia University. In May 1929, a year after the dinner at the Metropolitan Club, Rockefeller examined the preliminary architectural plans for the site and signed a binding lease with Columbia University for the Upper Estate. The annual lease fee for the property was $3.3 million.

Five months later, on October 29—"Black Tuesday"—the stock market collapsed. On December 3, 1929, in view of the now shaky financial condition of its donors, the Metropolitan Opera Association withdrew from the joint venture. The Opera would remain in its 1883 house for another thirty-five years, until another Rockefeller, Junior's son John 3rd, moved the company to Lincoln Center.

Meanwhile, when the Opera had withdrawn, Junior had the choice of abandoning the project and losing a great deal of money—every year he would owe Columbia about $3 million in rent—or of going it alone. He chose the latter course. Later, when discussing this decision with his biographer, Junior said, "I don't know whether it is courage or not . . . Often a man gets into a situation where there is just one thing to do . . . he wants to run, but there is no place to run to. So he goes ahead on the only course that's open and people call it courage."[6]

BY THE TIME the Rockefeller Center project got under way, both John 3rd and Nelson had joined their father's office at 26 Broadway. His brother

David described John 3rd as "most like Father, . . . hard working and conscientious . . . with a strong sense of duty." John 3rd had his Rockefeller grandfather's build, but was shy and introspective like Junior. Instead of being supportive, Junior was horrified by his eldest son's shyness and tried to toughen him up during his childhood and adolescence.

John 3rd attempted to please his father, but never succeeded to meet his standards, and in the end his failures resulted in alienation. From early on there was tension between Nelson, who would have liked to be the Rockefeller standard-bearer, and timid John 3rd, who envied his younger brother's ability to fit seamlessly into his surroundings. Their parents were aware of the discord. Abby preserved a letter from eight-year-old "Johnnie," which, as he proudly reported, he had typed himself: "Nelson and I have not had a quarrel." The letter also mentions that he missed his mom intensely.[7]

Unlike his four younger brothers, who would attend Manhattan's liberal Lincoln School, John 3rd, in an attempt by his parents to toughen him up, attended a series of boarding schools. His mother realized how homesick he was and wrote him loving letters. John 3rd treasured family vacations and was a good student, penning winning school essays. He took up tennis, which became a life-long pastime; collected stamps, autographs, coins; and read books about the Great War. He also kept a diary, whose entries record his emotional ups and downs. In some entries he admits that the other students were nice to him and that, for unknown reasons, he had a great time. Other entries attest to his depression and self-doubt: "I have no personal attraction. Nobody wants to sit next to me at the table." "I have no real friends here at school." "Wish I was more popular." "Nelson dances very well, I am rotten," "I wish I was different in many ways than I am."[8]

His father was pleased by the way his eldest son handled his finances. He spent only half of his weekly fifty-dollar allowance—a considerable sum in the 1920s—and saved or gave away the rest. John 3rd was an extremely responsible financial administrator, an ability that would later serve him and his philanthropic enterprises admirably. His father was

impressed, and in time would entrust him with a larger share of the Rocke-feller fortune than that given his siblings.

Junior had wanted his eldest to go to Dartmouth, but John 3rd pre-ferred Princeton. He was an excellent student and was reasonably happy. At one time he considered studying art, but as a good Rockefeller scion, he selected "deadly dull" economics, with art becoming his minor. His thesis dealt with American labor relations, a topic that, after Ludlow, had become one of Junior's concerns. Once again, Father was pleased.

In spite of his considerable achievements, John 3rd's diary entries re-mained morose and self-doubting. But he was also gaining some insight about family dynamics, wondering why Father "is so wonderfully broad in business relations but so narrow in some of his family ideas."[9]

After graduation, before starting to work for his father, John 3rd em-barked on a round-the-world trip, which intensified his interest in inter-national affairs, especially those concerning Japan. By comparison, life at the Rockefeller family office was dull. John 3rd became a member of twenty different boards, none of which represented a cause he himself had selected. In addition he managed the Pocantico estate, a task that would result in an open clash with his father, who was reluctant to grant his pri-vate staff benefits equivalent to those awarded unionized workers.

John 3rd's romance with Blanchette Ferry Hooker was the most im-portant event of his post-college years. The two had met fleetingly, but it was at a "postdeb[utante]" dance at the Hotel Pierre that they really clicked. They started out dancing, but soon sat down to talk while the rest of the crowd continued to swirl to the music. Their conversation revolved around social work and other serious issues. The next morning John 3rd invited Blanchette to come riding at Pocantico Hills on New Year's Day, a week hence. Their relationship progressed quickly, with the enthusiastic approval of both sets of parents.

During one of Blanchette's visits to Maine, John 3rd decided to con-front her with an enumeration of his faults. She was not deterred, and the couple married on November 11, 1931, in a glamorous ceremony at the new Riverside Church. Instead of the customary vows, Blanchette's socially

conscious bridegroom pledged his bride "a husband's love and protection." The ceremony was followed by a reception for a thousand guests at the Colony Club. The couple had hoped for a long honeymoon, but Junior was fatigued, and so John 3rd was back at the office after a two-week stay in Bermuda.

Blanchette was more like Abby than the other Rockefeller daughters-in-law, and clearly became her in-laws' favorite. She was elegant, beautiful, smart, conscientious, and loyal. Her forebears had arrived in America in Colonial times, and were financially successful. The family was artistically inclined, and Blanchette, like her mother and two of her sisters, went to Vassar, where she majored in music and minored in German.

After their wedding the couple moved to a duplex at 1 Beekman Place, in Manhattan, where they remained until their deaths. Again like Abby, Blanchette was her husband's staunch supporter. She and Nelson's wife Tod became best friends, in spite of the tension that existed between their husbands.

John 3rd never enjoyed working for his father and emerged from his shell only after World War II. Nelson was different. Born in 1908, on Senior's birthday, he was exuberant, daring, outgoing, unruly, and loved to be the center of attention. He would also turn out to be ruthlessly ambitious, putting his own interests and pleasures ahead of his concern for others. Both physically and mentally, Nelson was very much his mother's son.

Unlike John 3rd, Nelson never went to boarding school. In their search for an institution that would minimize the effect of the family's elite standing, Junior and Abby came across the progressive Lincoln School—initially funded by the Rockefellers' General Education Board—whose mentors included Charles W. Eliot, past president of Harvard, and the philosopher John Dewey. Nelson thrived at Lincoln. In fifth grade he had drafted an intricate class constitution that comprised five officers, each of whom had definite governmental roles.[10]

Nelson always liked women. Already at Lincoln he went steady with Geraldine Chittolini, considered the class flirt and the most attractive

girl in the school. During his senior year he realized that his dismal grades, most likely caused by a combination of procrastination, partying, and dyslexia—a then-unidentified condition that impairs reading and spelling—were far below college standards. Worried, he broke off with Geraldine and settled down with his books.

In 1926, Nelson entered Dartmouth College, in Hanover, New Hampshire. During college his profound fascination with art came to the fore. He took up photography and joined the staff of *The Pictorial*, the college's picture magazine, and soon assumed its editorship. Once in charge, he produced a superior publication that, according to Cary Reich, his biographer, "took on the style and panache of a slick New York magazine."[11]

Nelson also joined the college's anemic Arts Club, whose membership included the "tea-drinkers," a contemporary label for gays. After being elected president, he transformed the organization by inviting Sinclair Lewis, Carl Sandburg, Edna St. Vincent Millay, Thornton Wilder, and Bertrand Russell to lecture on campus. The club embarked on publishing a sumptuous *Poetry Anthology*, again a testimonial to Nelson's "exquisite taste and to his heedlessness about cost."[12]

Nelson also achieved academic excellence. He had toyed with the idea of studying architecture, but like his brother, he knew that for him it was not a realistic choice. He majored in economics instead, and for his senior thesis he decided to research the history of the Standard Oil Company. He must have known that the undertaking would please his grandfather and father. "I don't know when anything has interested me more than the study I did," he wrote to Junior, just then sojourning in Egypt.[13] "For the first time I felt that I really knew Grandfather a little—got a glimpse into the power and glory of his life."

Unlike his two elder siblings, Nelson managed to cope with his father's straight and narrow ways and occasionally even poked fun at Rockefeller reverence. David Rockefeller recounts how, as a child, Nelson shot rubber bands during family morning prayers, perhaps even to the amusement of their mother.[14] Most likely Nelson was both his parents' favorite.

Nelson continued to overstep boundaries even when he was older,

and when caught, he simply apologized for his misdeeds, promising to
mend his ways. He also made sure that his father received these missives
when he was safely out of reach.

> All my connections with accounting and accounts have been dis-
> graceful so far. I have said that I was going to improve, but have only
> gotten worse. I apologise which does no good I know and give you my
> word as a gentilman [*sic*] that you will have no more trouble with me
> in that line.[15]

Nelson relished being a Rockefeller. Throughout his life he relied on a
mixture of competence, charm, clout, unbridled enthusiasm, money, ambi-
tion, and the bending of rules to achieve his goals. Being second was never
good enough for him. At first he wanted to be the leader of the brothers,
then of New York State, and finally of the United States. Even when young
he was aware of his less admirable traits. In 1933 he sent an insightful letter
to his mother, answering a particular, now unknown, accusation:[16]

> I can assure you that you can't be any more worried about me than I
> am myself. I find life just as perplexing as Laurance does, only I have
> a driving force in me and a happy-go-lucky nature I keep going on . . .
> I think that you give me too much credit when you say that you
> don't think that I am not really hard and unfeeling. . . . I am both
> of these, not naturally but by schooling myself to be. That sounds
> strange . . . It is the result of my overpowering ambition. If one is to
> get very far in this world one must be impersonal and not waste one's
> emotional strength on irrelevant things. The result has been that I
> take a pretty cold attitude about most things. . . .
> Don't worry Mum, we'll all stick together anyway
> Your devoted bad boy, Nelson

Just to reassure his mother that he did not take life too seriously, he
added a P.S.

I bought a swell blue hippopotamus by Carl Walters from Mrs.
Halpert. Wait until you see it!

Fifty years later, during an interview with Bernice Kert, Abby's biog-
rapher, his sister-in-law Blanchette described Nelson's cavalier attitude in
similar terms: "He was bursting with energy and enthusiasm; one of those
men who is full of power and excitement and who could not get along
without women. In many ways he was the jewel of the family, in other
ways he remained always a naughty boy. He was just a little out of hand
all the time."[17]

During their summers in Seal Harbor the young Rockefellers had
befriended the Clark family, well-to-do Philadelphians with a lineage
that made the Rockefellers seem like newcomers. Nelson fell in love with
Mary Todhunter (Tod) Clark, who had joined Junior and Abby on their
voyage to the Near East. By nature, Tod was a tomboy, good with horses,
full of fun, and always ready to play a prank. She was a bit sharp-tongued,
but her barbs were softened by wit. Even during their courtship, Nelson
was not faithful, nor was he later as a husband. Tod and Nelson married as
soon as he graduated. The wedding took place at the Clarks' country place
near Philadelphia on June 23, 1930. Even though Prohibition was still in
effect, and to Junior's discomfort, champagne flowed freely during the fes-
tivities. The event was also a feast for the press. Tod, presaging her future
dislike for publicity, was most impatient, as photographers kept insisting
on additional pictures.

Junior and Abby believed in the educational benefits of travel and
treated the newly married Nelson Rockefellers to a nine-month-long hon-
eymoon. Back home at 26 Broadway, John 3rd handled his brother's ex-
travagant expenses. During the spring of 1931 a reluctant Nelson joined the
family enterprises, and quickly elbowed his older brother out of the way,
involving himself in shaping Rockefeller Center and assisting his mother
in creating MoMA.

UNTIL 1933, EVEN though the young Rockefellers were grown and had families of their own, Junior still monitored their expenses. Each child received an allowance, but money for major purchases such as houses and cars was negotiated. On May 1 of that year the siblings wrote a carefully worded letter suggesting that the arrangement be modified. In the florid prose they used to communicate with their father, they pointed out that they wanted and needed his advice more than ever, and stressed how much pleasure they got from being with him discussing his many interests. They pointed out that the routine discussion of business and financial matters intruded on the very limited time they spent together as a family and suggested that a different financial arrangement was in order.[18]

Their request came at a time when major changes in the laws governing inheritance tax were to occur, and Junior may have been predisposed to accede to their demands. The so-called 1934 trusts for his wife and six

The five Rockefeller brothers at the family offices. Left to right: David, Laurance, John, Nelson, and Winthrop. (Courtesy of The Rockefeller Archive Center)

children, each worth between $18.3 and $14 million, were the result of the negotiations. Use of the money and invasion of the capital were still strictly regulated, but the trusts finally bestowed financial freedom on the children and Abby.

WHEN ROCKEFELLER CENTER was still the Metropolitan Opera's project, John R. Todd, a successful developer of Manhattan real estate, participated in drawing up the early plans. When Junior took over, Todd visited him in Maine. After three days, during which the two men went on many lengthy carriage rides along Junior's new roads, Todd and his Engineering Corporation were entrusted with the construction and management of the entire project. Todd was determined to see the venture become a commercial success, and many of his decisions were driven by this goal. His role cannot be overestimated. "Without John R. Todd," writes Daniel Okrent, one of the Center's historians, "Rockefeller Center would have been no more than a collection of buildings in midtown."[19]

From the time Nelson joined his father's team he would challenge Todd's ultimate authority. To begin with, Nelson involved himself in renting Rockefeller Center offices using tactics that, according to author Frank Gervasi, were comparable to those of "John D. Rockefeller, Sr. at his roughest."[20] Using this foothold, Nelson gradually eased Todd out from his managerial position. Within eight years, Nelson had assumed the presidency of Rockefeller Center. With time off during the war and political appointments, he retained this title for most of his life. He was a consummate public relations man, and Rockefeller Center owes him much of its fame.

DURING THE DEEPENING 1929 Depression, Rockefeller Center became New York City's plummiest construction job. Junior and Todd awarded the contracts to three firms: Reinhard and Hofmeister; Hood, Godley and Fouilhoux; and Corbett, Harrison and MacMurray, globally referred to

as "The Associated Architects." In the end, three architects—Raymond Hood, Wallace K. Harrison, and Andrew Reinhard—played the primary role in designing the Center. They were supported by others as well as 120 draftsmen.

The withdrawal of the Metropolitan Opera presented the builders with a major design problem. What, they wondered, would replace the opera house that was to be the central focus? The answer was a spectacular skyscraper surrounded by a group of lesser buildings. The design was revolutionary insofar as the main building did not front a major thoroughfare but instead occupied the center of the site. The open plaza, initially planned to front the opera house, remained an important component of the complex. To increase road frontage, the architects also created a private street, Rockefeller Plaza, running from Forty-eighth to Fiftieth streets. This road bisects the entire site, separating the central skyscraper from a sunken plaza—a stand-in for the "Metropolitan Square" that was to have faced the opera house. A narrow promenade, flanked by low buildings, extends from the plaza to Fifth Avenue. The remainder of the three-block Upper Estate parcel is filled with buildings of various sizes.

During the 1930s, Beaux-Arts architecture and other adaptations of inherited styles were in decline, but "modern" architecture had not yet completely arrived. Many skyscrapers were still overly tall houses whose walls rose from the ground in continuous straight planes often embellished by traditional architectural details. Junior hoped the architecture of his Center would reflect his favorite Gothic style, which he had used with so much pleasure for the just-completed Riverside Church. Raymond Hood, the chief architect of Rockefeller Center, adhered to a different concept.

Hood had trained at MIT and, like most American architects, had completed his studies at the École des Beaux-Arts in Paris. To Junior's delight, Hood also had worked for Cram, Goodhue and Ferguson, the leading proponents of the Gothic style in America.[21] Hood thus had a classical training, but his unconventional and open mind helped him step outside the box.

Hood's career took off in 1922, when a Chicago-based colleague, John

Mead Howells, invited him to participate in a competition to design a sky-scraper for the *Chicago Tribune*. Howells and Hood won the competition; the skyscraper was built and acclaimed. Its shaft was pleasantly modu-lated, and its crown was adorned with flying buttresses and other Gothic-style decorations. The runner-up submission for the Tribune Tower had been a starkly modern design submitted by Eliel Saarinen, the prize-win-ning Finnish architect then teaching at Cranbrook Academy of Art in Michigan. The ever-modest Hood felt that Saarinen should have won the competition. In the future he would adopt some of his ideas.

After the Tribune Tower competition, Hood's lean days were over. He designed a new building for the American Radiator Company in New York and thereafter was commissioned by Joseph Patterson, the former co-owner of the *Chicago Tribune*, to build a printing plant for New York's *Daily News*. For practical reasons, the plant was to be located on Manhattan's pricey Forty-first Street. Patterson had planned to pair the plant with a simple office building. Hood instead designed a large office tower that would yield consid-erable rental income. Patterson was stunned by such a major proposal, but he finally agreed to build it. The resulting complex was efficient, cost-effective, and attractive, and Patterson was happy. The buildings were devoid of the Gothic decorations Hood had used in Chicago.

When Hood designed Rockefeller Center's central seventy-story tower, he heeded Todd's desire to maximize naturally lit office space by gradu-ally reducing the number of elevator banks serving the upper floors. This feature translated into the setbacks that give the building its elegant, soar-ing appearance. Indeed, 30 Rockefeller Plaza, the Center's main skyscraper, looks like a rocket poised to fly off into the sky.

There were protests as this seventy-story building rose in midtown Manhattan. The *Herald Tribune* described it as "utility sans beauty," "ugly," with an exterior that is "revoltingly dull and dreary." The *New York Times* deplored the fact that instead of taking advantage of a "magnificent and unparalleled opportunity for a great architectural development," the builders were creating "aberrations and monstrosities." *The New Yorker's* Lewis Mumford, who, a few years earlier, had vociferously panned the

design of Riverside Church, now talked of the "graceless bulk" of the RCA building.[22]

A major objection to Rockefeller Center's large skyscraper concerned the shadow it cast on the neighborhood. Even Junior and Abby, who could see the skyscraper from the upper floors of their town house, were perturbed by the building's presence. John minded the structure's irregular shape and lack of decoration, and he begged John R. Todd to soften its outline by adding columns and a pergola to the top.[23]

As Abby watched the growth of Rockefeller Center from the top floor of her brownstone, she commissioned Stefan Hirsch, a German-born American artist, "to paint a view she regretted losing, [because] Rockefeller Center was going up two stories a day." Hirsch obliged. In March 1931, he created *Midtown Range*, in which the sunlit Chrysler building peeks out amid dark clouds. The spires of St. Patrick's Cathedral still reach imposingly into the sky against a background filled with skyscrapers. David Rockefeller now owns the work.[24]

ROCKEFELLER CENTER MARKED the beginning of Harrison's career. Like Hood, he had been trained at the École des Beaux-Arts in Paris. It was during Rockefeller Center's long construction period that Nelson and Harrison started their lifelong friendship. Thirteen years his junior, Nelson viewed Harrison as his "idea man." Three months before his own death, Nelson dedicated his *Masterpieces of Modern Art* to Wallace K. Harrison, "the person who, next to my mother, had the greatest impact on my life in terms of understanding the relationship between the cultural creations of our times and the environment from which they spring."[25]

Harrison would become one of the Rockefellers' major "house architects," designing the United Nations headquarters, Lincoln Center, additions to Rockefeller University, various private family homes, and, finally, the Nelson A. Rockefeller Empire State Mall in Albany. Most of Harrison's larger buildings adhered to the sleek International style, dominant during the second half of the twentieth century. But he had another side,

and many of his smaller buildings and private residences were more lyrical. The architect was partial to round spaces, which he so successfully used for the Caspary Auditorium at Rockefeller University and in many of his other buildings, large and small.

During the building of Rockefeller Center, Harrison played an important role in reconciling flaring tempers and smoothing over disagreements. Junior, who kept close tabs on the construction, grew very fond of him and, in 1936, gave him a gilded folding ruler similar to the one that he himself carried.[26] At one point during the design process, Junior wanted to festoon his buildings with Gothic ornamentation. An incensed Harrison retorted, "Goddamn it, Mr. Rockefeller, you can't do that. You'll ruin the buildings if you cover up their lines with all that classical gingerbread."[27]

THE ULTIMATE SUCCESS of any commercial building is a high occupancy rate. During the 1920s, radio was in its ascendancy, movies were the country's favorite form of entertainment, and television was on the horizon. In 1919, the U.S. government, worried about British dominance of mass communication, sponsored the Radio Corporation of America (RCA).[28] In 1930, under the leadership of its young president, David Sarnoff, the company had grown and was looking for new headquarters. In June it leased large chunks of two of Rockefeller Center's future office buildings. The company's need for several theaters dovetailed with Rockefeller Center's original plans of being an entertainment center. Radio City Music Hall would be the first section of Rockefeller Center to be completed, opening on December 27, 1932.

All in all, RCA and its associate Radio-Keith-Orpheum (RKO) agreed to lease 1.5 million square feet of future space. Then as now, the major tenant of any Rockefeller Center building could name it, and RCA chose "Radio City" for the entire entertainment component. It took a while for the broadcasting company to attain a firm financial footing, but RCA has remained Rockefeller Center's most faithful major tenant. (The names of the buildings have changed over time, but the original names are used here.)

One of Junior's lifelong concerns was the improvement of international relations. As with the World Trade Center, sponsored thirty years later by his son David, Junior wanted Rockefeller Center to serve as a magnet for international trade and friendship.[29] Indeed, the earliest plans for Rockefeller Center already featured buildings designated as the "British Empire Building" and the "Palais de France," two low buildings flanking the formal entrance to the entire complex. They were separated by a promenade, the "Channel Gardens," named after the arm of the North Sea that separates England and France.

At one point, Italy and even Germany were also to have their own buildings—Palazzo d'Italia and Das Deutsche Haus—along Fifth Avenue. A model of Rockefeller Center was shown to an enthusiastic Benito Mussolini in 1932. Germany, too, vied for space. A somewhat naïve John 3rd, abetted by powerful members of his father's team, tried to persuade Junior that Hitler was innocuous and, from a trade point of view, that the new Germany would be an asset to Rockefeller Center. German companies began leasing space. Fortunately, in September 1933, Junior visited his Seal Harbor neighbor financier Henry Morgenthau, who convinced him of Hitler's nefarious nature, and the German leases were cancelled.[30]

DURING THE 1920S, when Rockefeller Center was being built, Art Deco was at its height. The style, which meant to demonstrate that mass-produced, machine-made objects could be well made and attractive, had actually emerged in Germany in 1907. World War I delayed the style's popularization until 1925, when it made news and acquired its name at the Exposition Internationale des Arts Décoratifs in Paris. Art Deco's hard-edged and unfussy lines represented not only a reaction to the soft, sinuous, nature-derived lines of Art Nouveau; it also suited the simpler modern lifestyle. Art Deco emphasized geometric forms, including circles and triangles, zigzags and parallel lines, which allude to the machine age. Art Deco pervasively influenced buildings, ocean liners, furniture, decorative objects, jewelry, script, clothing, and the arts. Although Junior and

his team of architects and planners never consciously opted for an Art Deco design, Rockefeller Center would turn out to be one of its permanent monuments.

Murals, sculptures, and bas-reliefs were always going to be part of the Center. Initially the developers factored them in at a cost of $150,000;[31] in the end, expenditures would be closer to $1 million. Both Abby, who as usual was Junior's most treasured advisor and, as he put it, his arbiter of last resort, and Nelson participated in its selection. It was decided that the art of Rockefeller Center should adhere to a unified style and have an overall lofty theme that could be adapted to the line of work of the principal tenant. Communication would be highlighted in buildings occupied by the Radio Corporation of America; performing arts would be used for the theaters; and national characteristics would predominate in the international buildings.

In 1931, Junior appointed Hartley Burr Alexander, professor of philosophy at Scripps College in Claremont, California, to develop a suitable theme.[32] A poet, philosopher, and writer, Alexander specialized in developing themes, amplified by inscriptions, to embellish public buildings. His past clients included the State of Nebraska, for its capitol building; the Joslyn Art Museum in Omaha; and the Los Angeles Public Library. For the Rockefeller Center project, Alexander submitted a lengthy report that paired lofty general concepts with such specific slogans as "Frontiers of Time, Creative Power of Our Civilization, and Man the Builder."[33] Much of Alexander's proposal was inscrutable, and after months of "thankless idea generation,"[34] the professor quit his advisory post. However, many of his suggestions, including the themes of the murals that now grace Rockefeller Center, survived.

After Alexander resigned his advisory post, Junior appointed a high-caliber Advisory Art Committee that included Edward Forbes and Paul J. Sachs of the Fogg Museum at Harvard; Herbert E. Winlock, director of the Metropolitan Museum; E. V. Meeks, dean of the Yale University School of Fine Arts; and Fiske Kimball, director of the Philadelphia Museum of Art.[35] The philosophy of the committee was extremely conservative and

contrasted with that of Alfred Barr, then heading the fledgling Museum of Modern Art, who had also been consulted. His suggestions had included Aristide Maillol, Constantin Brancusi, Gaston Lachaise, and Ernst Barlach, but the committee chose Lee Lawrie and Paul Manship. Eventually, however, a few "moderns," including Gaston Lachaise, Leo Friedlander, and Isamu Noguchi, contributed.[36]

About forty major artists—including those just mentioned and Hildreth Meière, Carl Milles, Alfred Janniot, and Attilio Piccirilli—contributed works to the Center. Some supplied a single work; others, more than a dozen. Most of the artists, especially the sculptors, were from the United States. Still, some people complained, insisting that, at a time when many American citizens were out of work, none of the assignments should go to foreigners.

A major unifying factor of Rockefeller Center art is that much of it consists of bas-relief cut into limestone, in many cases highlighted with gold and strong primary colors. The Egyptians, Greeks, Assyrians, Mayans, and the ancient sculptors of the Far East, had highlighted their works with gold and colors. These finishing touches mostly vanished with time, and ultimately the technique had fallen into disuse. Ceramicist Leon V. Solon revived it for Rockefeller Center. By chance, Solon learned that, prior to World War I, the German manufacturer Keim had developed a paint that bonded to limestone and formed a resistant surface. Aware that the weather-resistant paint was used successfully for concrete gun mounts, Solon ordered some from Germany.

For his first assignment, Solon colored *Wisdom, Sound and Light*, the relief that Lee Lawrie was creating for the entrance to 30 Rockefeller Plaza. The results were so stunning that Solon was engaged as the colorist for the entire Rockefeller Center project. He submitted eighty-seven different color schemes and ended up working steadily from 1934 to 1939, his bright flecks of color and the warmth and richness of the gold adding drama to the gray-colored walls.[37]

Robert Garrison,[38] who had crafted much of the stone masonry of Riverside Church, was the first artist hired. His assigned site at Rockefeller Center was the west façade of the RCA building, on Sixth Avenue. Gar-

rison illustrated "communication" as radio waves carried through the air by winged creatures mounted by barely clad youths. An eagle represents Morning; Pegasus, a winged horse, represents the Present, and a heron is a stand-in for Evening. In spite of their clear reference to classical Greece— the youthful figure of Present even carries a torch—the patterning of the clothing and of the wings of the animals is characteristic of Art Deco.

A popular American architectural sculptor, Lee Lawrie produced three hundred major works. Like Raymond Hood, Lawrie had worked for Bertram Goodhue while the latter built the Rockefeller Chapel at the University of Chicago and Nebraska's state capitol.[39] Lawrie was Rockefeller Center's most prolific sculptor, contributing fifteen works, including the enormous fourteen-thousand-pound *Atlas* guarding the entrance to the International Building, Rockefeller Center's second largest structure. *Atlas* stands in the building's relatively small forecourt, his massive, muscular arms carrying hoops encrusted with the signs of the zodiac. Junior liked *Atlas* so much that he authorized an overdraft of $2,000 to cast it in bronze instead of aluminum.[40] As a nice footnote to the continuity of art in America, *Atlas* stands across the street from New York's neo-Gothic St. Patrick's Cathedral, the work of Bertram Goodhue's teacher James Renwick. Ironically, Junior, a staunch Christian who had just erected one of North America's largest cathedrals, had now built an urban center celebrating antiquity's pagan gods.

Lawrie also created *Wisdom with Sound and Light*, a complex bas-relief work marking the entrance to the central skyscraper. Wisdom is represented as a bearded man holding a golden draftsman's compass. When Junior, who knew his mythology, first saw the work he pointed out that in ancient Greece, the goddess Athena represented wisdom. Therefore, Lawrie's Wisdom, which looked like "Old Father Time," should have been a young woman. Junior, however, lost the argument, and the old man remained.[41] The composition also appeared to have been copied from a drawing by William Blake, but in spite of its murky history, it has become an American icon. In 2006, the U.S. Postal Service imprinted the work on its one-dollar postage stamp.

In an allusion to the main tenant's growing radio and television business, Wisdom is flanked by Sound and Light. The three figures, highlighted with gold and primary colors by Solon, float atop a glass panel cast from 240 individual blocks of Pyrex, another new technique also used elsewhere in Rockefeller Center. During the day, the delicate-looking screen admits light into the lobby. At night, the illuminated lobby casts light onto the outside plaza. Like many other sculptures at Rockefeller Center, Wisdom is paired with an inscription. Both Junior and Lawrie searched endlessly through the Scriptures for an appropriate text, eventually settling on a quote from Isaiah: "Wisdom and knowledge shall be the stability of thy times."

Junior was so keenly interested in the front entrance to the RCA building because he abhorred the four bas-reliefs devised by the well-respected Art Deco sculptor Leo Friedlander for the side street entrances. Friedlander had chosen nude women to represent Radio, Television, Transmission, and Reception, his assigned theme. Not only was the meaning of Friedlander's message difficult to interpret, but the starkness of the images distressed Junior. In a letter to John Todd, Junior wrote that he hoped he would like Lee Lawrie's artwork above the main entrance, "since I shall not be able, with complete satisfaction and pleasure, to enter my new office building by either the north or south entrances because of the Friedlander sculptures."[42]

Another Lawrie work is a giant fanciful, twelve-part openwork plaque embedded on the south side of the International Building, representing mankind's four races, with symbols illustrating different forms of government, art, science, industry, trade, and transportation. A clock, rays of the sun, and stars surmount the composite, all wonderfully highlighted by Solon. Most of Lawrie's other works consist of smaller relief figures chiseled into the limestone, including the fleur-de-lis on the side of the Maison Française and the lions that represent England on the British Empire Building. Two of the most charming of Lawrie's creations are the elegant *Mercury with Blazing Sun* and the unpretentious *St. Francis of Assisi and Birds* on the International Building.

Rockefeller Center's other place of honor for outdoor sculpture, located at the head of the sunken plaza, was given to Paul Manship's *Prometheus Bringing Fire to Humanity*. Born in 1885, and three years Lawrie's junior, Manship had won the highly coveted Prix de Rome in 1909. While in Europe he became interested in preclassical and even Indian sculpture. His always-elegant style was acceptable to both conservatives and modernists. Manship, at the recommendation of Welles Bosworth, had executed a portrait bust of John D. Rockefeller, Sr., and though the sitter disliked it, his son and some art critics thought it extremely fine.[43] Rockefeller Center's *Prometheus* is an extravagant work, showing the half-god floating in midair above a large rock representing Mount Olympus and surrounded by a large open circle, the universe, embellished with the signs of the zodiac. After much deliberation, the entire statue was gilded. Paul Manship also designed the plaza substituting the open square that was to have fronted the opera house. The sunken court was to form a glorious entryway to the underground shopping mall, but

Paul Manship's Prometheus, *nicknamed "The Golden Boy," at the head of Rockefeller Center's sunken plaza.* (© 2010 Christine Roussel)

in the end it became either a skating rink or an outdoor café, depending on the season.

Although it is a far cry from the Place de l'Opéra in Paris, the space in front of 30 Rockefeller Plaza eventually started to function as New York's "village green." The lighting of an enormous Christmas tree—a tradition started in 1931 by construction workers excavating the ground for the British building—marks the beginning of the holiday season.[44] The Channel Gardens linking the plaza to Fifth Avenue are filled with ever-changing plants, cascading water, and charming tritons, Nereids, and dolphins. They are the work of René Paul Chambellan, a full-time employee of Rockefeller Center.

The Piccirilli Brothers, like Robert Garrison, were transplants from Riverside Church. They did much of the actual stonework at the Center, enlarging smaller models and drawings that had been prepared by others. Attilio, the most gifted of the six brothers, created four original works for Rockefeller Center. For the entrance of the Palazzo d'Italia he sculpted a panel entitled *Sempre Avanti Eterna Giovinezza* (Ever Onward Eternal Youth), in which the youth is represented by a muscular nude laborer wielding a spade. The work was paired with *Youth Leading Industry*. Like the lower portion of *Wisdom, Sound and Light*, both consisted of cast glass. Junior, not given to enthusiasm for much of the art created for his citadel, was so thrilled when he visited the Piccirilli studio that he did not even mind the artist's cost overrun, and had a check for $5,000 hand-delivered the very next day.[45]

Although the mottos accompanying *Sempre Avanti Giovinezza* and *Art Is Labor, Labor Is Art* sounded much like other Rockefeller Center often-obscure postings, those phrases unfortunately turned out to be part of Benito Mussolini's arsenal of slogans. In December 1941, when Italy and the United States were at war, the entire panel was covered by plywood, and then was ultimately destroyed. Unlike the Diego Rivera mural (discussed later), nobody mourned the fate of the Piccirilli work. The other Piccirilli glass work, *Youth Leading Industry*, survived. An extremely handsome work, it consists of two muscular nudes, one standing in a chariot drawn by two rearing horses, another leading it.

During World War II, the Italian Palazzo became the International Building South. In 1963, Giacomo Manzù, the great and aging Italian sculptor, created *Grapevines and Shafts of Wheat* (common Italian symbols for plenty) for Rockefeller Center, which replaced the ill-fated *Laborer*. A second work by Manzù, *The Immigrant*, is embedded on the north wall of what again is called the Palazzo d'Italia. The bas-relief depicts a poor barefoot woman and her squirming, naked son making their way to America, their possessions tied into a small bundle. Both Manzù sculptures were the gifts of Fiat's Gianni Agnelli to Rockefeller Center.

French artist Alfred Janniot sculpted an eighteen-by-eleven-foot bronze plaque for the Maison Française entitled *Friendship Between America and France*. It depicts the three graces—labeled Poésie, Beauté, and Elégance, in turn surmounted by women representing New York and Paris. Flying birds, plants, an ancient sailing vessel, and even models of Notre Dame and New York City fill the background of this delightful work. Carl Paul Jennewein's equally large work, *Industries of the British Empire*, is located across the Channel Gardens. Nine figures—representing tobacco, coal, sugar, wool, wheat, cotton, and other products of Britain and its colonies—are raised above a dark background.

Of special note is a stainless-steel panel created by the well-known Japanese American sculptor Isamu Noguchi at the beginning of his career. The twenty-two-by-seventeen-foot-wide panel, entitled *News*, crowns the entrance of what for decades was the Associated Press Building. The panel shows a group of reporters at work using modern technology, including telephones and radio waves, which captures the dynamic force of the moment when the press springs into action.[46] Noguchi became one of the Rockefellers' favorite artists. Thirty years later, the artist would build the abstract sixty-foot *Sunken Garden* commissioned by David Rockefeller for 1 Chase Manhattan Plaza in downtown Manhattan.

Gaston Lachaise, born and trained in France, had followed Isabel Nagle, his muse, model, and future wife, back to her native America. Lachaise, who later, in 1935, garnered a one-man show at MoMA, was an

up-and-coming sculptor, much admired by Abby, Nelson, and Alfred Barr, when he was commissioned to create a work for the Center.

Junior would not have liked the statuesque female nudes for which Lachaise is best known. Nevertheless, the Center's Art Advisory Committee commissioned four panels from him, entitled, in typical Rockefeller Center mumbo-jumbo, *Genius Seizing the Light of the Sun*, *The Spirit of Progress*, *The Conquest of Space*, and *Gifts of Earth to Mankind.*[47]

Lachaise created two more bas-reliefs for the International Building. One pays homage to the workers who demolished the old tenements of the Upper Estate; the other honors those who built the Center. By the time of their creation, the Art Advisory Committee had released its grip, and Lachaise's figures are much more free flowing. His work, like Noguchi's, would become part of the MoMA and Kykuit collections.

Rockefeller Center's art is conservative; its sponsors, according to Alfred Barr, favored "good taste" and "competent mediocrity."[48] *New York Times* reporter H. L. Brock argues more accurately that the art of Rockefeller Center expresses the age that created it.

THE ARTWORK THAT still receives more attention than any other is gone. Artists of international standing were to decorate the lobby of the RCA building. Frances Flynn Paine, who publicized Mexican artists during the mid-1920s, had introduced Abby to Diego Rivera. Abby liked his work and bought oils, drawings, studies for murals, and a sketchbook of forty-eight watercolors the artist had painted while attending the celebration of the tenth anniversary of the Russian Revolution. She paid a total of $9,000 for her Rivera purchases. Alfred Barr, who had met Rivera in Moscow in 1927 and was equally impressed, suggested that the infant MoMA give Rivera a one-man show. Thanks to Abby Rockefeller's financial cushion, Rivera and Frida Kahlo, his third wife, came to New York in 1931 to attend the opening.[49]

The Rockefellers welcomed Rivera with open arms. David Rockefeller recalled in his autobiography that his family enjoyed the company of the

mercurial artist.[50] Abby asked Rivera to paint her grandchildren, and she mothered the pregnant Frida, who would miscarry. Given Rivera's volatile temper and his political leanings, common sense should have provided a warning and dampened the friendship. But, as Cary Reich, Nelson's biographer, wrote,[51]

> Abby Aldrich Rockefeller was a connoisseur of truly catholic tastes. . . . But none of her affinities was as incongruous as her patronage of the flamboyant Mexican artist Diego Rivera. A dedicated Communist who viewed his work as agitprop as well as art . . . was truly an unlikely candidate of the doyenne's affection . . . But Abby loved his murals, sprawling cinematic figures frescoes populated by bandoleros and sombreroed peasants and bristling with primitive force.

Rivera's MoMA show was extremely successful and cemented his artistic reputation. The American Institute awarded him a gold medal, and he was commissioned to paint a fresco at the California School of Fine Arts and the San Francisco Stock Exchange. In California, Rivera met William Valentiner, by then solidly entrenched at the Detroit Institute of Arts. Valentiner, too, was won over by the artist, and he invited Rivera to visit Detroit, where Edsel Ford engaged the Mexican artist to paint murals for the Garden Court of the Detroit Institute of the Arts. A masterful rendition, they depict modern technology, an assembly line, the generation of electricity, the role of women, the different races that inhabit America, and even the birth of a child. Portraits of Edsel Ford and William Valentiner were included in a small cartouche. The reception to the murals was mixed. The right-wing *Detroit News* felt that they were essentially "un-American, incongruous and unsympathetic," to the American labor force. Another critic termed the murals blasphemous because the vignette depicting a doctor vaccinating a child held by a white-coifed nurse was a stand-in for the Holy Family. One Detroit writer called the painter a "half-breed Mexican Bolshevist." There were plenty of admirers, however, and in May 1935, Valentiner could report to Rivera that "your murals are

the greatest attraction at Detroit."[52] Mostly the public was offended by Rivera's Communist leanings and by the fact that U.S. dollars had gone to a foreigner while artists "at home" were starving.[53]

Rivera actually had his own troubles with the Communist Party. His membership had been cancelled in 1929 because his Mexican comrades considered him a false revolutionist, and a painter for American millionaires. For years Rivera tried to be readmitted to the party, and his political agenda may explain his intransigence in the Rockefeller Center saga.

The Center wanted a world-class artist to paint a large mural in its RCA building. They approached Matisse, Picasso, and Rivera and risked being turned down by all three. Thanks to the repeated diplomatic intervention of Nelson Rockefeller, Rivera relented, though from the very beginning there were major disagreements between the artist and chief architect Raymond Hood. After endless discussions, Rivera was allowed to use both the fresco technique and bright colors, instead of the subdued monotone Hood preferred.[54] Junior did not care much for Rivera or his art, but he knew that he was considered to be the world's greatest muralist, and he believed that his work would be a major drawing card. While in Detroit, Rivera was formally asked to paint *Man at the Crossroads Looking with Hope and High Vision to a New and Better Future*. After months-long negotiations, the job was his.[55]

Rivera submitted a vague sketch to Abby, inscribed, "*Avec mes homages très respectueux et affectueux à Madame Abby Aldrich de Rockefeller.*" (With my respectful and affectionate compliments to Mrs. Abby Aldrich Rockefeller.) In an accompanying letter, he wrote, "I assure you that in any case I shall try to do for Rockefeller Center and especially for you Madame, the best of all the work I have done up to this time."[56]

In March of 1933, Rivera began work on the New York fresco, assisted by, among others, a young Ben Shahn, whose Sacco and Vanzetti series he had liked, and Lucienne Bloch, who in addition to grinding paints, photographed the mural and kept a detailed diary of its progress.[57]

Rivera worked painstakingly, putting in twelve- to fourteen-hour days.

Fans, including members of the press, Tod Rockefeller, Gertrude Vander-
bilt Whitney, Nelson, and even Abby herself, gathered on his scaffold.[58]
Slowly the epic mural took shape, though even a casual glance indicated
that it did not resemble the sketch that had been submitted. The left por-
tion of the mural depicted capitalist society. A marching army occupied
the upper left corner of the mural. In one vignette, policemen clubbed
a worker holding a placard declaring, "Down with Imperialistic Wars
Against the Soviet Union." Elsewhere, on the left side of the work, de-
bauched, bejeweled society matrons, surrounded by a cloud of giant syphi-
lis and gonorrhea germs, drank and played cards. Thanks to medical slides
provided by New York Hospital, the images of the microorganisms were
scientifically accurate. As opposed to these debauched folks, handsome
construction workers, athletic youths, and cheerful women marching in
an orderly May Day parade—based on the sketchbook Rivera created in
Moscow and now owned by Abby—occupied the right side of the mural.

Hearing of the trouble that the Rivera frescoes had caused in Detroit,
John R. Todd became concerned about the progress of the Center's paint-
ing, even though the Rockefellers remained unconcerned. It was the press
who picked up on the fresco's political provocation. Reporters had a field
day. Rivera granted a long interview to Joseph Lilly of the *World Telegram.*
The headline of the ensuing article read, "Rivera Paints Scenes of Com-
munist Activity and J. D. Jr. Foots the Bill." Lilly wrote:

> Diego Rivera, over whose shaggy head many storms have broken, is
> completing on the walls of the RCA building a magnificent fresco
> that is likely to provoke the greatest sensation of his career . . . mi-
> crobes given life by poison gases used in war . . . germs of infection
> and heredity . . . communist demonstration . . . iron-jawed policemen,
> one swinging his club . . .
>
> The dominant color is red—red headdresses, red flags. Waves of
> red . . .
>
> "Mrs. Rockefeller said she liked my painting very much, [Rivera
> reported] . . . Mr. Rockefeller likes it too."

On April 28, four days after the article appeared, Lucienne Bloch recorded in her diary, "Diego asked us to find a good photo of Lenin . . . Diego explained to us that what he planned to do now. It is an afterthought. He is going to transfer the group showing the Soldier, the Worker and the Farmer . . . and move them to where they are more centrally located."

At first Rivera painted a veiled Lenin wearing a cap, but gradually the leader of the Russian revolution becomes fully recognizable, prompting Lucienne to write on May 1, the traditional Day of the Worker, that "the top part of the panel is finished, with Lenin holding hands with the group . . . there is no doubt about who is up there."

Until then Nelson Rockefeller had not reacted, but when he was told that the mural included Lenin's likeness, he confronted Rivera, demanding its elimination.[59] The painter refused to modify the work, though even Frida Kahlo pleaded with him to do so. There was an exchange of arguments and letters. Then, on May 9, 1933, Rivera received his full pay and was escorted out of the RCA building. His partially completed mural was covered up.

Given Rivera's popularity, there was uproar. For weeks there were loud outcries by the public and the press. Artists, including Alfred Stieglitz, Peggy Bacon, and John Sloan, all of them beloved by Abby Rockefeller, protested. E. B. White, the *New Yorker* writer, penned a poem entitled, "What Do You Paint, When You Paint on a Wall?," in which Senior's grandson Nelson questions an inscrutable Rivera about what he is going to paint on "his" wall. The Rockefellers had their supporters, and after the New York fiasco, Rivera's General Motors commission was cancelled. Like the Rockefellers, the Communist Party remained mostly silent, still considering Rivera a renegade.

For a while MoMA's staff tried to save the mural by removing it from the wall. This proved impossible, and on February 9, 1934, the mural was hacked to pieces. In 1934, Rivera re-created *The Man at the Crossroads* mural in the Palace of Fine Arts, in Mexico City, inserting a portrait of Junior into the nightclub scene.[60]

To the best of everyone's knowledge, Abby felt profoundly betrayed

by Rivera and broke off all contact with him. Soon after the debacle she donated his original sketch for the Rockefeller Center mural, which does not include the portrait of Lenin, and his May Day sketchbook to MoMA. Nelson mended his personal fences with Rivera and visited with him in Mexico.

ENGLAND'S SIR FRANK Brangwyn and Spain's José Maria Sert were commissioned to paint murals for the north and south corridors of Rockefeller Center's RCA building.[61] Brangwyn was at one time England's most renowned muralist, and an esteemed illustrator. His numerous murals, both in England and abroad, were much admired. For Rockefeller Center, Brangwyn's ponderous theme, *Man in Search for Eternal Truth*, would have pleased Professor Alexander. The subject had been subdivided into *Man the Creator, Man Laboring, Man the Master,* and the *Sermon on the Mount.* Brangwyn executed his murals, each coupled with long texts by Philip Macer-Wright, a well-known London literary figure, conscientiously. The religious connotation of the completed murals, especially the one depicting the Sermon on the Mount, was adjudged inappropriate for a commercial building by the Art Advisory Committee. Brangwyn made a few changes and, though the reception of his paintings was only lukewarm, his allegorical murals remained.

The political views of Spain's Fascist-leaning José Maria Sert differed markedly from those of Pablo Picasso, his countryman and contemporary. Early in life, Sert had decided to be a muralist, and his works adorn the churches in Vic and San Sebastián in Spain, the League of Nations Building in Geneva, and the Waldorf Astoria hotel in New York.

His initial assignments for Rockefeller Center were four panels for the north corridor. His overall subject was *Man's Mastery of the Material Universe Through His Power, Will, Imagination and Genius.* The interpretation of the theme was left up to the painter, and he broke it down into *Abolition of War, Abolition of Bondage, Conquest of Disease,* and *Powers That Conserve Life.*

Rockefeller and his advisors eventually engaged Sert to paint eight additional panels, including one on Rivera's so-called "wailing wall." The sixteen-by-forty-one-foot space had remained shrouded for four years. Sert interpreted *American Progress* as the flowering of a great nation resulting from the judicious combination of manual labor, spirituality, and leadership. Ralph Waldo Emerson represents spirituality; Abraham Lincoln, leadership; and muscular men, labor. An outline of Rockefeller Center appears in the background of the mural. Sert used a dark, monochromatic palette that endows his heroic figures with a sculptural quality. Iconographic scenes fill the murals. The planes seen in the background of the ceiling panel are an uncomfortable harbinger of Europe's military build-up and of the bloody wars that were to tear at its fabric. Although Sert's murals celebrate freedom and American history, they may very well also have paid homage to Franco. On April 20, 1943, *New York World-Telegram* reporter Helen Worden observed that five figures in José Maria Sert's mural "give an unmistakable Fascist salute."[62] This offense either went unnoticed or was purposely overlooked.

BARRY FAULKNER'S HUGE glass mosaic *Intelligence Awakening Mankind* adorns the Sixth Avenue entrance of the RCA building. Faulkner interpreted his theme rather slavishly. At first glance, the mosaic is reminiscent of a Last Judgment scene. Thought, occupying the center, is flanked by figures representing Written and Spoken Words. Figures representing Religion, Drama, Music, News, Politics, Poetry, Physics, Biology, Sports, Philosophy, Hygiene, and Publicity, all floating on sound waves, fill the panel. Cruelty and Ignorance, and Poverty and Fear plunge into hellish green fires at either end of the mosaic.

IN 1978, FORTY years after most of Rockefeller Center's art was in place, Nelson Rockefeller commissioned a major work from Japanese-born American kinetic sculptor Michio Ihara. The enormous *Sculpture of Light*

and Movement lines the north and south walls of the lobby of the International Building. The work consists of ten boxlike panels filled with sixteen hundred gilded steel leaves strung onto taut vertical steel cables. The little rectangles are thin enough to be in perpetual motion, as if wafted by a gentle breeze. Lit from below, the golden sculpture is reminiscent of a sunny fall landscape.

DURING THE FIRST decades of the twentieth century, some movie theaters were palaces whose glamour has not been rivaled since. These legendary entertainment centers, featuring Moorish, Oriental, Egyptian, and Chinese themes, were ornate, and dripping with decorations. Samuel L. "Roxy" Rothafel, one of the greatest showmen of the day, had built several of these palaces, including New York City's much-mourned Roxy Theatre.[63] The builders of Rockefeller Center recruited him to create a theater for their enterprise.

The task of building the music hall fell to Wallace Harrison, who in turn delegated most of the work to Edward Durell Stone, one of his principal designers. Ten years later, Stone would build MoMA's new home on Fifty-third Street. Donald Deskey, who had become a devotee of the Art Deco style after visiting the Exposition des Arts Décoratifs in Paris, was appointed as the music hall's decorator. The choice was fortunate. His whimsical, lighthearted décor resulted in Rockefeller Center's most joyous space. The art used to decorate the music hall also reflects the taste of Abby, by then in the process of becoming one of the foremost champions of America's contemporary artists, and that of Edith Halpert, one of her advisors.

From the outside, Radio City looks like an ordinary office building— the only clue to the splendor within is a large marquee and three enameled plaques representing Song, Drama, and Dance, by Hildreth Meière, affixed to its Fiftieth Street façade. Meière was not new to the Rockefellers; she had previously contributed major enameled pieces to the Rockefeller Chapel at the University of Chicago.

The lobby décor of the music hall is restrained. Large golden-rimmed light fixtures are embedded in the ceiling, and René Paul Chambellan's six plaques, illustrating *Acts of Vaudeville*, decorate the lintel above the entrance door. Visitors are not prepared for the soaring sixty-foot-high Grand Foyer. Once inside, one's gaze is captured by Ezra Winter's *Quest for the Fountain of Eternal Youth*, an immense sixty-foot-wide, forty-foot-high mural that occupies the back wall. The mural's most prominent figure is an elderly, toga-clad wanderer who contemplates both an abyss and a stream of humanity that prevent him from attaining his goal. Elegant twenty-nine-foot-high chandeliers light the entire room.

The Radio City auditorium sells itself as the world's largest indoor theater, able to accommodate 5,993 spectators. As Roxy was mulling over plans for this plum commission, he happened to be traversing the Atlantic aboard ship.[64] The story goes that the sun setting over the endless ocean inspired the five concentric golden arches that frame the music hall's immense stage. The arches represent the sun, whereas undulating rows of seats upholstered in wine-colored red velvet represent the waves of the ocean. A huge gold, scalloped stage curtain adds softness, as does the clever molding running along the walls. Despite its size, the hall does not overwhelm; it dazzles.

Radio City Music Hall is an engineering marvel. The hydraulic elevators of its stage, which so far have not needed replacement, served as a model for those on the aircraft carriers used during World War II. Balconies attached solely to the rear walls give a multitude of spectators an unobstructed view of the stage.

Donald Deskey's artistic concepts were rather avant-garde for the 1930s, and it was daring for cautious Rockefeller Center to have engaged him. He was partial to new, man-made materials: Bakelite, linoleum, tubular stainless steel, chrome, and aluminum. He designed much of the furniture and innovative lighting found in the lounges, powder rooms, bathrooms, and carpets. He created witty wallpaper, called Nicotine, for the smoking room. Ruth Reeves also designed carpets, including one called Visual Jazz, based on seven intertwining musical instruments. The elevator cabs

were lined in Canadian bird's-eye maple and decorated with roundels inlaid with wood, steel, Bakelite, and aluminum.

Through Deskey, artists represented by Edith Halpert (see chapter 6) gained a foothold.[65] (Halpert realized that the fees offered by Rockefeller Center were rock bottom.) Stuart Davis's *Men Without Women*—an abstraction featuring a pipe, cards, a horse, and barber pole—adorns a men's room. Witold Gorden's *The History of Cosmetics* decorates the adjoining ladies' lounge; Henry Billings conceived a *Crouching Panther* for another; and Yasuo Kuniyoshi painted exotic plants for a fourth.

Psychologists were consulted about the decoration of the Grand Lounge—sometimes called the Holding Pit because it filled with masses of people before, in between, and after shows. In order to minimize the feeling of being crowded, the experts recommended dark walls, a mass of columns, and diamond shapes. These appear in the lamps, the mirrored columns, and the pattern of the carpet. Louis Bouché's five humorous vignettes decorate the walls.

William Zorach, another Halpert artist, was to provide a sculpture for the foyer. He had accepted a payment of $850, a ridiculous fee for one of America's leading sculptors. His recollection of the events involving the execution of the much-beloved *Spirit of Dance* is an indication of the turmoil that accompanied the giant building project. His maquette for a three-foot-tall kneeling dancer was approved. When Deskey showed Zorach the enormous foyer where *Dance* was to go, he suggested tripling the figure's size, even though his fee would not "grow" accordingly.

With his *Goose Girl*, a nude standing beside a goose, Robert Laurent, also a Halpert artist, managed to transform a traditional subject into a "machine-age artifact."[66] Indeed, the sculpture is rather hard-edged, and the maiden's erect nipples, ponytail, and confident hand gestures endow her with a twentieth-century look. Gwen Lux—one of the few women artists employed at Radio City—contributed an ungainly nude *Eve*, holding an apple, to the Grand Foyer. When Rothafel inspected the site he was shocked by the stark style of the sculptures, commenting that Zorach's dancer looked "as if she had been hanged by her long neck."[67] Just prior

to opening, the three sculptures vanished by his order, allegedly removed because Rothafel considered their nudity offensive. The ever-valiant press splashed its pages with reports of these events, which contributed to the public's excitement about Radio City Music Hall. Eventually, the three sculptures were returned to their intended places.

Radio City Music Hall was a great success, but times change. Four decades after it opened, attendance had dropped, and it was about to be torn down, but in 1978, shortly before the arrival of sledgehammers, its fans and New York's Landmarks Preservation Commission saved it. Since then, Radio City has undergone a rebirth. It has been repeatedly restored—the last time, in 1999—and its glistening appearance reminds the 1.2 million annual visitors of the splendors of the past. Performance highlights include the Christmas Pageant, with its live nativity scene, and the high kicks of the descendants of the Rockettes who performed on opening night.

ROCKEFELLER CENTER WAS nearing completion in 1939. Nelson, forever mindful of publicity, arranged a major ceremony for November 1 of that year, to celebrate his father driving "the last rivet" into the U.S. Rubber Building, the final edifice of the original fourteen buildings.[68]

The guests of honor included Nicholas Murray Butler, president of Columbia University; Thomas A. Murray, president of the Building and Construction Trades Council; David Sarnoff, president of the Radio Corporation of America; and New York City mayor Fiorello La Guardia.

It was a happy, festive occasion. There were innumerable speeches, broadcast live by the Center's major tenant, the Radio Corporation of America, which ten years earlier had saved the commercial viability of the entire enterprise. There were many tributes to Junior. Murray reminded attendees that the enterprise had employed seventy-five thousand building trade workers, "when frankly our members very badly needed work." Sarnoff talked of Junior's courage in carrying on with the project during "the darkest days of the depression." Mayor La Guardia pointed out that, in addition to being one of the outstanding monuments of the City of New

York, the Center had become a major taxpayer. He urged Junior to build "a couple more Centers around the city." The most important speech of the day, however, was given by Junior himself, who took the opportunity of proclaiming publicly his profoundly decent and humane beliefs. He had fought against the use of the family name for the Center, and was convinced to do so only when other possibilities had been exhausted.

There was no memorial to Junior, but thirty years later, Steven Rockefeller [69] would see to it that his grandfather's personal creed was inscribed on a huge bronze plaque now standing at the head of the staircase leading down to the skating rink. It reads in part:

> I BELIEVE IN THE SUPREME WORTH OF THE INDIVIDUAL AND IN
> HIS RIGHT TO LIFE, LIBERTY, AND THE PURSUIT OF HAPPINESS.
> I BELIEVE THAT EVERY RIGHT IMPLIES A RESPONSIBILITY; EVERY
> OPPORTUNITY, AN OBLIGATION; EVERY POSSESSION, A DUTY.
> I BELIEVE IN THE DIGNITY OF LABOR, WHETHER WITH HEAD OR
> HAND; THAT THE WORLD OWES NO MAN A LIVING BUT THAT IT
> OWES EVERY MAN AN OPPORTUNITY TO MAKE A LIVING.
> JOHN D. ROCKEFELLER, JR.

Miraculously resurrected from storage, Paul Manship's sculptures *The Youth and the Maiden*, the original humans that were to accompany his Prometheus, now flank the tribute.

Rockefeller Center turned out to be a financial success, and eventually it became the main financial asset of the Rockefeller family. During its construction, Junior had lived knee-deep in blueprints, arbitrated differences among the three architectural firms, paid the bills that exceeded $50 million by 1935, and insisted on signing off on every major and minor detail.[70] As the project neared completion, he relaxed, and in 1935, he wrote to his father that for the first time in years he had gone four days without having a headache.[71]

No doubt the construction of Rockefeller Center had been a blessing during the Depression, but not everything had proceeded as smoothly as

portrayed during the Last Rivet ceremony. For example, Murray's declarations notwithstanding, there had been some strikes by elevator operators and sheet metal workers during the early phases of the construction. More important, despite Mayor La Guardia's expressed gratitude for considerable tax revenue from Rockefeller Center, the tax assessment of certain land parcels of the Center was extremely low. And as Nelson took over the stewardship of the Center from his father, he shoved aside John R. Todd, the man who by many accounts was responsible for the unique character of the entire complex. As Francis Christy, one of the Center's many construction contract lawyers, remarked, there was no plaque or statue commemorating John R. Todd, although there should have been one.[72]

By the time the "Last Rivet" was driven into place, the architectural world had changed its mind about Rockefeller Center and considered it a masterpiece. On December 9, 1933, *The New Yorker* wrote in its Notes and Comments section, "After all the carping we have done about Rockefeller Center, it pleases us to eat dirt . . . The Center is now one of the beautiful night sights of the town." In 1935, none other than Switzerland's Le Corbusier praised the architecture.[73]

Time has borne out that praise. In her epoch-making book *The Death and Life of Great American Cities*, published in 1961, Jane Jacobs describes Rockefeller Center's small plaza as a true "landmark," much more so than "the towering structures behind it." It, as well as Rockefeller Plaza, the street that bisects the monolithic city blocks, encourages street life. "None of today's pallid imitations of Rockefeller Center are," Jacobs concludes, as good as the original, built a half a century ago.[74] In 1981, architectural critic Paul Goldberger wrote:[75]

> Rockefeller Center's genius is that it exists—indeed it creates—a point of intersection between a number of things that would seem unable to coexist. It is strongly classicizing, yet it is lively and energetic; its layout is formal and axial, yet it is full of informing surprises; . . . What is most significant from the point of view of skyscraper design, however, is that it represents the first time skyscrapers had been con-

ceived as a group. None of the buildings . . . could exist alone; each
needs the context created by the others to achieve its meaning.

Given its very traumatic beginning, and the number of architects, art-
ists, advisory committees, and others involved in its creation, the fact that
Rockefeller Center ever turned out to be an architectural showpiece and
trendsetter is nothing short of remarkable.

Students of the Rockefellers may be amused by the fact that Junior
received so much praise for buildings erected in a style with which he was
unfamiliar and which he initially may even have disliked. Perhaps he was
able to put up with the construction of Rockefeller Center because, far
removed from the constant glare of the press, he was engaged in an affair
much closer to his heart: building New York City's Cloisters.

6

Mother's Museum: MoMA, 1929–39

O NE OF HIS wife's first enthusiasms was for Italian primitives, Junior recalled during the lengthy talks he had with Raymond Fosdick, his biographer, during the early 1950s.

I was not particularly interested [in the paintings] at first, but we kept them and studied them and finally commenced to buy them. And then all of a sudden my wife . . . became interested in modern art. I said to her: "Here, I have spent years trying to cultivate a taste for the great primitives, and just as I begin to see what they mean you flood the house with modern art."

Largely through her persistent efforts the Museum of Modern Art came into being, and during the first stormy years of its existence her wisdom and generosity did much to keep it going. Nothing outside her family so captured her interest. Hers was an adventurous and innovating spirit, and the success of the museum was to be an affirmation of her own buoyant confidence in the art of the future.[1]

Junior never altered his taste, but during the 1920s Abby became passionately involved in the art of her own time. From the 1920s until her death in 1948, Abby Rockefeller became one of America's greatest

champions of modern art and, given her social position, possibly the most effective.

Abby started collecting modern and contemporary art during the 1920s. Initially several men, William R. Valentiner, an art historian; Duncan Candler, her Maine architect; and artist Arthur B. Davies, fostered her interest, but she must have been aware of Europe's fermenting art world when she traveled to Europe with her father.

It was during the 1860s, a dozen years before she and her future husband were born, that a group of French painters started to rebel against established, academic art. A shocked public saw realistic paintings, "quick" sketches of everyday life, "unfinished" landscapes depicting the sun rising above a misty sky, people strolling in a park or dancing at a popular café, Parisians walking in the rain, dancers rehearsing a ballet, and women climbing into their baths or combing their hair. The style of the pictures was informal, and their colors vivid. Well-ordered scenes had been replaced by asymmetric arrangements. One critic disparagingly described some of these works as being "impressionistic," and the term stuck.

Today it is difficult to appreciate how thoroughly despised the Impressionist and other avant-garde paintings were when created. When, upon his death in 1893, Impressionist Gustave Caillebotte left to the French government the works he had bought from his friends, there was much public indignation. The academic painter Jean-Louis Gerôme, for example, declared that it was immoral for the government to accept "such filth." Fortunately, the authorities did not heed public opinion, and the paintings are now safe at the Musée d'Orsay in Paris.[2]

The Impressionists did have their advocates, which included a few Americans,[3] including Louisine Havemeyer, the New York collector; Mary Cassatt, the expatriate American Impressionist painter; and her protégée Bertha Potter Palmer of Chicago. Realizing that the New World might be more receptive than the Old to novel paintings, art dealer Paul Durand-Ruel mounted an exhibition of more than three hundred Impressionist works at his New York gallery in 1889, and sold quite a number of them.

As soon as the Impressionists had become accepted, their followers

combined their innovations with different approaches: realism, abstractions, and distortions. Many of these so-called "modern" painters had been influenced by Far Eastern, especially Japanese, prints, and by African and Oceanic art, so-called primitive art. The official establishment rejected most of these artists, but their work could be viewed at the Salon d'Automne of 1905 and other venues. Once more, the press was shocked. Because of the artists' use of strident colors, one writer described Matisse and his followers as *Les Fauves* (The Wild Beasts)—a name that, like *Impressionism*, went down in history. In 1913, German Expressionism, whose colors were even more strident than those of the Fauvists, was emerging in Dresden and Berlin. In 1910, Roger Fry, an art historian, curator, and brilliant writer, took up the cause of Europe's emerging artists and organized a major show of their work at the Grafton Gallery in London.

Artists in "provincial" America were catching up. The New World had already produced major artists such as Frederic Church, Thomas Cole, John Singer Sargent, Thomas Eakins, and George Innes. Paris, however, remained the center of artistic innovation, and most up-and-coming American artists spent some time in the French capital, where they were exposed to Impressionism, Postimpressionism, Fauvism, Cubism, and other "isms." As in Europe, some artists were responding to changes in the social climate and inaugurated a sober type of "urban realism," which concentrated on cityscapes, skyscrapers, machines, factories, bridges, slums, and ordinary people. In their paintings, the Brooklyn Bridge replaced Niagara Falls as an American icon. Both photographers and painters called attention to the poverty, strikes, and injustices that pervaded the world. They were called the Ashcan painters.

America's reigning National Academy of Fine Art repeatedly refused to select the work of these innovative contemporary artists for its officially sanctioned national art exhibits. Their work, however, could be seen in some galleries and at various non-juried shows. When these artists noticed how successful Fry's London exhibitions had been, they, too, considered mounting a very large group show. The task of finding a large exhibition space, raising funds, selecting and borrowing artworks, and other myriad

details proved too much for the hastily organized Association of American Painters and Sculptors. However, before abandoning the project altogether, the group persuaded Arthur B. Davies to assume the presidency of the organization.[4]

Davies was a judicious choice. He was a successful, popular artist. His friends included John Quinn, Esq., America's chief advocate of modern art; and Lillie P. Bliss, a future co-founder of the Museum of Modern Art. Davies was able to raise enough cash to mount the exhibition. John Quinn and Lillie Bliss became major financial backers, and Davies himself pledged the family farm he had inherited, as security.

Hoping to widen America's artistic horizons, Davies decided to include the work of contemporary European artists in the future International Exhibition of Modern Art that would forever be remembered as the Armory Show. Even though American artworks would vastly outnumber European entries, the art from abroad had such an impact that, in the end, some disgruntled local artists would criticize the organizers.

In the incredibly short space of four months, Davies, assisted by painter Walter Kuhn, assembled one thousand works by American artists and four hundred by Europeans. The latter included pieces by Eugène Delacroix, Jean-Auguste-Dominique Ingres, and Jean-Baptiste Corot—forerunners of modern French art—and paintings by Seurat, Degas, Renoir, Monet, Van Gogh, Cézanne, Signac, Manet, Gauguin, Matisse, Toulouse-Lautrec, Duchamps, and other then relatively unknown artists.

The Armory Show opened on February 2, 1913, in the large armory located at Lexington Avenue and Twenty-sixth Street in Manhattan. The cavernous space had been subdivided into octagonal galleries by moveable partitions. Cloth streamers diminished the height of the hall. A program decorated with the Pine Tree Flag of revolutionary Massachusetts and its motto, "The New Spirit," proclaimed the combative nature of the exhibition.

Even ninety years after it opened, one can still feel the excitement that the show generated. After a few, initially complimentary reviews, the press became indignant. The painting most often targeted was Marcel Duchamp's *Nude Descending a Staircase, No. 2*, now owned by the Philadel-

phia Museum of Art. A cartoon version of the work dubbed *The Rude Descending a Staircase*, and subtitled "Rush Hour at the Subway," appeared in the *New York Evening Sun*. In spite, or because, of all this criticism, the exhibition was a wild success; during its four-week run, it tallied seventy-five thousand visitors.

From New York the show went to the Art Institute of Chicago, where indignation again was widespread. Incited by their teachers, students of the institute hung effigies of Henri Matisse and the sculptor Constantin Brancusi. The show then traveled to Boston, where it attracted little attention because the press ignored it.

The Armory Show did have its champions—it is said that some people, including Lillie Bliss, visited it every day—and in the end, it ushered in a new era of artistic tolerance. Still, as evidenced by the discussions that took place in the Rockefeller household, America was not yet ready for modern art. In 1914, the year after the Armory Show, World War I erupted, and during the following four years, art simmered on the back burner.

America entered the war in 1917, and when the war was over, the nation's provinciality was a thing of the past. American tourists returned to Europe in ever-increasing numbers. The Rockefellers' benevolence would extend to Europe. Junior, who had always loved castles and cathedrals, would spend some of his vast fortune repairing France's Rouen Cathedral and restoring the Sun King's château in Versailles.

THROUGHOUT THE AGES, artistic recognition hinged on the passion of art's patrons. During the early years of the twentieth century, America's most important patron of modern art was John Quinn.[5] Of Irish extraction, he was born in Tiffin, Ohio, in 1870, and part of his soul remained anchored to his small-town origins. He studied law, moved to New York, and, in 1908, founded his own successful law practice. In his leisure time he became passionate about Irish literature, acquiring manuscripts and first editions. Eventually, however, he developed an even greater appetite for contemporary art.

In New York, Quinn became a staunch friend of the American art world, and he bought paintings by Walter Kuhn, John Sloan, Arthur B. Davies, Ernest Lawson, Maurice Prendergast, and others. Quinn also became fascinated by contemporary European art. By 1911 he had bought important paintings by Paul Cézanne, Vincent Van Gogh, Paul Gauguin, and others—in Europe and at Alfred Stieglitz's gallery in New York. It is at the latter that Quinn bought Henri Rousseau's *Sleeping Gypsy*.

Unperturbed by the ruckus of the Armory Show, and even by World War I, John Quinn had continued to buy art. When he died of cancer in 1924, his apartment on Central Park West in New York City was filled with nearly three thousand items. Canvases and sculptures were stacked all over the place. His possessions included fifty Picassos, twenty-seven sculptures by Brancusi, nineteen paintings by Matisse, eleven by Georges Seurat, and works by André Derain, Odilon Redon, Van Gogh, and Henri "Le Douanier" Rousseau.

During his illness, Quinn had decided that he did not want his beloved collection "consigned to the cold tomb of a museum and subjected to the stupid glance of a careless passer-by." Instead, he would offer the pleasure of the chase to another generation of buyers. Quinn also wanted to provide materially for his beloved sister, Julia Anderson, and her daughter, Mary. In the end, he specified the fate of only one painting. He willed *The Circus*, by Georges Seurat, to the Louvre, which at the time owned no work by this French master.

The sale of Quinn's magnificent collection was a total financial disaster. It would have been advisable to wait a few years until modern art had become acceptable. But for a variety of reasons—the terms of his will, and the prevailing uneasy feeling of Mrs. Anderson and the National Bank of Commerce about modern art—the sale was hurried. It yielded $750,000—only a quarter of a million more than Quinn had spent for it—but far, far less than it would have brought had it been sold piecemeal, and later. Its permanent loss to the art-loving public was great, and some people, including Arthur B. Davies, Lillie Bliss, and Mary Quinn Sullivan, murmured that if there had been an appropri-

ate museum of modern art in America at the time, Quinn might have endowed it with some of his choice pieces.

As is, some of the great works Quinn had collected fortunately did end up in museums. The Walter Arensbergs, Lillie Bliss, Dr. Albert Barnes, the Cone sisters, art dealers, and others snapped up paintings and eventually willed their collections to various institutions. Today, when admiring Matisse's *Blue Nude* at the Baltimore Museum of Art, Henri Rousseau's *Sleeping Gypsy* at MoMA, or Seurat's *La Poudreuse* at the Barnes Collection in Philadelphia, one should be reminded of the man who recognized the beauty of modern art long before others did.

Quinn was not the only American to champion contemporary European or American art. In 1905, Alfred Stieglitz, the groundbreaking American photographer, had opened his "Little Galleries of the Photo-Secession," where he exhibited artistic photographs and the work of a number of American avantgarde artists, including John Marin, Marsden Hartley, Max Weber, Arthur Dove, and Georgia O'Keeffe. Stieglitz also showed the work of a few selected Europeans: Henri Rousseau, Paul Cézanne, and Henri Matisse. In 1908 his was the first American gallery to exhibit Matisse, whose female figures critics deemed "superhumanly hideous."[6]

Gertrude Vanderbilt Whitney, a sculptor and patron, was another staunch supporter of American artists. In 1914 she opened the Whitney Studio, at 8 West Eighth Street, for American artists to exhibit their work "in a New York obsessed with European art and culture."[7] Gertrude Whitney exhibited and bought the work of many artists, supplementing their meager incomes. In 1928 the Whitney Studio morphed into the Whitney Studio Galleries, and then into the Whitney Museum, now housed in Marcel Breuer and Hamilton Smith's landmark building on Madison Avenue.

Other art pioneers included Katherine S. Dreier, who championed mostly European artists at her Connecticut gallery between 1913 and 1929[8]; Duncan Phillips, heir to a steel fortune, who founded America's first museum of modern art, in Washington, D.C.[9]; and Stephen Carlton Clark, heir to the Singer Sewing Machine fortune. He donated $200 to the orga-

nizers of the Armory Show and bought the exhibition's most expensive work, Wilhelm Lehmbruck's *Standing Woman*, for $1,620.[10]

WILLIAM R. VALENTINER, an art historian and Rembrandt scholar, joined the ranks of the Rockefeller friend-retainers during the early 1920s. J. P. Morgan, then president of the Metropolitan Museum, had hired him in Berlin in 1908. Valentiner's first assignment was to curate the Dutch Masters show, the museum's contribution to New York's Hudson-Fulton Celebration. After World War I, Valentiner had befriended the German Expressionists, and he became their life-long supporter, arranging their first American exhibition at New York's Anderson Gallery in 1921.[11] He was appointed director of the Detroit Institute of Arts in 1922, and under his guidance the museum, whose funds were buoyed by the fortune generated by the automobile, underwent a growth spurt. Valentiner also became the artistic advisor and personal friend of Edsel Ford, the Rockefellers' neighbor in Seal Harbor. Because his expertise included both traditional and contemporary art, Abby felt that Valentiner would be an ideal art advisor for both her and Junior.[12]

Always keen on learning, Abby engaged Valentiner to accompany her, sister Lucy, and daughter Babs on a European study tour. It was a typical Rockefeller expedition. The party traveled to Vienna by Orient Express and then on to Munich, Nuremberg, and Berlin. Abby's all-encompassing interest in art impressed Valentiner, though the indifference of her companions appalled him. His diary entry provides a glimpse of the glamorous voyages of the moneyed elite:

> We traveled like princes. At every stop we were greeted by a representative of the Standard Oil Company, which in Germany alone had nearly 50,000 small and very small branches. Very soon there was a most cordial relationship with the ladies, a real camaraderie, and the visits to the cities, the museums, the meals, the "shopping" . . . were completely harmonious. Mrs. Rockefeller was not only deeply

interested in various aspects of art but also a sympathetic leader of the party.[13]

In Germany, Valentiner introduced Abby to Karl Schmidt-Rottluff, Max Pechstein, Erich Heckel, Emil Nolde, Otto Dix, and other Expressionists. World War I, the Depression, and the upheaval that followed had hardened the artists' view of the world. Their images were disturbing, violent but beautiful. The colors of their paintings were as strident as those of the Fauvists, but their subject matter often depicted the seamier side of humanity. Babs was bored, and Lucy's contempt for modern art almost equaled Junior's, but Abby absorbed the art with her usual gusto and discerning eye. She bought an Erich Heckel watercolor entitled *Landscape* for $500.

Valentiner's friendship with the Rockefellers persisted. He endorsed Junior's purchase of a Veneziano and Botticelli from Duveen, and made suggestions about the plans for The Cloisters. The Rockefellers invited Dr. and Mrs. Valentiner to Babs's wedding in 1925.[14] In his honor, Mrs. Rockefeller donated a beautiful Swiss altar cover embroidered in 1546 to the Detroit Institute of Arts.[15] Most important, Valentiner contributed to the formation of Abby's collections. Their correspondence mentions an "expensive" Persian miniature, which Junior ended paying for; a Kolbe sculpture of a dancer; and multiple prints. Gracious as always, Abby wrote Valentiner:

> I appreciate more than I can tell you, your willingness to help me with my collection of German prints. I should really like to have a very complete collection of modern prints, either to pass on to Nelson—if he is interested—or to give to the Modern Museum. In a way it is very difficult for me to make this collection because it is practically never possible for me to buy modern prints in Europe. When we are over there I do not like to desert Mr. Rockefeller and prowl about, and over here I can only buy that what the dealers have seen fit to import.[16]

The Rockefellers' curious monetary arrangement hampered Abby's acquisitions. Junior had a firm grip on the family finances, and Abby did not

ask him to pay for art that he thoroughly disliked. For such art, she paid with Aldrich money. However, in typical Rockefeller fashion, on April 14, 1927, Junior wrote to his wife that, in addition to her allowance of $50,000 for charitable gifts, she could also spend up to $25,000 for "such art purchases as you might care to make during the year 1927 . . . these credits are available in the office . . . without reference to me. Hoping that this will facilitate the carrying out of your desires, I am affectionately, John." Abby sent Junior a formal thank-you letter. The next year, Junior doubled the art budget.

Abby spent her new allowance instantly. On May 24, 1927, she reported to Valentiner that at the sale of the famous Quinn collection, she had bought three small paintings—an oil by Prendergast ($1,200), one watercolor by Henri Cross ($30), and another "delightful one in blue and red and white" by Derain ($140). In addition, since Valentiner's last visit, she had bought a "lovely Winslow Homer of two men in an open boat pulling a shark," about which she felt most enthusiastic, some lithographs by Arthur Davies, and an etching by John Sloan. Abby was most eager for Valentiner to see them.[17] Occasionally Abby deplored the fact that she did not have enough money to buy oils. It is a bit bizarre to read letters that America's wealthiest woman wrote to various artists apologizing for the fact that she could not buy their expensive works.

As a consequence of the 1934 revamping of the Rockefeller family's financial arrangements, Abby's personal finances improved dramatically. However, she still preferred to buy small, acquiring hundreds of inexpensive prints. With rare exceptions her top price was $1,000. She felt that this approach yielded the best work of unknown artists and the second-rate work of men with established reputations. The system resulted in a highly personal collection whose diversity is a testimonial to her excellent taste. Eventually it also would form the nucleus of MoMA's Abby Aldrich Rockefeller Print Room.[18]

MUCH LATER, WHEN Abby Rockefeller had become America's doyenne of modern and contemporary art, A. Conger Goodyear, MoMA's first

president, once asked her how she had developed an interest in modern art. She explained that she had started with Japanese and early American prints. Thereafter, she discovered "Buddhistic art and European china and all sorts of beautiful things . . . created by older civilizations." As she was immersing herself in this art, she became curious about how this heritage had influenced the artists of her own time.[19]

In addition to Valentiner, Abby had plenty of others with whom to share her interest, one of them being Duncan Candler, her Maine architect. While living in Paris he had become fascinated by Impressionism and Postimpressionism. Upon his return to America he had become involved with the contemporary art scene, and under his guidance Abby bought works by Maurice Prendergast, Edward Hopper, John Marin, and John Sloan. Candler was also responsible for introducing Abby to the art dealer who would play an important part in her role as an art patron. One evening, by mistaking it for one of the many speakeasies that dotted Greenwich Village during Prohibition, Duncan Candler entered the Downtown Gallery soon after Edith Halpert opened it. The warm atmosphere of her gallery captivated him, and he became a regular visitor and client.

Born in Russia in 1900, Edith had arrived in America with her mother and her sister when she was six years old. At fifteen she started working full time for Bloomingdale's and other department stores. Quick with figures, and a good writer and illustrator, Edith was repeatedly promoted at her various jobs. Her real passion, however, was art. She started to attend evening art courses and became part of New York's burgeoning artistic community, visiting Alfred Stieglitz's gallery at "291" Fifth Avenue, the Whitney Studio, and the Montross Gallery.

Edith met and eventually married Samuel Halpert, an up-and-coming artist, who was a Jewish-Russian immigrant like her, and her elder by sixteen years. She abandoned her own artistic ambitions, devoting herself to Sam's career and supporting the two of them on an ever-increasing salary as an efficiency expert. In 1925 the Halperts journeyed to France. Edith explored art galleries, and met Ambroise Vollard, Paris's best-known art

dealer. Edith was impressed by the respect the French accorded to their artists and vowed that after her return to the United States, she would help American artists attain a similar status.

In the fall of 1926, Edith opened the Downtown Gallery in New York's Greenwich Village, representing Stuart Davis, Arthur Dove, Ben Shahn, William Zorach, and other avant-garde artists whose works would eventually be collected by Abby Rockefeller. A décor of inexpensive early American antiques, the presence of art books, and always-available coffee gave the gallery an intimate feeling.

Edith's personality was dominated by two distinct, somewhat diametrically opposed traits. Her difficult youth and work experience had turned her into a sharp businesswoman. She was not adverse to bending the truth or driving a hard bargain. On the other hand, she was imbued with the fiercely egalitarian and socialist attitude of the 1920s. In 1932, she exhibited Ben Shahn's *The Passion of Sacco and Vanzetti*, and her gallery was known to exhibit other politically outspoken artists, such as Jack Levine.

Edith was skilled at handling the press, which, since the Armory Show, did its share in popularizing modern art. The most prominent art critic to do so was Henry McBride, who had started out studying art but had discovered that art criticism was his real talent. In 1913 he joined the *New York Sun*, and remained its art critic for thirty-six years. McBride was particularly fond of the Downtown Gallery, praising the artistic merit of some exhibits, even when their message was at variance with his politically conservative outlook.[20]

For someone living in the 1920s, Edith was refreshingly colorblind. In 1941 she introduced African American Jacob Lawrence to *Fortune* editor Deborah Calkins, who would publish twenty-six of the sixty panels of Lawrence's *Migration* series in the November issue of the magazine. Edith also gave Lawrence a solo show and managed to sell the *Migration* series to the reluctant Museum of Modern Art and to the Phillips Collection, each museum paying $1,000 for half the images!

DURING ONE OF Candler's visits, Edith told him that she was planning an exhibit that would pair inexpensive contemporary watercolor landscapes with examples of work by established masters. To emphasize her point, she wanted to include a watercolor by Winslow Homer, but could not borrow or buy one because his work had become too costly. Candler promised to help, and a few days later he arrived with a Homer watercolor, lent anonymously by Abby Rockefeller. It was valued at $10,000. Edith's *Landscape* exhibit was a great success, with several visitors wanting to buy the Homer.[21]

One day an aristocratic-looking woman wearing an elaborate hat came to see the watercolor show. She admired the John Marin and the William Zorach watercolors that flanked the Homer and inquired about prices. According to Edith Halpert's biographer Lindsay Pollock, Halpert told the woman that neither work was for sale because she was holding them "for the idiot" who had refused to sell the Homer for so much money. "I am the idiot," the woman replied, and proceeded to buy the two paintings, paying $750 for the Marin and $250 for the Zorach.

Thereafter, Abby visited the Downtown Gallery frequently, and during the next two decades it was from Edith, whose biography by Pollock is subtitled *The Making of the Modern Art Market*, that Abby bought a large fraction of both her contemporary and American folk art collections.[22]

The bond between Abby and Edith developed into a mother-daughter-type relationship. In August 1930, after Edith, who by then was single and living alone, underwent surgery for acute appendicitis, Abby insisted that she recuperate in Pocantico Hills while the Rockefellers were in Maine.[23] Both Abby and Edith were passionate about the welfare and success of America's contemporary artists. The Depression threatened their livelihood, and it has been suggested that Abby's insistence on buying many inexpensive works was triggered by her desire to spread her wealth to as many artists as possible.

In 1928, Nelson Rockefeller, then a Dartmouth sophomore, accompanied his mother to the Downtown Gallery. It became one of his pivotal experiences. Upon his return to college he wrote to Abby:

I feel as if I had been introduced to a new world of beauty, and for the first time I think that I have really been able to appreciate and understand pictures, even though only a little bit. I hope to continue when I am in New York and maybe do a tiny bit of collecting myself.[24]

Abby was delighted with her second son's interest in art. In response to his letter she sent him a Daumier lithograph, writing, "We could have such a good time going about together . . . If you start to cultivate your taste and eye so young, you ought to be very good at it by the time you can afford to collect much."[25] During that same spring Abby shared with Nelson her plans for a new museum of modern art, and mused on how "splendid it would be if it would be ready for you to be interested in when you get back to New York to live."[26]

Abby's confidence in Nelson's future involvement was justified. "I would like to have the Sistine Madonna," he had written in a Lincoln School essay when he was seven. "I would hang it in my dining room. I would not sell it for all the money in the world. I would not give it to the Museum. It is one of the most wonderful paintings that Raphael painted."[27] Art had come easily to the dyslexic child who had such trouble reading and spelling, and who, during his college years at Dartmouth, embarked on many artistic ventures.

DURING HIS SENIOR year, Nelson visited the shows of Harvard's groundbreaking Society for Contemporary Art, reporting to his mother that "he met the fellows who were running it and enjoyed both the exhibition and the sponsors."[28] The society was the brainchild of Lincoln Kirstein, the son of the owner of Filene's department store in Boston. His tolerant parents allowed him to devote his life to art, never insisting that he earn a living. At thirteen, Lincoln had gone to see ballerina Anna Pavlova. He attended five of her performances in a row and never looked back.[29] In 1933, he persuaded George Balanchine to move to America. The two men

founded a classical ballet school, created the New York City Ballet, and ultimately sparked America's unabated passion for dance.

While at Harvard, Kirstein founded *Hound and Horn*, an avant-garde literary journal. In addition, assisted by Eddie Warburg and John Walker, he decided to bring contemporary art to staid Boston. The threesome explained their plans for a future Society for Contemporary Art to Paul Sachs and Edward Forbes of the Fogg Museum. Alfred Barr, then teaching at Wellesley, also attended the meeting.

Both Sachs and Forbes were a bit ashamed of Boston's artistic insularity,[30] but its citizenry had reacted so violently to modern art that they had delayed hanging such art on the walls of Harvard's Fogg Museum. Kirstein's proposal provided the two professors with a half measure, enabling them to acknowledge new artistic developments without really getting involved. They promised their support to the venture.

Kirstein, whom Walker described as having "energy, determination, a streak of genius and a touch of bravura,"[31] assembled an impressive board, which included Alfred Barr, Lillie Bliss, Frank Crowninshield, Conger Goodyear, Abby Rockefeller, and Paul Sachs. Gallery space was rented from the Harvard Cooperative. Armed with impressive letters of introduction, the fledgling society had no trouble borrowing art from leading collectors and art dealers, including the Downtown Gallery.[32]

Americans, the initial show, featuring works by Thomas Eakins, Albert Ryder, Robert Henri, George Bellows, Edward Hopper, John Sloan, Charles Burchfield, Charles Demuth, and Arthur Davies, opened in February 1929. To the surprise of the organizers, it attracted eleven hundred visitors, and attendance remained high during the next two years. Reviews by the Boston press were favorable.

After this debut, the society became more daring, presenting works by Buckminster Fuller, Chaim Soutine, Isamu Noguchi, the Mexican Modernists, and the German Expressionists. They also asked young Alexander Calder to exhibit some of his "inventions." To the astonishment of the organizers, Calder arrived with a coil of wire and, within forty-eight hours,

created some figures for his *Circus*, now one of the most cherished posses-
sions of the Whitney Museum in New York.[33]

There is no indication that Abby Rockefeller ever visited the society,
but Lincoln Kirstein became a member of Nelson's circle and would be
elected to MoMA's Junior Advisory Committee, organizing its infamous
Murals show. In 1941, Nelson sent him to South America as an art envoy.[34]
Later, Kirstein's path would cross that of John D. Rockefeller 3rd during
the building of Lincoln Center.

AFTER HIS INITIAL visit with his mother to the Downtown Gallery,
Nelson, too, would become one of Edith Halpert's faithful clients. Like his
father, he enjoyed haggling. In 1930, William Steig, the cartoonist, briefly
embarked on making wood sculptures. Fourteen of these earned him a
solo show at the Downtown Gallery. When Nelson saw the small sculp-
tures he offered to buy six, at $10 apiece.[35] Nelson and Edith cooperated on
several projects, one being the extensive Municipal Arts Exhibition held at
Rockefeller Center, February through April 1934. Intended to relieve the
financial plight of American artists during the Depression, it was spon-
sored by Mayor Fiorello La Guardia, organized by Edith Halpert, and
paid for by Nelson Rockefeller.[36]

IN 1930, ABBY transformed her children's former playrooms at Fifty-
fourth Street into a picture gallery. Architect Duncan Candler did the
remodeling, and decorator Donald Deskey, who shortly thereafter would
mastermind the decoration of Radio City Music Hall, designed the fur-
nishings. The rooms were professionally lit and contained comfortable
sofas and chairs, glass cabinets filled with ceramics and eighteenth-century
porcelains, and specially designed aluminum frames for an ever-changing
display of graphic art. By then Abby owned so many prints, watercolors,
and drawings that she employed a full-time curator. "I am having a very
interesting time with my own pictures and prints," she wrote Nelson.[37]

Junior was as disdainful of the gallery as of Abby's other activities involving modern art. When Abby informed her traveling husband that she and Halpert were hanging American prints in "her" gallery, he answered, "I can imagine how much you are enjoying playing with your picture gallery again and only wish I could share the interest you take in it."[38]

Abby took comfort in her children's support, writing to Nelson, "Papa [thinks] that the pictures [works by George Overbury 'Pop' Hart, of which Abby was very fond] are terrible beyond words."[39] Both David and Laurance were troubled by their father's attitude, as were Alfred Barr and even strangers such as Matisse.

Matisse had come to America that year, 1930, and was to dine at the Rockefellers' on December 18. After Abby was told that Matisse was partial to pretty blondes, she seated him next to Eliza Bliss, Lillie's French-speaking niece. Frank Crowninshield, who was deeply appreciative of Junior's patronage of the arts, memorialized the dinner in *Vogue* magazine. Matisse was impressed by his host's erudition, his many accomplishments, his perfect French, his prowess on the dance floor, and by the beauty of his Chinese porcelains, Polonaise rugs, and, lastly, the modernity of Rockefeller Center.

"After coffee Monsieur Matisse turned to Mr. Rockefeller," Crowninshield wrote,

> and began half seriously to plead his cause; to explain that the men who had created the incredibly beautiful green, yellow, red and black porcelains [that surrounded them] were really in pursuit of exactly the same aesthetic goals as those to which Matisse had personally dedicated himself. He tried to persuade him that Braque, Picasso, Juan Gris . . . had merely followed the decorative designs and emotive experience of the Persians who had designed what Matisse called Mr. Rockefeller's "modern" rugs, . . . and that there was no such thing as modern art or ancient art . . . and that the deadest art imaginable was that of the hack painters who now flourish in so many of our academies of art.

Rockefeller refused to be convinced, but added that the French painter "must not altogether despair because . . . he suspected that Mrs. Rockefeller, thanks to her very special gifts of persuasion, would eventually wear him down to the consistency of jelly."[40]

THAT SAME YEAR, Abby granted a rare interview to Helen Appleton Read, of *Vogue*, during which she stressed that the support of young American artists was an important factor in her collecting activity.

> Quietly and without fanfare or publicity, one of the most personal and therefore, one of the most interesting collections of contemporary art has been forming during the past four years. This is Mrs. John D. Rockefeller, Jr.'s collection, which has recently been installed in modern galleries, designed by Donald Deskey, on the top floor of the Rockefeller residence.[41]

Junior judiciously avoided Abby's gallery, but other members of her large family, especially her daughters-in-law, and her friends and MoMA staff eagerly arrived for tea and even "forbidden" sherry. They viewed new prints and listened to informal lectures, often given by Alfred Barr, MoMA's founding director. Like her other "advisors," Barr enlarged Abby's art collection. In 1931, while in Paris gathering material for MoMA's Matisse exhibition, he bought for her prints by Fernand Léger, Jean Lurçat, Louis Marcoussis, Picasso, Maurice de Vlaminck, Juan Gris, Giorgio De Chirico, and Joan Miró.[42]

LILLIE BLISS AND Abby Aldrich had met in Washington, where each girl served as her father's hostess, replacing her ailing or unwilling mother. Lillie, who never married, was a gifted amateur pianist. She practiced the piano for two hours each morning and was proficient enough to play with

the Kneisel Quartet, which she sponsored. After her father's death, she devotedly took care of her mother, even sleeping in her bedroom.

Lillie discovered modern art in her forties. She fell in love with the work of Arthur B. Davies and eventually sought him out.[43] She became his admiring patron and friend, and even though her mother protested, she moved a piano into his Manhattan studio. He was a prolific painter whose erotic, symbolic paintings filled with dancers and ethereal women were widely bought by museums and collectors.[44]

Lillie Bliss commissioned a Davies mural for her music room and bought many other works.[45] He taught her about modern art, and she helped him financially when he became the moving force behind the Armory Show. It was at that exhibition that Bliss started buying her first important pictures, including Renoir's *Fog on Guernsey*; two Degases, *Race Horses* and *After the Bath*; and two Redons, *Roger and Angelica* and *Silence*. Bliss later bought Cézanne's *The Road*, *Still Life with Apples*, and a portrait of his wife. Her mother did not appreciate most of her purchases, and Bliss kept them hidden on the third floor of their house. After her mother's death, Bliss rented several floors atop 1001 Park Avenue and displayed her beloved paintings in this private gallery, whose visitors included Abby Rockefeller.[46]

Davies's family life was extremely complex. He was married to Lucy Meriwether, a physician in upstate New York and the mother of his two sons. Secretly he also shared a home with Edna Potter, a dancer, and their daughter. In addition, there was Davies's twenty-year friendship with Lillie Bliss! It was she who had introduced Abby to him during the mid-1920s. Abby acquired many of his watercolors and commissioned a mural for New York's International House. In 1928, Davies died in Florence, alone. Mrs. Rockefeller's letter of condolence to one of Davies's sons expresses her deep esteem for the painter:

> . . . I had for him the deepest admiration, and although I had known
> him only for a few years, I felt a real affection for him. I feel I owe him
> a great deal, because he inspired and encouraged me to acquire modern

paintings, and without the confidence, which his approval gave me I should never have dared ventured in the field of modern art.[47]

Art critic Henry McBride eulogized Davies in the *New York Sun*:

It is too soon, of course to try to make up posterity's mind in regard to Davies, and, anyway posterity has a trick of making up its mind for itself . . . [Davies's] instinct for the talents of others was quite remarkable . . . It was he more than any other who was responsible for the amazing success of the famous Armory Show of modern art, and he lived to see many of his early and daring judgments confirmed by the best minds of the world. He was an inveterate collector himself, and aided many of his friends to collect.[48]

AFTER THEIR ACCIDENTAL meeting in Egypt, Abby and Lillie Bliss continued to talk about creating a museum for modern art in New York. Mary Quinn Sullivan, whom Abby had met during the Rockefellers' return trip aboard the *Ile de France*, joined their meetings.

Mary Sullivan was born in Indianapolis in 1877 to second-generation Irish immigrants. In school she excelled at drawing, and at age twenty-two she became an art teacher at New York's DeWitt Clinton High School. In 1902 the Board of Education sent her to Europe to see how art was taught there. Mary Quinn became fascinated by the Impressionists and Postimpressionists and attended lectures given by Roger Fry—the very same art historian who had inspired New York's Armory Show. At forty, Mary Quinn married Cornelius J. Sullivan, a successful lawyer. Cornelius had been a classmate of John Quinn (no relation of Mary's), who introduced the Sullivans to modern art. Soon they started buying paintings by Cézanne, Georges Braque, Modigliani, and other future modern masters. The Sullivans lived in a charming house in Astoria, where they entertained their many friends and displayed their growing art collection, some of which was purchased at the Downtown Gallery.[49]

As a result of their art-minded deliberations the three friends issued an unexpected invitation to lunch at the Rockefeller mansion to A. Conger Goodyear in May 1929. The women had chosen their guest carefully. Goodyear, who had made a fortune in Buffalo's lumber business, was committed to modern art. He also had been a trustee of that city's Albright-Knox Art Gallery. Picasso's *La Toilette*, at one time owned by Quinn, captivated him, and during his brief tenure as president of the Albright-Knox, he bought it on the museum's behalf for $5,000. The museum's board was so incensed by his action that they voted him out.

For Goodyear, the Rockefeller luncheon invitation had come as a total surprise. Commenting on it later, he wrote:

> I was mystified but accepted. On the appointed day I found Miss Bliss and Mrs. Sullivan as the only other guests. I had never met any of the three ladies before. There was some discussion of the possibility of organizing a modern art museum. . . . Half way through the luncheon Mrs. R. asked the other two ladies if they felt she should propose the question they had in mind . . . I was told that I should be chairman of a committee that would organize such a museum.[50]

The fact that the "ladies" chose a front man for their museum, even though they were the real force behind the project, was a symptom of the times. They felt that a board headed by women would not be taken seriously. Whatever their reason, Goodyear, who accepted the job the following day, was an excellent choice. During the next ten years he worked ceaselessly on behalf of MoMA for the sum total of one dollar per year.

The women were an ideal team. According to Russell Lynes,[51] MoMA's historian:

> Abby Rockefeller was the most executive and the best organizer; Lizzie [Lillie] Bliss was the most thoughtful, and certainly the most retiring, and Mary Sullivan was . . . "a whizbang." It was a splendid combination of talents, taste and temperaments to launch an enter-

prise . . . [The women also were] the source of a great deal of money . . . though . . . compared with the other Ladies . . . Mrs. Sullivan was . . . "a church mouse."

By June 1929, Goodyear had formed an organization committee that included Professor Paul J. Sachs, also serving on Rockefeller Center's Art Advisory Committee; Mrs. W. Murray Butler, a scion of the Crane Paper Company, which still manufactures fine stationery and the paper for U.S. currency; and Frank Crowninshield, the editor of *Vanity Fair.* Like Mc-Bride, Crowninshield was enthusiastic about modern art, and his publications were an important educational forum. Cornelius Sullivan, Mary's husband, agreed to handle legal matters for the future museum. The Regents of the University of the State of New York granted a provisional charter for the museum on September 19, 1929. Thereafter, the temporary committee morphed into a regular board and added four more socially prominent trustees: Stephen C. Clark, Sam Lewisohn, Chester Dale, and Duncan Phillips. Lillie Bliss became vice-president, Crowninshield secretary, and Abby A. Rockefeller treasurer, charged with raising $100,000 annually for a period of three years. Not surprisingly, Junior questioned his wife's role as treasurer, feeling that the job would be better handled by a man. Goodyear encouraged Abby to retain the post.[52]

THE FIRST ORDER of business of MoMA's organizing committee was to find a director and to hire staff. Paul Sachs unhesitatingly recommended Alfred Barr, whom he described as being brilliant but "very young." Barr would spend his entire professional life at MoMA.[53]

Alfred Hamilton Barr was born in 1902 in Baltimore. He was extremely bright and precocious, and his family hoped he would enter the ministry like his father. Instead he would be a missionary of another kind. Barr attended Baltimore's Boys' Latin School, graduating at the top of his class. *The Inkwell*, the school's newspaper, described Barr upon his high school graduation as "a sincere nut of the silent but deadly type . . .

He's a born scientist with a real desire for things bizarre, grotesque and occult."[54]

In the fall of 1918, Barr went to Princeton on a scholarship. A course on medieval art, taught by Professor Charles Rufus Morley, which examined the interrelationship of everyday life, culture, art, and architecture during medieval times ignited Barr's interest in art. He majored in art history, obtained his BA in 1922, and stayed on at Princeton for his master's. In 1924 he entered Harvard's innovative Museum School, founded by his future friend and mentor J. Paul Sachs. In addition to Barr, Sachs trained many future museum directors, including James J. Rorimer, the founding curator of The Cloisters; and Sherman Lee and Charles Richardson, both of whom would become John 3rd's art advisors. While at Harvard, Barr wrote Sachs a lengthy critique, pointing out that his course was shortchanging modern art. Sachs thanked the young man for "his frank and constructive letter."[55]

Since his finances were limited, Barr alternated attendance at graduate school with teaching assignments and European study trips. Barr spent an entire year in Europe, from 1927 to 1928. As far as MoMA's future was concerned, his visits to the Bauhaus were most significant. The Bauhaus and its school blossomed in Germany during the short-lived Weimar Republic. The

school promoted a unified approach to architecture, painting, crafts, graphics, cinema, and other disciplines involving design. The Bauhaus's brief existence, from 1919 to 1933, in no way diminished the immense impact it had on the taste of the twentieth century. It was the Bauhaus's all-encompassing approach to art and design that impressed Barr. After Germany, he went for several months to Russia, where he happened to stay at the same Moscow hotel as Diego Rivera. During the 1920s, cultural life in Russia was vibrant, though it was soon to be stifled and "frozen" for decades by Joseph Stalin.

Predictably the Hermitage's treasure trove of Cézannes, Picassos, Matisses, and Derains impressed Barr, though he recorded in his diary that the collection had "too few Braques and Henri Rousseaus." (Sergei Shchukin and Ivan Morozov had assembled two astounding modern art collections prior to the Russian Revolution.) Barr also developed a love for icons, which he would collect throughout his life, and became entranced with the Russian cinema.

From early on, Alfred Barr, like Abby Rockefeller, his future protector and friend, was committed to contemporary art. When Wellesley College hired him as associate professor of art in 1926, Barr taught America's first-ever course on the subject. Professor Morley's Princeton course served as his model. Barr's curriculum included viewing of avant-garde art, the evaluation of the shape of ordinary things such as eggs, the selection of well-designed objects at dime stores, and the reading of articles about modern art in popular magazines such as *Vogue* and *Vanity Fair*. While at Wellesley, Barr mounted an exhibition that, according to writer Alice Goldfarb Marquis:

> still reads like a roll call of important modern figures: Max Weber, Edward Hopper, Charles Sheeler, Georgia O'Keeffe, Camille Pissarro, Claude Monet, Georges Seurat, Henri Rousseau and others . . . That Barr was able to discern so long ago who the lasting innovators of the twentieth century would be is a tribute to his wide-ranging knowledge and incomparable taste. But even more, it demonstrates his extraordinary power to impose his taste upon his contemporaries and successors.[56]

Each object was accompanied by concise information about the artwork and its importance. Such elegantly written "critical catalogues" became a Barr trademark.

Barr was twenty-seven years old when Abby Rockefeller invited him to visit her in Seal Harbor and offered him the directorship of modern art's future museum. From the very first they shared a common vision for the institution. Barr was the age of Abby's children, and her relationship to him became somewhat parental. In order to accept the job, Barr left Harvard without having finished his doctorate. Almost twenty years later, Harvard would accept Barr's book *Picasso: Fifty Years of His Art* as his thesis.

It is remarkable that within six months of the initial luncheon with Goodyear, MoMA opened its doors. During this time the founders had formed a board, named their "baby," gotten incorporation papers, found a locale, transformed it into galleries, hired staff, raised money for their venture, decided on the opening exhibits, borrowed the pictures, written and printed a catalogue, publicized their new museum, and attended to myriad other details.

There was much discussion about the subject of the opening exhibit. The men—Paul Sachs, Alfred Barr, and Frank Crowninshield—wanted it to consist of American painters, but Abby and her accomplices campaigned for French masters. In the end the ladies prevailed, and a show featuring thirty-five Cézannes, twenty-six Gauguins, seventeen Seurats, and twenty-seven Van Goghs opened on the twelfth floor of the Heckscher Building at Fifth Avenue and Fifty-seventh Street.[57]

An elegant and knowledgeable catalogue written by Alfred Barr accompanied the exhibition. Using his pull as editor in chief of *Vanity Fair*, Frank Crowninshield had it printed at Condé Nast. It was "almost" ready for the opening, which according to Russell Lynes, "was a unique occurrence at the Museum during its early days." The catalogue proudly stated, "The Museum of Modern Art, First Loan Exhibit, New York, November 1929." The show included Abby Rockefeller's Van Gogh's *Hospital Corridor at Saint-Rémy* (1889), which recently, according to Abby's will, migrated from MoMA to the Met.

The exhibition was a great success. To the consternation of the other

tenants, during the next four weeks, forty-seven thousand people rode the elevator at the Heckscher Building. The press, which had been so scathing about modern art sixteen years earlier during the Armory Show, bestowed accolades. Some newspapers, as evidenced by an article in the *New York Evening World* of September 7, 1929, actually welcomed the institution before it opened its doors: "The Museum of Modern Art, which will open November 1, is very badly needed. There is a curious apathy toward current paintings in this country. The average woman never buys any of it, decorating her home with prints that she obtains at the department store."

The article goes on to explain that in the mind of the public, "Art ... is a collection of old masters brought over from Europe at fabulous expense, to be gaped at occasionally but never for a moment associated with ordinary living."[58]

The art world took note of the new museum. Sir Joseph Duveen, who had supplied so much art for the Rockefellers' nearby brownstone, visited the exhibit, accompanied by the museum's assistant director, Jere Abbott, and proved to be totally ignorant of modern artists, including Van Gogh.[59]

Legend has it that Margaret (Marga) Scolari-Fitzmaurice was introduced to Barr by a common acquaintance during the museum's initial exhibition. Soon thereafter, Barr invited her to tea, and then their courtship intensified. Alfred and Marga married in a civil ceremony in New York on May 8, 1930, and again, later that month, in a religious ceremony in the rectory of the American Church in Paris. Their honeymoon consisted of scouting out pictures for MoMA's forthcoming Corot-Daumier show.

Marga, who had been teaching Italian at Vassar, became Alfred's translator, assistant, and staunch protector. Instead of attending to her own career, she watched over her high-strung and often frustrated husband, helping him complete his many writing projects, which, because of his innate perfectionism, were always late.

The press was less complimentary about *Paintings by Nineteen Living American Artists*, MoMA's second show, but the third exhibition, *Painting in Paris from American Collections*, again received rave reviews. Thereafter the museum put on about half a dozen art shows annually. Barr's persis-

tence, zeal, and innovative ideas, and the willingness of the board to sanction them, quickly made MoMA, in the words of art critic Aline Saarinen, "the most important taste-making institution in the world."[60]

MOMA'S FOUNDERS WERE middle-aged, but they wanted to appeal to the next generation, and in 1930 Nelson's Junior Advisory Committee was to organize a show. By then the membership of the committee included composer George Gershwin; philanthropist Edward Warburg; Eliza Bliss; Lincoln Kirstein, who had organized the Society of Contemporary Art at Harvard; future architect Philip Johnson; and Elizabeth Cobb, Lillie Bliss's niece and a stepdaughter of Conger Goodyear; many of them would also leave their mark on America's arts community.

The meetings of the Junior Advisory Committee were extremely vociferous, and rather ineffectual. Its members criticized the museum's trustees, accusing them of favoring European artists and ignoring the plight of living American artists, whose livelihoods were being destroyed by the ever-deepening Depression. As the subject of their first exhibition the group chose *Murals by American Painters and Photographers.* Lincoln Kirstein was to organize the exhibition. He invited sixty-five American artists to participate. Given the economic climate, some of the entries lampooned captains of industry. Hugo Gellert's mural, entitled *Us Fellows Got to Stick Together—Al Capone,* for instance, depicted J. P. Morgan, J. D. Rockefeller, Sr., President Herbert Hoover, and Henry Ford hiding behind a pile of moneybags while Al Capone wields a machine gun. When they saw some of the submissions, MoMA's trustees were horrified. They certainly did not want to anger the captains of industry who supported their museum. The board considered canceling the show, but in the end they feared that such a drastic step would generate more adverse criticism than would letting the exhibition take place. The Rockefeller family lawyer, whom Nelson consulted, concurred. Junior insisted that Nelson explain the matter to his grandfather and to J. P. Morgan, the son of the great collector, and both forgave him.[61] When the show finally opened in 1932,

the reaction of the press was rather mild, one critic terming it "a riot of propaganda," with few redeeming features. When calm was restored, Barr cabled Abby on April 18, 1932: "Problem has been extremely difficult hope solution will be satisfactory." As part of the fence-mending, in 1935 she donated to the museum Ben Shahn's *Sacco and Vanzetti*, which she had bought from the 1932 Downtown Gallery show.[62]

LILLIE BLISS'S DEATH, in March 1931, changed MoMA's course from a gallery with epoch-making exhibitions to a great museum. On March 16, 1931, the *New York Times* wrote: "A cultural community in area much more extensive than the geographical New York City has lost one of its outstanding figures . . ."

After recalling Miss Bliss's devotion to music, the eulogy continued:

It is, however, in the field of painting that she put forth her chief energies, particularly during the later period of her life. A close friend and patron of Arthur B. Davies, she had her part in the historic Armory Exhibition of Modern Art in 1913 when this country was introduced to the startling new world of Cubism and Fauvism . . .

In the Museum of Modern Art . . . Miss Bliss has her most conspicuous monument. Miss Bliss' death last Friday fell on the opening day of the eleventh exhibition staged by the Modern Museum . . . the show of modern German paintings and sculptures is now under way . . .

At the time of her death, Lillie Bliss owned twenty-four paintings by Cézanne and works by Daumier, Picasso, Gauguin, Kuhn, Matisse, Redon, Rousseau, Segonzac, Signac, and Toulouse-Lautrec. As Conger Goodyear recalled, "She had talked to me about plans of leaving to the Museum the greater part of her remarkable collection [of about 150 works of art]; asking if this picture, or that seemed appropriate. [But it was the terms of her will that] established it on a firm foundation of

permanence . . . [thereby] she assured the assumption of lasting responsibility for the care of the collection and the carrying on of our work."[63]

Bliss indeed had willed most of her collection to MoMA with the provision that within three years of her death the institution's endowment fund would be large enough to care for it. At first her brother Cornelius N. Bliss requested that the fund be $1 million, but later he reduced it to $600,000. There was some discussion about whether to accept the gift. The terms *modern* and *contemporary* are, by definition, transitory, and it is difficult for a museum that acquires a world-class collection to remain on the cutting edge of art. As Gertrude Stein said to the young Alfred Barr, "You can't be a museum and be modern."[64]

Barr nevertheless strongly advocated for the museum to take up Cornelius Bliss's challenge. Trustee Stephen C. Clark was much opposed, but Barr obtained the cooperation of Mrs. Rockefeller and Goodyear, and the fund-raising effort was under way. A mysterious anonymous donation of $100,000 enabled the museum to reach its goal within the allotted time. Eliza Bliss was curious about the identity of the mysterious donor and asked Nelson. After he swore her to secrecy, he, whose fortunes had been swelled by the 1934 trust funds, admitted that the donation was his, though he did not want his mother to know because he felt that the gift would mean more to her if it came from somebody other than a Rockefeller.[65]

Once the Bliss bequest was secured, Barr devoted a great deal of attention to developing MoMA's permanent collection.[66] He had excellent taste and a phenomenal memory for who owned what picture, and who might be willing to pay for a particular work he felt the museum needed. His mind "earmarked" certain paintings, and sometimes it took years before he brought his quarry home. Today MoMA owns the world's greatest collection of late nineteenth-century and early twentieth-century art, though some critics feel that Barr had too personal a vision and neglected some important artists.

AS EARLY AS 1930, Stephen Clark[67] had given MoMA Hopper's *House by the Railroad*, Burchfield's *Railroad Gantry*, and Lehmbruck's *Standing Woman*, which he had purchased at the Armory Show in 1913. Unlike many collectors, Clark did not amass artworks. He wanted to display what he owned in his, albeit large, house. He thus bought, sold, traded, and, starting in 1930, donated art, usually anonymously, to museums.

Clark was a prickly man, a character trait his biographers attribute to extreme shyness. He was hardworking, conscientious, and utterly correct in all his business dealings. He was unforgiving of slights, and sometimes, when he believed that he was right, he got himself into fights. In 1934 he gave MoMA Brancusi's *Bird in Space*, an astonishing abstraction in highly polished bronze, a version of which so puzzled the American Customs authorities that they levied import duty on it because they refused to classify it as art. Another version of this sculpture now guards the entrance to Kykuit.

Perhaps because of their underlying animosity—Clark being irritated by Barr's unorthodox working habits and high-minded attitude, and Barr considering Clark's artistic taste rigid and limited[68]—Barr did not acknowledge Clark's gifts. However, in 1941, when Clark gave the museum a group of nine pictures all at once, Barr finally made amends, stating in the museum's bulletin that Clark's latest gift was "the most important group of oil paintings acquired since the bequest of the Lillie P. Bliss Collection." All in all, Clark's twenty-two gifts provided MoMA with many of the public's favorites: Bonnard's *Breakfast Room*, Maillol's *The Mediterranean*, Picasso's *Guitar* and *Still Life with Fruit Dish on a Table*, Matisse's *Coffee*, and works by Derain, Rouault, Orozco, and Siqueiros. Upon Clark's death, Georges Seurat's *Circus Sideshow*, a work Barr had hoped to obtain for MoMA, went to the Metropolitan, and Van Gogh's *Night Café*, another much-beloved work, went to the Yale University Art Gallery.[69]

IN 1935, Mrs. Rockefeller gave Barr $1,000—the museum's first acquisition fund—to spend as he wished. Upon his return from Europe, an ecstatic Barr reported how he had used the gift:

Dear Mrs. Rockefeller:

 Wouldn't you like to look over the things I bought for the
Museum with the $1000, which you sent me? . . . I want to say again
how much I appreciate [it]. This was the first money that I have ever
had for purchasing paintings for the museum and I am very pleased
with some of the things I got.

The works included oils by Giorgio De Chirico, Hans Arp, Joan Miró,
René Magritte, and Yves Tanguy; collages by Kurt Schwitters and Max
Ernst; a construction by Alberto Giacometti; and some drawings.

 Barr also thanked Mrs. Rockefeller for paintings by Rivera she was
about to donate and for the artist's Moscow notebook, and he reported that
he might be able to buy a big sculpture by Wilhelm Lehmbruck for $1,000.[70]
The sculpture was purchased. In 1935, Mrs. Rockefeller added $2,500 for the
purchase of work by living American painters, and another $2,000 for pur-
chases abroad. Finally, in 1938, she established a personal purchase fund of
$20,000, to which Nelson added $11,500 in his mother's name.

 In 1937, Mrs. Simon (Olga) Guggenheim became MoMA's fairy god-
mother. She had marched into the director's office and declared that she
wanted "to give the museum an important modern painting." She added
that she did not necessarily have to like the work, but that it did have to
have the unanimous approval of the director and the Acquisitions Com-
mittee and their expectation of it "becoming a masterpiece." To begin with,
Barr bought Picasso's *Mirror*, which carried a price tag of $10,000. Two years
later Mrs. Guggenheim gave Barr money to buy Henri Rousseau's *Sleeping
Gypsy*, which at one time had been part of the fabled Quinn collection. Mrs.
Guggenheim gave the museum a total of sixty-nine artworks costing more
than $1 million. They include such perennial favorites as Marc Chagall's *I
and the Village*, Picasso's *Three Musicians*, and his sculpture *She-Goat*.[71]

 Mrs. Guggenheim was not the only patron to let Barr pick works of
art that he deemed necessary for the glory of MoMA. The terms of Lillie
Bliss's will allowed the museum to sell or exchange works from her collec-
tion. Exerting this right helped MoMA to acquire Picasso's *Les Demoiselles*

d'Avignon, from 1909, and Van Gogh's *Starry Night*, from 1889, and *Portrait of Post-Master Roulin*, from 1889.

BARR HAD ALWAYS wanted MoMA to be more than a traditional museum, and the creation of a Department of Architecture seemed a good beginning. During the summer of 1930, while the Barrs were honey-mooning in Paris, they ran into Philip Johnson, the future architect, and Henry-Russell Hitchcock, an architectural historian. The foursome discussed mounting a show featuring modern architecture. It took two years to assemble *Modern Architecture: International*. Twenty-five, mostly European, architects agreed to participate in the exhibition. Material was gathered, models were built, and the organizers rapidly exceeded their minuscule budget. Mrs. Rockefeller and Stephen Clark plugged the hole with $10,000 each, and Johnson's father also pitched in.

A catalogue with essays by Frank Lloyd Wright, Walter Gropius, Le Corbusier, Mies van der Rohe, and Raymond Hood, who was building the RCA skyscraper a few blocks south in Rockefeller Center, accompanied the exhibition. The harshness of the "International Style"—a term Hitchcock coined to describe it in the catalogue—shocked critics and museum visitors, who were used to mellow Beaux-Arts architecture. In spite of their displea-sure, the International style—which emphasized simple, straight lines and right angles; the use of stainless steel, concrete, and glass; and the avoidance of decorations—would dominate architecture in America for many decades.[72]

By 1932, MoMA had outgrown its space in the Heckscher Building and was looking for new quarters. After a brief search, the museum rented a commodious brownstone at 11 West Fifty-third Street, owned by none other than John D. Rockefeller, Jr. He graciously reduced its annual rent from $12,000 to $10,000. Goodyear and Barr planned the renovation, and when it opened in May of that year, the museum now included a small theater, a library, and galleries for the permanent collection, photographs, and changing exhibitions.[73]

With nineteen exhibitions, featuring furniture and decorative arts; a

one-man photographic exhibit; *American Sources of Modern Art (Aztec, Mayan, Inca)* and *American Folk Art,* 1933 was a banner year. New departments opened, including the Department of Circulating Exhibitions, whose first venture was to send the *Modern Architecture* exhibit to museums around the country.

AS WITH MOST museums, money was always a problem. From 1934 on, when Abby's personal cash flow increased, she supported MoMA liberally. Expenses always exceeded income, even though, in 1939, the museum began to sell memberships and charged an admission fee of twenty-five cents (which would correspond to four dollars in 2010). Abby made up the annual shortfall, which often exceeded $50,000.[74]

But money was only one aspect of Abby's contribution. The entire staff, but especially the museum's fragile director, felt her commanding presence. She was Barr's greatest ally, and he, in turn, revered her. Brilliant as he was, Barr was touchy, emotionally frail, and difficult to deal with. As long as Abby was actively involved in the museum, she provided Barr with the stability he required. This is one reason why Nelson urged his mother to assume the presidency of MoMA in 1933.

Even Abby, however, was often frustrated by Barr's lack of administrative talents, his skewed sense of priorities, and his procrastination.[75] She and Goodyear knew that Barr was not temperamentally fit to handle many of the duties of a museum director, but when anyone suggested a reorganization of the museum's leadership, Barr simply turned a deaf ear.

By 1932, Barr was so exhausted that even Abby Rockefeller became concerned about his mental and physical health. She insisted that he consult her own physician, who confirmed that Barr was suffering from nervous exhaustion. The museum granted him a yearlong sabbatical at half pay. The Barrs spent most of that time in Europe. In Germany they were shocked by the newly elected Nazi government's wreckage of contemporary art and the closure of Barr's beloved Bauhaus. In the near future, Barr and MoMA would do what they could to save artists persecuted by Hitler.

IN THE OLDEN days it was said that the name of a well-brought-up woman appeared in the newspaper only three times in the course of her life: when she was born, when she got married, and when she died. Junior must have been shocked, therefore, when in January 1936 the cover of *Time* magazine[76] featured his wife, and the cover article extolled her contributions to modern art.

The occasion for the article was the exhibit entitled, *New Acquisitions: The Collection of Mrs. John D. Rockefeller Jr.* It included 127 paintings, watercolors, and drawings by the world's best-known modern artists. The *Time* article also reviewed MoMA's history.

> The magazine reported that during the six years of its existence, among other achievements, the museum held forty-six major art exhibitions in its own quarters, sent twenty-eight traveling shows to ninety-eight cities in the U.S. and Canada, published thirty-eight different books and pamphlets, and established a cinema museum which is preserving valuable films.

> The magazine paid tribute to Mrs. Rockefeller's discerning taste, her thriftiness, her generosity, and her preference for unretouched drawings, which she considered to be the best way to study the manner and character of an artist. Sizing up Abby's philosophy, *Time* characterized her as a collector who considered her collection as "a sort of private investment, to provide artists with a little money to paint more and better pictures." One of the works discussed in the article was *View of Central Park, 1932*, which Mrs. Rockefeller had commissioned from Charles Sheeler. Once it was finished it became one of her favorite among the hundreds of works on paper she owned. The work descended to Winthrop, from whose estate David Rockefeller acquired it.[77]

Barr himself never made the cover of *Time* magazine. His biography by Alice Goldfarb Marquis is subtitled, *Missionary of the Modern*, and much of MoMA's fame is due to the founding director's talent as writer and

teacher. His output encompasses fifty catalogues and numerous books. His style was incisive, readable, and never condescending. Some of his books on Cubism and abstract art were long and scholarly; others were short and addressed a general audience. His most popular work, *What Is Modern Painting?*, is conversational:

> This booklet is written for people who have little experience in looking at paintings, particularly those modern paintings, which are sometimes considered puzzling, offensive, incompetent or crazy. It is intended to undermine prejudice, disturb indifference and awaken interest so that some greater understanding and love of the more adventurous painting of our day may follow.[78]

Modern artists, even self-satisfied Picasso, recognized the debt they owed Barr and MoMA. Today the museum owns one of the world's top Picasso collections, including *Girl with the Mirror* and *Les Demoiselles d'Avignon.*

BARR'S MOST CAPABLE helper joined MoMA in 1934. Dorothy C. Miller's art-minded parents had hoped that she would become an artist. However, while she attended Smith College, Dorothy decided that she would not be the "great artist" her family had hoped for, and she majored in art history. At the suggestion of one of her professors, she would become a museum curator instead. In her senior year she received an invitation from John Cotton Dana, the founder and director of the Newark Museum, to attend his novel curator apprenticeship program. Dana's program preceded Harvard's Museum School by one year.[79]

Though the Newark Museum was tiny, when compared with New York and Philadelphia's mighty institutions, Dana's artistic taste was amazingly progressive. He exhibited contemporary American, African American, and "ethnic" art long before this became acceptable. He also paired contemporary German artists with well-designed industrial products, anticipating the German Bauhaus by ten years and MoMA by twenty. After complet-

ing her apprenticeship, Miller joined the staff of the Newark Museum in 1925, at age twenty, and was its only professionally trained art historian.[80]

In Newark, Dorothy met and eventually married Edgar Holger Cahill, by then one of America's greatest experts in both American contemporary and folk art. Both Miller and Cahill ended up working at MoMA and participated in the shaping of the Rockefellers' art legacy. Nelson and David were quick to recognize and make use of Dorothy's good judgment. In 1958, Miller hung the new governor's artwork in Albany, and David Rockefeller appointed her to the committee that started assembling the Chase Bank's corporate collection.

A native of Iceland, Cahill moved to North Dakota with his family during his infancy.[81] Against many odds, he managed to finish high school, which was the end of his formal education. In 1913, when he was twenty-six, he arrived in New York's Greenwich Village and befriended up-and-coming artists, including John Sloan and other members of the Ashcan School. Recalling this period much later, Cahill referred to the "Catacomb Period of Modern Art" that reigned in America at the beginning of the twentieth century.[82] A gifted writer, he started covering the New York art scene for various newspapers and magazines. His articles were so well received that, in 1920, the Society of Independent Artists asked him to handle their publicity. Cahill so successfully countered the conservative taste of the National Academy of Art that Dana engaged him to do the same for the Newark Museum. Cahill, who shared his mentor's concern for the "common people," stayed at the Newark Museum until Dana's death in 1929, championing contemporary American artists.[83]

When Dorothy Miller attended MoMA's opening in 1929 she was so impressed that she resolved to work there one day. Her opportunity came in 1932, when Holger Cahill temporarily replaced Alfred Barr, who was recuperating in Europe from overwork. Miller agreed to assist Cahill in mounting shows and writing catalogues. Upon Barr's return, Miller stayed as his personal assistant. Given her expertise in American art, Miller was a good counterweight to Barr and his European partiality. Her excellent shows featured mostly unknown contemporary American artists, and

since they often toured Europe she helped American artists attain a leadership position there.

BY THE LATE 1930s, when it was approaching its tenth birthday, MoMA had again outgrown its quarters and was ready to construct its own building. There were protracted negotiations with Junior, who owned property on Fifty-third Street. In a typically convoluted Rockefeller transaction, Junior sold the land to the museum for $250,000, and then Abby reimbursed him for the outlay.[84]

The search for an architect was on, with Barr insisting on hiring a well-known European architect, preferably Mies van der Rohe, but Stephen Clark and Nelson Rockefeller, who headed the building committee, outmaneuvered him. They selected Philip Goodwin, a traditional Beaux-Arts architect and a MoMA board member, and paired him with Edward Durell Stone, a young architect who had worked with Raymond Hood and Wallace Harrison on Radio City Music Hall.

Today a much larger structure engulfs MoMA's 1939 construction. The innocence of that earlier small, six-floor edifice—the clean lines of its glass-and-chromium façade, its metal canopy, and the white curtains that shielded its entrance lobby—is apparent only in vintage photographs. The modernity of the building contrasted with the romantic character of the neighboring brownstones, and many critics hissed at the museum's factory-like appearance. Some, however, were ready to be reconciled. Even though a European architect did not design it, the Bauhaus-like looks of the museum heralded the International style that would blanket Manhattan a few decades later. When the building was almost completed, John D. Rockefeller, Jr. relented and decided to loan—and eventually give—the museum the land in back of it, where, facing Fifty-fourth Street, the Rockefeller family houses had stood for fifty years. Barr was delighted. Within a matter of days, and with very little money, he and an associate designed a sculpture garden. Nelson recruited gardeners from Rockefeller Center to plant a few trees.

Nelson Rockefeller, Conger Goodyear, and Stephen Clark with the model of MoMA in 1939. (© The Museum of Modern Art/Licensed by SCALA/Art Resources, NY)

By the time MoMA moved into its 1939 building, it owned 271 paintings, 97 sculptures and constructions, 308 watercolors, and numerous prints, drawings, and pastels. This inventory included the modern art collection Abby Rockefeller had given to the museum by 1937, when she and Junior moved to 740 Park Avenue, Manhattan's premier apartment residence. MoMA's permanent collection looked great in the new building.

To accompany the opening exhibition, Barr wrote the catalogue *Art in Our Time.* It summarized the museum's accomplishments during the past ten years. Works in the show ranged from those from the end of the nineteenth century to art of the present. The oldest American work on view was a Winslow Homer from 1860; the oldest European painting was Renoir's *Le Moulin de la Galette,* from 1876. Calder's mobile *Lobster Trap and Fishtail,* commissioned by MoMA, was brand new. Barr explained that unlike other museums, MoMA was a conglomerate of six interrelated

curatorial departments: Painting and Sculpture, Architecture, Industrial Design, Photography, Prints, and Film.[85]

"Now that the scaffolding has been removed and the chromium and glass have been polished up," McBride wrote in the *New York Sun* on May 13, 1939, "the extreme cleanliness of the affair mitigates somewhat the nudity . . . [though it] calls loudly for some flagpoles or other ornament." Indeed, soon festive banners would decorate its façade, announcing the shows within. McBride also reminisced that *Art in Our Time* was "wonderfully like that of the famous and historic Armory Show . . . The chief heroes remain the same. Picasso and Matisse and Redon and Marcel Duchamp and Malliol and Lehmbruck are still on deck."[86]

Abby herself had masterminded the celebrations that accompanied the opening of the new building. For an entire year she and her committee had worked out the details of the trustees' dinner, held in the museum's new lounge. Table decorations consisted of lilies and greenery intertwined with silver candelabra created by Alexander Calder. Abby herself looked splendid in a red chiffon gown designed by Lanvin.[87]

Only two speakers addressed the audience. Paul Sachs praised Barr's catalogues, urged the museum to be more scholarly, and cautioned it to slow its growth so as to avoid burning out its able personnel. Crusty "Toughie" Goodyear recalled the initial luncheon for which he had bought a dignified gray garment, nicknamed thereafter his Rockefeller suit. He pointed out that six of the original seven trustees—Cornelius N. Bliss had taken his sister's seat—were still on board. Of the frenzied months prior to the 1929 opening, he recalled,

"Frank Crowninshield found galleries in the Heckscher Building and with Mrs. Sullivan saw to their remodeling . . . Mrs. Rockefeller and Miss Bliss performed miracles of highway robbery on their friends for the funds to carry on our three year plan . . ."

He lauded Paul Sachs for suggesting Alfred H. Barr, whom he likened to the museum's pituitary gland. Even though Goodyear had wrestled with Barr during the past ten years, he said,

"It is useless for me to attempt to tell you what Alfred has done for us . . . look about you. Under his leadership . . . and in cramped quar-

ters [he] has performed prodigies of display and scholarship." Goodyear remembered Lillie Bliss, her gifts and her vision, and lavished praise on Abby Rockefeller as well as on her husband without whose "cooperation and generosity certainly this building could not be."[88]

The museum officially opened two days later. The celebration began with forty dinners sponsored by various members of New York's upper crust. A selection of America's Who's Who attended. A special publicist, hired by Nelson Rockefeller, arranged for interviews and radio broadcasts with celebrities, including Walt Disney and Edsel Ford. Franklin Delano Roosevelt[89] delivered a speech based on material submitted by MoMA staff members:

> The arts that ennoble and refine life flourish only in an atmosphere of peace... And in this hour of dedication we are glad again to bear witness before all the world to our faith in the sanctity of free institutions...
>
> The arts cannot thrive except where men are free to be themselves ... The conditions for democracy and for art are one and the same.

A change in MoMA's leadership accompanied the move to the new building. Goodyear handed his president's baton to Nelson Rockefeller, Stephen C. Clark became chairman, and Abby Rockefeller became a simple member of the board. Even though he had put on a good show, Conger Goodyear had felt slighted during the celebration, especially by Nelson Rockefeller. After the move, he reduced his involvement with MoMA and, much to Barr's disappointment, would leave his marvelous collection of modern art to the Albright-Knox Art Gallery in Buffalo.

Mary Sullivan died six months after the move. Abby bought André Derain's *Window at Vers* and a limestone head by Modigliani from Sullivan's collection and gave them to MoMA in her memory.[90]

Two weeks after the glamorous party celebrating MoMA's move into its new building, World War II broke out, and for the next six years the world was again plunged into darkness. The museum would weather this new catastrophe as it had survived the stock market crash, which occurred two weeks after it opened its doors in the Heckscher Building ten years earlier.

The Cloisters

I N 1911, AS he was remodeling Kykuit, William Welles Bosworth in-
troduced Junior to George Grey Barnard. He was a popular artist, now
best remembered for the muscular statues that adorn the capitol of his
native Pennsylvania, in Harrisburg, and his powerful Abraham Lincoln
in Cincinnati. John D. Rockefeller, Jr., commissioned three outdoor stat-
ues from Barnard, but it was as a collector of fragments of medieval sculp
tures that this artist would have a major impact on Junior's life. As a young
man traveling in Europe, Junior had fallen in love with Romanesque and
Gothic architecture. Therefore, when he learned that, as a sideline, Bar-
nard was selling some of the medieval architectural fragments he had col-
lected in France and Spain, Rockefeller purchased one hundred items for
$100,000.[1] He did not know what he was going to do with these objects, but
the thought of building a medieval museum may have occurred to him.

Born in Bellefort, Pennsylvania, in 1863, Barnard had a Huck Finn
kind of youth. At thirteen he visited the Centennial Exhibition in Phila-
delphia and was awestruck by the bronze and marble sculptures on view
at the fair. At eighteen he resolved to become a sculptor. After three years
in Chicago he managed to relocate to Paris, where he planned, when he
could afford it, to attend the École des Beaux-Arts. In the meantime, in-
spired by Auguste Rodin, he just sculpted.

In 1886, while he led the life of the starving Parisian artist, Barnard had the good fortune of being introduced to Alfred Corning Clark, the father of Stephen Clark, MoMA's future president and chairman of the board. Alfred, who had just emerged from a nineteen-year-long liaison with a famous Norwegian tenor, became totally enthralled by Barnard, though their relationship seems to have been platonic. Alfred Clark commissioned several sculptures from young Barnard, of which one, *The Struggle of the Two Natures in Man*, ended up in the Metropolitan Museum of Art, where for many years it occupied a place of honor at the foot of the grand stairs. After spending decades in storage, it was moved to the remodeled American wing in 2009.

Alfred supported the gifted Barnard lavishly. In 1894, six of his works, more than from any other exhibitor, were accepted at the Salon du Champs-de-Mars. *The Struggle of the Two Natures in Man* earned high praise. Rodin is said to have visited the exhibition several times, once in the company of a young lady. When she asked Rodin to identify the sculptor, he introduced her to Barnard, allegedly saying, "this young man, right from the prairies of America."[2]

While in France, Barnard had fallen in love with Gothic and Romanesque art. He foraged the countryside in southern France, searching and buying for a pittance scattered architectural fragments. He also acquired medieval objects from art dealers. To bolster his sagging finances, he sold some of this material to American collectors and museums. He also planned to use some of his finds as teaching aids for the courses he taught at the Art Students League in New York City.[3] Barnard's little enterprise came at the right time. Just then the appreciation for Gothic art, previously ignored in the United States, was undergoing a revival.[4]

From the very beginning of their relationship, Barnard's personality must have irritated modest Junior. The sculptor engaged in self-aggrandizement, relating, for example, that "Rodin had wept openly [when he saw one of Barnard's sculptures,] declaring that he would never create anything so fine." He was also a romantic storyteller and would exaggerate the exploits involved

in assembling his collections.[5] The two men nevertheless shared a love and deep reverence for medieval art.

At the end of the nineteenth century, certain affluent intellectuals adopted an antimodernist philosophy. They revered medieval civilization, appreciated its sensitivity, and treasured its spiritual concerns, which they believed their own contemporary culture lacked. Within that context they felt that art created during the Middle Ages would exert a wholesome influence on their contemporaries. These thoughts appealed to Junior, who was impressed by the craftsmanship of medieval art, had no great liking for most graphic art, and thoroughly disliked modern art.[6] He may have wanted to demonstrate to his contemporaries what he thought good art looked like.

CHRISTIAN MONASTICISM AROSE in Egypt during the fourth century. The movement spread to Western Europe around 500 CE. By 1200, Western Europe was dotted with monasteries. They varied in size, but in general, important buildings were grouped around a central open court, or atrium (the cloister), enclosed by a covered arcaded walkway (the ambulatorium). Monasteries also usually included a chapel or church, a refectory, a chapter house, and a kitchen. Dormitories, or individual cells, were located on a second floor. The abbot had his own dwelling.

Most communal activities took place in the cloister, where the monks or nuns meditated, prayed, walked, and sometimes talked with one another. Religious services, often shared with the lay community, took place in the chapel, and business-type meetings were held in the chapter house. Except for the often lavishly decorated church, the cloister, with its enclosed garden, fountains, and sculpted columns, was the most attractive and lively portion of the monastery.[7]

Many of Europe's monasteries were vandalized during the English Reformation and the French Revolution. Others were abandoned, their buildings used as stables or for storage. For centuries, builders reused the

stones and marble of the former religious establishments to build other edifices. Villagers helped themselves to sculpted arcades, doorways, and fountains and used them in their gardens or houses. Around 1906, when Barnard started his collection, he succeeded in assembling a massive number of columns and arches from four cloisters. His biggest haul— forty-eight columns and their carved architectural bases and fifty-six arches—came from the Benedictine abbey of Saint Michel-de-Cuxa. He managed to ship these to America, shortly before the French government tightened laws pertaining to the export of historical monuments.[8]

Barnard had hoped to sell these four cloisters in their entirety to the Metropolitan Museum, but when that plan fell through, he assembled them himself on land he owned on Fort Washington Avenue in Manhattan. In 1914, he opened the reassembled cloisters as a small private museum. It was a remarkable achievement for a private citizen with small resources.

"Mr. Barnard was not a man of means," Joseph Breck, the Metropolitan's curator of decorative arts, wrote in 1925. "The project to establish here, through his own efforts, a shrine of medieval art might therefore, to one who did not know the man, seem visionary in the extreme. But difficulties only served to fan the flame which burns in every true collector's heart."[9]

Even though Barnard charged visitors twenty-five cents admission, he soon ran out of funds. He asked the City of New York and the Metropolitan Museum of Art for help. When both refused, Barnard turned the matter over to P. Jackson Higgs, an art dealer, who approached Junior. Higgs's letters detail the worth of Barnard's collection: $1.5 million for the original "catalogued" collection, $240,000 for the "non-catalogued" additions, $140,000 for the land, and $40,000 for the building, for a total of $1.92 million. According to Higgs, Barnard was willing to settle for about half.

The sculptor was not easy to deal with. He frequently changed his mind about the terms of the sale. Moreover, he threatened to break up the collection. After a while, Junior, who had indicated his willingness to buy the entire collection for the Metropolitan Museum of Art, refused to speak with Barnard directly.

The job of negotiating with Barnard fell to Junior's associates and to

Robert de Forest, director of the Met. In April 1925, de Forest reported to Junior that he had gone to see Barnard, "listened to his panegyric, assured him of [the museum's] deep interest," and come away reassured that the negotiations were progressing satisfactorily, even though "this particular kaleidoscope is changing about once every ten minutes."

By the middle of May 1925, Barnard and the Metropolitan had settled on a final price of $650,000. This sum approximates less than half of what Higgs said both the artworks and the property were worth. According to Breck, the collection included six to seven hundred examples of sculpture, paintings, and other forms of art, mainly French in origin, from the Romanesque and Gothic periods. Four years later Barnard's Cloisters reopened as a branch of the Met.

THE REOPENING OF The Cloisters, however, was not the end of the story. In 1917, Junior had bought Manhattan's choicest piece of real estate—sixty acres located on a cliff at the northern end of Manhattan, which included the colonial Fort Tryon. Most recently the land belonged to the Billings family, who had built a many-turreted mansion on the site's highest hill. Junior intended to donate the property to New York City, for a park, but the then-mayor refused the gift because of the cost involved in developing it. In 1935, after the Olmsted Brothers, at Junior's expense, turned it into a dramatic park with views up, down, and across the Hudson, the city changed its mind and accepted it.[10]

The unobstructed view across the river was no accident. Starting in 1901 the Palisades Interstate Park Commission had acquired the rocky cliffs that form the western edge of the Hudson to safeguard them for future generations. Wealthy and concerned citizens, including the Rockefellers, had provided money for the project. Now Junior, later aided by Laurance, son number three, would acquire land atop the Palisades, thereby ensuring the view from both Fort Tryon Park and the future Cloisters.

When he donated the park to the city, Junior had reserved the four northernmost acres for himself, with the intention of relocating Barnard's

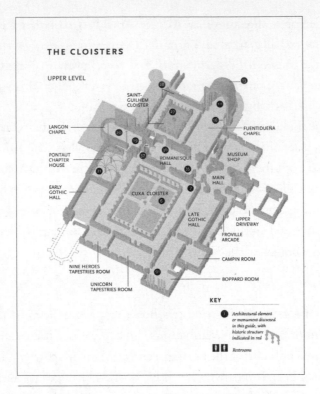

Plan of The Cloisters. (© The Metropolitan Museum of Art, New York)

collection. The 1930s, however, were not a very propitious time to build a new museum. Not only was the Depression at its height and Junior was immersed in building Rockefeller Center, but something as esoteric as a showplace for medieval art seemed superfluous. The project nevertheless progressed, albeit slowly.

The first problem was to decide on the type of building. As usual Junior consulted a number of experts, including James Forbes and Paul Sachs of Harvard's Fogg Museum and William R. Valentiner of the Detroit Museum of the Arts. Junior asked John Russell Pope, who would design the National Gallery of Art in Washington for Andrew Mellon, and River-side Church's Charles Collens to submit preliminary architectural proposals. Junior felt that the present site, a "high, rocky, wooded hill . . . clearly

suggested something picturesque and romantic . . . rather than a highly sophisticated type of building." At first he favored a castle-like structure resembling Scotland's Kenilworth, of which he was particularly fond. Ultimately, however, he felt that a structure modeled on a fortified monastery was more suitable for the building's future use. Junior decided that it had to be tall enough to compete "with the towers of the Hudson River [George Washington] Bridge just beyond." He wondered whether "a high chapel with a nave and apse," as in Avignon, could supply the required elevation, but ultimately rejected the idea because it "would involve wasted cubage within," and therefore would reduce exhibition space.[11]

Though Joseph Breck was his liaison with the Met, Junior was more impressed by Breck's young assistant, James J. Rorimer, and it was with him and Collens that Junior worked closely during the entire building process. Rorimer had gone to Harvard, where he attended Sachs's Museum School. Upon graduation in 1927, the young man started on his life-long career at the Met. After Breck died in 1934, Rorimer became the curator of the museum's newly formed Department of Medieval Art.

Junior and Rorimer were ideally suited to each other. Both were socially awkward, hardworking perfectionists who preferred work to play. Rorimer treated Junior with great deference, accurately judging that his patron wanted to be involved in every decision, be it large or small. He also understood and respected Junior's combination of generosity and parsimony, and his liking for accurately kept records. The two men became completely absorbed in the creation of The Cloisters. Whenever he was in town, Rockefeller visited the building site almost daily, and often Rorimer stopped at the Rockefeller mansion in Manhattan in the morning before going to work.

Most important, Rorimer combined the sophistication of a medievalist with the practical ability to do manual labor. His father, Louis Rorimer, Cleveland's top decorator, had taught James an eye for detail, as well as elementary carpentry and masonry. He honed his son's tastes on European trips. During his studies, the younger Rorimer traveled to Spain and fell in love with Romanesque and Gothic architecture, a fact that would benefit him, his patron, and future generations of art lovers.[12]

Looking at the integrity of The Cloisters today, it is hard to imagine how Collens and his associates ever managed to develop a design that incorporated all the elements bought from Barnard and the various other components acquired as building progressed. But early on, Collens, with the assistance of Rorimer, came up with a design that, with some minor modifications, is the one we see today.

Collens had done his homework. He visited Valentiner's new medieval art galleries in Detroit and was unimpressed.[13] He felt that the New York museum should not be too ecclesiastic in feeling and that it would be best "to use a simple Benedictine or Cistercian plan with the Cuxa Cloister as the central motif and with the Trie and Saint-Guilhem cloisters placed in subservient locations." He also suggested that the rooms surrounding the central cloister "be domestic in character and the ecclesiastical element confined to two or three small chapels in which the better altar pieces and church carvings could be placed."[14] Finally, he suggested a facing of plain, rough stones so that it looked as if the building were growing out of the hilltop.

Junior still hesitated to approve Collens's proposal, and he asked Rorimer to erect a scale mock-up based on the architect's design. With the help of a Rockefeller caretaker, using ropes, plywood, burlap, and cardboard, Rorimer built an in situ plywood rendition of the first floor. It included parapets and terraces. Junior came to inspect. Since views were always of paramount importance to the Rockefellers, he started out by mounting the ramparts. He was thrilled.

That summer, after having submitted another preliminary blueprint, Charles Collens took a prolonged exploratory trip to Europe. One can sense the architect's enthusiasm from the eleven-page, single-spaced typewritten report, accompanied by photographs and sketches, he sent Junior upon his return:[15]

> Went to Bordeaux inspected best Romanesque cloisters and churches examining stone work, . . . Went to Saintes, Ecoyeux, Perigueux, Bergerac, Sarlat, Souillac, was very impressed by Monsempron, Toulouse, Auch, liked St. Bertrand de Comminges . . .

We are making a mistake in the Saint Guilhem Cloister by closing up the river side with small embrasures. I think that the whole side ought to be opened up as it is at St. Bertrand so that the magnificent view of the Hudson can be seen to the fullest extent.

Referring to the enclosed drawings and photographs, Collens explained that he liked the way the buttresses from the church ran down into the cloister; it seemed to him "that the Trie Cloister could be treated very much in the same way as it is at low enough level to admit this interesting motif." Collens then visited the town of St. Gaudens, the source of many of Barnard's columns, and noted that:

Its church had a circular apse placed against the square end of the nave. It made me think that it would be much better to finish the end of the Romanesque chapel in a manner similar to it . . . rather than to fit it into the square end which is shown in our present sketches.

Repeatedly Collens was impressed by the fact that the European cloisters are open to the air, and he advised his client to duplicate this in New York, "provided that it would be possible [to develop] suitable protection against the winter weather. The effect is charming in all cases."

Collens crossed the Pyrenees and visited the now-denuded site of Saint Michel-de-Cuxa. He felt reassured that the original ambiance of Cuxa was replicated in his designs. Thereafter, he went on to Arles, where he visited the Cloister of Saint Trophime, one of the most beautiful in all of France. Paris was last. He visited the Cluny, its medieval museum, and called upon Mr. George Blumenthal, a trustee and future president of the Met, to inspect the reconstructed medieval chapel in his home. He appreciated its fine workmanship. Collens reported that during the entire trip he had paid close attention to the ancient building methods and materials used.

The thorough nature of the report reassured Junior, and on September 25, 1931, he finally gave Collens a contract. Before the actual building started, Rorimer, assisted by WPA craftsmen, built a detailed wooden

scale model of The Cloisters. The model featured diminutive, appropriately illuminated plaster casts of the sculptures, columns, archways, and windows. When Rockefeller saw the display he was overwhelmed. "Mr. Rorimer," he said, in obvious amazement, "is this the way The Cloisters are going to look? . . . 'No, Mr. Rockefeller,' [Rorimer] said quietly. 'This is the way they could look if you wish them to.'"[16]

THE DESIGNERS OF the museum alternated galleries with cloisters and chapels. The ensemble never feels like a museum, and visitors are magically transported to the European Middle Ages. Even though care was taken to avoid a religious atmosphere, the museum's ambiance is conducive to meditation and inner reflection.

During the Romanesque and Gothic periods most art was created for the Church and its princes and servants. The objects, however, are far from humble. The skills of goldsmiths, jewelers, enamellers, ivory carvers, and sculptors were at their height then, their handiwork delicate and sometimes extremely lavish. Barnard's collection provided many of the capitals, bases, columns, arches, and fountains for the reconstruction, and four of his cloisters were rebuilt as such in the new museum. Many artworks and the windows, doorways, and other architectural elements were specifically bought for The Cloisters. The elements dated from the twelfth to the fifteenth century, thus including both Romanesque and Gothic material.

Overwhelmingly, Barnard's architectural fragments came from southern France, near its present border with Spain. Since the new museum would be considerably larger and more complex than Barnard's reconstruction, much additional material was purchased. Some of these new acquisitions came from other areas, thereby widening the geographical overview of medieval Europe.

The Saint-Michel-de-Cuxa Cloister in the French Pyrenees was one of Barnard's principal sources. Built during the second half of the twelfth century, the monastery was extremely large, and the New York version is about half of the original size. Still, it is sizable enough to form the central

portion of the museum. The capitals and arches are clearly Romanesque. All stonework consists of mottled pink Languedoc stone. Fortunately replacement elements could be fashioned from this same stone, quarried near Cuxa. The capitals throughout that cloister are varied. Some consist of forcefully carved animals or humans; others are solid; and others, still, are Corinthian. As elsewhere in the museum, the walkways around the periphery are covered with timbers and roof tiles manufactured as they were in medieval times. The central court is divided into quarters by footpaths. As is customary, there is a central fountain surrounded by low plantings. Potted plants are casually distributed throughout the roofed walkways, as are the stone benches that invite visitors to linger, meditate, read a book, or listen to the Gregorian chants often piped through the museum.

The Cloisters is not copied from any one particular building. The imposing tower of the New York museum, however, is modeled on the one still standing at Cuxa's original site. One can imagine armed knights peering out of its small windows, making sure that the peace of this medieval enclave not be disturbed.

ACCORDING TO RORIMER, "No architectural unit could be more perfectly suited to The Cloisters than the twelfth-century chapter house from the former abbey of Notre-Dame-de-Pontaut." During meetings at which the rules and business aspects of their community were discussed, monks would sit on the stone benches lining the periphery of the chapter house. Now it abuts the Cuxa Cloister and provides a good illustration of the round-arched, ribbed vaulted ceilings used during the Romanesque period.[17]

The small Saint Guilhem-le-Desert Cloister is also located on the main level. The finely carved acanthus leaves, vines, and other botanical themes that decorate the capitals of its paired columns were one of "the chief treasures of the original Cloisters collection."[18] Except for an intricate fountain—once a column capital—the center of the cloister is often bare. Clay pots of flowering plants, heralding the end of winter, fill

it during the Easter season, and the windows offer a framed view of the Hudson.

The Romanesque sculpture hall separates the Cuxa and Saint-Guilhem cloisters. Though it was clearly conceived as a museum gallery, it does not feel like one. Two huge colorful frescoes, created for the chapter house of the monastery of San Pedro de Arlanza near Burgos, in northern Spain, are affixed to the wall. Dating from about 1200 CE, the stern mustachioed lion and the winged, horned dragon are charming and naïve looking. Even though each panel measures seven by eleven feet, the pictures are reminiscent of medieval illuminated manuscripts. Also from the medieval bestiary are two more realistic-looking lions—the king of the animals is a symbol of Christ—which flank the entrance to the Cuxa Cloister. *The Adoration of the Magi*, a group of four figures, also from northern Spain and dating from about 1200 CE, are mounted nearby. Junior had gone to see the sculptures at the request of Joseph Breck, when they were for sale at Joseph Brummer, the foremost purveyor of Romanesque and Gothic antiquities in America. They were priced at $140,000. On May 5, 1930, he reported on his visit:

> I saw the four Romanesque statues at Brummer's, . . . Mrs. Rockefeller also saw them. She was more enthusiastic about them than I, my enthusiasm being somewhat restrained because of the damaged stones about the faces of two or three of the statues. Since you and your associates feel so clearly that these are exceptionally important . . . I will contribute whatever sum may be necessary up to $140,000.[19]

Junior's reaction to a mutilated medieval statue recalls his initial response to the famous seventh-century Tang period bodhisattva he bought from Yamanaka in 1924. Then, he had successfully bargained with the art dealer; and though he now was willing to pay the asked-for price for the *Adoration*, he advised the Met to try to bargain with Mr. Brummer. The large size of the four figures of the *Adoration* illustrates the monumentality of some of the Romanesque sculptures.

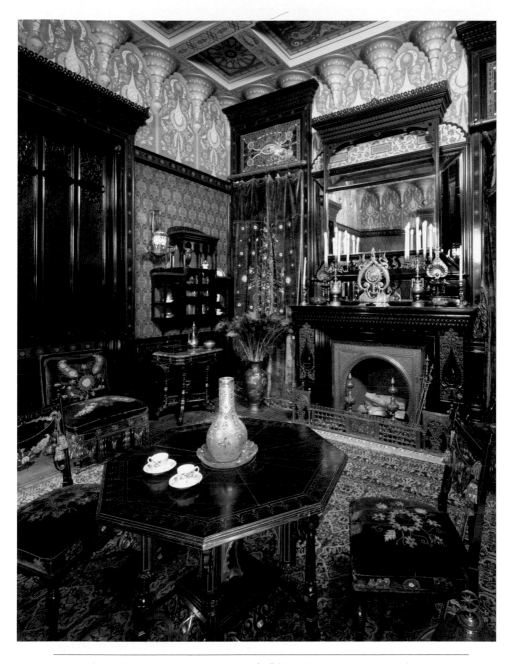

Moorish smoking room of John D. Rockefeller's house at 4 West 54th Street, dating from 1864–1865. Brooklyn Museum, New York. *(Brooklyn Museum, New York)*

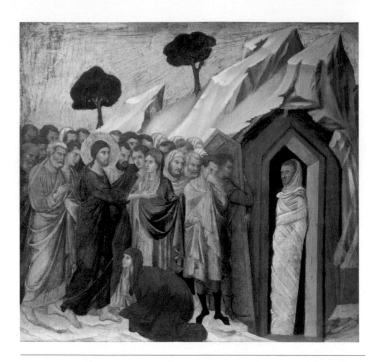

Duccio (de Buoninsegna): *The Raising of Lazarus*, Kimbell Art Museum, Fort Worth, Texas. *(Kimbell Art Museum, Fort Worth, Texas/Art Resource, NY)*

Nuihaku (robe), Edo period, collected by Lucy Truman Aldrich and donated to the Museum of the Rhode Island School of Design. *(Museum of Art, Rhode Island School of Design)*

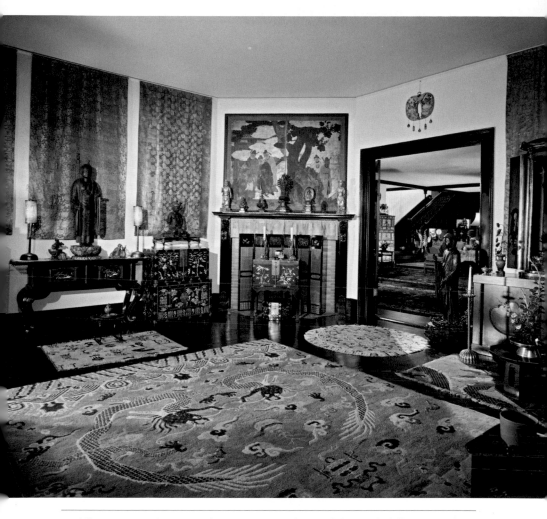

Buddha Room at the Eyrie, the summer residence of the Rockefellers in Seal Harbor, Maine. (*Ezra Stoller © Esto*)

Lamasu (Assyrian man-bull) dating from 710 BCE. It was excavated by Dr. Breasted's Oriental Institute at Dur Sharrukin (Khorsabad), the capital of King Sargon II, and is now at the Oriental Institute of the University of Chicago. John D. Rockefeller Jr. gave a similar pair of *Lamasu* from Nineveh to New York's Metropolitan Museum of Art. (*The Oriental Institute Museum of the University of Chicago*)

WISDOM AND ✳ KNOWLEDGE ✳ ✳ SHALL BE THE ✳ ✳ STABILITY OF THY TIMES

Lee Lawrie: *Wisdom.* The bas-relief, which to John D. Rockefeller Jr. looked like Father Time, is over the main entrance of 30 Rockefeller Plaza. (© *Christine Roussel*)

Vincent van Gogh: *Corridor in the Asylum.* Upon Abby A. Rockefeller's death the painting was bequeathed to MoMA with the provision that after fifty years it be transferred to the Met. *(The Metropolitan Museum of Art, New York NY, USA/Art Resource, NY)*

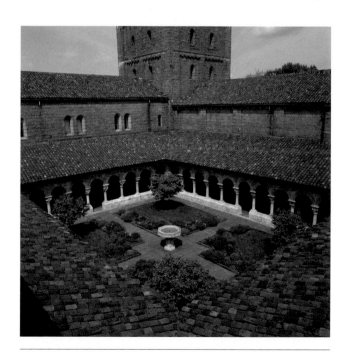

View of Cuxa Cloister, the Cloisters, New York.

(© The Metropolitan Museum of Art /Art Resource, NY)

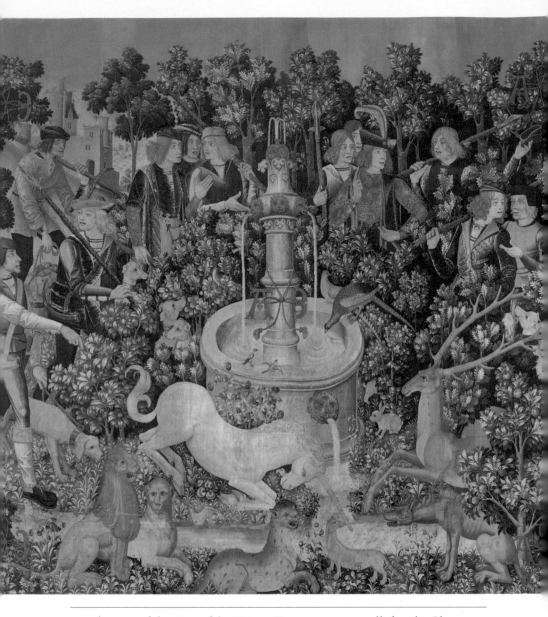

Another one of the *Hunt of the Unicorn Tapestries*, now installed at the Cloisters in New York City. (© *The Metropolitan Museum of Art/Art Resource, NY*)

Unidentified Artist: *The Old Plantation*, probably South Carolina, possibly 1790–1800. (*Abby Aldrich Rockefeller Folk Art Museum, The Colonial Williamsburg Foundation*)

Edward Hicks: *The Peaceable Kingdom*, 1832–1834. (*Abby Aldrich Rockefeller Folk Art Museum, The Colonial Williamsburg Foundation*)

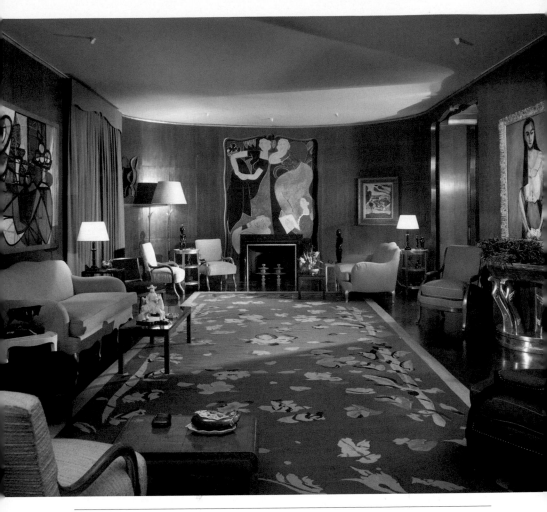

Nelson Rockefeller's living room in his triplex on Fifth Avenue. Note the mural surrounding the fireplace by Henri Matisse as well as Matisse's *Italian Woman* and a large still life by Picasso. Many of these works were given to the Museum of Modern Art in New York. (*Ezra Stoller © Esto*)

Henri Rousseau: *The Dream*, 1910. Nelson's Rockefeller's gift to the Museum of Modern Art on the occasion of its twenty-fifth anniversary. *(The Museum of Modern Art, Licensed by SCALA/Art Resource, NY)*

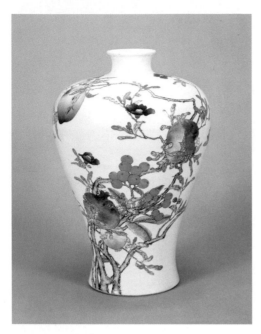

Bottle, China Jiangxi Province, Quing Period, 1723–1735, The Asia Society. *(Courtesy Asia Society, New York)*

George Caleb Bingham: *Boatmen on the Missouri*, 1846. *(Fine Arts Museums of San Francisco, donated by Mr. And Mrs. John D. Rockefeller, 3rd)*

Lacquered crane from
Guerrero, Mexico. San Antonio
Museum of Art. Collected in
the 1930s. *(Lee Boltin)*

Josefina Aguilar: *Couple
on Their Way to Church*,
Oaxaca, 1970s. San
Antonio Museum of Art.
(Lee Boltin)

Anonymous: *El Niño de Atocha*, Central Mexico, mid–19th century. San Antonio Museum of Art. (*Lee Boltin*)

Albert Bierstadt: *Cathedral Rocks*, Marsh-Billings-Rockefeller Mansion, Woodstock, Vermont. (*Marsh-Billings-Rockefeller National Park*)

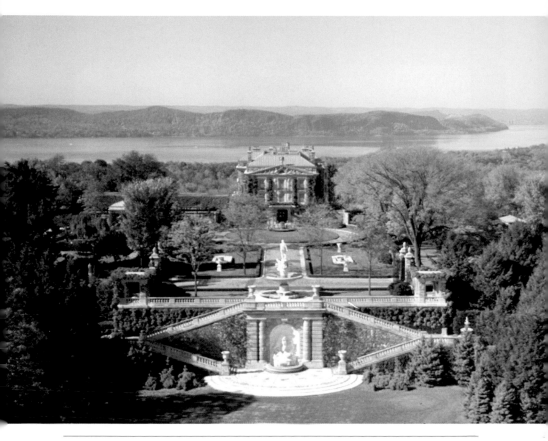

Aerial view of Kykuit, the Rockefeller mansion in Pocantico Hills, New York.
(Mick Hales for Historic Hudson Valley/www.hudsonvalley.org)

Bodhisattva, China, Tang period, eighth century, in front of a west window at Kykuit. *(Mary Louise Pierson)*

Marc Chagall: *The Good Samaritan* stained glass window in
memory of John D. Rockefeller Jr. The Union Church, Pocantico
Hills, New York. *(Mick Hales for Historic Hudson Valley/www.hudsonvalley.org)*

Henri Matisse, rose window in memory of Abby A. Rockefeller. This was Matisse's last work; he died within days of completing the maquette for the window. The Union Church, Pocantico Hills, New York. *(Historic Hudson Valley)*

Doorway from Moutiers-Saint-Jean in Burgundy, thirteenth
century. Rorimer located the figures of the founder princes Clovis
and Clothar in France years after the entryway was in place.
(© The Metropolitan Museum of Art/Art Resource, NY)

The Moutiers-Saint-Jean doorway, originally from the abbey of the
same name, closes the Romanesque Hall at its western end. Much dam-
aged, the thirteenth-century Gothic doorway had survived as the entrance
to a Burgundian farmhouse. According to Rorimer it "shows at its very best
the unison of architecture and sculpture of the golden age of the Gothic . . .
Moldings, ornament, and figure sculpture, brilliantly carved, are harmoni-
ously worked into a single unit. A story is told with the chisel; . . . Each part
bears a definite relation to the whole."[20]

Junior had bought the doorway from Joseph Brummer at Rorimer's
recommendation. Though magnificent, it was incomplete. At one time it
clearly had held the life-size statues of King Clovis, who founded the mon-

astery around 500 CE, and of his son King Clothar. Missing since the French Revolution, or even since the Huguenots vandalized the monastery in 1567, the statues were believed to be lost. In 1900, Chabeuf, a French scholar, however, exhibited photographs of Clovis and Clothar at a meeting. He suspected that the statues were originally from Moutiers-Saint-Jean, but he was convinced that they were too large to fit the niches of the doorway. The statues continued to grace a garden in the village of Moutiers-Saint-Jean until sold to a Paris collector in 1909. In 1938, Rorimer inspected the statues and the iron rods that used to attach them to their niches, and concluded that, in spite of their size, they had been part of the cloister's doorway.

When the statues came up for sale, Rorimer asked the Boston Museum of Fine Arts, which by then had become interested in acquiring them, to desist, and then successfully pleaded with Junior to buy them for The Cloisters.[21]

In April 1940, Rorimer expressed to his patron his happiness about the doorway:

> The doorway from Moutiers-Saint-Jean with the two figures of King Clovis and Clothar now stand majestically in the Romanesque Hall of The Cloisters. The heads are back in their original position [they had been switched during the statues' odyssey] and restorations at various surface blemishes have been removed, . . . [they are in my opinion] masterpieces of 13th century sculpture. I cannot tell you how glad I am that you were willing to show "faith" in my judgment at a time when there was so much opposition and hesitancy to their acquisition. . . . It would give me great pleasure to show you the doorway.[22]

Forty years later, art historian William H. Forsyth made an in-depth study of the doorway and declared it, without doubt, the finest Gothic portal in America.[23]

The doorway forms the entrance to the small early Romanesque chapel, constructed with twelfth-century limestone from the church of Notre-Dame-du-Bourg at Langon. Two large columns and seven capitals survived

from the original chapel. One of them includes a likeness of Queen Eleanor of Aquitaine.

A spectacular array of virgins, sculpted from wood or stucco, with and without the infant Jesus, fills the Early Gothic Hall. Rorimer was particularly proud of one that was part of a choir screen of the Strasbourg Cathedral. The screen that truncated the nave was dismantled in 1682, its life-size figures of the apostles, dating from about 1250, being mostly placed elsewhere in the cathedral. The whereabouts of the Virgin remained a mystery until it surfaced at a London sale, where it fetched £85 5s. According to a seventeenth-century source, the Christ child was originally part of the composition. He was seated on a rosebush "offering his mother what appears to be a fruit on which a bird is perched." After the statue of the Virgin started on its peregrinations, it was covered with an additional layer of paint, easily removed during restoration, which protected the original paint from deteriorating. Today the remarkably fresh-looking Virgin is a reminder of how these statues looked when new. An ecstatic Rorimer described the new acquisition as "perhaps the most important Gothic sculpture on this side of the Atlantic." He contrasted the subtlety and simplicity of the Virgin's face, crown, gown, and veil with the angular Gothic folds of the gilded mantle, whose borders were studded with red and green jewels.[24]

A short staircase leads into a small Gothic-style chapel filled with magnificent Spanish and French tomb effigies. The spectacular sculptures provide much information about life during the thirteenth and fourteenth centuries. Jean d'Alluye, shown wearing full armor, visited the Holy Land and allegedly returned with a fragment of the True Cross.[25] The imposing tomb of the Count of Urgell occupies the west wall of the chapel.

Stairs lead from the chapel to a gallery devoted to magnificent examples of medieval sculpture and artifacts. Its doors open to the Trie-en-Bigorre and Bonnefont cloisters. Both are open to the sky, a result of Collens's enthusiasm for the open-air configuration of the cloisters he encountered on his European trip. The Trie Cloister is the smaller and more delicate

of the two. All in all, eighty-one of the cloister's capitals survived, but only twenty ended up in Barnard's New York collection. Probably carved between 1484 and 1490, the capitals contain multiple coats of arms, including those of Catherine, Queen of Navarre and Countess of Bigorre, and of her husband, Jean d'Albret.

Collens needed twenty-three columns and capitals for his reconstruction, but was short three. Luck would have it that, in 1913, Stephen Clark had engaged George Barnard, his father's former protégé, to help him and his wife shop for antique artifacts to incorporate into a Gothic-style house they were building on Seventieth Street in Manhattan. Among their acquisitions was a set of columns and capitals from the Trie Cloister in southern France. Although the columns were now part of an arcade on the terrace of the Clark house, Stephen Clark, a member of the Met's Board of Trustees, graciously donated the three additional columns and capitals to The Cloisters.[26]

The Trie Cloister is small and intimate. A tiled walkway and an arcade of delicate columns surround a small garden filled with flowers that recall the *millefleurs* background of the Unicorn Tapestries. The adjacent Bonnefont Cloisters has a more worldly feeling. Well-defined beds are filled with pharmaceutical and culinary herbs. Four small quince trees encircle the cloister's central fountain, and an espaliered fruit tree hugs a wall. The panoramic view of Fort Tryon Park, the Hudson, and the Palisades evokes distant times, but the elegant span of the George Washington Bridge is a reminder that this is the twenty-first century.

AN OFTEN-TOLD STORY has it that when Junior examined the evolving blueprints of The Cloisters he noticed that one of the galleries was marked "Tapestries." Shocked, he asked Rorimer what he meant, and the young man answered that it would be nice if the room contained something like Mr. Rockefeller's Unicorn Tapestries. "What?" was Junior's surprised response.[27] He had acquired these works in 1920, and they were his favorite possession. The entire Rockefeller family cherished the tapestries,

and in his autobiography David Rockefeller recalled how he loved showing them off to visitors.

Even though Junior was reluctant, the Unicorn Tapestries were hanging in The Cloisters when it opened. Woven in the South Netherlands between 1495 and 1505, they are considered the most beautiful example of Gobelin tapestries in existence. Their closest rival is *The Lady with the Unicorn Series*, in the Cluny museum in Paris. The French tapestries were exhibited at the Metropolitan Museum in New York in 1947, at which time Rorimer compared the two, "rabbit for rabbit and dog for dog," and concluded that those from The Cloisters "are definitely more alive, more brilliantly conceived and executed."

When first moved to The Cloisters, the Unicorn Tapestries hung in a large, unadorned gallery, where their former owner frequently visited them. After five years he concluded that such a museum-like atmosphere was unsuitable and that they needed the warmth given off by a room in a private home. At his request the space was transformed into a room with a Gothic fireplace, an authentic fifteenth-century oak cupboard, and a pair of shiny brass candlesticks. Through a stained-glass window rescued from a Gothic house and a flamboyant Gothic doorway Junior bought from Barnard the gardens of the Cuxa Cloisters can be glimpsed.[28]

Unlike the Unicorn Tapestries, the three *Nine Heroes Tapestries*, another gift from Mr. Rockefeller, had been cut up. The Metropolitan Museum had acquired *King Arthur*, one of the nine heroes, in 1932. Four years later Joseph Brummer uncovered five pairs of window curtains consisting of ninety-one tapestry fragments, which Rorimer identified as being related to *King Arthur*. Prolonged negotiations, followed by years of expert needlework, yielded reconstituted tapestries.

As Rockefeller wrote to Rorimer on July 11, 1947:

At length the dream which you and I have had . . . [that these tapestries] and the Unicorn tapestries should be exhibited in adjacent rooms at The Cloisters and should remain at the Cloisters for all times for the enjoyment and inspiration of the public is about to be realized. My heartiest congratulations![29]

Only five (*Julius Caesar, Hector, King David, Joshua,* and *King Arthur*) of the nine heroes survive. Each one sits on an imposing throne framed by architectural elements. Arthur, whose image was least damaged, is powerful and majestic. Appropriate courtiers and attendants surround the principals. Musicians accompany Caesar; and clergymen surround Arthur, a champion of Christianity.[30] The design, detail, and imagery of the faded tapestries are reminiscent of that of medieval stained-glass windows.

IN 1935, WHILE The Cloisters was under construction, a dealer approached Junior with photographs of a remarkable Romanesque apse from the church of San Martin at Fuentidueña, near Segovia in Spain. The apse was all that had survived from the church built toward the end of the twelfth century. Rockefeller showed the photographs to Rorimer, and the two men concluded that the apse would admirably complement The Cloisters' other architectural masterpieces. Upon investigation, however, it turned out that the apse was not for sale, since the Church of San Martin was a national monument.

The talks, interrupted by the Spanish Civil War and World War II, resumed in 1952. After prolonged negotiations, Rorimer persuaded the Spanish government, in exchange for six medieval Spanish frescoes and funds for the reconstruction of the original church, to loan the Fuentidueña apse permanently to The Cloisters. Junior, by then eighty-four, eagerly followed the negotiations.[31] In 1958 the apse, dismantled into 3,300 carefully numbered blocks, arrived in New York, where it was reassembled, adjoining the Saint-Guilhem Cloister.

Its height and sparse décor make the Fuentidueña apse especially awe-inspiring. Two surviving columns depict Saint Martin, Bishop of Tours, and Mary accompanied by an angel announcing the birth of Jesus. A severe Byzantine-style fresco of the Virgin and Child surrounded by a mandorla (semicircle), and flanked by archangels and the three Magi, dominates the upper portion of the half-dome.[32] A large crucifix dating from 1150 hangs from the ceiling, above a simple altar. According to authors Peter Barnet and

Nancy Wu, the crucifix "represents Christ in a characteristically twelfth-century manner, triumphant over death, with eyes open and crowned."[33]

THE CLOISTERS' TREASURY is like Ali Baba's cave. Finely wrought enamels, ewers, carved ivories, silver-gilt beakers decorated with inlaid enamels, embroidered ecclesiastic vestments, jewel-encrusted reliquaries, and illuminated manuscripts fill Lucite viewing cases.

One of the best-known objects is the Bury St. Edmunds Cross, acquired during the stewardship of colorful Thomas Hoving, one of Rorimer's special protégés. Hoving, a specialist in medieval ivories, became intrigued when offered a wondrous ivory cross by Ante Topić-Mimara, a shady collector and art dealer involved with the post–World War II return of looted art to its Yugoslav owners. At the time, many experts deemed the cross a fake, but Hoving bought it for The Cloisters.

Further investigation proved the walrus ivory cross to be English, dating from about 1150–60. Scenes from the Old and New Testament and about one hundred figures decorate the twenty-three-by-fourteen-inch cross. They include the women at Christ's tomb, the symbols of the four Evangelists, nine Old Testament prophets, the Lamb of God, and Moses. Adam and Eve, hoping for resurrection, crouch at the foot of the tree of life, which occupies one vertical surface. Highly anti-Semitic inscriptions confirm that the cross dates from the time when the Jews were about to be expelled from England.[34]

Many of the objects in the treasury are extremely luxurious. There is a reliquary in the shape of a hand, a miniature jeweled reliquary shrine made by a Parisian goldsmith during the fourteenth century, crosses encrusted with precious stones, and lavish chalices, cruets, beakers, patens, straws, and other implements used during Mass.

An object of pride for Junior, and one of his special gifts, is the Antioch Chalice, dating from the first half of the sixth century. Initially believed to be the Holy Grail—the cup Jesus used during the Last Supper—then a vessel for the Eucharist, it is now thought to be a stand-

ing lamp, illustrating Christ's pronouncement "I am the light." The silver-and-silver-gilt chalice is covered with fruited grapevines, birds, mammals, and human figures, most likely representing Christ and the apostles.[35] A more mundane possession is a pack of playing cards made in the Lowlands about 1475. It is the oldest complete set in existence, consisting of four suites of thirteen cards.

GEORGE GREY BARNARD, the man who started it all, did not live to see the opening of The Cloisters, but he was able to visit when the museum was almost complete. His letter to the man with whom he had had such a stormy relationship is filled with relief that his vision had been realized so beautifully:[36]

> April 30, 1936
>
> Dear Mr. Rockefeller
> I am glad I lived long enough to realize the splendid plans now completed, for replacing The Cloisters. I just visited the entire museum and came away with *deep emotion* . . . The American public will be thrilled and profit [from] your gift, so beautifully arranged.
> We shall all be gratefully yours.
> George Grey Barnard

The Cloisters opened officially two years later, on May 10, 1938. John D. Rockefeller, Jr., first declined to participate in the ceremonies, but then relented:

> I would not have missed this [opening] occasion for anything: but I never was more embarrassed than I am at this moment. I have derived so much pleasure from the part I have had in the development of Fort Tryon Park and The Cloisters, that I am far from being entitled to the gracious words, which have been spoken by Mr. Blumenthal, by Mayor La Guardia and by Commissioner Moses. . . .

With the opening of The Cloisters, Fort Tryon Park is complete
... Thus there is realized today an ideal toward which I have been
working for twenty years ...

When we were considering what kind of structure would give the
greatest distinction and interest to this unique and commanding site,
with the majestic Hudson flowing by, the Palisades rising like a battle-
ment on yonder shore, and the greatest city in the world lying at its
feet, we hardly dared to hope that it would ultimately be crowned
with a building so beautiful, housing so appropriately some of the
world's great works of art.[37]

Junior remained immensely proud of, and devoted to, The Cloisters.
He came frequently, sometimes enjoying the view from the ramparts,
always spending time with his beloved Unicorn Tapestries. "I hope that
you take as much pleasure and satisfaction in The Cloisters, so largely
your creation, as I do," he would write Rorimer in 1951. "Both inside and
out it seems to me as nearly perfect as a building and collection of this
kind could be."[38]

In 1943, Rorimer left his post at The Cloisters and enlisted in the U.S.
Infantry. After basic training, the army sent him to language school and
groomed him to be the head of the Monument, Fine Arts and Archives
Section of the Western District's Seventh Army. One of his tasks was to
recover the art looted by the Nazis, and though his job was only partially
successful, the French as well as the Americans covered him with deco-
rations. From Europe he wrote to his patron and friend, "You know by
now that I believe in long-term planning, and will readily realize that I
have the future of The Cloisters in mind. . . . I will keep my eyes open as
I did when a younger man."[39]

After his discharge, Rorimer was appointed to the new post of di-
rector of The Cloisters. With Junior's help he continued to acquire new
masterpieces for the collection and shepherded the loan of the Fuenti-
dueña apse through acres of red tape. In 1955 the Metropolitan Museum
appointed him to its directorship. As director, he acquired Rembrandt's

Aristotle Contemplating a Bust of Homer, one of the museum's most re-
nowned pictures.

In 1952, Rockefeller discussed with Rorimer the future of his beloved
museum. He considered leaving The Cloisters $1 million, then $5 mil-
lion, but he finally opted for a $10 million trust fund, to be used "for the
enrichment of The Cloisters in the broadest sense of the term and for the
preservation, housing and presentation of its collections."

The Cloisters continues to be, in Brooke Astor's words, among New
York's "crown jewels." It fortunately cannot grow in size, and retains its
intimacy, but it continually seems to acquire exceptional treasures. Its gar-
dens, cloisters, galleries, and chapels emanate serenity and spirituality, in
a world that desperately needs them.

The Cloisters is beloved not only by the public but also by profession-
als. Shortly after it opened, Germain Bazin, the director of the Louvre, de-
scribed it as "the crowning achievement of American museology." Other
curators are equally enchanted, considering The Cloisters the most perfect
museum of the twentieth century. As Calvin Tomkins, historian of the
Metropolitan Museum of Art, states, "The creation of this paragon among
museums is also, perhaps, the supreme example of curatorial genius work-
ing in exquisite harmony with vast wealth."[40]

Colonial Williamsburg and the Abby Aldrich Rockefeller Museum of American Folk Art

IN 1924, JOHN D. ROCKEFELLER, JR., attended the annual meeting of Phi Beta Kappa in New York. He was the chairman of the committee engaged in raising money for a memorial hall on the campus of the College of William and Mary, where the honors society had been founded in 1776. The Reverend W.A.R. Goodwin, pastor of the Bruton Parish Episcopal Church in Williamsburg, gave the keynote address. He talked about his dream of restoring Virginia's old colonial capital to its former glory.[1] Goodwin struck up a friendship with Junior and invited him to visit Williamsburg. Junior did so in 1926, and returned that same year to attend the dedication of the new hall.

Earlier, in 1907, Goodwin had restored Williamsburg's badly neglected Bruton Parish Church and had fantasized about doing more. At the time, he had tried to interest Henry Ford and J. P. Morgan in his venture, but failed. Now, some twenty years later, he was happy to show the Rockefellers the remnants of the once-flourishing town. Junior, a history buff, was much interested.

During that visit the party stopped at Bassett Hall, a charming, some-

what derelict eighteenth-century clapboard building. Rockefeller, who loved trees, was taken with the giant oak that shaded the backyard and said that if he ever came back he would enjoy picnicking under it. During the visit, Goodwin talked about the possible restoration of the town. After his return to New York, Rockefeller informed Goodwin of his willingness to fund preparatory architectural plans for the project. He hinted that he might be willing to buy individual properties that would prove important in the future.

Though Junior had insisted that his commitment was limited, he soon immersed himself in the restoration project, eventually spending more than $66 million. As in the case of James Breasted and his Near Eastern excavations, Rockefeller had been captivated by another man's dream.

The first property Junior acquired was the relatively well preserved Ludwell-Paradise House. Thereafter, Rockefeller bought much of the rest of the old town. In order to keep real estate prices within reason, purchases were made in the name of "Mr. David." Both Junior and Abby became engulfed in the renovation. He delighted in resurrecting the governor's mansion, the capitol, taverns, shops, the town jail, and old thoroughfares. Ably supported by Abby, he concerned himself with all the decoration of the restored buildings. "In my father's house there [is] a four poster rosewood bed," Junior wrote to Williamsburg's chief architect in 1935, which "might be useful in one of the bedrooms of the Governor's Palace." The Rockefellers shopped for appropriate Colonial-era furniture in London and Boston, and Abby even had Frances Paine, her Mexican contact, buy items that might have originated in Mexico or the West Indies.[2] Abby personally added small touches to the guesthouses of the restoration. In particular, she supervised the building of a first-class hostelry that was to house the increasing number of tourists.

GOODWIN'S GOAL WAS to memorialize Colonial America. At about the same time, Hamilton Easter Field, a wealthy New York art patron, founded the seasonal Ogunquit School of Painting and Sculpture on

Maine's spectacular seacoast.[3] To lodge the participants, Field acquired a series of old fishing shacks. They were simply furnished, except for their decoration of decoys, weathervanes, hooked rugs, and paintings, which Field had bought at local auctions and in junk shops.

By 1920, Field's colony was flourishing. Regulars included Marsden Hartley, Stefan Hirsch, Bernard Karfiol, Yasuo Kuniyoshi, and the William Zorachs, each paying seventy-five dollars a season for their lodging. Most would eventually become Abby Rockefeller's protégés; Robert Laurent and William Zorach contributed sculptures to Radio City Music Hall.

Robert Laurent was so taken with Field's décor that he became an important early collector of what were then referred to as "American Primitives." Fifteen years later Bernard Karfiol, adopting a folk art style, would paint *Making Music*, a view of Laurent's living room. It depicted Laurent's sons playing an accordion and a lute, *The Dover Baby* and *The Child with Kitten* hanging on the wall. Both *Making Music* and the *Dover Baby* are now part of the Abby Aldrich Rockefeller collection in Williamsburg.

Field died in 1922, and Robert Laurent inherited his entire estate, including the fishing shacks in Maine, which he continued to rent to members of the art colony. In 1925 he welcomed Samuel and Edith Halpert. A year later Holger Cahill, who was romantically involved with Halpert, accompanied them. Edith became so enchanted by the colony's folk art décor that she displayed and sold it at her Downtown Gallery, which she was then in the process of opening.[4]

Actually, Halpert's was not the first gallery to market American folk art. In 1924, Boston's Isabel Carlton Wilde had bought *The Grapevine*, an intricate painting on velvet consisting of bunches of grapes intertwined with their stems, leaves, and tendrils. At first Wilde mistook the painting for a Far Eastern work, but when she realized it was American, she was enchanted and searched out other examples of American folk art. Eventually *The Grapevine*, too, entered Abby's collection.[5]

There were good reasons for Abby to become a folk art enthusiast, though her folk art collection might never have come into existence

without Edith Halpert's drive and boundless energy, and Holger Cahill's growing expertise. Abby was proud of her New England roots and partial to American antiques. In 1903, during her very first trip with the senior Rockefellers, she had dragged her new husband to antiques stores in New Orleans, where he was a bit puzzled by his wife's enthusiasm for what looked to him like "old furniture." The young couple took a side trip to Mexico, where the dramatic landscape and the country's flamboyant culture, including the art that had survived the Conquistadors and the contemporary folk art, enchanted Abby.[6]

As in the case of contemporary art, Abby's casual interest rapidly changed into a serious commitment, and since she was Mrs. Rockefeller, it added enormous weight to the popularization of the medium. As with her other collections, experts were astonished by Abby's unfailing eye and growing expertise. As Carolyn Weekley, a former director of the Williamsburg museum, observed, Mrs. Rockefeller chose many works by Edward Hicks, Ammi Phillips, "The Beardsley Limner," and certain anonymous artists long before their work acquired the label of masterpieces.[7]

Abby was aware of the parallel between the simplicity, boldness, distortion, and primary colors of the folk art painters and the works of contemporary European and American artists she had started to collect. She may even have found a kinship between the American folk art and the early, unsophisticated "Italian Primitives," with their still-uncertain perspective, which she and Junior collected during the early part of their marriage. Finally, the informality, gaiety, and directness of folk art certainly appealed to this cheerful woman. Thrifty by nature, Abby enjoyed buying inexpensive, out-of-favor art. Also, her interest in folk art fit Junior's fascination with Colonial Williamsburg. Even though most American folk art postdated the glorious days of Colonial Williamsburg, both were intimately related to the history of the United States. As son Winthrop would write in 1959 in the preface to *American Folk Art*, "Few if any, of my mother's many interests gave her more pleasure than her collection of American folk art, and none, I think, more clearly demonstrates her deep pride in the cultural life of the American people."[8]

Once enthused, Abby pursued her new interest with vigor, and whenever part or all of her collection was on view, it was highly praised. Aware of the public's growing interest, Halpert had added a special gallery for American folk art to her main establishment. She preferentially selected works because of their relationship to contemporary American art, and not because of their historical significance.[9] Selling folk art became lucrative; in fact, it carried the Downtown Gallery during the Depression, when sales of contemporary art lagged.

To find suitable merchandise, Halpert bought an old station wagon and combed New England, New York, and Pennsylvania during the summer months, when her gallery was closed. Wearing frumpy, unfashionable clothes, she rang the doorbells of unsuspecting farmers, often wangling an invitation to inspect their attics, where she unearthed neglected family heirlooms. According to biographer Lindsay Pollock, she once convinced a dairy farmer to trade a rare deer weathervane for a cow weathervane she had bought earlier that day.

Halpert's correspondence with Abby illustrates her tenacity and conscientiousness. In February 1933, for example, she wrote, "This morning I received a letter from the Albert R. Lee Company which reports that the statue [a photo of a cast-iron George Washington lawn figure was included] is in excellent condition and is now being cleaned of all paint." Halpert explained that she had been offered similar figures previously, which she suspected of being "clever" recast forgeries. "It is fortunate," she continued, "that we started [collecting] long before the present popularity of folk art, as many reproductions will appear in the market soon." As an afterthought, she warned that the *Minnehaha* statue Abby had recently lent to an exhibit in Philadelphia was very delicate and could not stand much traveling "even if handled very carefully."[10]

Abby's folk art collection lacked works from the South, so she engaged Cahill to remedy the situation. He spent four months in the southern United States collecting folk art works to plug the gaps. Cahill located *The Old Plantation*, possibly dating from 1790 to 1800, one of the few works illustrating the life of African Americans during slavery. In Atlanta he se-

cured *The Portrait of a Merchant*, painted on August 16, 1836, by R. B. Craft, an itinerant portrait painter, or limner, working in Indiana, Kentucky, and Tennessee. The painting is a masterful portrait of a young gentleman sitting at his desk, quill in hand.[11]

Abby's selection criteria were aesthetic rather than historic or cultural. In addition to paintings and sculptures, her requests included artfully decorated objects and documents. The rapidly assembled joyous collection included more than four hundred different items. Between July and November 1931, the Rockefeller office paid the Downtown Gallery more than $22,000 for American folk art.[12]

THE ROCKEFELLER-CAHILL-HALPERT TRIO joined a select group of American folk art enthusiasts in that period. In 1923 the sculptor Elie Nadelman—whose work, posthumously, would be much beloved by Nelson Rockefeller—had begun buying folk art. The Nadelmans would spend half a million dollars on fifteen thousand objects. The couple exhibited their remarkable collection in a private museum located on their Riverdale, New York, estate. The Depression, however, wiped out the Nadelmans' fortune, and they had to sell their folk art. Fortunately, some of the choice pieces entered Mrs. Rockefeller's collection.

The founding of the American Wing at the Metropolitan Museum of Art in 1924 demonstrated that the country was starting to appreciate the furniture and furnishings crafted by its ancestors. That same year, Juliana Force, the founding director of the Whitney, organized a folk art exhibition at the Whitney Studio Club. The next notable exhibition consisted almost entirely of Robert Laurent's collection, including the famous *Dover Baby*. A facetious newspaper article suggested that the picture "should certainly be given a place of honor" in the Met's American Wing, but the writer continued, "*The Dover Baby* is, I think, much too alive to be condemned so young to a museum. Even in Mr. de Forest's new wing he wouldn't, I fear, be entirely happy."[13]

Aware of contemporary trends, and to mark the Massachusetts Tercen-

tenary, the Harvard Society for Contemporary Art organized a folk art show in 1930. Lincoln Kirstein's catalogue defined folk art as "springing from the common people . . . in essence [being] unacademic, unrelated to established schools, and generally speaking anonymous."[14]

Almost simultaneously, *American Primitive Paintings*, a comprehensive exhibition curated by Holger Cahill, opened at the Newark Museum. The first art historian to champion the Ashcan artists, Holger Cahill had now rallied to the cause of the art produced by untrained, long-forgotten men and women. His knowledgeable and unaffected catalogue is still considered one of the best texts on the subject:[15]

> The word primitive is used to describe the world of simple people with no academic training and little book learning in art . . .
> Up to the nineteenth century there were not many professional artists in this country. People who cared for pictures had to depend on occasional artists. Their needs were supplied by house and ships' painters, coach and carriage and sign painters, and itinerant limners of portraits who turned their hands to painting shop and tavern signs when the portrait business was dull.

Lenders to the Newark show included Robert Laurent, Elie Nadelman, William Zorach, Isabel Wilde, and Abby Rockefeller, whose ten paintings were lent anonymously. Surprisingly, the exhibition included contemporary folk art: two paintings by Joseph Pickett, a New Hope, Pennsylvania, grocer who had taught himself to paint in his old age. The show was so popular that it traveled to other museums.

Within the year, Cahill mounted *American Folk Sculpture* in Newark.[16] The catalogue pointed out that most likely the earliest examples of American sculpture were ships' figureheads and weathervanes, followed by cigar store Indians, which Cahill deemed inferior. The exhibition included flocks of wildfowl decoys "made by hunters, village whittlers, carpenters, blacksmiths and professional decoy carvers in every section of the United States where there is bird hunting." More than half a century later, Abby's

grandson Steven C. Rockefeller would found a small museum for Wendell Gilley, a plumber turned bird carver, in Southwest Harbor, Maine.

In 1932, during Alfred Barr's sabbatical, Cahill, then MoMA's acting director, suggested mounting a comprehensive folk art exhibition there. Abby Rockefeller loaned every item except one. To promote the exhibition, Conger Goodyear urged her to allow the use of her name. Publicity-shy, Abby hesitated and asked Nelson for his opinion. Her letter is the first indication that the Rockefellers planned to donate the folk art collection to an initially reluctant Colonial Williamsburg, because the former's apogee postdates America's life as a colony.[17]

July 16, 1932

Would you be good enough to let me know how you feel about this? Mrs. Halpert is opposed to it because she hopes to go on selling me things. She thinks that the minute it is known that I have a collection the price of Early American things will go up. I don't see how they could go up any higher than she puts them . . . Alfred Barr is rather opposed to my having my name used for reasons unknown to myself. I, on general principles, seem to dislike any kind of personal publicity but if you and Mr. Goodyear want me to I shall be perfectly willing . . . because I feel that having it exhibited in New York will enhance its value in the eyes of Williamsburg and also . . . of the public generally when it goes there.

American Folk Art: Art of the Common Man, 1750–1890, which opened during the 1932/33 winter, was the first public viewing of Abby Aldrich Rockefeller's extensive collection. *The Baby in Red Chair*, which so prominently appeared in the photos of Abby's private gallery, opened the exhibit. Elsewhere hung *Child with a Woodpecker*; *Mr. and Mrs. Harrison*, he wearing a uniform and holding a sword; *Pocahontas Saving Captain John Smith*; and Edward Hicks's *Peaceable Kingdom*. Portraits of children in their Sunday best far outnumbered those of stately looking adults. To the many unfamiliar with folk art, the exhibition was a revelation of the charm and whimsical

Reuben Law Reed, Washington and Lafayette at the Battle of
Yorktown, *1860–80.* (Courtesy of the Abby Aldrich Rockefeller
Folk Art Museum, The Colonial Williamsburg Foundation)

nature of the school. The public and critics responded enthusiastically. Mc-
Bride, reporting in the *New York Sun* of December 15, 1932, wrote:

> These extraordinary objects of art are as different as can be, the one
> from the other, but all are alike in springing, untaught and carefree,
> from a culture that was in the making. . . . It is impossible to regard
> them even casually as one is apt to do in museums, without a nostalgic
> yearning for the simple life that is no more.

Cahill's masterful catalogue[18] again became a seminal work in the
field. Instead of *primitive,* he now used the term *folk art,* believing that it
was the best word to describe the artifacts made by

> the strong personalities thrown up from the fertile plain of every-day
> competence in the crafts . . . it is the expression of the common people,
> made by them and intended for their use and enjoyment . . .
>
> [It] is the unconventional side of the American tradition of the fine
> arts . . . It is a varied art, influenced from diverse sources, often frankly

derivative, often fresh and original and at its best an honest and straightforward expression of the spirit of a people. This work gives a living quality to the beginnings in the story of American beginning in the art, and is a chapter . . . in the social history of this country.

When *Art of the Common Man* finally returned to the Rockefeller residence from its tour of six American cities, Abby realized that she did not have enough space to accommodate the collection. Junior asked Kenneth Chorley, then-president of Colonial Williamsburg, whether the foundation would be interested in owning the collection. Junior's impatience can be gleaned from a memo that reads in part, "If the collection goes to Williamsburg, I think the sooner Mrs. Rockefeller gets it out of the house, the sooner she will be relieved of the constant thought and planning . . . which its presence [at 10 West Fifty-fourth Street] involves."[19]

Anonymous, Baby in Red Chair, *1810–30.* (Courtesy of the Abby Aldrich Rockefeller Folk Art Museum, The Colonial Williamsburg Foundation)

In 1935 the folk art was loaned to Williamsburg for exhibition in the Ludwell-Paradise House. Abby, assisted by Edith Halpert, installed it personally. Some of the paintings were loaned to other Williamsburg houses, and some went to Bassett Hall. In 1939, Mrs. Rockefeller converted the loan to a donation.[20]

Not all of Abby's folk art treasures went to Williamsburg. Mrs. Rockefeller donated fifty-four paintings to MoMA, which later shared the gift with the Metropolitan. This transaction included such favorites as the *Baby in Red Chair* and one of Hicks's versions of *Peaceable Kingdom*. Later David Rockefeller was able to buy some of these works and reunite them with the bulk of the collection in Williamsburg. Other works went to Dartmouth College and the Newark Museum.

IN 1956, EIGHT years after Abby's death, Junior decided to house his wife's collection in a newly built museum located outside Williamsburg's historic district. Nelson, Laurance, and Winthrop attended the 1957 opening festivities for the Abby Aldrich Rockefeller Folk Art Museum, which included a dinner for sixty. Kenneth Chorley, then heading the Colonial Williamsburg Foundation, wrote to Junior that Winthrop spoke very beautifully about his mother's interest in folk art, which he said "was largely brought about by her great love of human beings." Then, Chorley continued, Laurance "in that charming and simple manner of his . . . also remembered of his Mother in the most moving way and ended his remarks by proposing a toast to her." [21]

Forever thoughtful of the institutions he endowed, Junior was concerned about the future of the Folk Art Museum. In 1957 he asked Kenneth Chorley for recommendations regarding future acquisitions. Chorley ascertained that the greatest strength of the collection were nineteenth-century portraiture, sculpture, and "schoolgirl" paintings. On the other hand, eighteenth-century portraiture; calligraphy; marine, genre, and landscape paintings; and the "architectural" panels typical of nineteenth-century dwellings were comparatively weak. To remedy the situation he

recommended Edward Hicks's *The Leedom Farm* ($25,000) and two companion portraits by J. Brown of *Mr. and Mrs. Calvin Hall* for immediate purchase. Junior must have acquiesced, because these items now are showpieces of the museum. Finally, Chorley suggested an endowment fund yielding about $20,000 to $25,000 annually.[22] The fund Junior allocated was large enough for the museum to acquire one hundred items during the first year of its operation.

The Abby Aldrich Rockefeller Folk Art Museum was the first institution to be devoted entirely to folk art. It owns a large number of works by Edward Hicks, Joseph H. Hidley, and Ammi Phillips, and from the Prior-Hamblin school, and the watercolor and ink *Sketch Book of Landscapes in the State of Virginia*, drawn over a period of fourteen years (1853–67), by Lewis Miller, a talented carpenter-artist. Some of the detailed drawings, enhanced by handwritten text, provide a rare glimpse of the life of African Americans prior to the Civil War.

The Folk Art Museum stayed in its pleasant brick building until 2004, when it moved to the refurbished and expanded Public Hospital, reputed to be America's first hospital for the insane. The dingy hospital quarters, left as they were two hundred years ago, contrast with the refurbished airy galleries housing Abby's greatly expanded collection. She had left Williamsburg 424 pieces of folk art. By 2007, it owned 5,000 paintings, sculptures, carvings, textiles, metalware, furniture, pottery, and miscellany.[23] The museum's collecting philosophy adheres to that followed by Mrs. Rockefeller. Most items date from the late eighteenth through the nineteenth century, but the collection also includes contemporary works. All capture the spirit of people from widely different backgrounds growing into one nation, then being torn apart by a bloody civil war, and then slowly recovering from the rift.

The objects on display relate to everyday life and its pleasures. As illustrated by a large weathervane of *Lady Liberty Enlightening the World*, created by an anonymous New Yorker and dating from 1900 to 1910, many folk artists celebrated America. The portraits depict people who look as if they had attained a comfortable lifestyle, and it had been falsely as-

sumed that their fine accoutrements were supplied by the limners who painted them spent the winter months preparing stock pictures—bodies clad in fine clothes against lavish backgrounds—from which their clients selected one that suited their fancy.

The portraits, so crucial before the advent of photography, fill several galleries. They include *Baby in Red Chair*; *The Boy with Finch*; the twin portraits of *Mr. and Mrs. Pearce*, attributed to Erastus Salisbury Field; *A Young Boy in a Green Suit*, carrying books, attributed to "The Beardsley Limner"; and *Mrs. Russell Dorr* stiffly holding *Mary Ester Dorr*, who looks like a wooden doll. Particularly pleasing is a picture of *Deborah Glen* in a flowered dress and about to add a rose to the wreath she is holding. A portrait of Deborah's formally dressed fiancé is on an adjoining wall.

As opposed to that young couple, *Mr. and Mrs. Jonathan Jaquess*, by Jacob Maentel, are way past middle age. He is pointing to a many-masted sailboat flying the American flag; she is clutching her glasses—a status symbol. The glasses are on a string, presumably to be worn around her neck: a reminder that absentmindedness and its remedy do not necessarily change with time. The delicate *Deborah Richmond* is all in pink lace, wearing an elaborate pink hat. A schoolteacher, she looks extremely frail; she died, unmarried, when she was thirty. The fan she holds is also in the museum's collection.

Other major categories of works include landscapes, seascapes, and story pictures. According to the catalogue, a self-confident *A. Dickson, Entering Bristol in 1819*, by Alexander Boudro, has "long been recognized as a folk art masterpiece." The wild-eyed, white stallion and his black-clad, top-hatted rider dwarf the Bristol Township Inn, which in turn towers over the rest of the landscape. The picture of *Washington and Lafayette at the Battle of Yorktown* shows America's first president astride a white stallion, while his French ally rides a brown one.

The museum owns several versions of Edward Hicks's *Peaceable Kingdom* and his *William Penn's Treaty with the Indians* and *The Residence of David Twining, 1787*. The Twinings raised young Edward Hicks as one of their own children, and later in life he recalled growing up on their farm

as the happiest period of his life. He paints himself in the foreground as a small child being read to from the Scriptures by Mary Twining. A group of peaceful farm animals is also listening.

The Old Plantation, collected by Holger Cahill on his trip "down South" in 1935, is often on view. It dates from 1795 to 1800 and shows slaves dancing and making music. Charles J. Hamilton's *Charleston Square*, with its top-hatted white men, foursome of horses pulling a covered wagon, and African Americans carrying fruit-filled baskets on their heads, is another one of Cahill's southern finds. In *The Quilting Party*, old and young women stitch a huge quilt spread on a table. Not everyone sews: one couple dances, and a white-haired gentleman holds a baby. The design of the quilting party was not original, but based on a print that appeared in *Gleason's Pictorial*, a popular magazine, on October 21, 1854.

Folk art sculptures created by cabinetmakers, carpenters, shipbuilders, blacksmiths, stonecutters, and other craftsmen or amateurs are distributed throughout the galleries. The museum owns scores of weathervanes depicting horses, sheep, roosters, butterflies, Indians, and even the aforementioned deer Edith Halpert collected in Pennsylvania. A broadside, dating from 1889, advertising factory-made weathervanes presages America's future.

The *Hippocerous*, a fanciful mix between a hippopotamus and a rhinoceros, is the centerpiece of the Music Room. Upon request, its concealed gramophone plays "Animal Crackers in My Soup." Other old-fashioned instruments include dulcimers, African musical instruments, and a fiddle made from a turtle.

Animals are emphasized in the young visitors' gallery. An Edward Hicks painting is paired with contemporary folk artist Mary Lou O'Kelley's tale of *Prince*, a city dog who wanders from farm to farm looking for his country cousins.

IN 1927, WHEN Junior bought much of old Williamsburg's real estate, he also acquired, for his own use, Bassett Hall, whose yard held the great

oak he had admired on his first visit. The current occupants were granted life tenancy, but after a fire destroyed much of the interior, they vacated the house in 1930. Junior told Abby "that she could have the house if she promised not to take in tourists."[24] Renovation took a while; the Rockefellers did not occupy Bassett Hall until 1936. Compared to their other abodes it was tiny, but the family did not exactly rough it.[25] They had discreetly added a wing accommodating three new bathrooms, a dining room, and servants' quarters. Junior happily tamed the property's six hundred acres of woodland with allées, walks, and vistas, as he had done on a larger scale at Forest Hill, Pocantico Hills, and in Maine. Abby was in charge of the fourteen acres adjoining the house, planting boxwood and flowers so chosen that they bloomed during the Rockefellers' stays in the spring and fall.

Today Bassett Hall, carefully restored in 2006 by Abby O'Neill, Junior and Abby's eldest granddaughter, is cozy. In furnishing this Colonial home, as always Abby followed her own taste rather than slavishly adhering to any particular period. She was extremely conscious of scale. An eclectic mix of furniture, gathered from her girlhood home in Providence and from other Rockefeller houses, fills two average-size living rooms on the ground floor of the house.

Bassett Hall, the Rockefeller home in Williamsburg, Virginia.
(Courtesy of The Colonial Williamsburg Foundation)

In the "Morning Room," a Georgian sofa keeps company with conventionally upholstered armchairs. Junior's Turkish prayer rugs cover the wide-plank hardwood floor. An Aubusson rug covers the floor of the slightly more formal parlor. The rooms are rather simple, giving the impression that the home belonged to a comfortable middle-class family rather than to America's richest man.

The dining room was Abby's favorite. It, too, is rather small and has a low ceiling. A table extended to seat eight almost fills it. It is set with fancy china, and in her letter of June 8, 1935, to Lucy, Abby requested that she buy more:

> I'm delighted to hear that shopping is so good in England this year.
> Do buy some more fascinating things for the table. John enjoys so
> much having me change the table decorations. Both he and the chil-
> dren seem to love china and he is very much interested in whatever
> we put on the table, as it seems to give him pleasure.[26]

Abby contributed her own needlework and bought quilted, knitted, and crocheted bedspreads at a local crafts exhibition. Everything was carefully color-coordinated. The upstairs bedrooms are simply furnished. A large wooden chest sits in the hall that separates the two rooms facing the street. It is elaborately carved and equipped with ornamental brass hardware. It was especially dear to Abby. As she wrote to her brother Stuart Aldrich on October 23, 1936:

> I have been carefully going over this house to find pieces of furniture
> that seem worthy of Williamsburg and which would be useful and
> appropriate as well. I have decided to take down there the beautiful
> chest that you made for me and gave me as a wedding present. It fits in
> perfectly with the Georgian and early American furniture and I shall
> be very proud to show it to my friends as having been . . . carved by
> you. Please accept for a second time our most grateful appreciation.[27]

Abby stuffed Bassett Hall with 125 pieces of art, most of it folk. The portrait of a serious little girl dressed in silk taffeta and cuddling a large brown tabby cat hangs over the fireplace. Considered to be Bassett Hall's best work of art, it is attributed to "The Beardsley Limner." There are, however, many other delights, some, such as an embroidered view of St. Joseph's Academy, stitched by an unknown schoolgirl. There is Chinese export ware, which was imported by well-to-do burghers in Colonial times. Six exquisite Chinese reverse paintings on glass decorate the entrance hall; the subjects have Oriental facial features but wear elaborate Western-style clothes.

In 1935, Abby asked Charles Sheeler, one of her favorite contemporary artists, to visit Bassett Hall. He took 130 photographs and painted portraits of the place, and of the Governor's Palace, including its kitchen. (Blanchette Rockefeller, John 3rd's wife, donated the kitchen painting to the Fine Arts Museums of San Francisco.)[28] Sheeler rendered the old furniture, copper pots, and cake pans of his *Kitchen, Williamsburg, 1937*, as precisely as his much-admired views of factories and railways.

The mantelpieces throughout Bassett Hall are laden with a variety of color-coordinated objects. Chalkware and porcelain figures fill two corner cabinets in the Morning Room. Two larger folk art figures are placed atop the cabinets. A room on the second floor, referred to as Mr. Rockefeller's Room, is decorated with American historical images, including *George Washington Crossing the Delaware*, and a view of Mount Vernon, the first president's home.

The somewhat artificial old-fashioned, down-to-earth environment of Williamsburg, and the relative simplicity of the house, might be one of the reasons why both Junior and Abby considered Bassett Hall their favorite home.[29] Abby's letters from Williamsburg are rather rhapsodic. In November 1945 she wrote to her sister:

I am sitting in the most beautiful sunshine, listening to a mocking bird. John [3rd] and Blanchette are arriving late this afternoon to

spend three or four days with us and then on Monday Winthrop and Nelson are coming down to stay until Friday. Now that they are more or less their own bosses, they all seem to have a desire to come down here, which of course pleases John and me enormously. Sometime after the wedding David and Peggy are coming down.[30]

IN 1960, AFTER Junior's death, his Williamsburg neighbors organized a memorial service under the Great Oak at Bassett Hall. Raymond B. Fosdick, his friend, biographer, and a former head of the Rockefeller Foundation, spoke of the man he had grown to love. In his biography of Junior he had described that during his later years he had grown particularly fond of Bassett Hall.

> Here, surrounded by the details of a vast project, he found the satisfaction of creation, of being a part of one of his great dreams. . . . [This] community was in a real sense a home . . .

Fosdick went on to quote what Junior had written to the *Richmond Times-Dispatch* on December 7, 1941.

> Sunday Mrs. Rockefeller and I sat in front of the post office and watched the people passing by. We often do that. And we like to walk home from the movies at night. We look . . . at the moon and the stars . . . I really feel that I belong in Williamsburg.[31]

This sentiment echoes Junior's recollections about his college days at Brown, where he was simply "Johnny Rock," a student among many, and it illustrates how burdened this shy man felt by the responsibility of his great fortune. Junior willed Bassett Hall to John D. Rockefeller 3rd, the son who resembled him most. John D. 3rd and Blanchette enjoyed the house. Upon John's death, the house was left to the Colonial Williamsburg Foundation, which opened it to the public.

9

MoMA Under Nelson A. Rockefeller's
Stewardship, 1939–69

I T WAS A given that Nelson Rockefeller would play a major role in shaping "Mother's Museum." Indeed he assumed its presidency at its glamorous tenth birthday party, on May 8, 1939. The move had been engineered by Abby, who had become a simple member of the board so as to leave her thirty-one-year-old son room at the top. Partially necessitated by Abby's poor health, the reshuffling pleased Junior, who had always resented Abby's exhaustive involvement with MoMA.

AT THE TIME, Nelson, sometimes dubbed the "Imperial Rockefeller," was also busy using some of the money Junior had settled on him in 1934 to create his own lavish nest. It turned out to be so spectacular that sixty-seven years later, *Architectural Digest* featured it in its series "Historical Interiors."[1] Nelson had bought a large apartment at 810 Fifth Avenue, where Central Park provided the requisite Rockefeller view. Nelson asked Rockefeller Center architect Wallace Harrison to remodel the apartment, and Jean-Michel Frank, a leading French avant-garde decorator, to coordinate the art and furnishings. What Nelson jokingly called "the firm of Harrison and Rockefeller" created an elegant mixture of traditional and modern

in which eighteenth-century parquet flooring, purchased in France, and Rococo moldings harmonized with contemporary art.

At the time, many future artistic icons of the twentieth century were still establishing their reputations, and few artists could resist Nelson's genuine interest and admiration. Alberto Giacometti's brother, Diego, supplied one-of-a-kind lamps and other items. Gaston Lachaise, the sculptor best known for his amply endowed women, created fireplaces. Always partial to circular spaces, Harrison transformed Nelson's twenty-four-foot-square dining room into a round room, whose walls and ceiling Fritz Glarner covered with abstract murals in 1964.

Nelson and Tod were traveling while the apartment was being remodeled. During their absence, when Abby checked on the well-being of her grandchildren Roddy and Ann, she was profoundly shocked by the decoration of the apartment:

> I had to be nice when [Harrison] showed me your new living room with the Lachaise mantel in it . . . It seems to me that it threw the whole thing out of scale. He has introduced a mantelpiece, which is absolutely Victorian in outline, and when it is covered with the Lachaise figure, my own feeling is that nothing else in the room will count. Your furniture will look—in my humble opinion—as if it were having to associate with people it did not like. All the rest of the room I think is exceedingly attractive . . . Of course [I too] like to be different, but I see no point in sacrificing one's comfort and pleasure on the altar of originality . . . Mr. Harrison explained . . . that you were not committed in any way. That is why I am expressing myself so frankly. If it were absolutely settled I would say nothing but grin and bear it so to speak.[2]

Nelson did not listen to his mother and kept the fireplace murals and other works of art specifically commissioned for the apartment. In 1938 he acquired the apartment beneath the one he already owned, thereby increasing the space for displaying art. Harrison connected the two apart-

ments by a grand staircase and designed a large living room. The room had two fireplaces. For one, Matisse created a mural entitled *La Poésie*. Fernand Léger would decorate the other with an abstraction of plants and flowers. Nelson was so pleased with the results that he commissioned Léger to paint the stairwell.

Nelson was proud of his living room, shown on the dust jacket of *The Nelson Rockefeller Collection: Masterpieces of Modern Art*. In addition to the fireplace mural, two other oils by Matisse are visible: *View of Collioure and the Sea* and *The Italian Woman*. There also is a tapestry based on Picasso's *Pitcher and Fruit* and a standing bull by Elie Nadelman. Christian Bérard, the great French stage designer, made the rug that looks as if it were strewn with autumn leaves. Traditional furniture, including a large gilded console, makes the room look elegant and festive. Most of the art on view was eventually donated to MoMA.

Between his political aspirations, business interests, and active involvement with the arts, Nelson's schedule was backbreaking, but whenever he was in town, the morning routine resembled that established by his father. Nelson and his children assembled in his dressing room, which Steven Rockefeller recalled as being stuffed with pieces of art awaiting a permanent home. The family engaged in prayers, followed by pushups, before everyone went their separate ways.

In 1940, Nelson wanted a house of his own in Seal Harbor, Maine. When he and Harrison visited the site—a small rocky peninsula jutting into the sea—Nelson drew a curve in the soil, indicating the location of the picture window, and left the rest to the architect. The Anchorage is one of Harrison's most successful designs. Nestled amid rocks and pines, it is one with its surroundings. Its footprint consists of a giant curve, fronted by a porch. Every room has a view of the ocean and of the swimming pool carved out of Maine's ever-present granite. Even Junior, critical of modern architecture, complimented Harrison on his design.[3] Given all the windows, the Anchorage could not accommodate Nelson's growing art collection, and during the 1950s he asked Philip Johnson to transform an old coal wharf into a picture gallery, ideally suited to his collection of Abstract Expressionists.

By the late 1960s, Nelson and Tod's marriage was becoming increasingly strained. In 1965, in order to have a weekend home of his own, Nelson asked Harrison to build him a small retreat on the family compound in Pocantico Hills. Harrison came up with a small two-bedroom house, capped like a mushroom, with a shallow saucer-like roof. The curvature of the roof is repeated throughout the house. Large sliding windows provide a view of the pond, stream, rocks, trees, and ferns that surround the house. Nelson also maintained residences in Washington, Albany, and Venezuela, where he built himself a fabulous hacienda.

FOR NELSON ROCKEFELLER, as it was for his mother, art was a basic necessity. As his son Steven recalled in 2007:

> I remember that as a child I was aware of how much joy and pleasure my father got out of art. It was rest and relaxation for him. He loved to come home and arrange furniture and paintings. He was not interested in mastering art theory or the movements of art in history. He had a general knowledge he acquired from his friends at MoMA. But his real enthusiasm was his direct response to the art, and we children acquired from him a great appreciation of and delight in art.[4]

Buying art was Nelson Rockefeller's favorite pastime. His vast collections would include costly pieces of modern art, primitive and Hispanic art, and masses of inexpensive items picked at random. During the 1970s, for example, a small *New York Times* article, "Animals That Grew on the Farm," caught the eye of the then-governor of New York. Whimsical creatures assembled from farm implements by Heise and Zack, two Vermont sculptors, were on sale at B. Altman, the venerable Fifth Avenue department store. The customers who assembled at the store the following morning included Nelson A. Rockefeller, and in a matter of ten minutes he had bought numerous sculptures.[5]

Art historian Aline Saarinen distinguishes between people who collect

"pack rat" style and those dedicated to collecting specific things, thereby implying an involvement with the coveted objects. "Nelson Rockefeller," Saarinen writes, "was subject to both, and sometimes the [styles] overlapped."[6] He was, however, most committed to his collection of modern and twentieth-century art. Some collectors collect in anonymity and silence, but Nelson always wanted others to be aware of his activities, and of his reactions to art. In October 1939, shortly after he assumed MoMA's presidency, he explained to Holger Cahill, then hosting a CBS radio program, what art meant to him:

> I'm interested in art that relates to the life of our own day—that expresses the spirit of our own time—art that isn't cloistered and set apart—art that includes the house and the motor car . . .
>
> The true enjoyment of art is more than a vague and dutiful respect paid to the traditions of the past . . . [It is the pleasure felt] when we put a picture on the wall . . . What attracts me most about the art of our time is its vitality—the way it explores new possibilities and makes use of new materials.[7]

Soon after he graduated from college Nelson managed to intertwine his artistic acquisitiveness with his other activities. By the time he was twenty-four he was a member of the board not only of the upstart MoMA, but also of the venerable Met. He was involved with Rockefeller Center's art projects, and in 1935 he asked Abby to donate a major art collection to Dartmouth College, his alma mater. Although Nelson claimed that intuition and personal reaction played the dominant role in his selections, he also relied heavily on the know-how of friends and professionals. He trusted Alfred Barr, who was heavily involved in creating Abby's collection, but whereas she bought mostly prints, up-and-coming contemporary artists, and out-of-favor folk art, Nelson spent freely and often bought the work of established masters. Barr and Nelson liked and respected each other. In spite of their differences concerning the administration of MoMA, they spent hours talking about art and hanging and rehang-

ing Rockefeller's growing collection. Nelson admired the depth of Barr's scholarly background, combined with an extraordinary sensitivity; Barr appreciated Nelson's "insatiable appetite" and "the deep almost therapeutic, delight and refreshment" art gave him that "other men may find in music or alcohol."[8] Nelson also relied on the advice of Lincoln Kirstein; René d'Harnoncourt, who was instrumental in fostering Nelson's interest in both Mexican and primitive art; MoMA's assistant director Dorothy Miller; and Carol Uht, his private curator.

FROM AFAR, MOMA looked like a settled institution, but it continued to be in ferment. With an annual budget of $500,000 and an income of a mere $200,000, finances were a major concern. To reduce the shortfall, Nelson hired efficiency experts. He also fired a number of employees while Barr was in Europe assembling pictures for the forthcoming Picasso retrospective. The morale of the remaining (already overworked) staff fell to an all-time low, but they carried on as best they could.

Nelson's other measures were more successful. He was an excellent fund-raiser and established a publicity department, the first for any U.S. museum. He also developed a profitable museum store, which sold art-related materials, and an upscale design store. He appointed Monroe Wheeler director of publications, and the museum's many books, initially often written by Alfred Barr, not only garnered citations from the American Institute of Graphic Arts but were also income producing. In 1945, for example, the museum would sell fifty thousand books, twenty-two thousand color reproductions, and seventy thousand postcards.[9]

ARTISTICALLY, IN SPITE of its financial difficulties and the instability of the world during the Second World War, MoMA continued to shine. The *Picasso: Forty Years of His Art* exhibition opened on November 15, 1939, ten weeks after war erupted in Europe. Barr had been working on a major Picasso retrospective since 1931, but it had been repeatedly postponed, par-

tially because it was extremely expensive to mount. It finally came about when the Art Institute of Chicago agreed to share costs. For the opening, Barr wrote his landmark *Picasso: Forty Years of His Art.*

The centerpiece of the Picasso exhibition was *Guernica*.[10] The Spanish Republican government had commissioned the country's greatest painter, the expatriate Picasso, to create a major work for the Spanish Pavilion at the 1937 Paris World's Fair. Picasso had procrastinated.

On April 26, 1937, German planes dropped high-explosive bombs on Guernica, a sleepy Basque town. Sixteen hundred civilians were killed or wounded. Less than a week later, Picasso started sketching an enormous mural. Few viewers fail to respond to the horror of the dismembered, braying horse, the head of the bull, the screaming child, the woman with the raised arms, the gaping mouth with its conical tongue, or the dismembered foot, heads, and limbs. Echoing the impact it had on many viewers, Nelson Rockefeller described the work as "one of the great revolutionary paintings of our times . . . It's a social commentary."[11]

The painting had toured widely to raise money for the Spanish refugees. In 1939, *Guernica* arrived in America, where Picasso entrusted it to Barr, his friend and champion, and to "his" museum, where it stayed for more than forty years, until it could be given to a democratic Spain. In 1981, on the hundredth anniversary of Picasso's birth, *Guernica* finally arrived in the painter's homeland, at the Museo Nacional Centro de Arte Reina Sofia, in Madrid.

World War II, which by 1940 had engulfed most of Europe, landed two unexpected exhibitions on MoMA's doorstep. The first of these involved Italian masterpieces that had been exhibited at the San Francisco World's Fair in 1939. On the return voyage the pictures stopped in New York before having to cross the mine-infested Atlantic. The twenty-eight pictures included works by Botticelli, Donatello, Titian, Raphael, Fra Angelico, Michelangelo, and Bellini. Because the insurance premium for them was so high, the Met had refused to mount the exhibition, and MoMA took up the challenge. It turned out that the exhibition was an unexpected, much welcome, moneymaker.[12]

The other show, entitled *Twenty Centuries of Mexican Art*,[13] had been assembled in Mexico for the Jeu de Paume Museum in Paris. World War II precluded its European trip, and five thousand objects, including pre-Columbian, Colonial, folk, and contemporary art arrived in New York packed in three railway freight cars guarded by two Texas cowboys. MoMA's garden was transformed into a Mexican marketplace, its auditorium into a concert hall filled with Mexican music. By then the fame of the museum was such that Miguel Covarrubias painted a cartoon for *Vogue* that included everybody who was anybody in the art world—Abby Rockefeller, her son Nelson, Stephen Clark, Alfred Barr, A. Conger Goodyear, Paul Robeson, Edsel Ford, and forty others—attending the opening of the show. In the accompanying article, Frank Crowninshield wrote that "the success of this exhibit with its dual flavor of ancient and modern, Indian and Hispanic, sacred and profane, has been as immediate as its influence has been immense."[14]

For the occasion, using money from the Abby A. Rockefeller Fund, MoMA commissioned a large, six-paneled fresco from José Clemente Orozco. The abstract, somber-colored *Dive Bomber and Tank* is filled with a jumble of bombs, aircraft parts, tank treads, heavy chains, and human legs. The painting elicits the same mix of horror and admiration as Picasso's *Guernica*. Ironically, Orozco insisted that his fresco had no political significance. "I simply paint the life that is going on at the present. What we are and what the world is at the moment. This is what modern art is."[15]

THE WAR CREATED an influx of art. Pictures that had been loaned to American museums could not be returned. Scores of avant-garde, Bauhaus, and Jewish artists had to be rescued from Hitler's clutches. They begged for visas, jobs, and money. The Barrs, aided by Abby Rockefeller and others, tried to provide all three. Marga Barr especially was instrumental in writing letters, finding sponsors, and obtaining and paying for passage for the many who contacted the museum. The Emergency Rescue Committee masterminded the operation. One of the artists so saved was

Marc Chagall, who decades later did the magic stained-glass windows at the Union Church in Pocantico Hills. He was one of the last endangered artists to leave Europe.[16]

In September 1941, Barr sent a pamphlet issued by the rescue committee to Mrs. Rockefeller noting that the museum had raised money for the committee, to which she had contributed generously. Barr wrote that "several of the artists about whom we were most concerned are now safely in this country, including André Masson, Marc Chagall, Jacques Lipchitz, and Max Ernst." Barr hoped that Kandinsky, Pierre Roy, and Hans Arp would soon follow.[17]

HIS FIRST TRIP to Mexico in 1933 had kindled Nelson Rockefeller's fervor for Latin America, which became as important to him as Asia was to John D. 3rd. Nelson loved the vibrancy of the Hispanic culture, its art, music, and languages. His children remember going with him to markets and engaging in the haggling that was such an important part of the experience.

Nelson's knowledge of Latin America had brought him to the attention of President Franklin D. Roosevelt. In 1941, after he moved to Washington, Nelson resigned MoMA's presidency for the duration of World War II. Still, in 1942, he established MoMA's Inter-American Fund and gave it $26,000 to buy artworks in Latin American countries. Alfred Barr, Lincoln Kirstein, and philanthropist Edgar Kaufmann happily spent the money in South America, Cuba, and Mexico. They came back with about two hundred "bargain" pictures and sculptures, in whose selection, Barr felt that he had not applied the same high standards he used to evaluate European works.[18]

MoMA mounted many war-related exhibitions. In 1941 it sponsored a competition entitled *Posters for National Defense*, and followed it by an exhibition entitled *Britain at War*. The *Daily Worker*, a Communist newspaper, even praised a photographic exhibition entitled *Road to Victory*. Servicemen were admitted free of charge throughout the war. Hundreds of

American, British, and French soldiers attended parties, dances, and concerts in the museum's garden and enjoyed refreshments distributed by a Salvation Army canteen.[19]

In 1944, believing in the healing power of art, Abby, aided by Stephen Clark, founded and financed MoMA's War Veterans' Art Center. It offered classes in drawing, painting, ceramics, woodwork, book illustrations, jewelry making, metalwork, and weaving to anyone who had served in the U.S. Armed Forces. The three-hour workshops met once or twice weekly and lasted three months. The Center became so popular that there was a waiting list for admission. During its four-year existence, it served 1,485 veterans. On occasion, Abby herself visited and enjoyed meeting the men who were recovering from physical wounds, battle fatigue, or shock.[20]

Directly and indirectly, World War II swelled MoMA's permanent collection. Refugees and artists who arrived in America were usually short of cash and willing to sell their art inexpensively. The Nazis had confiscated from German museums and collectors about ten thousand works of art that they considered degenerate. Most of these were burnt in the courtyard of Berlin's main fire station, but about seven hundred works ended up at auction in Lucerne, to be turned into foreign cash. There was considerable discussion among art dealers as to whether it was ethical to buy these works. MoMA bought several important works of art through the good offices of the Buchholz gallery in Paris. These included Ernst Ludwig Kirchner's *Street Scene*, Wilhelm Lehmbruck's *Kneeling Woman*, Paul Klee's *Around the Fish*, and Matisse's *Blue Window*.[21] At Barr's request Philip Johnson purchased Oskar Schlemmer's *Bauhaus Staircase* when it was expelled from a show at the Stuttgart museum and gave it to the museum in 1942. He paid $500. Alerted by Barr, Abby bought Max Beckmann's *Family Picture*, for under $100, from the same show and gave it to MoMA in 1935.[22]

JOHN HAY WHITNEY assumed MoMA's presidency after Nelson resigned. A few months later, Whitney, too, went off to war and Stephen

Carlton Clark became both the president of the museum and the chairman of its board. Abby Rockefeller ably assisted the overburdened museum executive. Since its founding thirteen years earlier, the museum had grown beyond anyone's expectations. Stephen Clark later described to Mary Ellen Chase the tasks he and Abby encountered:

> In undertaking the management of the Museum during the war years, we were faced with an unusually difficult situation. Our chief concern was to keep the organization intact and make the members of the staff work together in harmony . . . For both Mrs. Rockefeller and me, this was a novel experience.[23]

Barr was both overworked and clearly lacked administrative skills. He selected the museum's shows, wrote the catalogues (often late), and, most of all, built the permanent collection by locating, selecting, and lobbying for the purchase of extraordinary works of art. He helped the trustees form their personal art collections, hoping that their best pictures would eventually be given to MoMA. Unquestionably he made MoMA the preeminent museum of modern art in the world.

But he was touchy and arrogant. He implied that Clark had poor artistic judgment, and his own poor administrative performance became more evident as the museum grew to adulthood. Abby was skilled at calming Barr's temperament, a task at which neither Goodyear nor Steven Clark excelled.

The situation came to a boil in 1943. At Christmastime an extravagantly decorated shoeshine stand appeared in MoMA's lobby. It was the work of Joe Milone, a Sicilian immigrant, and Barr described it to a reporter of the *New York Times* as "festive as a Christmas tree . . . as jubilant as a circus wagon . . . as lavish as a wedding cake." He also reluctantly agreed to exhibit the work of Morris Hirshfield, a sixty-seven-year-old retired manufacturer of slippers and dresses sponsored by Sidney Janis, an art dealer whom MoMA's director wanted to butter up. The press derided the exhibit, *The New Yorker* terming it the museum's worst show and *Art*

Digest calling Hirshfield "The Master of the Two Left Feet." Clark feared that MoMA was becoming an artistic laughingstock.[24]

After discussing the matter with Abby and the other trustees, Clark relieved Barr of his duties as director, though he would continue with many of his other museum activities. He also cut his salary of $12,000 in half. As far as Barr was concerned, the action, of which he was notified by letter, was totally unexpected. Art historians still discuss his dismissal, painting Clark as the villain and Barr as the victim. This may very well not be fair, since Barr had also driven other officers of the museum to distraction. Given Barr's service to the museum, the manner in which his dismissal was carried out seems unwarranted, even though the last paragraph of Clark's letter was conciliatory:

> May I say . . . how greatly we regret the necessity of taking this step. . . . When the first shock of this decision wears away you may, perhaps realize that in taking this step we are acting in your own real interest . . . If you go on worrying over petty details of museum management . . . you will soon lose the capacity to do any original work of your own. You have great talent and a great reputation in the world of art . . . You will now have the opportunity and the incentive to devote your undivided attention that will be of real value to yourself and the Museum.[25]

Marga Barr recorded in her journal that, upon receipt of the letter, her husband became deeply depressed, even more so after he received a letter from Abby Rockefeller that told him that his demotion "was for his own good."[26] Barr could easily have gotten another, better job, but he refused to leave his museum. Instead, he retreated to the library, where he worked on his publications and continued to be adored by most of the staff of the museum.

After the war, Clark's relations with the museum soured. In 1951, while still a member of the Acquisitions Committee, he became furious when MoMA was considering acquiring Giacometti's *The Chariot*, which he

considered bad art. However, he continued to be a loyal member until 1959, when MoMA embarked on its major thirtieth-anniversary fund-raising campaign. Someone told him that David Rockefeller had "put him down for a contribution of one million dollars." Clark felt that this assumption was arrogant, and he broke off all relations with the museum he had served so faithfully for thirty years. Subsequently he left his collection, including Seurat's *Circus Sideshow*, so valued by Barr, to the Met and Van Gogh's *The Night Café* to Yale's Art Gallery.[27]

RENÉ D'HARNONCOURT, NICKNAMED the "gentle giant" by Russell Lynes, [28] MoMA's historian, would assume the museum's directorship in 1948. Born in what was then the Austro-Hungarian Empire, he studied chemistry, but also was interested in art, which eventually would provide him with his livelihood. In 1925, when d'Harnoncourt was twenty-four years old, he left for Mexico, where he worked for antiquities and folk art dealer Frederick Davis, who contributed to the revival and popularization of traditional Mexican crafts. In 1929 the Mexican Ministry of Education asked d'Harnoncourt to assemble forty-eight separate Mexican folk art collections to circulate in the schools of the forty-eight U.S. states. Thereafter, the Carnegie Corporation arranged for a larger exhibition of Mexican art destined for the Met. D'Harnoncourt installed the show and then toured with it throughout the United States.

By the mid-1930s, d'Harnoncourt had moved to the United States and was teaching part time at Sarah Lawrence. He met the Nelson Rockefellers over dinner one evening at the Barrs'. Nelson quickly grew to appreciate René's talents, and the latter would play an important role both at MoMA and in helping Nelson assemble his collections of primitive and Mexican folk art.

D'Harnoncourt had an extraordinary gift for displaying art and installing shows. He would make an exact model of the forthcoming exhibit, painted in the carefully chosen background colors, and then fill the space with small replicas of the objects to be displayed. His lighting was dramatic, and unexpected juxtapositions heightened the pleasure of the

viewers. Nelson Rockefeller's sculpture garden at Pocantico Hills still reveals d'Harnoncourt's genius.

In 1941 an exhibition entitled *Indian Art of the United States* brought René d'Harnoncourt to MoMA. Heralded by a large totem pole on Fifty-third Street, the show was a larger version of a Native American art exhibition held at the Grand Central Galleries in New York City, to which Abby had contributed. The MoMA show established d'Harnoncourt's New York reputation, and Nelson was so impressed that he asked him to head the art section of the Center for Inter-American Affairs in Washington.[29]

After World War II, d'Harnoncourt joined MoMA. Initially Nelson paid his $10,000 salary. In 1948, d'Harnoncourt assumed the directorship of the museum, vacant since Barr's firing, and calm returned. D'Harnoncourt was a born diplomat and staunch admirer of Alfred Barr, by then director of the museum's collections. The two men worked in harmony for the rest of their tenures.

By the mid-1940s the museum had outgrown its "hell-raising enfant terrible" status, and Alfred Barr, too, had progressed from being a brilliant wunderkind to a respected authority on modern art.[30] During the nineteen years of its existence, MoMA had assembled an extraordinary permanent collection and expanded the concept of what was considered an appropriate museum activity. MoMA showcased films, industrial design, advertising art, books, photography, and architecture. The museum's shows highlighted folk, non-Western, and contemporary art. It had sent traveling shows of modern art around the United States and the world, and it had published hundreds of art books.

ON APRIL 5, 1948, at seventy-three years old, Mrs. Rockefeller died. She left a tremendous void in the lives of many, including Alfred Barr, the man she had helped assume the helm of what was to be their common legacy. For years she had suffered from high blood pressure, and everyone close to her was aware of her frailty. Upon their return from Arizona, Junior and Abby had spent the weekend at Kykuit. Always fond of clothes,

she had donned a new dress for the family reunion. On Sunday evening, while driving with his parents back to New York, David Rockefeller had a premonition that this might be his mother's last trip. The next morning Abby felt ill. The family doctor was called, and while he was examining her, she died of a massive heart attack.[31]

Services were held at Riverside Church, the Reverend Harry Emerson Fosdick presiding. In his eulogy, he painted a poignant portrait of the woman who had been an example to her family and friends:

> She went out to people—all sorts of people—across boundary lines of race, nationality, occupation and class. She did it naturally, spontaneously out of genuine interest . . . but there was another quality in her . . . there was a granite base beneath all that foliage of kindness and goodwill . . . [she had] sturdy convictions about right and wrong . . .
>
> [Mrs. Rockefeller also] lived with zest and gayety; she was vital, vibrant, and resilient. She loved life and kept to the end a spirit whose enthusiasm nothing could quench.[32]

The Bulletin of the Museum of Modern Art (Summer 1948) reprinted an editorial from the *New York Herald-Tribune*:

> Position and wealth were hers from the start. But they meant nothing to her in comparison with her family, her friends, and a chance to be herself.
>
> In just one field did Mrs. Rockefeller, in being herself serve the general public . . . it was to modern art that she gave her heart, and the city should long be grateful to her for her discerning eye and her generous, modest leadership . . .
>
> Just how keen her eye became the public learned for the first time when part of her extraordinary fine collection, mainly watercolors and drawings, reached the museum in 1936 through her gift. She had the great happiness of living amid beauty, which she herself assembled and sharing it with the people of the city in which she lived.[33]

According to his eldest son, Junior had been "terribly hard hit" by his wife's sudden death. He continued to adhere to their routine of spending winters in New York, summers in Maine, and spring and fall in Williamsburg, where occasionally his daughters-in-law and his eldest granddaughter, Abby O'Neill, alleviated his loneliness. He immersed himself in work and grew "in gentleness and understanding." Three years after Abby's death, Junior married Martha Baird Allen, a talented pianist and the widow of Arthur Allen, his friend and former Brown University classmate.[34]

Alfred Barr had learned of Abby's death while on his way to Europe. On May 29, 1948, he wrote to Nelson from Rome:

It's about a possible memorial exhibition of your mother's gifts and bequests to the Museum Collection. You may recall we had such an exhibition after Miss Bliss' death in 1931 . . .

Before making a decision, we need your advice both as the Museum's president and as a son who knew your mother's feelings about her gifts perhaps better than anyone else.

Your mother gave the museum a very large number of works of art perhaps in all 2500 objects . . . oils, watercolors, sculpture, over 150 drawings and about 2000 prints. Because of her modesty as a collector most of these were small in scale.

Your mother was always reluctant to have her name used but often we could persuade her to do so on the grounds that it helped both the Museum and the artist . . . in 1942 she asked for the list of all her gifts of painting and sculpture and withdrew her name . . . because it occurred too often . . . besides, she said there were a good many works she had bought "for the Museum" which she really did not like . . . Unfortunately [in this way] she withdrew her name from many of her best and most important works.

Barr went on to explain the dilemma: If the museum respected Abby's wishes, the memorial exhibition would belittle her tremendous contributions. On the other hand, if the museum added her name, even temporar-

ily, to her many donations, the exhibition would violate her wishes. Barr suggested that instead of a memorial exhibition, the museum dedicate the forthcoming print room to her memory:

> ... though some might think it inadequate as a tribute to your mother's interest in the museum ... [I] feel that she herself would have liked naming the print room after her since prints were her chief interest.[35]

The print room had always been a major concern of Abby's. Alfred Barr recalled in the pamphlet accompanying its inauguration that during the planning of the 1939 building, "Mrs. Rockefeller, with gentle insistence, argued for the inclusion of a print room, reminding her colleagues that prints, because they were low priced enough to be available on a democratic scale should hold a place of special importance in a museum concerned with encouraging the widespread collecting of original works by living artists."[36]

The Abby Aldrich Rockefeller Print Room opened on May 11, 1949, accompanied by an exhibition of master prints from the museum's collection. Abby's gift of sixteen hundred prints and original drawings includes works by important and lesser-known artists of the first half of the twentieth century. Some prints are moving, some are well known, others made art history, and others, still, such as Diego Rivera's *May Day* sketchbook from 1928, are records of a place and time. The forty-five small watercolors illustrate ordinary life in Moscow and, of course, many sketches of the May Day Parade, used by Rivera as he worked on his ill-fated Rockefeller Center mural.

The print collection is particularly strong in works by French Postimpressionists, Mexican art, German Expressionism, and American art from the second quarter of the twentieth century. Many of Abby's selections underline her discerning taste, and even though by 2004 the collection had grown to fifty thousand items, her prints are still outstanding.[37]

The Print Room at MoMA is off-limits to the general public. It consists of a specialized library, offices, storage rooms, and a study center for viewing prints on request. The laboratory-like space overlooks the Rockefeller apartments on Fifty-fourth Street, which Harrison built, at Nelson's

request, during the 1930s, and 13 West Fifty-fourth Street, where Abby and Junior lived before they built their imperial brownstone. Most members of the third generation of Rockefellers were born at 13 West Fifty-fourth Street, and Nelson died there in 1979.

In her will, Abby left the museum two works by Seurat and two by Van Gogh, including the much-beloved *Corridor at San Remy* (1898), and her residual financial assets of about $850,000.[38] The total number of works Abby donated to her museum exceeds four thousand, many bought after her death by her purchase funds. Only a few of the works are officially credited to her. Two huge Lehmbruck sculptures—*Kneeling Woman* (1911) and *Standing Youth* (1913)—are so identified, but most are not. More important than these material gifts, Abby bequeathed the museum the devotion of two of her sons and that of her daughter-in-law Blanchette.

Eventually Junior would feel a bit guilty about his disdain for Abby's activity on behalf of modern art. In 1949, after Abby's death, he contacted Mary Ellen Chase, his wife's biographer, and told her that in spite of his dislike for modern art, he had donated the equivalent of $1.25 million to MoMA, which at the time made him the museum's single largest contributor. Three years later he contributed another $4 million, as he wrote to Nelson, "In memory of Mama's devotion to the Museum and the realization of its objectives."[39]

NELSON'S ART COLLECTION and that of MoMA evolved simultaneously. Nelson often bought works of art with the intention of giving them to the museum, either immediately or upon his death. Between 1946, when he returned from Washington, and 1955, when he ran for governor, he did much of his own art shopping. In New York and during his travels, he visited galleries, artists, and dealers. He bought books and devoured auction catalogues, and his collections grew. After he became governor he delegated the actual buying to others. In 1963 he talked with Francine du Plessix about the evolution of his collection. "Sculpture is really my passion, rather than painting," he declared. "I love twentieth century painting

too of course, otherwise I would not buy it, but basically I feel sculpture more." By then Nelson's private collection had already become massive, including more than five hundred paintings and sculptures, nine hundred works on paper, and a thousand pieces of primitive sculpture.[40]

Sooner or later, whenever Nelson Rockefeller talked about art, the conversation got around to his mother and to the passion she had instilled in her children. Two of his most beloved artworks remained a Miró oil and a Matisse *Odalisque* his mother had given him.[41]

During the 1930s, Nelson had begun collecting Cubist paintings by Braque, Picasso, and Juan Gris. Picasso would remain his favorite artist, though Matisse was a close second. His tastes were catholic, and his collection included examples of most major twentieth-century painters: Miró, Klee, Rivera, Léger, and Kandinsky, to name only a very few. Later Nelson became an advocate of the New York School, and bought paintings by Achille Gorky, Willem de Kooning, Mark Rothko, Robert Motherwell, Adolph Gottlieb, Franz Kline, Jackson Pollock, and others.

During the 1940s he began accumulating large and small twentieth-century sculptures by Lipchitz, Moore, Maillol, Arp, Calder, Lehmbruck, Giacometti, and Noguchi. Whimsical Elie Nadelman was a particular favorite. Nelson liked the playful nature of his work, and approved of the artist's use of low-cost papier-mâché as a medium, chosen so as to keep the price of his sculptures affordable. The governor's purchases ended up in Kykuit's sculpture garden, his most personal legacy.

Nelson was extremely generous, and MoMA owes him for many of its landmark works. For its twenty-fifth birthday he gave the museum Henri Rousseau's *The Dream*. Rousseau, nicknamed Le Douanier, started painting when he was forty-one years old. Entirely self-taught and endowed with an innate sense of design, he produced wondrous, dreamlike paintings filled with exotic plants, inspired by visits to Paris's Botanical Gardens, and wild beasts copied from photographs and picture books. Rousseau's paintings presaged the Surrealists.

Rousseau painted *The Dream* in 1910. A nude woman rests on an elegant red settee in the midst of a flamboyant jungle. A snake-charming

flute player, a friendly lion that could inhabit Hicks's *Peaceable Kingdom* so beloved by Abby, an elephant, and snakes and birds hide among mammoth blossoms. The picture was exhibited at the Salon des Indépendents in Paris and was ridiculed by the press. A few months later the painter died.

When Nelson's gift arrived at MoMA, Max Weber, an American Cubist painter who had studied with Rousseau, Picasso, and Matisse in Paris, was visiting with Monroe Wheeler, director of publications. Describing the visit in a letter addressed to Nelson, Wheeler wrote:

When I showed Max Weber *The Dream* . . . together with the newly cleaned *Sleeping Gypsy*—(now twice as beautiful as before) he wept at the thought of how his friend would have loved to see them here. He told me of his friendship with Rousseau [and of what he saw when he watched Rousseau paint.] The room was exactly the length of [the canvas of] *The Dream*. Rousseau would begin at the left side and paint the picture in vertical strips, simply applying, methodically, a picture that was already complete in his mind. When he arrived at the right edge of the canvas the picture was finished.[42]

In 1963, Nelson gave MoMA Matisse's *Dance*. The Russian collector Sergei Shchukin had seen the work in 1909 at a Paris exhibition and commissioned another version of it, and a companion piece, *Music*, for his palatial home in Moscow. The original *Dance* lingered in Matisse's studio for decades, until the artist's son Pierre, an art dealer, sold it to Walter P. Chrysler in 1936. Twenty-three years later Chrysler sold it to Nelson.[43] Rockefeller donated the picture in honor of Alfred Barr. When he learned of Nelson's "magnificently handsome gesture," Barr wrote "that few things have touched me more in my association with the Museum than the thought that my name will be linked with yours in the history of this extraordinary picture."[44]

In 1969, art journalist Grace Glueck reported that part of Nelson's vast art holdings were on view in three New York museums: the Museum of Modern Art, the Museum of Primitive Art, and the Metropolitan Museum

of Art. It was, Glueck wrote, "the biggest representation ever given in New York City to a single collector."[45]

The MoMA show, entitled *Twentieth Century Art from the Nelson Aldrich Rockefeller Collection,* included two hundred artworks, and before it opened, the governor announced that upon his death he would leave MoMA twenty-five of these paintings. He had asked Alfred Barr to select those paintings that would be most useful to the museum. In a long memo, Barr explained why he had chosen specific works:

- Boccioni's *States of Mind I, II, and III:* "These three pictures taken together are the most important Futurist works in painting."
- Juan Gris's *Le Buffet:* "To my mind, one of the best of the great period, 1916–1917 . . ."
- Braque's collage *The Clarinet:* "If I had to choose a single work from Braque's entire oeuvre, I would choose this one."
- Miró's *Hirondelle Amour:* "The largest and one of the best Miro's I know."

Barr praised Matisse's *Italian Woman,* even though it was "not a popular work, but one which seems to me powerful and ascetically beautiful." Picasso's *Girl with a Mandolin* Barr thought was "the most famous of all cubist paintings between *Les Demoiselles d'Avignon* and the *Three Musicians*" (both of these works were already owned by MoMA). To Barr, *Girl with a Mandolin* "seemed more beautiful than ever." It was his favorite among the entire selection, with Nelson's big Braque *Clarinet* collage coming in second.[46]

Art critic Hilton Kramer reviewed the exhibition for the *New York Times* and found it to be a:

historical survey of modern art almost museum-like in itself. . . . it is a stunning collection [whose preference clearly is for works of art that have] a clearly stylistic force . . . with little interest in the overly precious, the ethereal or the mythical, and almost no interest at all in the purely illustrational.[47]

In spite of his growing involvement with politics, Nelson Rockefeller worked at refining and completing his art collections. In 1977, when he returned from his last unsuccessful bid to be the Republican nominee for president, he embarked on writing several definitive books about his collections. The introduction to *Masterpieces of Modern Art* summarizes his collecting philosophy:

> Twentieth century art has been a vital part of my life; in fact it has become a way of life for me. It has given meaning and value, perspective, and fulfillment to my life as well as a constant joy. It is a current that has run deep and strong in me regardless of the pressures, turmoil, and responsibilities, with which I have lived and worked.
>
> Art has always been a source of faith and hope, of inspiration to people throughout the world. It is a bridge between peoples everywhere who otherwise have little contact—and often less understanding and trust. I cannot conceive of a nobler pursuit.[48]

IN 1948, NELSON and David Rockefeller persuaded their sister-in-law Blanchette Hooker Rockefeller to work for MoMA. They hoped that she would assume Abby's mantle, and they would not be disappointed. Blanchette's first assignment was to form a Junior Council, whose aim was to interest younger people in MoMA's future. The Junior Council differed markedly from the Junior Advisory Committee that Nelson himself had headed during the 1930s.[49]

Unlike Nelson, John 3rd and Blanchette avoided the limelight as much as possible. For most of their life, the couple divided their time between Beekman Place in Manhattan, Fieldwood Farm in Pocantico Hills, Millstream Cottage in Maine, and eventually Bassett Hall in Williamsburg.

Alfred Barr, whom she first encountered at Abby's gallery talks, became one of Blanchette's mentors. Under his tutelage, and that of Philip Johnson, she started collecting modern art, favoring the New York School's Abstract Expressionism. Since John 3rd disliked modern art as much as his

father did, Blanchette decided to buy it with her own Hooker trust fund. Her purse was fatter than Abby's had been a quarter of a century earlier.[50]

On Barr's recommendation, Blanchette bought Marino Marini's joyous *Horse and Rider*, although she had only seen a photograph of the sculpture. When it arrived, Blanchette was shocked by its size. It was too large for the Beekman Place apartment and it clashed with the home's delicate Chinese ceramics, Impressionist paintings, and formal furniture. As Aline Saarinen wrote in *The Proud Possessors*, "the horse needed a stable."[51]

Philip Johnson, then in charge of MoMA's Architecture Department, suggested that Blanchette build a guesthouse-cum-gallery. She talked the idea over with her mother-in-law, who encouraged the undertaking, saying "that a wife needed space of her own." She told Blanchette that "she had the same problem with her husband . . . [that] Junior would not allow modern art throughout the household," and that was why she had created her private gallery on the top floor of her house.[52]

Philip Johnson did not yet have his architectural license in 1947. Nevertheless, he built Blanchette a small house at 252 East Fifty-second Street in Manhattan. It was the first commission for America's future foremost architect. Championing the International style derived from the work of Le Corbusier and Mies van der Rohe, Johnson's work would include the Seagram Building and AT&T headquarters in New York, numerous museums, and his own famous glass house in Connecticut. For the Rockefellers he would build the Abby Aldrich Rockefeller Sculpture Garden at MoMA, the New York State Theater at Lincoln Center, and two private art galleries for Nelson.

Johnson's Fifty-second Street Rockefeller guesthouse was spare, open, art friendly, and ideally suited for displaying art, holding meetings and parties, and lodging guests. It featured a central reflecting pool that foreshadowed MoMA's sculpture garden. Now that she had space, Blanchette enlarged her art collection and included works by Mark Rothko, Jackson Pollock, Willem de Kooning, Robert Motherwell, and Alberto Giacometti.

By 1948, MoMA had absorbed quite a bit of Blanchette's time. In addition to the Junior Council, she established an art lending service through which members could rent and then buy artworks by young and upcom-

ing artists. The undertaking was successful, and by 1970 about eighty muse-
ums throughout the United States had copied the program. Blanchette also
assumed the leadership of MoMA's new International Council, formed to
familiarize the world with American art, in particular the emerging New
York School. By recruiting its membership from outside the metropolitan
area, the International Council emphasized MoMA's national mission. The
council was especially dear to Nelson, and in 1953 it received a five-year
grant from the Rockefeller Brothers Fund—a new philanthropic fund cre-
ated in 1940 by the Brothers to donate money to projects and institutions
they were particularly interested in. During the cold war the U.S. State
Department decided not to participate in the Venice Biennale. MoMA
stepped into the breach and, from 1954 to 1962, exhibited the work of dis-
tinguished American artists at the event.[53] On behalf of the museum, the
International Council also supplied art to embassies in Japan, Germany,
Norway, India, and elsewhere.[54] MoMA's administrators and curators loved
Blanchette's guesthouse and used it almost incessantly for meetings, din-
ners, and small parties. This distressed John 3rd, who not only disliked at-
tending these parties, but also resented his wife's increasing involvement
with MoMA, complaining at one point that Blanchette was "running two
households." Blanchette reluctantly agreed. She was ready to give MoMA
her guesthouse, but could not afford to pay the gift tax. John 3rd came to
the rescue. He bought the house from his wife, paid the gift tax, and do-
nated the structure to MoMA; all in all, his monetary gifts to the museum
amounted to about $750,000. Blanchette donated some of her art to the
museum, including masterworks of the New York School and the Jacques
Lipchitz sculpture, which had been a gift from David and Nelson.

In the late 1950s her brothers-in-law pressured Blanchette to accept
MoMA's presidency. She demurred because John 3rd, who by then, ac-
cording to biographer Lynes, "was up to his eyes in the affairs of the new
Lincoln Center, and wished her by his side," objected.[55] Eventually he re-
lented, and Blanchette was elected MoMA's president in 1959. She resigned
in 1964, because of family obligations, but resumed the post in 1972.

Since collecting art and MoMA absorbed so much of Blanchette's time,

she decided to educate herself. "When I was forty-five," Blanchette told Paul Cummings:

> I decided to go to Columbia University and work towards a master's degree. I took courses in art history and in the history of Japan . . . I never enjoyed anything as much as I did that. I had the motivation, you see, and it was a return to academic life after being all bogged down with the children and domestic problems . . . It was just so exciting![56]

Blanchette studied both modern and Asian art, the latter an interest she shared with her husband, whom she accompanied every year to Asia.

IN 1959, IN honor of its thirtieth anniversary, MoMA embarked on a $25 million fund-raising campaign earmarked for another expansion.[57] A large fête was to mark the anniversary in November. To plan it, trustees and staff members journeyed in August to the Rockefeller enclaves in Seal Harbor. They were so numerous that, for their transport, the State of Maine express train had to attach extra railroad cars. During the four days of the planning meeting, buses shuttled the participants between David's and Nelson's "cottages" and Mrs. Edsel Ford's estate.

The November celebration started with a festive dinner held at the Four Seasons restaurant. The program unrolled with military precision:

> 7:45 P.M. soup served; 8:10 P.M., main course served; 8:52 to 9:20 P.M. speech by Governor Rockefeller delivered. Coffee and dessert were served two minutes after he finished and everybody left by 9:45 P.M.[58]

There was a flurry of publicity. The *New York Times* pointed out that MoMA was now a landmark comparable to the Statue of Liberty, the Empire State Building, and Rockefeller Center. The museum's statistics were impressive. Since its birth, it had exhibited some 70,000 individual objects and works of art, had mounted 630 exhibitions attended

by 12 million people, and had published 250 books. Unquestionably the museum had the best collection of modern art in the world. By 1959, it owned 19,000 items. The film collection, which had been started with a $100,000 grant from the Rockefeller Foundation, was the most extensive available in any public institution. The museum had the largest collections of many individual painters, and there was no indication that its growth would stop.

Museum bureaucracy, however, had grown along with the collections. During the 1930s, Barr had planned exhibitions a few months ahead of schedule, then gone off to Europe to gather the pictures. The schedule of the museum could be manipulated when an opportunity arose, as in the case of the Italian masterpieces or the Mexican exhibit. However, by 1959, inflexible schedules ruled. It now took five years to plan exhibitions. Where once Barr wrote most of the catalogues himself, now they were farmed out.[59]

Many of those who had created the museum were still on staff to celebrate MoMA's thirtieth birthday, but this was about to change. Barr retired in 1967. His annual pension of $25,000 was greater than any salary he had ever earned. In view of the astronomic current salaries for CEOs, including those of museum directors, it is sobering to recall that, in 1929, Alfred Barr's starting salary was $10,000 annually and that MoMA was entitled to the royalties from the sale of his many books.[60]

After his retirement, Barr retained an office in the museum and stayed involved in its affairs. By then he had become America's, if not the world's, undisputed apostle of modern art. Prizes and honors descended on him, and in 1975 "his" museum renamed its permanent collection galleries in his honor.

Other changes were about to occur. René d'Harnoncourt retired in 1968; Dorothy Miller, Barr's able assistant, followed in 1972. Nelson Rockefeller, who was as devoted to MoMA as Abby had been, and had helped to shape its policy for almost fifty years, would die in January 1979. All these events resulted in some confusion and soul-searching by the administration and trustees.

Barr had always suffered from poor health, and after his retirement he became increasingly feeble. Gradually it became clear that he had developed Alzheimer's disease, and in 1975 a reluctant Marga committed him to a nursing home. He died on August 15, 1981. Grace Glueck, who wrote his obituary in the next day's *New York Times*, described him as:

> a paradoxical mixture of shy scholar and inspired showman who had been called the soul of the Modern, he was possibly the most innovative and influential museum man of the twentieth century.
>
> ... Mr. Barr lured the public with spectacular and well-researched shows, ranging from the "high" art of Matisse and Picasso to the display of such mundane objects as typewriters and gasoline pumps. As a sharp acquisitor with a sense of the historical importance, he built the museum's collection of 20th century art into the world's most significant.

MoMA mounted a small memorial exhibit in Barr's honor that featured Rousseau's *Sleeping Gypsy*, which Barr had bought with Olga Guggenheim's blank check; and Matisse's *Dance* and Picasso's *Two Nudes*, both of which had been donated to MoMA in Barr's honor.[61]

On October 21, 1981, the museum organized a memorial service.[62] William S. Paley, the then-chairman of the board, recalled that almost from the very beginning, Barr had fixed in his mind the museum's course for the future.

Beaumont Newhall, whom Barr hired in 1935 as librarian and who went on to create the Department of Photography, quoted Christopher Wren's memorial tablet in London's St. Paul's Cathedral: "if you need a monument, look around you." Art historian Meyer Schapiro, professor emeritus at Columbia University, emphasized Barr's close contact with artists and his role as teacher, scholar, and author. Remembering the museum's beginning in 1929, Schapiro said, "I do not know anyone who could have accomplished what he did in those years."

Blanchette Rockefeller, MoMA's current president, expressed her per-

sonal gratitude and that of the museum. Noting that she had known Barr for more than fifty years, she said:

> How lucky I was to be introduced to Alfred Barr one afternoon in [my mother-in-law's] private modern gallery on the top floor of the family home at 10 West 54th Street. She and Alfred were choosing some modest works by contemporary artists for her to acquire and hang in the gallery for an informal exhibition. Alfred was a born teacher, among his other great attributes. We, my mother-in-law and I, both listened to him speak about the selection he had assembled, fascinated by his slow meditative analysis of each work. After considerable discussion, he was careful to see that Mrs. Rockefeller made her own independent choice. I remember that some beautiful Demuth watercolors, as well as some Ben Shahns were in our conversation that day . . .
>
> I believe that the Museum of Modern Art has had an important impact over the years on many people like myself. Alfred's presence here was all pervading, and from the beginning he created an atmosphere that made the institution an exciting place to be. There have been many wonderful people through the years who have further contributed to the Museum's importance. However the concept of a museum of modern art was his—Alfred's—and he set the pattern and high standard that we all strive to carry on.

A Modest Man Assumes His Birthright:
The Asia Society and Lincoln Center

THE ASIA SOCIETY

IN 2006, to celebrate its fiftieth birthday, the Asia Society mounted an exhibition entitled *A Passion for Asia: The Rockefeller Family Collects.*[1] The shows—actually there were two consecutive ones—occupied two floors of the New York headquarters of the Society at Park Avenue and Sixty-ninth Street in Manhattan. Various institutions and members of the Rockefeller clan loaned the objects on display, and the exhibition combined great art with more mundane objects. Old photographs of interiors at 10 West Fifty-fourth Street, the Eyrie, 740 Park Avenue, and Kykuit reminded visitors that the objects on display had been bought for private use. Visitors familiar with Rockefeller lore were informed of who had collected what, and what had been willed to whom. Objects had been subdivided into four separate sections: "Nourishing the Spirit" included photographs of Abby's Buddha rooms and of related sculptures. "Home as Aesthetic Retreat" emphasized decorative arts and prints. "Landscape Design" illustrated the great Rockefeller gardens at Kykuit and Seal Harbor. "The Archival Room" documented Junior and Abby's only trip to Asia and the history of the Asia Society.[2]

A large gilded Buddha from the Ming period (1368–1644) greeted visitors upon their arrival. This seated *Amitabha Buddha*, also known as *Buddha of the Western Paradise*, usually lives in the Abby Aldrich Rockefeller Garden in Maine, where it is paired with an almost identical *Shakyamuni Buddha*. The most famous of the Rockefellers' Asian statues, the seventh-century Tang-period bodhisattva, which at one time greeted visitors in the entrance of their brownstone on Fifty-fourth Street, shared a gallery with other large statues.

The Museum of the Rhode Island School of Design sent a selection of Abby's Utamaro and Hiroshige prints, and robes from the Lucy Truman Aldrich Textile Collection. Abby's grandson Steven C. Rockefeller contributed a contemporary Japanese woodcut by Itō Shinsui of a traditionally clad young woman shown against a full moon. Steven, professor emeritus of history and religion at Middlebury College in Vermont, also lent a small ivory statuette of *Guanyin with Child*, from China's fifteenth-century Ming period, which closely resembles a medieval European work, and a wooden cross, created by George Nakashima, the American modernist furniture maker. The simplicity and beauty of the finished artwork attests to the artist's reverence for the life of the tree, and of his responsibility to justify its sacrifice.[3] The Met loaned some of Junior's Chinese porcelains and *Kashyapa*, a wooden polychrome figure from 1700 Korea, a gift from Abby Rockefeller. John D. (Jay) Rockefeller IV and Hope Aldrich, two of John 3rd and Blanchette's children, sent an elaborate gilt-bronze *Eleven-headed Lokeshvara* encrusted with jewels, and a simple Buddha from Thailand.

The David Rockefellers had a particular liking for animal art and contributed a unicorn and a deer, from Nepal, dating from the thirteenth to fourteenth century CE, and an eighteenth-century *Tureen* and *Cover in the Shape of a Goose* they had inherited from their aunt Lucy. The most beautiful objects of the show, however, were favorites selected from the 285 pieces Mr. and Mrs. John D. Rockefeller 3rd specifically collected with the Asia House in mind.

JOHN D. ROCKEFELLER 3RD loved the Far East as much as Nelson loved South America, and similarly his devotion shaped his career. As a child, long before he ever traveled to Asia, he had fallen in love with Japan. He may have identified with his father's Chinese porcelains or his mother's Japanese prints and Buddha rooms or his grandfather's Japanese garden at Kykuit. When he was nine years old, Florence Scales, the Rockefellers' governess and Abby's alter ego, reported in a letter to his traveling mother that John 3rd was searching for pebbles and a tiny tree to fix up a Japanese garden for his room.[4] He was fifteen when his parents went off on their historic journey to Asia. He resented staying home. His mother's frequent letters extolling the beauty of the palaces, temples, and gardens might have mollified him.[5]

The highlight of John 3rd's post-college world tour was his participation in a conference at the Institute of Pacific Relations in Kyoto. While there, he formed a life-long friendship with Shigeharu Matsumoto, an assistant secretary to the conference. He also met up with his aunt Lucy, with whom he visited shrines, temples, country inns, and other scenic places. By the time he returned to New York, he had formed a lasting bond with Japan and its people, whose disciplined and restrained nature perhaps matched his own ingrained reserve.

World War II not only liberated John 3rd from the oppressive atmosphere of the family office, but also allowed him to combine service in the navy[6] with his postwar management of occupied countries in East Asia. In 1945 he authored a major report dealing with the development of a positive policy for the reorientation of the Japanese people, and Washington began looking upon him as an expert in South East Asian affairs.[7] In 1950, President Harry Truman asked Foster Dulles, then chairman of the Rockefeller Foundation, to explore and formulate a formal peace treaty with the Japanese. Dulles, in turn, asked John 3rd to accompany the American mission. By then John 3rd had developed his own philanthropic concerns, which included worldwide overpopulation and hunger. He founded the Population Council and supported the Green Revolution, which dramatically increased the food supply of developing nations.

John D. Rockefeller 3rd and Blanchette Hooker Rockefeller aboard the Ile de France. (Courtesy of The Rockefeller Archive Center)

Starting in the 1950s, John 3rd and Blanchette, sometimes accompanied by their children, visited South East Asia annually for periods of four to six weeks. Their personal diplomacy was so successful that it helped heal the wounds left by World War II. After General Douglas MacArthur, Rockefeller was Japan's best-known American, and he became an unofficial extension of the State Department. A state visit of South East Asian dignitaries to the United States often included a stay at John and Blanchette's home in Manhattan, Westchester, or even Williamsburg.

It was, however, also crucial to promote Asian-U.S. relations in America. In 1952, John 3rd revived the Japan Society founded in 1907. During its first postwar annual meeting, Japan's red-and-white "rising sun" flag flew from the Plaza Hotel—a sight not seen in the United States in years.

In 1956, John 3rd founded the Asia Society, a social and cultural organization for Asia. In America, McCarthyism and witch-hunting were at their height, and even such a staunch capitalist as John D. Rockefeller 3rd encountered some problems in getting his new venture started. At first the Asia Society had small quarters on Sixty-second Street in Manhattan.

It was so successful that within a few years John 3rd moved it to larger quarters. During its first fifty years the Society has sponsored lectures, concerts, plays, dances, art shows, book readings, social gatherings, and other cultural events that enhance the understanding between America and South East Asia.

Art was to be an integral part of the John 3rds' involvement. In 1953, at their instigation, the Met and the National Gallery of Art mounted a major exhibition of Japanese art. Blanchette persuaded MoMA to erect a Japanese House in its garden. The couple also decided to assemble a world-class collection of Asian art. They were well equipped for this new venture. John had grown up with his mother's Buddha rooms and Japanese woodcuts. Chinese porcelains had been his father's first, and most constant, artistic involvement, and Blanchette had studied Asian art at Columbia. Nevertheless, they felt that their expertise was limited. In 1963 they asked Sherman Lee, one of America's foremost Asian art experts, to serve as their advisor.

Sherman Lee had studied with Paul Sachs and apprenticed at the Detroit Institute of the Arts with William R. Valentiner. Lee went on to form superior Asian art collections at the Seattle Art Museum and the Cleveland Museum of Art; he assumed the directorship of the latter museum in 1958.

"John and Blanchette were united in their desire that the collection be based on artistic merit," Sherman Lee recalled in the preface to *Treasures of Asian Art: The Asia Society's Mr. and Mrs. John D. Rockefeller 3rd Collection.*[8] According to Lee, they also wanted it to be representative of the breadth of South East Asia's cultures. Indeed, the collection includes an amazing number of different cultures, its relatively small size being offset by its high percentage of "masterpieces." As they assembled the collection, John, Blanchette, and Sherman developed a scheme that rated each potential acquisition from A to C, accentuated by plus and minus signs.[9]

Throughout their marriage Blanchette felt that her shy, excessively conscientious husband did not receive the recognition he deserved for his accomplishments. Even though she had studied art history, she in-

sisted that it was John 3rd who made the final decisions about what was to become part of the Asian art collection.

"He's been very nice about wanting to share it all with me and we sort of made decisions together. At least he's made me feel that I was influencing him," Blanchette told Paul Cummings, who interviewed her on behalf of the Smithsonian's Archives of American Art:

> In Asian art [our tastes are very much the same] although I feel that if my husband could have taken some of [the Asian art] courses he would have had a slightly different slant on some of the things—getting a little more of the historical slant . . . rather than having to rely only on his own aesthetic reaction.[10]

Unlike his mother and Nelson, both of whom bought art impulsively, John 3rd shopped carefully and deliberately. In this and other respects he resembled his father. Art dealers were most pleased when they realized that John 3rd was collecting Asian art. They showed him only their best pieces, since they knew that Sherman Lee was advising him. According to Lee, John was a quick student, asking good questions and becoming an ideal collector. He was able to balance the emotional appeal of an object with practical considerations of its historical importance and of the requirements of the collection, the dates of whose pieces would range from 2200 BCE to the early nineteenth century.

Agreeing on two-dimensional works that both John and Blanchette liked was more difficult. Nevertheless, the Asia Society now owns a number of impressive paintings, scrolls, and screens from China, Korea, and Japan. *The Four Seasons*, two six-paneled folding screens from the Japanese Muromachi period, have a magic of their own. They tell the story of two youths who travel on foot and by boat to a teahouse, which resembles the one Senior built at Pocantico Hills.

"Chinese ceramics were particular favorites of the Rockefellers, and numerous examples from the Tang through the Qianlong constitute the strongest single holding of the collection," Sherman Lee writes in *Treasures*

Ganesha, the elephant-headed son of Shiva and Parvati, India, eighth century.
(Courtesy of The Asia Society, New York: Mr. and Mrs. John D. Rockefeller 3rd
Collection, 1989)

of Asian Art. He singles out several especially outstanding acquisitions, but to less sophisticated visitors all the objects are spectacular. They include seemingly simple white porcelain dishes whose incised designs appear under the glaze and an unadorned Korean stoneware storage jar dating from the sixth century.

John and Blanchette were particularly sensitive to the compassionate ideals of Buddhism, and the Asia Society's collection is rich in religious art. Among the many Buddhas and bodhisattvas in the collection, the undisputed masterpiece is the small serene *Jiza Bosatsu* (1223–26) holding a staff with metal attachments. The figure is made of cypress wood with cut gold leaf and pigment. He is standing on a cluster of lotus leaves.[11] Another outstanding piece is the many-armed *Shiva, as Lord of the Dance*, encircled by a flaming mandorla from India's Chola period (about 970 CE).[12] A tall *Shiva* accompanied by *Parvati*, his much shorter wife (South India, early Chola period), is particularly charming, as is the sandstone figure of *Ganesha*, their elephant-headed son (eighth century), which often greets visitors in the lobby of the Asia Society in New York.

IN 1973, JOHN 3RD concerned himself with the ultimate fate of his Asian art, and the financial foundation of the Asia Society. As expected, the man whose biography is entitled *The Rockefeller Conscience* consulted many experts about the eventual recipient of his beloved collection. It was obvious that the relatively small collection would become lost in a big museum like the Metropolitan. The Asia Society was selected as the recipient, and since it could not afford to maintain it, John 3rd established an endowment fund to care for it in perpetuity.[13]

Before retiring from the chairmanship of the Asia Society, John 3rd decided that the institution needed a new home. It was both difficult to find and expensive to buy a large enough building site in midtown Manhattan. After a prolonged search a parcel was located at Park Avenue and Seventieth Street. The new "Asia House" was to be built by Edward Larrabee Barnes, the architect whom Blanchette favored. Before construc-

A Modest Man Assumes His Birthright ...

tion began, John 3rd was killed in an automobile accident. By then the estimated construction cost of $11 million had almost doubled, and the pledge of $5.5 million made by John 3rd covered only a quarter instead of half of the expenditures. In spite of these difficulties, the new head-quarters of the Asia Society opened its doors in 1981. Since then the society has become the leading global organization working at strengthening relationships between Asia and the United States. It now operates centers in Hong Kong, Houston, Los Angeles, Manila, Melbourne, Mumbai, San Francisco, Shanghai, and Washington, D.C.

THE BUILDING ON Park Avenue and Seventieth Street, extensively reno-vated in 2000, is stunning. Its most extraordinary feature is a free-floating staircase consisting of thick, bluish glass treads, which connects the build-ing's eight floors. Elegant meals are served in a large garden court whose slanted triple-height glass roof and large weeping polikarpa trees give the impression that one is dining in the country. A vase filled with branches of flowering quince stands at the entrance; the floor of the court consists of green marble, and the walls are of chiseled limestone.

The museum is located on the second and third floors. Displays in-clude works from the permanent collection and temporary shows. Plexi-glas cases enable visitors to view objects close up. In the spring of 2007 the Asia Society featured an exhibition entitled *Collectors' Choice*. The cura-tors had paired objects from the permanent collection with items from contemporary collections. The Rockefellers' *Nandi*, a corpulent bull fes-tooned with necklaces, bracelets, garlands, and an elaborate saddle, was paired with the impish *Sambandar*. Both figures are from the Chola period of South India, dating from the tenth to eleventh century. A label informed visitors that *Nandi* was the bull mount of the Hindu god Shiva and that Robert Ellsworth, a longtime Asian art dealer and collector who sold *Nandi to* John 3rd and Blanchette, owns *Sambandar*. The museum also features contemporary Asian artists.

LINCOLN CENTER

On any evening at around seven thirty a crowd streams into a large plaza located on Manhattan's Upper West Side. At this time of the day few people linger by the fountain occupying the center of the plaza or by the reflecting pool in the North Plaza. Instead, they hurry to one or the other of the severe-looking travertine-clad buildings to attend concerts, operas, or dance performances. Each year five million people visit Lincoln Center.

The Center's plaza is by far not as charming or grandiose as its one-time model, the Piazza San Marco in Venice, nor do Lincoln Center's International-style buildings have the splendor of Europe's Beaux-Arts theaters, or the revolutionary excitement of Sydney's winged opera house, but they do form a unified whole and help New York feel like the cultural capital John 3rd was hoping for. As Amyas Ames, president of the Philharmonic Symphony-Society, stated upon Rockefeller's retirement from the chairmanship of Lincoln Center's Board in 1970, "Without John Rockefeller, Lincoln Center could not have been built. It was his leadership and inspiration that carried us through to its completion. Sometimes he pulled us, sometimes he pushed us, but he always carried us onward toward the true goal of completing the Center."[14]

Until the 1960s, John D. Rockefeller 3rd's philanthropies focused on Asia. Always afraid of neglecting some obligation, he wanted to do something for his native New York. When asked, he agreed in 1956 to head the Lincoln Square Exploratory Committee, created to develop a major performing arts center on Manhattan's Upper West Side. During the next fourteen years, John 3rd headed the enterprise and managed to get six strong-willed organizations, and as many architectural teams, to collaborate on building a cultural acropolis.

IN 1955 THE owners of Carnegie Hall notified the New York Philharmonic Society, which had performed there since the hall was built in 1891, that they wanted to raze the building. Thus, the orchestra was obliged

to look for new quarters. So was the Metropolitan Opera, still marooned in the antiquated quarters it had wanted to shed twenty-five years earlier, when Junior was roped into building the future Rockefeller Center. It so happened that, coincidentally, spokesmen for both institutions approached Wallace K. Harrison, who was just emerging from the trauma of having supervised the building of the United Nations headquarters on New York's East Side, on land donated by Junior.

New York's parks commissioner, Robert Moses, a personal friend of Harrison's, talked to him on behalf of the Opera. Moses was spearheading New York's urban renewal, which was at its height during the 1950s, and the vicinity around Lincoln Square on Manhattan's West Side was slated for rehabilitation.[15] Harrison was the logical choice for someone to approach. As a young architect working on Rockefeller Center, he had hoped to design a new house for the Metropolitan Opera Company. The Great Depression had nixed the project, but ever since then there had been plans for a new Opera variously located in Manhattan on Fifty-third, Fifty-seventh, or Fifty-ninth streets; north of Rockefeller Center; on Washington Square; south of Washington Square; or on Columbus Circle. For most of these proposed sites Harrison had submitted architectural drawings, and though the projects never came to fruition, he had not given up hope.

Two days after his conversation with Moses, Arthur Houghton, Jr., then chairman of the Board of the Philharmonic Society, consulted Harrison about the predicament of his orchestra. Combining the two projects became an obvious possibility, though the multiple problems involved in the creation of a musical arts center must have been immediately apparent.

From the beginning it was obvious that even the exploration of such a large undertaking had to be spearheaded by an impressive national figure. As in the case of the "Metropolitan Square Project" (i.e., Rockefeller Center) twenty-five years earlier, thoughts immediately turned to the Rockefellers. It was Charles M. Spofford, chairman of the Board of the Metropolitan Opera Association, who approached John D. Rockefeller 3rd in September 1955.[16] From 1935 to 1939, a young Nelson had been involved with Mayor Fiorello La Guardia's Municipal Art Committee,

which had hoped to establish a center comprising concert halls, theaters, and opera houses; a music library; and several museums. For years the rent-free headquarters of that committee were in Rockefeller Center. In the end, however, the plan came to naught.[17]

Now it was John 3rd's turn. According to historian Julia L. Foulkes,[18] Rockefeller felt that America's prosperous postwar society had more leisure time to enjoy itself. He believed that "throughout history cities like Rome, Athens, Kyoto and others were known for their arts and not their political, economic, or business success." John 3rd wanted New York City to be so remembered. Had he known that the development of Lincoln Center would be so very troublesome, and would take fourteen years, he might have refused the job.

Not everyone agreed with the project. Jane Jacobs, New York's "Urban Visionary," for one, was opposing the city's then-ongoing extensive slum clearance, including that of the substandard housing surrounding Lincoln Square. Deaf to her criticism, Mayor Robert Wagner and Robert Moses were offering the developers a swath of low-cost land that would eventually extend from Sixty-second to Seventieth streets. The Metropolitan Opera and the New York Philharmonic would be the prime tenants, but from the beginning there was talk of including a dance theater. In time, the three original constituents of Lincoln Center were joined by Fordham University, which was looking for a Manhattan campus; the Juilliard School of Music; the New York Public Library, which would establish a performing arts branch; and a theater for a yet nonexistent repertory company.

The initial meetings of the so-called Lincoln Square Exploratory Committee for a Performing Arts Center—even the name is reminiscent of John 3rd's father's Metropolitan Square Project—took place in the fall of 1955. In addition to representatives from the Metropolitan Opera and the New York Philharmonic, the committee included Lincoln Kirstein, Wallace K. Harrison, and John 3rd, who would assume the chairmanship.

It had always been assumed that Lincoln Center's projected "theater for dance" would be occupied by George Balanchine/Lincoln Kirstein's New York City Ballet Company. Until then the company had shared its

City Center quarters with the New York City Opera Company, which offered inexpensive opera tickets. The planners felt that it, too, should relocate to Lincoln Center, but the upscale Metropolitan Opera objected violently. It took years of negotiations and diplomacy to resolve the issue, but by 1961, it had been resolved that Lincoln Center would include the Metropolitan Opera, Philharmonic Hall, Juilliard, a repertory theater, a library, and a theater for dance housing both the New York City Ballet and the New York City Opera.

Each one of the participating institutions was allowed to select its architect. After considerable deliberation the lineup was as follows: Wallace K. Harrison, the supervisory architect, was also to design the opera house; his partner, Max Abramovitz, Philharmonic Hall (now Avery Fisher Hall); Pietro Belluschi, the Juilliard School of Music; Eero Saarinen, the repertory theater (now the Vivian Beaumont Theater); Gordon Bunshaft, the library-museum; and Philip Johnson, the dance theater (the New York

John D. Rockefeller 3rd and architects atop a model of Lincoln Center. (Courtesy of The Rockefeller Archive Center)

State, later David H. Koch, Theater). The buildings had to harmonize with
one another, and there was much disagreement among the architects. At
one point, the headline of an article in the *New York Times*, by music critic
Harold Schonberg, read, "Six Architects in Search of a Center." John 3rd,
who doubted his own architectural judgment, did not want to resolve
their disputes, and asked René d'Harnoncourt, by then MoMA's director,
to act as artistic advisor.

AS IN THE case of Rockefeller Center, art was to be an integral part
of Lincoln Center's design. An Art and Acquisition Committee, headed
by Frank Stanton, president of the Columbia Broadcasting System, was
formed. It included MoMA's René d'Harnoncourt and Andrew Ritchie
from the Yale University Art Gallery. In reality, the individual architects
mainly selected the art for their buildings. Both Harrison and Johnson,
for instance, were closely associated with Nelson's collection, and their
taste, as well as his, is reflected in the Opera House and the New York
State Theater. The cost for the art was supposedly included in the over-
all budget of each institution. Individuals, foundations, and even foreign
governments, however, donated many of the artworks. The Albert A. List
Foundation awarded Lincoln Center $1 million, its largest art grant.

THROUGHOUT THE ENTIRE construction process insufficient finances
hampered builders. The architects developed drawings whose cost and/
or execution would be so much out of line that they were sent back to
their drawing boards. Problems kept popping up. The travertine selected
to face the buildings proved to be too expensive. The committee wondered
how much would be saved if it were substituted with Indiana limestone.
More steel than projected was required to build Philharmonic Hall; and
the workers hired to build it balked at their contract and went on strike.

 There was no funding for the projected dance theater. Fortunately
Nelson Rockefeller, then governor of the State of New York, figured out

that an unrelated event, the 1964–65 World's Fair, to be held in Flushing Meadows, Queens, might resolve that particular issue. A search of the archives revealed that New York State had contributed funds to the 1939 World's Fair. Therefore, it would be appropriate for the state to contribute $15 million toward a theater at Lincoln Center to be used during the 1964 fair. It was mandatory, however, that this structure, henceforth called the New York State Theater, be ready in time for the summer opening of the New York fair.[19]

John 3rd continually raised additional funds. Not only did he solicit major foundations, American industry, and wealthy friends, but he also approached foreign governments, Greek shipping owners, Japanese businessmen, and city, state, and federal agencies.

In the end the Center cost about $186 million, of which John 3rd personally donated $11.5 million. Millions more came from other Rockefeller sources. Junior, who should have been cross with the Metropolitan Opera for having abandoned him in 1929, contributed more than $10 million, and there were major contributions from Martha Baird Rockefeller, Junior's second wife; the Rockefeller Brothers Fund; and from one of Senior's granddaughters, whose will specified that her inheritance revert to his estate were she to die childless, as she did. In spite of all these donations, Lincoln Center often teetered on the brink of bankruptcy during its construction.

THE FIRST QUESTION to be resolved was the layout of the center. Were the theaters going to be aligned along a north-south axis or one that ran east to west? Was the principal access to be from Amsterdam Avenue to the west, or farther east, from Broadway? One early design shows a wide promenade extending from the future center to Central Park. In the end a relatively narrow eastern access from Columbus Avenue was chosen. Unlike Rockefeller Center, which was part of the fabric of the city, Lincoln Center sits on an elevated platform that separates it from the hustle and bustle of ordinary street life. An acropolis consisting of theaters and

concert halls precluded the mixed use of the area that Jacobs deemed so crucial to healthy city life.[20] In fact, the Center's uniform polished-marble palaces deliberately turned their back on the shabby housing stock to the west. The celebrations that would accompany Lincoln Center's fiftieth birthday in 2009 included a broadening of the eastern access of the performance center.

By early 1959, demolition of the old housing stock was completed and it was time to start building. Dwight D. Eisenhower, then president of the United States, attended the groundbreaking, and the roster of the other participants reads like a cultural Who's Who of mid-twentieth-century New York. Leonard Bernstein conducted the New York Philharmonic in Aaron Copland's "Fanfare for the Common Man," the National Anthem, Beethoven's "Egmont Overture," and "Stars and Stripes Forever." Rise Stevens and Leonard Warren, two of the Metropolitan's reigning stars, sang arias from *Pagliacci* and *Carmen*. A choir of Juilliard students performed, and there were speeches by Leonard Bernstein, Rudolf Bing, John D. Rockefeller 3rd, New York mayor Robert Wagner, and Robert Moses.[21]

The New York Philharmonic's new residence had to be ready in a hurry, since Carnegie Hall, its longtime home, was to be torn down. (In the end, after a vigorous campaign headed by violinist Isaac Stern, Carnegie Hall was saved.) Aesthetically the new hall would have to harmonize with its companions across the plaza. Unification was achieved by facing the buildings with travertine mined from the same Italian quarry, and by the use of arches, porticos, balconies, and glass façades throughout. Lincoln Center looks magic and festive at night when the theaters are illuminated and one sees the spectators float from one level to the next. During intermissions people spill out onto their respective balconies and watch water gush from the brilliantly lit fountain that occupies the center of the main plaza. Philip Johnson paved the plaza in an intricate design of light and dark circles surrounding the spectacular fountain, an afterthought, whose cost was borne by the Revlon Foundation.

PHILHARMONIC HALL OPENED on September 23, 1963. A red carpet was rolled out for First Lady Mrs. John F. Kennedy, Mayor Robert Wagner, Governor Nelson A. Rockefeller, and other dignitaries. The orchestra, conducted by Leonard Bernstein, intoned the National Anthem. That night the live audience consisted of three thousand people—but another twenty-six thousand listened in, hearing for the first time the now-familiar announcement "Live from Lincoln Center."

The auditorium is the heart of any theater. Philharmonic Hall's has proved to be a headache. From the very beginning the orchestra did not like the way it sounded. It was repeatedly adjusted and, in 1974, totally overhauled. Audio specialist and inventor Avery Fisher donated $10 million for the rebuilding, and the hall now bears his name.

Philharmonic Hall's art reflects the 1960s. Two sculptures—*The Hunt*, by Dimitri Hadzi, and *Archangel*, by Seymour Lipton—are the gifts of David and Peggy Rockefeller.[22] *Orpheus* and *Apollo*, two mobiles by Richard Lippold, the first works of art specially commissioned for Lincoln Center, hang from the high ceilings of the Grand Promenade. Each mobile consists of 190 gilded metal ribbons suspended by thin steel wires, a modern interpretation of old-fashioned chandeliers.

Philharmonic Hall turned out to be Max Abramovitz's most famous building. Ada Louise Huxtable, then the chief architectural critic of the *New York Times*, called it "impressive and handsome . . . from the outside, the drama of light, movement and color, seen through the glass walls, enclosed by the great tapered frame, make the structure a spectacular success in action." Critic Paul Goldberger and others were more critical, calling the major buildings of Lincoln Center "prissy and overdelicate both inside and out, with a heavy-handedness of form and vulgarity of detail that looked poor in the 1960's and look no less so now."[23]

PHILIP JOHNSON DESIGNED the State Theater and met his tight April 23, 1964, deadline. Its plaza façade echoes that of Philharmonic Hall. Eight unequally spaced columns run from the ground to the roof, forming a

portico and a large balcony. Johnson collaborated closely with George Balanchine. The dance impresario and choreographer claimed that he could not visualize blueprints. Consequently, he requested changes when the structures were already in place. Thus, the orchestra pit had to be enlarged after the concrete had been poured, and the steel light towers flanking the stage had to be modified after they had been anchored.

The inside of the almost three-thousand-seat New York State Theater is festive. Its décor, chosen to evoke the elegance of classical ballet and traditional opera, is at variance with the simplicity of the architecture. The ceiling and the front of the four tiers (rings) are gilded. The seats are upholstered in red velvet. Circular light fixtures reminiscent of giant mounted diamonds—or, some say less kindly, automobile headlights—are inserted in the front of the balconies. The same light fixtures are used throughout the theater, clustered chandelier-fashion on the front façade and on the ceiling of the auditorium, and singly elsewhere.

Because the State Theater was to host official festivities during the New York World's Fair, Governor Rockefeller had requested an extra-large foyer or promenade. Johnson designed a vast atrium running the entire width of the building and extending up to the roof. Doors open from the promenade on to a terrace from which one has a spectacular view of the entire plaza.

The most remarkable pieces of art in the State Theater, Elie Nadelman's *Two Circus Women* and *Two Female Nudes*, dominate the ends of the Grand Promenade. They are enlargements of the five-foot-tall sculptures Nadelman fashioned from papier-mâché and later cast in bronze. The Lincoln Center versions were copied and enlarged from the original bronzes belonging to Nelson Rockefeller. For the reproductions, Johnson chose white polished marble, which, when highlighted by high-intensity spotlights, illuminates the foyer. The architect felt that the roundness of the figures effectively counterbalanced the rectangular sharpness of the promenade. Johnson felt so strongly about these works of art that he donated them to Lincoln Center.

Like most of Nadelman's creations, the women are humorous, and con-

The Grand Promenade at the New York State (now David H.
Koch) Theater at Lincoln Center. The two sculptures by Elie
Nadelman are enlargements of smaller sculptures owned by
Nelson Rockefeller. (Courtesy of Jerry L. Thompson)

trast nicely with the seriousness of the State Theater. The reaction of the press to the sculptures was mixed: some writers found them monstrous; others, very satisfying. John Canaday, then chief art critic of the *New York Times*, wrote on March 23, 1964, "These paired figures have a combination of high style, sly levity and swelling monumentality that unifies with the scale and elegance of the architecture and at the same time involves them in a kind of amorous badinage with its angularities."[24]

The rest of the art distributed throughout the theater is abstract. Near the entrance is an *Untitled Relief,* by Lee Bonthecou, another one of Johnson's favorite artists. It is an assemblage of found objects, including old fire hoses and the Plexiglas turret of a World War II bomber. It was a gift of the Albert List Foundation. *Numbers,* a bas-relief by Jasper Johns, which includes a footprint of dancer-choreographer Merce Cunningham, is on the other side of the entrance.

Lincoln Kirstein commissioned and gifted two plastic-and-gilt sculptures from Yasuhide Kobashi. *Ancient Song* and *Ancient Dance* greet spec-

tators as they ascend twin travertine staircases from the entrance hall to
the orchestra level. Blanchette Rockefeller gave the State Theater Jacques
Lipchitz's *Birth of the Muses*, spiritually related to her brother-in-law's *Le
Chant des Voyelles* by the same artist.

The opening-night program included a scene from *Carousel*, performed
by the Music Theater of Lincoln Center, and *Allegro Brillante* and *Stars
and Stripes*, danced by the New York City Ballet. Governor Rockefeller
praised the legislators who had voted to fund the theater, stressing that, for
politicians, it took courage to vote for culture.

AT 8:00 P.M. SHARP, the crystal chandeliers, donated by the Republic
of Austria, ascend to the gold ceiling of New York's Metropolitan Opera
House. The buzz made by 2,563 spectators ceases. The orchestra rises,
greets its conductor, and intones the overture. The gold curtain ascends as
if by magic. For the next three hours or so, the audience is transported to
another world.

Of all the thespian arts, opera is considered the most glorious, and the
Metropolitan Opera House is Lincoln Center's grandest building. Wallace K.
Harrison, the overall architect of the entire Center, reserved this building's
design for himself.

In hindsight it seems surprising that New York City, the cultural capi-
tal of the United States, never had a grand opera house. Its first small opera
house, the Astor Place Opera House, debuted in 1847 and was followed by
the Academy of Music, which functioned as such from 1853 to 1886. The
Metropolitan Opera House, founded by the nouveaux riches of the day,
opened in 1883 on Broadway and Thirty-ninth Street.[25]

Architect Josiah Cleaveland Cady, who admitted to never having at-
tended an operatic performance, designed it. The most convincing aspect
of his winning submission was that he had fitted more boxes into the
"Diamond Horseshoe" than his competitors had. In spite of the fact that
the structure looked like a factory—it was built of bisque-colored brick
and was commonly referred to as the "new yellow brewery"—lacked stor-

age space, and had crowded lobbies and an auditorium with very poor sight lines, it made musical history. Arturo Toscanini and Gustav Mahler conducted its orchestra, and Enrico Caruso, Nellie Melba, Lilli Lehmann, Ezio Pinza, and Maria Callas enchanted its audiences.

Rudolph Bing was the Opera's director at the time it moved to Lincoln Center. Anthony Bliss headed a very conservative executive board, and it was surprising that they selected an avant-garde architect like Harrison to build their new home. Harrison submitted an elegant sketch for the opera house in 1956. Its most distinguished feature was a circular colonnade, inspired by Saint Peter's in Rome, fronting a dome-shaped hall. All told, Harriman submitted forty-three different designs for the new opera house, most of the variations necessitated by excessive cost. In 1961 he was given an ultimatum of six weeks to come up with a design that fit the budget. He did. Sacrifices included the elimination of stage elevators, turntables, and a festive entrance lobby.[26]

What emerged was a pleasing eight-story structure fronted by five arches. Some of the cutbacks are evident. Instead of spectators entering a grandiose lobby that allows them to transit from everyday bustle to the magic experience of an operatic evening, they must immediately ascend the elegant marble-clad double stairs, approved before they could be axed by a specific cost-cutting measure. The interior of what is one of the world's largest opera houses is an updated version of the red-and-gold color palette of Europe's grand halls. Various decorating committees had imposed on Harrison traditional details such as red satin swags and clusters of crystal lights.

Most important for music lovers are the excellent acoustics, the result of the close cooperation between Harrison and two sets of sound engineers. The opera house is the only major hall in Lincoln Center that did not need to have its acoustics reworked. The sight lines of the hall are also good.

Reflecting Harrison's taste, the opera house's art is representational and softer than that chosen for Philharmonic Hall or the State Theater. Visible from the plaza are two enormous Chagall murals affixed to the eight-story

walls that rise behind the glass façade. In 1948, Chagall had written to
Nelson Rockefeller expressing "a nostalgic desire to paint . . . murals . . . for
public buildings" to commemorate his stay in America during World War
II.[27] The request came to naught, but now the Metropolitan Opera Art
Committee commissioned *Les Sources de la Musique* north of the entryway
and *Le Triomphe de la Musique* to the south. Chagall's mystical beasts and
figures fill the panels. Yellow dominates the *Source* panel. It is a tribute to
Mozart, whom Chagall revered with almost religious fervor. Orpheus and
King David float in the center of the panel, sharing a lyre. They are sur-
rounded by evocations of Wagner, Bach, Tristan and Isolde, Manhattan's
skyline, and the George Washington Bridge.

Red dominates in the *Triomphe,* which incorporates portraits of Maya
Plisetskaya, the famous Bolshoi ballerina, and Rudolph Bing, and a self-
portrait of Chagall and his wife. The outline of St. Patrick's Cathedral
and silhouettes of several skyscrapers anchor the work to New York City.
The panels don't have the strength of earlier Chagall works, but they are
nevertheless upbeat and pleasing.

Modern sculptures are distributed throughout the building, most
notably three sensuous nudes by Aristide Maillol. A. Conger Goodyear,
who shepherded the MoMA through its first decade, donated the sculp-
tor's *Kneeling Woman: Monument to Debussy*, located in the foyer of the
dress circle. Two other Maillols, *Venus Without Arms* and *Summer,* are on
the grand tier level. The romantic beauty of Maillol's work complements
the restrained elegance of Harrison's architecture. More modern and less
ideally proportioned is Wilhelm Lehmbruck's elongated *Kneeling Woman,*
from 1911, which greets spectators at the top of the grand stairs. The opera
house's version was a partial gift of the Federal Republic of Germany,
which also contributed $2.5 million toward the stage facilities. At vari-
ance with these sleek modern sculptures, glass cases located throughout
the theater display historical costumes worn by past stars.

The opera house opened on September 16, 1966, with a premiere of
Samuel Barber's *Antony and Cleopatra.* By then Lyndon B. Johnson was
president, and his wife, Lady Bird Johnson, attended on his behalf. Mayor

John Lindsay, representing New York City, and other dignitaries partook of a celebratory dinner held at the Top of the Met. By then Lincoln Center and its creators were gathering laurels. Even before the opera house had been finished, Robert Moses, the instigator of the entire project, visited it, and wrote to Harrison:[28]

> Dear Wally:
>
> You know I'm not given to slobbering, so mark my words ... *I was enormously impressed yesterday by the Metropolitan Opera House*, not only by its space, lift and size, *but by its inspiration but by what you* ... were able to wring from all the sub-basement architects, acousticians and critical pit vipers, There won't be another pleasure dome like this for a long, long time if ever ...
>
> ... In spite of differences and shortcoming, *Lincoln Center will be regarded as a triumph of citizenship.* It makes me proud of the town when I begin to despair of it.

WELL-KNOWN ARCHITECTS Eero Saarinen and Gordon Bunshaft, respectively, were to design the relatively small repertory theater and library. The city would finance the library, and Mrs. Vivian Allen Beaumont, the 1,080-seat arena theater. Saarinen had designed the TWA Flight Center at the JFK International Airport, the famous Gateway Arch in St. Louis, and popular furniture. Gordon Bunshaft was responsible for Lever House in Manhattan, the Hirshhorn Museum in Washington, and the Beinecke Rare Book and Manuscript Library at Yale. Just then David Rockefeller had engaged him to design new headquarters for the Chase bank in Lower Manhattan.

Since neither architect liked his small site located in the northwest corner of Lincoln Center, they decided to combine the library and theater into a single building fronted by a reflecting pool. No significant theater had been built in New York City in decades, and the repertory theater was a stunning, welcome addition. Its entire façade consists of glass, which is

reflected in the pool. The name of the theater, and that of the current production, is written in red neon letters, adding lightness to Lincoln Center's staid atmosphere. Eero Saarinen died in September 1961, but his architectural plans for the library were complete, and underwent little change. The New York Public Library for the Performing Arts houses three different collections—music, dance, and drama—a children's library, an area for listening to recorded music, and a small exhibition space.

The library and the Vivian Beaumont share *Zig IV*, an impressive sculpture by David Smith, and *Reclining Figure*, a two-piece sculpture by Henry Moore, paid for by Lincoln Center's largest art grant: $1 million from the Albert A. List Foundation. Moore visited the site in 1962 and agreed to the placement of his sculpture in the reflecting pool fronting the Beaumont. It took him many years to complete the commission, which he describes as "a work that evokes the force of primitive art, and of a powerful human presence."

Adjacent to the reflecting pool is the Center's other major outdoor sculpture, a stabile by Alexander Calder, slyly named by its creator *Le Guichet* (The Box Office). It is a spider-like creature, which, as intended, amuses passersby. With its benches, trees, clipped hedges, and tranquil pool, the northwest area of the complex is very private, an ideal place for quiet reflection, reading a good book, or eating an al fresco lunch.

The Juilliard School is located across Sixty-fifth Street and was until recently linked to Lincoln Center's main campus by a footbridge. Pietro Belluschi, an Italian-born architect, now practicing in Oregon, designed the complicated structure accommodating auditoriums, classrooms, rehearsal halls, and dance and soundproof music studios. Alice Tully, granddaughter of William Houghton, the founder of Corning Glass, had studied music and even performed as a soprano in Europe before devoting her life to supporting the arts in New York City, her hometown. In 1966, at the suggestion of her cousin Arthur Houghton, Jr., the president of the New York Philharmonic, she funded a chamber music hall.

Together Juilliard and Alice Tully Hall were given five major works of art, including a kinetic sculpture by the Israeli artist Yaacov Agam, located

on the Juilliard terrace above the entrance to Alice Tully Hall. *Nightsphere-Light*, one of Louise Nevelson's large environmental sculptures, decorates the lobby of a Juilliard theater. To thank the Japanese business community for their $1 million gift to Lincoln Center, John 3rd gave Juilliard an impressive sculpture by Masayuki Nagare. Alice Tully gave "her" hall one of Emile-Antoine Bourdelle's brooding portraits of Beethoven, quite different from the one in Philharmonic Hall. A full-length portrait of Alice Tully herself, two small dachshunds resting at her feet, hangs in the entrance hall.

AFTER ENDLESS YEARS spent turning Lincoln Center into a reality, John 3rd finally received some hard-earned recognition. In 1964 the Concert Artists Guild bestowed on him their annual award and honored him at a glamorous dinner, and Mayor John V. Lindsay, who could not attend the dinner, recorded his tribute to John 3rd in the Congressional Record.[29]

As with his mother and "her" MoMA, John 3rd did not want Lincoln Center to be a Rockefeller institution. Indeed a large portion of the $11.5 million he contributed to the project was given anonymously, and whenever possible he avoided the limelight. Upon his retirement from Lincoln Center's chairmanship on May 11, 1970—fifteen years after he had accepted the position of president of the Exploratory Committee—a bronze plaque reminds the casual visitor of the reasons why he persevered:

> The arts are not for the privileged few, but for the many. Their place is not on the periphery of daily life, but at its center. They should function not merely as another form of entertainment but, rather, should contribute significantly to our well being and happiness.[30]

The Rockefeller Collection at the Fine Arts Museums of San Francisco

THE BUDDHAS, SCROLLS, and Asian pottery Blanchette and John D. Rockefeller 3rd collected with such enthusiasm overwhelmed the décor of the Beekman Place apartment in Manhattan and of Fieldwood Farm, their home in Pocantico Hills. In his role as ex officio participant in postwar United States–Far Eastern relations, John 3rd hosted many foreign and domestic dignitaries. As he told Martha Hutson during an interview for *American Art Review*, he had become concerned that people who were unfamiliar with Oriental art would be startled and overwhelmed by the décor:

> So we thought, to help a non-Oriental person feel more at ease, we'd get just a few French Impressionists. Everybody likes those. They're known and respected and enjoyed . . . We did that. Then all of a sudden, we realized that we had nothing that represented our own country. We have quite a few foreigners come to our home . . . [and] felt a little embarrassed.[1]

To remedy this situation the couple decided to buy a few American paintings during their regular visits to New York art galleries and auction houses.

Winslow Homer, Backgammon, *1877.* (Fine Arts Museums of San Francisco, Gift of Mr. and Mrs. John D. Rockefeller, 3rd)

At Hirschl and Adler, a prominent art dealer, they came across *Backgammon*, a watercolor by Winslow Homer, and bought it in 1960. In this genre painting, two Victorian ladies sit on a red sofa playing the then-popular game. Fresh from Homer's easel in 1877, the work had been exhibited at the New York Academy of Design Water Color Exhibition, where a reviewer found it so exquisite that he at first mistook it for a European work.[2]

In 1964, John 3rd and Blanchette bought Fitz Henry (Hugh) Lane's *Approaching Storm, Owl's Head*, painted in 1860. Given their attachment to Maine, it is not surprising that the couple were enchanted by the view of the stately sailing boats floating on a calm sea threatened by ominous clouds. During the 1960s, Lane, like most eighteenth- and nineteenth-century American painters, had been seemingly forgotten, and was undervalued.

Like his mother, John 3rd kept an eye on his checkbook. Even at the height of forming his American collection, his expenditures averaged only $1 million to $1.5 million annually.[3]

As they became more serious about American art, John and Blanchette recruited a suitable expert. Like Sherman Lee, their Asian art expert,

Edgar Preston Richardson was a museum director whose early career was shaped by William R. Valentiner. Richardson had trained at the Pennsylvania Academy of Fine Arts, America's oldest surviving art museum. After graduation in 1930, he joined Valentiner at the Detroit Institute of the Arts, assumed its directorship in 1954, and stayed until 1962.

Richardson was a busy man. He became the country's foremost expert on American art, believing that an in-depth study of this field was essential for an understanding of America. A prolific writer and researcher, he founded the Archives of American Art, the principal repository of primary sources for the field. In 1970 the Smithsonian assumed responsibility for the archive. After his retirement from Detroit, Richardson headed Henry Francis Du Pont's Winterthur Museum in Delaware, became an advisor to the Smithsonian's National Portrait Gallery, and president of his alma mater in Philadelphia. Richardson was the ideal person to help the Rockefellers form their American art collection. In December 1964 he visited them at their home in New York and rapidly developed a deep friendship with John 3rd. The men were roughly the same age, intensely devoted to America, and aware of the grave problems it faced in Vietnam and elsewhere.

At first the Rockefellers viewed their collection as a private undertaking and contemplated the acquisition of about fifteen to twenty paintings. When they formalized their arrangement with Richardson they explained that the criteria determining their choices were a personal liking of the paintings, their high quality, and that they fit in with the décor of the apartment.[4]

Richardson began by educating his advisees about the nature of American art. Painting of the nineteenth and early twentieth century, he explained, could be divided into eight groups: early nineteenth-century Romantic paintings, early landscape, early genre, paintings of the West, early still life, late nineteenth century, still life, and early twentieth century. He supplied the names of the most representative painters of each epoch. Comparing American works to French works of the same period, he wrote:

The French in the nineteenth century had a few great figures in painting, surrounded by a mass of mediocrity, just as in France there is Paris surrounded by the provinces. Our country is a big and varied continent and our paintings are somewhat of the same kind . . . there are many interesting figures but none dominant. The good men sometimes did bad pictures. This makes it fun to try to pick the enchanting pictures but it discourages an attempt to draw up a canon of twenty names.[5]

John, Blanchette, and Richardson adopted a rating system similar to the one used with Sherman Lee to evaluate their Asian purchases. A was for paintings of exemplary beauty; B was for top museum quality; C was acceptable museum quality; D was for works that were good but undistinguished; X was for exceptional works by little-known artists; and O was for "exquisite, small-scale works that no matter of the artist's fame prompted the exclamation 'Oh, what a delightful little picture.'"[6] According to Marc Simpson, it is the X and O pictures that make the Rockefeller Collection such a delight.

The Rockefellers rapidly exceeded the number of American paintings they intended to buy. In 1965, Richardson suggested Thomas Sully's painting of his son, *Alfred Sully*, and William Michael Harnett's *The Meerschaum Pipe*. The Rockefellers bought both, as well as *The Mother*, by Eastman Johnson, which they discovered on their own. All three works were small. That year Lawrence and Barbara Fleischman of Detroit decided to sell their collection of American paintings at the Kennedy Gallery in New York. When John 3rd consulted Richardson about the sale of the Fleischman pictures, Richardson told him that he had been intimately involved with the collection and was sad to see it dispersed. He also felt that the availability of the collection was fortuitous, and he recommended paintings by Thomas Cole, Frederic Church, Charles Willson Peale, Raphaelle Peale, William Page, Thomas Eakins, and Grant Wood. The Rockefellers would buy them all.

The Kennedy Gallery let the Rockefellers take the pictures home on

consignment. In his letter to his advisor, John 3rd wrote that he felt that Cole's *View Near the Village of Catskill, 1827* was a bit bleak and did not stir his emotions. Richardson answered immediately:

> It would be a great mistake to buy the Cole, or any other picture, unless you genuinely enjoy it. You are not creating a museum of the history of art in the United States . . . the collection should reflect your own temperament, and your personal exploration of the long story of art in America. It will be a much more interesting collection for you, and for visitors to your apartment, if it remains truly personal.[7]

At the outset John 3rd had told Richardson that he was particularly fond of works by John Singleton Copley. Thus, like his mother, he celebrated America's artistic beginnings, though Abby had chosen to assemble works of America's untrained artists, while her son favored academically trained ones. However, there would be some overlap. John and Blanchette, for example, bought a version of Abby's beloved *Peaceable Kingdom*, by Edward Hicks (ca 1846). They also bought early formal portraits by the "De Peyster Painter" (1730), John Smibert (1732), and Robert Feke (1748), and works by John Singleton Copley (ca. 1771). John 3rd had told Richardson that he loved Charles Burchfield (1893–1967), whose mythical paintings were also a favorite of his mother. Abby's patronage had contributed to the success of this shy Midwesterner who early on had supported himself by designing wallpaper. For their collection, John and Blanchette chose *Spring Flood*, an image of a raging stream framed by the arches of a bridge and denuded tree limbs. Grant Wood's crisply horizontal *Dinner for Threshers*, dating from 1934, a splendid example of Depression-era painting, was inspired by the painter's childhood in Iowa.

Abby Rockefeller's influence is apparent elsewhere in the collection. There is Ben Shahn's *Ohio Magic*, which Timothy Anglin Burgard, who became curator-in-charge of American art at the Fine Arts Museums of San Francisco (FAMSF) in 1996, compares to "the proto-Surrealist metaphysical paintings by the Italian modernist artist Giorgio De Chirico."[8]

Abby would also have approved of the works of Marsden Hartley, William J. Glackens, and Rockwell Kent.

Beginning in 1970 the Rockefellers' view of their collection as a purely private undertaking began to change. They bought more expensive and larger, museum-size pictures, including George Caleb Bingham's 1846 *Boatmen on the Missouri*. Bingham, who grew up and lived in Missouri, then the American frontier, was mostly self-taught. He trained as a cabinetmaker, but soon became a portrait and genre painter. In 1973, John 3rd purchased *The Mason Children: David, Joanna and Abigail* (1670), attributed to the Freake-Gibbs Painter, for half a million dollars.

John 3rd and Richardson started to discuss the fate of the collection.[9] They considered institutions located in the nation's capital, and in the middle or western part of the country, where a superior collection of American art would fill a definite need. In 1970, John 3rd visited San Francisco's California Palace of the Legion of Honor and the de Young Museum— then still two separate institutions—and was favorably impressed.[10]

Horace Pippin, The Trial of John Brown, *1942*. (Fine Arts Museums of San Francisco, Gift of Mr. And Mrs. John D. Rockefeller, 3rd)

It would, however, take John 3rd seven more years to make a definite commitment; in the meantime, the Rockefellers went on collecting, emphasizing the acquisition of major works. Because so many early American works were portraits, they were partial to pictures that told a story. One such painting was Thomas Anshutz's *The Ironworkers' Noontime*, a superior work by a lesser-known painter (a fact that John 3rd liked),[11] whom Richardson had featured in his widely used textbook *Painting in America*.[12] A poignant image of America's industrial age that presages the work of the Ashcan artists, the painting has a definite Old Master quality.

Two other works that tell an important story are Thomas Hovenden's *The Last Moments of John Brown*, from around 1884, and Horace Pippin's *The Trial of John Brown*, from 1942. The Hovenden picture shows abolitionist Brown, surrounded by guards with fixed bayonets, descending the front stairs of the Charles Town, West Virginia, jail. As a last gesture he hugs a small African American child held up to him by the baby's enslaved mother. When the painting was exhibited at the Met in 1884, the art critic of the *New York Times* wrote, "Certainly it is the most significant and striking historical work of art ever executed in the republic."[13]

Fifty-eight years later, Horace Pippin, a self-taught African American artist, painted a bearded John Brown lying on a stretcher in front of his jury. In "How I Paint," a collection of interviews by Holger Cahill conducted at MoMA, Pippin explains about the picture:

> The colors are very simple such as brown, amber, yellow, black, white and green. The pictures, which I have already painted, come to my mind, and if to me it is a worth while picture I paint it . . . My opinion of art is that a man should have love for it. Because my idea is that he paints from his heart and mind. To me it seems to be impossible for another to teach one of Art.[14]

Landscapes, interiors, and still lifes are an important component of the collection. One of the earliest landscapes, Thomas Cole's *View Near the Village of Catskill, 1827*, was acquired from the Fleischmans, even though

John 3rd had not liked it initially. The couple also bought Cole's *Sunrise in the Catskills*, which Blanchette donated to the National Gallery of Art, in Washington, D.C.

The portrait of *Luman Reed*, by Asher B. Durand, painted in 1836, memorializes an early patron of the Hudson River School. Once a week the wholesale grocer opened the doors of the private museum housed in his Greenwich Street mansion in New York. After his death the collection was transferred to the museum of the nascent New-York Historical Society, which in time would absorb other orphaned collections.[15]

THE MUSEUM TO which John 3rd was going to donate his collection had to demonstrate its serious interest in American art. To this end, Ian McKibbin White, the then-director of FAMSF, had stepped up the institution's American art and furniture purchasing program and had increased gallery space devoted to its American collection. In 1976, to celebrate the Bicentennial, White suggested an exhibition of a large portion of the Rockefeller collection. The invitation was accepted, and 106 Rockefeller pictures traveled to San Francisco. The Whitney Museum, perhaps in a belated attempt to capture the collection, arranged a New York venue.

The public responded warmly to the San Francisco show. It drew an average of a thousand visitors a day, totaling ninety-two thousand during the entire length of its stay. The press was most enthusiastic. Joshua C. Taylor reported for the *Smithsonian* that "Such a group of paintings provides endless questions and infinite satisfactions. The collection has been put together less with a sense of possession than with a delight in knowing." The *Los Angeles Times* found the exhibition rewarding, filled with pictures that "seem to inspire affection." When the show opened in New York, Emily Genauer speculated in the *New York Post* of September 18, 1976:

What American art does a man buy for himself who was brought

up to see in his home each day the Unicorn Tapestries, now at the
Cloisters. . . . What does a man buy for himself when his mother was
one of the three founders of the Museum of Modern Art . . . a lover
and buyer—long before most people ever heard of them—of works by
Cézanne, Gauguin and Seurat?

What [the Rockefellers] live with . . . are simple, modest, generally
small, genteel and even homely works by American artists from the
17th century to the present.

Tongue in cheek, Genauer goes on to discuss the portrait of *Anna
Porter Brown*:

There is no suggestion of a smile or warmth in her long, severe face.
Her costume is mostly gray . . . She carries in her hand what must be
a Bible. The one person she calls to my mind more than anyone in the
world is John D. Rockefeller, Sr.[16]

Not all reactions to the exhibition were positive. Some viewers and re-
porters were incensed because the collection did not include more women
or minority painters. Artists Meeting for Cultural Change, an umbrella
group protesting the use of art to celebrate the Bicentennial, wrote that it
was improper to use the art of "a wealthy minority sector of the popula-
tion" to celebrate the Bicentennial.[17] In New York the show at the Whit-
ney was picketed, and Hilton Kramer, art critic of the *New York Times*,
described the collection as a "very pleasant, placid unspectacular exhibi-
tion of (mainly) small 19th-century American realist paintings guaranteed
to act as a soothing poultice for sensibilities inflamed by a surfeit of mod-
ernistic art."

The Rockefellers' pace of collecting after 1976 slowed considerably,
though they continued to add important pictures to their collection, in-
cluding works by Albert Bierstadt, Charles Burchfield, Horace Pippin, Ce-
cilia Beaux, Andrew Wyeth, and, finally, as they had begun, a Winslow
Homer.

In January 1978, John D. Rockefeller 3rd designated the Fine Arts Museums of San Francisco as the sole recipient of his American Art collection. He was to retain a lifetime interest. Six months later he was killed in an automobile accident near his home in Pocantico Hills. In 1979 his family transferred more than one hundred paintings to San Francisco. The city proved to be a magnet for other major gifts; one donor, Edna Root, a San Francisco artist and philanthropist, endowed an American art curatorship. Both Blanchette and son John (Jay) D. Rockefeller IV attended the official opening of the collection in San Francisco. Thereafter, Blanchette visited it repeatedly, making additional gifts. After her death in November 1992, her children transferred an additional twenty-eight works of art to San Francisco.

SAN FRANCISCO'S MAJOR art museums, the M. H. de Young Museum and the California Palace of the Legion of Honor, grew up separately but merged at about the time that John 3rd was looking for a suitable home for his collection. As a result of the reorganization, all American paintings moved to the de Young, located in Golden Gate Park.

By the end of the second millennium the old de Young had been so extensively damaged by successive earthquakes that it was decided to replace it with a new building. The design was awarded to the Swiss team of Herzog and de Meuron, who incidentally had been finalists for MoMA's latest incarnation. The media reaction to the stark ultramodern building was favorable. Reviewing the museum for the *New York Times*, Nicolai Ouroussoff declared on October 13, 2005:

> At times it seems that architects have become the big bad wolf of the museum world. Too often flash and bravura win out over contemplation, the argument goes—and architecture triumphs over art. . . . But the new de Young Museum . . . is proof that despite these naysayers, a museum can be both gorgeous to look at and a cozy place to view art.

The American art galleries are located on the second floor of the new de Young. As befits much of the work on view, the space is traditional. The paintings, lit by indirect natural light, are well spaced, so that each work receives its due.

As John 3rd had hoped, the museum's American art collection continued to grow. Today the de Young owns approximately one thousand American paintings and thousands of works in other media, dating from the seventeenth to the twentieth century. Even so, the Rockefeller paintings continue to shine. As director Harry S. Parker III notes in his foreword to *Masterworks of American Painting at the de Young*:

> Begun in 1979 as a gift, and completed as a bequest in 1993, the Rockefeller Collection, principally comprising works from the colonial period to the nineteenth century, served as a catalyst for the growth of a survey of American paintings unrivaled in the western United States. Of the 117 essays on works selected for this book, forty-five discuss paintings that came from the Rockefellers.[18]

WHEN HE DIED so unexpectedly, on July 10, 1978, John D. Rockefeller 3rd was seventy-two years old. His memorial service was held on July 13 at Riverside Church, where he had been married forty-six years earlier.[19] Jay Rockefeller, by then the governor of West Virginia, spoke lovingly and proudly of his father, characterizing him as a "Gentle person—dignified, modest, some say shy—but yet a man of bedrock strength and perseverance. He spent his entire life in service to others . . . but never thought of himself as a do-gooder. He was not self-satisfied. He was serious, purposeful, idealistic, realistic, totally dedicated."

Steven Rockefeller described his uncle as the most understanding of the Rockefellers. Sherman Lee, John 3rd's Asian art advisor, recalled his friend's inborn reserve and his life-long struggle between his material and intellectual gifts: "John Davison Rockefeller 3rd was committed by tradi-

tion and by personal conviction to aiding the fulfillment of others, both privileged and underprivileged. He was successful in this because he was himself privileged and underprivileged—privileged in his legacy, intelligence and tenacity; underprivileged in his reticence..."

In 1963, Rockefeller had established the John D. Rockefeller 3rd Fund, which, inspired by his involvement in Lincoln Center, included a program for early education in the visual arts. Singling it out in the conclusion of his eulogy, Lee Sherman said: "The success of such an effort can only be judged by later fruition in adult life; but John was a patient man and knew that one began at the foundation, in the early years."

Blanchette outlived her husband by fourteen years. In December 1992, she died at home surrounded by her four children. Jay Rockefeller and Richard E. Oldenburg, MoMA's current director, reminded attendees at her memorial service at Riverside Church[20] of the close bond between Abby and Blanchette, and how both had defended their love of contemporary art in spite of their spouses' hostility.

Jay spoke of his mother's grace and loveliness, pointing out that some people believed that Blanchette had shown the Rockefellers how to be Rockefellers. "My mother was both a very public and a very private person. But ... she was always the same unique woman. She kept her special nature and changed for no one." He recalled how, together with Nelson, Blanchette had "turned the New York State legislature on its head" to win air rights for MoMA so that it could build the Museum Tower apartment house on Fifty-third Street. "Today, we want to celebrate the fullness of my mother's life it was a glorious, happy, vital and productive life ... Her commitment to the arts and to classical music was total and greatly fulfilling for her."

Richard Oldenburg recalled that when she was MoMA's president, Blanchette tactfully and effectively smoothed the transition from a "private institution to a much more public one [which was rather painful.] ... In her quiet way, she promoted such changes and initiatives, while firmly opposing any that might compromise the Museum's stan-

dards or integrity." Daughter Alida recalled the peaceful times at their house in Pocantico Hills, with classical music filling the rooms, her mother writing letters, her father reading, while "outside the picture window, soft green pastures gave way to a view of the Hudson River and the Jersey Palisades beyond."

Jay Rockefeller, however, did not forget his mother's last tortured years when she suffered from Alzheimer's, "deeply painful to her children and friends, and . . . profoundly humiliating to her." In 2000 he founded the Blanchette Rockefeller Neurosciences Institute, an $80 million joint re-search venture of Johns Hopkins University and West Virginia University, located in Morgantown, West Virginia.[21]

The Nelson A. Rockefeller Empire State Mall

N O ONE WAS happier than eighty-four-year-old John D. Rockefeller, Jr., when, in 1958, his son Nelson was elected governor of New York State. It was, in Cary Reich's words, "a climactic vindication, the capstone of a half century's struggle, to efface the [family's] robber baron past."[1] Three years after the dramatic election, and after his father's death, Nelson would have shocked him by divorcing Tod and marrying Happy (née Margaretta Fitler) Murphy, the mother of four young children. In time, Nelson and Happy would have two sons of their own, Nelson Aldrich, Jr., and Mark Fitler.

Nelson viewed the governorship as a stepping stone to the U.S. presidency; nevertheless, he loved his job and was an active, effective governor.[2] Two of his priorities were education and art. He transformed a handful of teachers' colleges into a sixty-four-campus state university system, the largest in the country, and his administration enacted America's first Council for the Arts, which served as the model for the National Endowment for the Arts.

As soon as he arrived in Albany, Nelson also promoted art on a more personal basis. On December 31, the afternoon of the day the government was changing hands, a truckload of his collection of modern art arrived at New York State's many-turreted Victorian executive mansion. The new

governor, assisted by MoMA's Dorothy Miller and his personal curator, Carol Uht, was still busy hanging pictures when guests arrived for the inaugural dinner.

Five years later, Nelson argued that his bringing all this strange art to the state capital had "far-reaching and beneficial effects."[3] During the 1964–65 World's Fair, held in Flushing Meadows, the New York State Pavilion was the only one to exhibit contemporary American art. In 1971, Nelson Rockefeller enlarged on the topic:

> When I was fortunate enough to be elected Governor of New York, I decided I would share my enjoyment of some of the modern art objects . . . with my fellow politicians . . . It was a new experience for Albany . . . [To begin with] I got the standard reaction: "My son who is five years old, could have done better." [But] little by little they got used to the art. Soon they would come to see whether there was anything new in the house.[4]

THE GOVERNORSHIP REQUIRED a move to Albany, New York State's capital since 1797. In 1609, when Englishman Henry Hudson sailed the *Half Moon* up the river that would bear his name, he claimed the site for the Netherlands. In 1624 the Dutch West India Company founded Fort Orange there, which became a prosperous fur trading post. Forty years later, when the British took over, it became Albany. Its early citizens dwelled along the banks of the Hudson, which included The Pastures, a large waterlogged parcel of common grazing land. As the town grew, it climbed up the steep hills hugging the river, though multiple streams and ravines traversed the terrain.

Albany's days of glory began in 1807, when Robert Fulton adapted the steam engine to maritime use. In September of that year Fulton used his newly built steamship, the *Clermont*, and ran the world's first scheduled passenger service between Albany and New York City. Five years later, ground was broken for the Erie Canal, which connected Albany with the

Midwest. The canal opened in 1824, turning New York City into the East Coast's most important port, and Albany into a key transport junction and a major industrial and lumber-milling center. Albany's population, swelled by Irish, Italian, and Jewish immigrants, and by African Americans, grew steadily. From 1810 to 1850, it was the ninth or tenth largest city in the United States. The town prospered, building a cathedral, elegant legislative buildings, a grand railroad station, hotels, and saloons; it sported a red-light district second only to the one in Chicago.

By the mid-1900s the economic fortunes of the city and its neighborhoods, especially the old historic areas of town, had declined, and by the time Rockefeller arrived, the city was drab, almost an object of ridicule. The neighborhood in the vicinity of the old Pasture, by then referred to as "the Gut," had suffered most. It was run down and filled with rooming houses, cheap eateries, saloons, gin mills, and houses of prostitution, though here and there solid citizens had hung on to their abodes.[5]

UNTIL THE CIVIL WAR, New York State's governing body had met in modest buildings located up the hill from the densely populated older parts of town. In 1865 the legislators approved plans for a new capitol fit for America's Empire State. Its construction would take thirty-two years, involve three different sets of architects, and gobble up more than $25 million, a sum that exceeded the cost of any other state capitol, and even that of the Capitol Building in Washington. One reason for this enormous expenditure was that the subsoil of the building site consisted of shifting quicksand, which hampered construction and resulted in numerous cost overruns. While the "Château-on-the-Hill" reached completion, governors, including several who would go on to the presidency of the United States, came and went.

Today New York State's Capitol is a majestic memento of a bygone era. Its price and the difficulties in building it are forgotten. The building has served its state well, and it is still a conversation piece. "No one is ever lukewarm in his opinion of the Capitol in Albany," wrote Albert B. Corey,

New York State historian, in 1963. "Either he looks upon it as an atrocity of jumbled architecture or he enjoys it as a successful blending of architectural forms which is aesthetically pleasing." [6]

AT THE TIME of his election, Nelson had recently visited Brasilia, Brazil's glamorous new capital, built in forty-one months between 1956 and 1960. He had been even more impressed by the Potala Palace, the Dalai Lama's former mountainous residence in Tibet, which sat on a huge platform that straddled a ravine. Soon after he arrived in Albany, Governor Rockefeller toured the capitol. He was impressed, and requested the writing of the aforementioned history. The rest of Albany horrified him. He hated the down-at-the-heels neighborhood that surrounded the Executive Mansion as well as the nearby State Capitol. He also realized that the administration had outgrown its by-now-inefficient physical plant. Office buildings were scattered around Albany. The Motor Vehicle Bureau alone did its business in sixteen different locations.

Just then Princess Beatrix of the Netherlands came to town to celebrate the 350th anniversary of Henry Hudson's discovery of the river now bearing his name.[7] Like her erstwhile countryman, the princess arrived by boat—a yacht loaned by Laurance Rockefeller. The story goes that Nelson was ashamed of Albany's shabbiness and decided to change matters. But surely if the Royal House of Orange had not come to visit its former colony, Rockefeller would have found another pretext for a major building project. As he admitted, he suffered from an "edifice complex."[8] Two years into his first term he convinced the legislature to build, in his words, "A Capital City for New York State second to none in our nation— or indeed, in our world."[9]

Nelson was not the first governor who considered revamping the state's administrative center. Thomas E. Dewey had wanted to move it to Albany's outskirts. Though this would have been much cheaper and would have avoided tearing down entire neighborhoods, the business community had opposed the plan.

Nelson's vision was grander. He was to create an enormous center-city campus extending from the old capitol to the Executive Mansion. The fact that the scheme involved straddling a valley—the site of the old Rat Creek—or that it required the demolishing of Albany's oldest neighborhoods, did not faze him. On the contrary, he figured that the old ravine could accommodate a subterranean road system, thereby eliminating automobile traffic from the center proper. An immense, quarter-mile-long "platform" building, giving the Mall the appearance of the Dalai Lama's palace, which Nelson so admired, would top the highways. Conveniently, the platform building would provide parking, connect the individual buildings, and house restaurants and stores. Ultimately the construction of the arterial highway system increased the cost of the project, necessitated the demolition of existing housing stock, and contributed to the disruption of normal city life.

MOST MAJOR ROCKEFELLER-SPONSORED enterprises were well thought out and highly successful; the Albany project was a disaster— at least during the endless years of its construction. From the very first, Nelson realized that he needed allies to shepherd his extravagant scheme through the legislature. He started small. In March 1962, he asked the legislature to condemn 98.5 acres in the city center and provide a mere $20 million to pay for the land and housing stock.[10] The area, which included much of the Gut, consisted of 40 city blocks, 350 businesses, and 3,300 dwellings housing 6,800 residents.[11] Mayor Erastus Corning 2nd was violently opposed to the project, as was State Comptroller Arthur Levitt. To overcome their initial objections, Nelson appointed a commission consisting of businessmen. They found that the proposed location of the so-called South Mall was perfect. The city of Albany opposed the scheme and sued the state; but it lost the suit, and the expropriation proceeded.

Erastus Corning 2nd changed his mind about the desirability of the Mall and devised a complex plan for financing it without having to ask for legislative and voter approval. He became the project's "financial archi-

tect," without whom, according to Rockefeller, it would not have come to fruition. The initial cost estimate for the undertaking was $400 million, but this kept being revised upward. As expected, Wallace K. Harrison was asked to be the Mall's chief architect. In spite of his current involvement with Lincoln Center, he accepted. Harrison would not be the sole architect involved in this mammoth project, though the remarkable uniformity of the finished buildings indicates that he and his patron had the final say in what would be built.

On April 23, 1963, a scale model of the complex was exhibited in the lobby of the Capitol. It included ten separate buildings: a large forty-four-floor skyscraper—now named the Erastus Corning 2nd Tower—four twenty-three-story "Agency" (office) buildings, plus the Legislative Office Building, the Justice Building, the Performing Arts Center, the quarter-mile-long Swann Building housing the Motor Vehicle Bureau, the equally

The Nelson A. Rockefeller Empire State Mall in Albany. (New York State Office of General Services, GNAR Empire State Plaza, Albany, New York, USA)

long Platform Building, and the old capitol. Apart from the Swann Building, which delimits the campus to the west, all the new buildings were grouped around the long axis of two aligned reflecting pools. The finished Mall would closely resemble its scale model.[12]

That July, Nelson mounted a giant crane and officially started the demolishing project. He would maintain an upbeat mood during the entire building process. Once more Albany was plunged into decades of noise, demolition, and construction.[13] Once the site was cleared, the churned earth of the now-vacant acreage looked to Happy Rockefeller, the governor's wife, as if "*Lawrence of Arabia* could have been filmed right here."[14]

Almost as soon as they started digging, construction workers hit the quicksand that a century earlier had plagued the builders of the Capitol. As before, the unstable subsoil made it both extremely difficult and costly to erect the necessary foundations. The enormous five-floor-deep Platform Building required twenty-four thousand steel pilings. For two years the construction site and an infernal noise filled the neighborhood.

Barbara R. was a child at the time the Mall was built. Her very desirable home was in the path of one of the approach roads, and the family was forced to relocate. "I still divide my life in 'before' and 'after' the Mall," she recalled forty-five years later. However, she also remembered the friendly flagman who monitored the endless trucks that dumped part of the three million cubic yards of excavated clay and mud at the end of the road and the booming business of her lemonade stand.[15]

Other problems emerged. There were intense labor shortages and disputes, and strikes and delays caused by temporary shortages of funds. The unorthodox way in which the Mall was financed invited graft, cheating, theft of building materials, featherbedding and blackmail by labor unions, and other types of thieving. All of this went unpunished, even though the local Albany press documented the malfeasances.

Costs kept rising. From an initial $400 million, estimates rose to $1 billion. At one point it was feared that the final tab would be $2 billion. In the end, the Mall cost about $1.7 billion. Construction also took much longer than expected.[16]

Rockefeller was too impatient to wait for the actual cornerstone to be laid. On June 21, 1965, he dedicated an enormous block of white Vermont granite at an outdoor ceremony.[17] His passion for the huge project never flagged. Happy Rockefeller recalled "the many weekends at home in Pocantico with Nelson and Wally scrutinizing plans and blueprints while lunch was waiting."[18] Decisions had to be made about the sheathing of the building—white marble except for the Performing Arts Center, whose rounded form required poured concrete. The latter, nicknamed The Egg, is by far the most interesting building of the Mall. According to a popular tale, Nelson conceived it during a lunch when he inverted half a grapefruit on a plastic container of cream and told Harrison that the plaza needed "something like that." Harrison, who felt that the ovoid shape of the auditorium would relieve the boxlike uniformity of the Mall, complied.[19] In any case, the two auditoriums of the Performing Arts Center have the roundness the architect favored. The lighting and ambiance of these spaces are reminiscent of Rockefeller University's gemlike auditorium.

The triumphal arch proposed for the southern end of the Mall was deemed too slight a counterweight to the old Capitol. The airy-looking, elegant Cultural Education center replaced it. Reminiscent of the buildings at Lincoln Center, it sits on a platform of its own. Typical of Harrison's designs, a portico of columns and arches fronts the ground floor. The building houses an old-fashioned carousel, a museum, and various other cultural services, and offers relief from the overly rigid atmosphere of the Mall.

Completing the Mall was uppermost in Nelson's mind. In 1966, when he was campaigning for his third gubernatorial term and feared that he might lose, he instructed his staff that "before we go" all the proposals for the South Mall must be under contract and all the art must be bought.[20]

The South Mall was Nelson and Harrison's last common venture. At the beginning of the project the two were in their prime. A photograph shows them standing in front of an unidentified building. An inscription by Nelson reads, "To Wally Harrison from his devoted friend and admirer with gratitude." In Albany, however, an increasingly headstrong Nelson

kept overruling a progressively resentful Harrison, and the project ended their friendship. For years Nelson had supplemented Harrison's income by paying for the care of his mentally ill daughter. After Albany, Nelson withdrew both emotional and financial help from the aging architect.

THE MONOLITHIC ALBANY MALL garnered few laurels. The press lampooned the government complex. "Stylistically, the Albany Mall leaves one not knowing whether to laugh or cry" was one comment; Paul Goldberger[21] described it "as a monumentally silly work of architecture . . . [looking more] like a Buck Rogers view of the city of the future than like anything real." Architectural art historian Carol Herselle Krinsky[22] called it "St. Petersburg-on-the-Hudson." She also experienced it as a ceremonial place, writing, "The separateness of the complex is made clearer by its elevation on a platform, which differentiates the ground level here from that of the rest of Albany."[23]

In 2005, Lo Faber, a jazz musician and essayist, reviewed the building of the Mall in great detail. The twenty-three page article, entitled: "Rocky's Last Erection: The Architectural, Economic, and Urban Planning Fiasco that is the Albany Mall," stressed the indignant reaction of the architectural community. Farber extensively invokes art critic Robert Hughes, a vociferous opponent of International style architecture. Hughes's book, *The Shock of the New*, compares the mall to totalitarian architecture and describes it as illustrating the "International Powers Style of the Fifties."[24]

Professional critics and laypersons alike felt that Nelson was building a memorial to himself. Albany-born journalist William Kennedy put it most eloquently: "that billion-dollar monument he foresaw as a hymn to forever, its vast acres of marble designed to be whispering 'Nelson . . . Nelson . . .' to the silent infinity next door, long after the last of us has gone away."[25]

TO NELSON ROCKEFELLER art was as essential as religion was to others. From the very first it was to be part and parcel of the Mall. Tastes

in art had evolved since Junior and his Art Council chose European-born Art Deco to embellish Rockefeller Center. American Abstract Expressionism dominates Albany. Most works are by artists associated with New York State. The Empire State collection consists of ninety-two paintings, sculptures, and tapestries. It is the largest collection of modern American art in any single public space that is not a museum.

A small art commission appointed by the governor selected the works. The commission was chaired by Wallace K. Harrison and included MoMA's René d'Harnoncourt—who upon his death was succeeded by Dorothy Miller—Robert M. Doty, and Seymour H. Knox, of the Albright-Knox Art Museum in Buffalo. Though Nelson was not a member of Albany's art commission, he had final approval of the art selected. He never used his veto, but the commission was certainly aware of his taste.

Most of the works of the Empire State Collection date from the 1960s and '70s, which makes them ideally suited to public spaces. Art historian Irving Sandler points out that these artists used "color in larger and larger expanses to make a visual and emotional impact . . . To intensify the immediate effect of their pictures the artists turned them into environments, sometimes replacing entire walls, figuratively enveloping the viewer."[26] Sculpture, too, had grown in size.

Rockefeller built the Albany collection when he was buying art for his sculpture garden and galleries at Pocantico Hills, and according to curator Dennis Anderson, there was a lot of cross-fertilization. It was almost as if he were saying, "one for me, one for them."[27] The art displayed in the Erastus Corning Tower is most intimately related to Nelson Rockefeller. Mark Rothko's blue *Color Field Painting* is Dennis Anderson's favorite: "The painter's luminous fields of color, often in window-like rectangular arrangements such as this one, epitomize the spiritual side of Abstract Expressionism. Mark Rothko described his paintings as the simple expression of a complex thought."[28]

The legislature had budgeted about $2.5 million for the art collection. As extrapolated from *White Center*, a Rothko painting David Rockefeller bought in the 1960s for $10,000 and sold forty-seven years later for more

than $72 million, Albany's art collection was indeed a good investment, and the only bargain of the entire building project.

In the Corning Tower, Albany's Rothko currently hangs across from a silk-screen portrait of Governor Rockefeller by Pop Art founder Andy Warhol. New York's vivacious governor literally appears to burst out of his frame. The portrait is on loan from Happy Rockefeller. Two likenesses of Nelson and Happy by Warhol hang in Kykuit's underground art gallery.

Number 12, 1952, a very colorful, large Abstract Expressionist work by Jackson Pollock, is a gift of Governor Rockefeller to New York State. "It is the oldest artwork we have," Dennis Anderson says, "and it survived a serious fire [which swept through the Executive Mansion on March 2, 1961] and caused the paint to bubble and burn. Then the water from the fire hoses washed away some background color. The painting ended up like

Jason Seley's Colleoni II, *from the period 1969–71, is constructed out of automobile bumpers.* (New York State Office of General Services, GNAR Empire State Plaza, Albany, New York, USA)

a charred monochrome." The work was expertly restored to its original appearance in 1988.

The glass-enclosed atrium of the Corning Tower, with its spectacular view of the river and the highlands, is an ideal space for the display of sculpture. It holds Dennis Anderson's other favorite: a group of abstract steel constructions by David Smith. Nearby, Alexander Calder's *Four at Forty-Five*, a large orange-black-and-yellow mobile, swings from the ceiling.

During the 1950s, Jason Seley used automobile bumpers to weld an equestrian statue inspired by the one created by Andrea del Verrocchio in Venice in 1496. The tongue-in-cheek pomposity of Seley's *Colleoni II* horseman adds a note of merriment to the mostly serious works of the Empire State Collection.

George Segal's plaster-cast sculptures feature ordinary people, unemployed workmen, and even concentration camp victims. The Empire State Collection owns *The Billboard*, depicting a white plaster-cast man perched on a wooden walkway laboriously painting a blue *O* onto a black background. Louise Nevelson's construction *Atmosphere and Environment V*, displayed in the atrium of the Corning Tower, looks fabulous. The almost legendary Russian-born artist who arrived in Maine as a six-year-old became a quintessential New Yorker. Nevelson was a Rockefeller favorite; Blanchette donated a section of the sculptor's *Dawn's Wedding Feast* to Vassar. Other important icons of the New York school of Abstract Expressionists—Franz Kline, Helen Frankenthaler, Joan Mitchell, Clyfford Still, and Arthur Gottlieb—are displayed in the lobby of the Corning Tower or in the atrium.

A third of the Empire State art collection is displayed in the large concourse that runs from the Cultural Center to the Capitol. The works are poorly visible amid the many stores, offices, and restaurants that line the passageway. *Untitled (1969)*, by Steven Lukin, is one of sixteen specifically commissioned for the Mall. The blue, soft green, pink, and orange twelve-foot-long enamel-on-wood painting looks like a folded ribbon that leads people along the seemingly endless corridor.

Many works, such as Noguchi's three studies for the *Sun*, one of the sculptor's signature pieces, have a strong connection with the Rockefel-

lers; the Japanese-American sculptor created works for Rockefeller Plaza, 1 Chase Manhattan Plaza, and Kykuit.

Fritz Glarner, a native of Switzerland, contributed a thirteen-and-a-half-foot mural to the concourse. His *Untitled (1968)*, a geometric abstraction executed in primary colors, must have reminded the governor of the walls and ceiling of his Manhattan dining room, which were decorated by this artist during the 1930s.

On a nice day, the exterior of the Empire State Mall is filled with employees and tourists lounging along its reflecting pools, enjoying its eighteen fountains or any one of about thirty-two artworks of the Empire State Collection. Most prominent among these is Alexander Calder's *Triangles and Arches*, from 1965. Ellsworth Kelly's *Yellow Blue, 1968* was specifically designed for the Mall. In 1954, Kelly explained that he painted his sculptures in strong primary colors so as to relieve the starkness of contemporary monochrome buildings.

François Stahly's *Labyrinth* sits at the far end of the Plaza, between the Corning Tower and the Cultural Center. It is a big construction of separate arches, horizontal and vertical beams, and an intricate thirty-nine-foot tower—all made from teak wood. Stahly was French, and not a New Yorker, so he shouldn't have been included, but an exception was made because Nelson Rockefeller had a Stahly piece at his home in Kykuit and admired the artist's work.

THE OFFICIAL NAME of the Albany complex, the South Mall, always reminded Rockefeller of a shopping mall, so on November 21, 1973, he renamed it the Empire State Mall. During that ceremony, Nelson proudly declared that "great architecture reflects mankind at its true worth."[29] Two weeks later, he resigned the governorship to seek a higher national office. Eight months later, Richard Nixon resigned and President Gerald R. Ford asked Nelson to be his vice-president. When Ford ran for reelection in 1976, his ticket did not include Rockefeller, who returned to private life.

Happy Rockefeller felt that the Mall business in Albany was unfin-

ished. She lobbied the then-governor Hugh Carey and Ray Corbett, the state's AFL-CIO union president, to once more rename the Plaza. On October 6, 1978, in the presence of the former governor and assembled dignitaries, Carey proclaimed that Albany's government center be henceforth known as the Nelson A. Rockefeller Empire State Plaza.[30]

WHAT HAS NELSON'S extravagant building plan done for Albany? In 2009 the response of three Albany residents, young at the time the Mall was constructed, was unanimously positive.[31] Barbara R., whose childhood home fell victim to the Mall, loves the rich cultural life it created, the reflecting pools, the outdoor art; in retrospect, she believes that rebuilding Albany was a good thing. Richie Bamberger despised and bad-mouthed the Mall from 1967 to 1972, when he studied at SUNY Albany. He returned to live there in 2005 and now loves its surrealistic appearance, especially when seen from afar. Jonathan G., who lived there from 1981 to 1991, says, "I have strong memories of the Mall. It was striking and impressive. I had a great sense of pride when I showed it to visitors. While many were very critical of the rather stark and modern architecture, I liked its clean and very futuristic architecture."

Even William Kennedy, censorious of Rockefeller's modus operandi, realizes that Nelson is responsible for the town's "turnaround from being an object of ridicule to being a city of quality." As soon as the Mall was finished, crowds flocked to the museum, the convention halls, the performances in the Egg; they toured the Capitol, viewed Nelson's art collection, and skated on the reflecting pools; they liked it and returned. The Mall remains a conglomerate of its own. The elevation of the site, the platform on which it sits, and the arterial roads that surround it separate the Mall from the rest of Albany, an arrangement that violates Jane Jacobs's principle of mixed urban usage. Nevertheless, the Mall spurred a revival of Albany's old neighborhoods. The "Gut," as Kennedy observes, has disappeared, and its gentrified replacement is once more called The Pastures. Miraculously, it still has a few houses that survived the cataclysms of its past.

Nelson Rockefeller, Kennedy concludes, left a mixed legacy, both re-markable and disreputable. "Only a mother, and an uncommonly saintly mother at that, could love Nelson Rockefeller unequivocally," he writes. "He was loathed by the political left, and the political right; . . . he was cold-blooded in the exercise of power . . . his contempt for the law and the state constitution when they stood in the way of his plans was never more visible than in the history of the Mall." In spite of this record, Kennedy takes great pride in the revived downtown filled with pubs and restaurants and the crowds celebrating the simple joy of being alive.[32] In a manner of speaking, Kennedy reiterates Blanchette Rockefeller's assessment that her brother-in-law was at once the pride of the family but also felt entitled to breach the limits set by society.[33] Unlike Junior, Nelson was not overly concerned with criticism, and he could very well have adopted Senior's attitude: "Let the world wag."

ON JANUARY 26, 1979, four months after the renaming of the Mall, Nelson, like his mother had forty years earlier, died of a massive heart attack. He himself had been aware of the conflict between his unbridled ambition and his happy-go-lucky nature. Art gave him the opportunity to be both elitist and democratic. His fortune allowed him to buy the best pictures and sculptures of the modern masters he adored, but he also trea-sured the work created by anonymous artists past and present. He was de-termined to share these treasures with the world at large and provide joy to others, and he never tired of teaching that art is a matter of personal taste. On the occasion of his death, newspapers around the world extolled his virtues and his faults. Both President Jimmy Carter and ex-president Gerald Ford attended the memorial service, held at Riverside Church.[34] Nelson's eldest daughter, Ann Rockefeller Roberts, the family biographer, recalled that for her and her siblings it had not always been easy to be their father's children, but that he had filled their lives with excitement and had challenged them to reach beyond their grasp. She remembered her father sharing his love of art by having them participate in hanging

his pictures. "To Father," she concluded, "life was meant to be lived . . . he would want us to get on with it—to go forward, to take our lives in our hands fully and joyfully, as he did."

Henry A. Kissinger, who had met Nelson in 1955 and who became his political advisor and close friend, gave the principal eulogy:

> [Nelson was] . . . ebullient, yet withdrawn, gregarious and still lonely, joyful and driven . . . He could be pugnacious in his beliefs but he respected those who differed with him. Nothing was too trivial for his attention . . . he rearranged a friend's furniture with the same enthusiasm that he rebuilt Albany . . . he loved caviar and hot dogs . . . he loved art not only for love of beauty but because it expanded the reach of the human spirit.

With Babs, John 3rd, Nelson, and Winthrop all having died during the 1970s, the third generation of Rockefellers had shrunk to Laurance and David, both of whom had inherited their grandfather's and father's longevity. They had decades left in which to leave their personal stamp on what has sometimes been called the Rockefellers' Century.

David Rockefeller:
The Museum of Modern Art
and the JPMorgan–Chase Corporate
Art Collection

THE MUSEUM OF MODERN ART

IN 2005, WHEN he was ninety years old, the Museum of Modern Art threw David Rockefeller a birthday party. It was held in the Abby Aldrich Rockefeller Sculpture Garden.[1] Rockefeller told everyone that the site was most appropriate, since the garden was located where his birth house had once stood.

The garden's creation in 1953 was also David Rockefeller's first task for his mother's beloved museum. Philip Johnson designed the very urban environment, so unlike that in which Nelson Rockefeller would display his personal sculpture collection in Pocantico Hills. Ever since it opened, MoMA's Sculpture Garden has been one of Manhattan's most beloved outdoor spaces. Its terraces are filled with carefully chosen trees, ivy, benches, and about two dozen familiar and important works by leading sculptors of the twentieth century. Olga Guggenheim donated Maillol's *The River*, a large nude seemingly dipping her hair in one of Johnson's signature re-

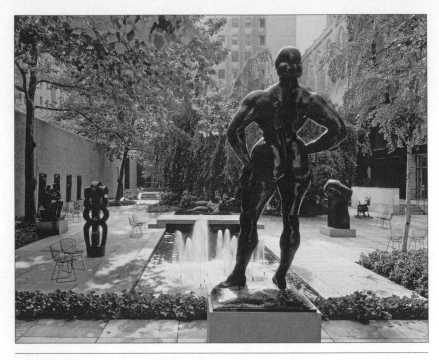

The Abby Aldrich Rockefeller Sculpture Garden at the Museum of Modern Art in New York. Note the nude by Gaston Lachaise in the foreground. (The Museum of Modern Art/ Licensed by SCALA/Art Resource, NY)

flecting pools. Other works include Pablo Picasso's *She-Goat*, Henri Matisse's *The Back (I, II, III, IV)*, Gaston Lachaise's *Standing Woman*, and Elie Nadelman's *Man in the Air*. One of Hector Guimard's entrance gates to the Paris Métro illustrates the museum's commitment to utilitarian art.[2]

David was fourteen when his mother and her friends founded MoMA, and it took a while for his interest in modern art to develop.[3] He was thirty-three when his mother died, and he was flattered when the museum asked him to replace her on the board of trustees.

By the time David assumed his trusteeship, the character of the museum had already been established. To a large extent, however, MoMA owes him its financial survival and its transformation into a mega-institution. David would also be the last family member wealthy enough to support the Rockefeller-founded institutions in a grand manner.

David Rockefeller's involvement with the museum increased dra-
matically in 1958, when Nelson ran for New York State's governorship.
David became the temporary chairman of the board until sister-in-law
Blanchette managed to persuade John 3rd, her reluctant husband, to let
her assume the job. In 1962, David was again chairman of the board. By
then the role fit: collecting art had become an important aspect of his and
Peggy Rockefeller's lives.

ART HAD ALWAYS been an important topic at the Rockefeller dinner
table. Abby frequently hosted established artists such as Matisse and
Rivera, and up-and-coming ones such as Arthur Davies, Charles Sheeler,
and the Zorachs. There were art lectures in Abby's private gallery. David
met his mother's accomplices who came to the Rockefeller mansion for
the planning sessions of the future museum, and he recalled how impa-
tient his father was for the meetings to be over. Abby's devotion to MoMA
did not lessen after the museum opened, and Alfred Barr, Dorothy Miller,
Holger Cahill, and other staff members came regularly to 10 West Fifty-
fourth Street. Junior had his own artistic involvements, and quite natu-
rally, as a boy, David adopted some of his father's skepticism about new
and unfamiliar art forms. David Rockefeller never tired of recounting how
he was often delegated to show visitors the *Hunt of the Unicorn* tapestries,
pointing out all the large and small details of this marvelous artwork. In
time, however, Abby won him over. As he declared in 2002, "I owe much
to my mother. She had an expert's understanding, but also approached art
emotionally. She taught us to be open to all art, to allow color, texture,
content, and composition to speak to us."

Family trips shaped his taste as well. He attributes his enthusiasm for
English antiques to a London sojourn when he helped his parents pick out
furniture for the Williamsburg restoration. He gives his aunt Lucy credit
for his appreciation of Asian art and porcelains, and he revered Alfred
Barr, writing that the MoMA director opened his eyes to a lot of things he
would never have seen without him.[4] Like the rest of the Rockefeller clan,

David was a born collector. He started with stamps and beetles, and it was the latter that won out. By now he owns more than fifty thousand specimens. Brother Nelson delighted in giving David prints of beetles as gifts.

David and Peggy McGrath married in 1940 as World War II escalated. After he returned from the war, David joined his uncle Winthrop Aldrich, then heading the Chase Bank. David spearheaded the bank's domestic and international growth. Twenty-three years later he became the bank's CEO. It was mostly up to Peggy to raise their six children and furnish and decorate their various houses. Peggy prided herself on relying on her own taste rather than employing professional decorators.

David is the only Rockefeller to have written an autobiography, and starting in 1984, the David Rockefellers, with the help of Margaret Potter, compiled an extensive four-volume illustrated catalogue of their possessions. Most items are accompanied by lengthy personal comments on how and why they were acquired.[5]

David insists that, unlike John 3rd or Nelson, who assembled focused collections, he and Peggy simply bought art to decorate their homes. Since there would eventually be five, they had the pleasure of covering quite a few walls. The family owned a Manhattan town house on Sixty-fifth Street and spent weekends at Hudson Pines in Pocantico Hills. This house had been built for sister Babs in 1938 and, sentimentally, had been sheathed in the bricks recycled from Senior's house on Fifty-fourth Street. Eventually, David and Peggy would also own houses on St. Bart's in the Caribbean, in Seal Harbor, and on Bartlett Island in Maine.

Great art to decorate these houses had to wait, but the walls were far from bare. David asked his mother for the art that hung in his rooms at 740 Park Avenue and at the Eyrie, which consisted of many Japanese and Daumier prints, and watercolors by Arthur Davies. Many additional works owned by Abby and Junior would end up on David's walls, including *The Rivals*, by Diego Rivera, according to Alfred Barr, the best of four paintings Abby bought during the 1920s.

In 1946, David and Peggy embarked on a mission to improve the art in their town house. They visited the Knoedler art gallery. Taking a leaf

Peggy and David Rockefeller, 1965. (Courtesy of The Rockefeller Archive Center)

from Abby, who often chose works on paper over expensive oils, they started buying good-quality out-of favor prints. They also bought some inexpensive oils, including eighteenth-century English portraits, which included two of gentlemen wearing bright red coats.[6] The couple still was not much interested in modern art, but with David's growing involvement at MoMA, that was about to change.

Soon after David and Peggy redecorated, the Barrs came over for cocktails, and Marga quite shocked them by saying "that she could not understand how they could be satisfied with such banal and uninteresting paintings, when there were so many exciting things to be had." David distinctly remembered her commenting about the "little men in red coats." The remark obviously stung, and from then on they listened when Alfred Barr, sensitive to his protégés' tastes, steered them to French painters of the nineteenth century. Rapidly the David Rockefellers acquired works by Boudin, Corot, Courbet, and Delacroix. Soon they were ready for more modern works.

The helping hand of museum curators is seldom altruistic. They hope that their institutions will eventually inherit whatever their patrons ac-

quire. In the case of David and Peggy, Barr's faith was well founded. In 1994, to thank them for their many past and future gifts, MoMA mounted *Masterpieces from the David and Peggy Rockefeller Collection: Manet to Picasso.*[7] The exhibition comprised twenty-one remarkable paintings, a very small fraction of the couple's eclectic art collection.

In the foreword to the exhibit catalogue, David explained that his only formal art education consisted of some college-level art history courses. "Peggy and I learned about art together." He also stressed that their collection was a cooperative effort. David credits his wife with some of the intuitive recognition of great art he had so admired in his mother. Once they started buying art, the collection grew rapidly. One of their early major purchases was Renoir's *Gabrielle at the Mirror.* The scantily clad young woman hung in their living room in Manhattan, where it shocked some of Peggy's family.

As they were becoming more serious about collecting, Alfred Barr told them that A. Chester Beatty's Impressionistic paintings were about to come on the market. Beatty, a Colorado mining magnate, had amassed an enormous collection of art and artifacts, which are now housed in a Dublin library that bears his name. In 1955 his widow asked French art dealer Paul Rosenberg to auction off some of her possessions. The works included Cézanne's *Boy with a Red Vest*, once owned by Claude Monet, which Barr wanted for MoMA. Since the museum lacked funds, Barr offered to have the Rockefellers preview the entire Beatty collection at Rosenberg's art gallery, provided that they would eventually leave the painting to MoMA. Thanks to this arrangement, David and Peggy bought the Cézanne, along with Seurat's *The Roadstead at Grandcamp* and Edouard Manet's *La Brioche.*

David and Peggy bought two additional Cézannes: *Mont Sainte-Victoire*, a delicate view of the painter's famous mountain—in which he used watercolors so sparsely that the painting looks almost unfinished—and *Still Life with Fruit Dish.* The latter once belonged to Gauguin, who loved it so much that he managed to keep it in spite of his disastrous finances. All three Cézannes would end up at MoMA. The couple also acquired several Bonnards, including the highly decorative *Promenade*, a four-part screen

whose composition is reminiscent of Japanese prints. Derain's *Charing Cross Bridge* sets the Thames aflame with vivid Fauve colors. In his catalogue David comments that it was the first of their four Fauve paintings. The couple's *Suburban Landscape,* by Maurice de Vlaminck, was promised to the Boston Museum of Fine Arts, which at the time did not have a single Fauve painting.

Collecting Fauve paintings led the couple to the German Expressionists. David Rockefeller reports on a 1960 trip that he and Peggy took on the spur of the moment to attend an art auction held in Stuttgart, where unexpectedly they acquired six more Postimpressionist works. They grew especially fond of Emil Nolde and his Fauve-colored flowers and seascapes, acquiring his *Sailboat on the Sea,* painted surreptitiously during World War II because the Nazis had forbidden the, in their view, degenerate artist to paint.

DAVID ROCKEFELLER IS very proud of the role he and Nelson played in helping MoMA bring Gertrude Stein's art collection to America. Left to her heirs, with lifetime use by her companion, Alice Toklas, it was being sold in 1968.[8] Stein's nieces and nephews agreed to sell it to MoMA for about $6.8 million. Since the museum did not have the funds to buy the collection, it set up a consortium of six buyers, Nelson and David among them, who agreed to donate or will certain paintings to the museum.

Lots determined the order in which participants could select pictures. David, who had managed to obtain two slots, drew lot one and three. This enabled him to choose Picasso's *Girl with a Basket of Flowers,* a transitional work between the artist's Blue and Rose periods. The young girl, a flower vendor by trade, has an innocent, prepubescent body and a much older face. Except for the dark mass of hair and the vivid red flowers filling the small basket, the painting's colors are subdued.[9]

David's second choice was Picasso's *The Reservoir, Horta de Ebro.* Like the girl with her flowers, it is a very early Picasso, which illustrates the painter's move toward Cubism. It is highly geometric and shows the

houses of the Spanish town where Picasso summered stacked one upon the other. The work complements *Houses on the Hill, Horta de Ebro,* painted a year earlier and given to MoMA by Nelson.[10] All in all at the sale, David acquired eight works by Picasso and two by Juan Gris; their selection included three of the Picassos MoMA had chosen.[11] In 1970, before the collection's permanent dispersal, MoMA mounted an exhibit entitled *Four Americans in Paris: The Collection of Gertrude Stein and Her Family.*

AFTER ALFRED BARR'S death, David Rockefeller stayed in close touch with Barr's wife. In 1984, soon after the first volume of the Rockefeller catalogue was published, he sent her a copy. In her thank-you note she recalled her original disparaging comments about his and Peggy's art. This time the couple rated an A+. Marga wrote:

> Your collection has a consistency that certain others lack—there are no discrepancies. It is exciting to perceive the magnetism that these pictures exert on you: it is not only a question of quality it is also a question of singularity. A good collector must dare and you both did. Alfred would be proud of you.[12]

As a rule, David and Peggy abstained from buying purely abstract works of art. However, while she was helping assemble Chase's Corporate Collection, Dorothy Miller persuaded David to buy two Mark Rothko paintings that she felt would enhance the anteroom of David's new offices at the Chase Manhattan Center.[13] *White on Maroon* was eventually auctioned off by MoMA to benefit the Southern Christian Leadership Foundation after Martin Luther King, Jr.'s assassination, but David kept *White Center* in his office, until, as previously stated, it was sold at a huge profit.[14]

Volume II of the *David and Peggy Rockefeller Collection* catalogue also provides some information on what happened to artworks once beloved by Junior and Abby. David had inherited *The Raising of Lazarus,* by Italian Renaissance painter Duccio. Feeling that it did not go with their other

art, the couple sold it to the Kimbell Art Museum in Fort Worth, Texas. Junior and Abby's other Duccio, *Christ and the Woman of Samaria*, now hangs in the Thyssen-Bornemisza Collection in Madrid.

David had always been fond of Arthur Davies's paintings. He had in-herited about thirty from his mother, and these decorated the stairwell of the David Rockefellers' Manhattan house until they were replaced by a set of Picasso bullfight prints David acquired from Nelson's estate.[15] Other works were hand-me-downs from Junior. Remarkable among these is a portrait of *John Beale Bordley*, painted by Charles Willson Peale in 1790. Bordley, a friend of George Washington, had created a self-contained com-munity on Chesapeake Bay, which was able to send large quantities of food to the Revolutionary Army. David likened Bordley's enterprise to the farming he and Peggy did on Bartlett Island in Maine. The portrait was a gift from David to his father, because Bordley was one of his distant paternal ancestors.

OF THE ROCKEFELLER brothers, David was the savviest money-wise. Being Senior's grandson—and probably his favorite—he started with much money and, as chairman of the Chase Manhattan Bank, increased it mightily. Shortly after his ninetieth birthday party, he announced that he would leave MoMA $100 million in his will, the largest gift ever made to a museum.

The museum, however, would not have to wait until then to profit from his benevolence. In addition to the millions he and the Rockefeller Foundation provided, David persuaded his father's sole surviving older sister, Alta Prentice, to donate to MoMA the two brownstones in which she had lived most of her life. These houses abutted the museum to the east. Philip Johnson was chosen to build a new East Wing on their site.[16]

During the mid 1970s chairman of the board and banker David Rocke-feller was deeply disturbed by the museum's balance sheet. The annual deficit usually exceeded more than $1 million, a sum that rapidly reduced the museum's small endowment. Clearly something had to be done. The

museum owned quite a few parcels of land to its west, along Fifty-third Street. One of David Rockefeller's associates suggested a complicated scheme that involved the creation of the "Trust for Cultural Resources of the City of New York," which would have certain tax advantages. By conveying the land to the trust, which then sold it to a developer, the museum would generate income. In addition, the developer would lease the lower six floors of a forty-four-foot residential tower back to the museum at one dollar a year, for ninety-nine years. There would be space for classrooms, workshops, offices, and large galleries to accommodate the gigantic-size works characteristic of contemporary artists. Architect César Pelli remodeled the museum, and the space problem was solved for a number of years.

RENÉ D'HARNONCOURT RETIRED in 1968. After extremely short reigns by Bates Lowry and John B. Hightower, Richard Oldenberg was appointed director in 1972 and ably headed MoMA for twenty-two years. One of the difficulties in governing the museum had always been a power play between the overall director and the six curatorial departments created by Barr. Disagreements were most likely to arise between the curator of paintings and sculpture, the most powerful department, and the director, if both were specialists in modern art.

When Oldenberg retired in 1993 the museum once more searched for the perfect candidate. According to David Rockefeller, Glenn Lowry was it. Relatively young, he had presided over the expansion of the Art Gallery of Ontario, and because he had specialized in a different area of art history, he would not threaten any of the directors who headed MoMA's curatorial departments. David Rockefeller considered him "brilliant, tactful, full of energy and a natural leader." At seventy-eight, shortly after MoMA hired Glenn Lowry, David Rockefeller relinquished his chairmanship. As chairman emeritus, however, he continued to struggle with MoMA's space and financial problems.

Very quickly, Lowry changed some of the ways in which the museum operated. According to him, there had been little communication among

department heads, each administering his own fiefdom in isolation. Lowry insisted on interdepartmental meetings and a more centralized operation.[17]

FROM ITS INCEPTION, MoMA's trustees had argued about whether the museum should acquire a permanent collection. The Lillie Bliss gift tipped the scale in favor of the collection, a mandate brilliantly carried out by Barr. By the beginning of the third millennium, the museum owned more than a million objects. Certain trustees wondered whether the museum should refrain from making further acquisitions and simply exhibit its treasures of the "golden age of modern art." Attendance grew along with the size of the collection. The number of annual visitors was approaching the two-million mark, the galleries were overcrowded, and there were long lines at the ticket booth and coat room.

David Rockefeller was strongly opposed to restricting the growth of the collections and setting an arbitrary cutoff date as to what art to collect, even though he found many new artistic developments strange and even repulsive. He did not want MoMA to make the mistake of earlier generations, who had rejected the Neo-Impressionists, Fauvists, and Cubists, and he hoped that some of the contemporary artists had more to offer than he gave them credit for. He knew that his mother would have felt that way. To relieve the pressure of having to be too contemporary, MoMA had signed an agreement with the P.S.1 Contemporary Art Center in Queens in 1999. Founded by Alanna Heiss in 1972, in an 1890 school building, P.S.1 does not collect, and it exhibits many artists at the beginning of their careers. Several, including Richard Serra and Robert Mapplethorpe, have become major figures in the art world.

BY 2000, MoMA was clearly running out of space. On Fifty-third Street it was wedged between the thriving St. Thomas Episcopal Church and the Museum Tower. The building housing the Dorset Hotel, which occupied the southwestern corner of Fifth Avenue and Fifty-fourth Street, repre-

sented the only possibility, but its price was too high. Eventually, however, the site was acquired for $50 million.

Glenn Lowry excelled in fund-raising and supervising the expansion. Chairman emeritus David Rockefeller, chairman of the board cosmetics tycoon Ronald S. Lauder, MoMA president Agnes Gund, and other trustees contributed an unprecedented amount of money for the expansion. David suggested the creation of a new donor category whose initial contribution was $5 million or more. New York City, under the guidance of Mayor Rudolph Giuliani, kicked in $65 million, agreeing that MoMA was both a cultural resource for New York and a profitable tourist venue.

Yoshio Taniguchi, a Japanese architect, won the museum's international design competition, entered by two hundred leading architects. Operation of MoMA shifted to temporary quarters in a surplus staple factory in Queens, and for years steam shovels and other building equipment demolished, tunneled, and then rebuilt the block once occupied by two generations of Rockefellers. MoMA reopened in 2006.

What resulted is a far cry from the Bauhaus look-alike building of 1939. If you search very carefully you can still find its famous staircase and small galleries embedded on the north side of the building. A large, triple-height entrance hall, which feels more like an indoor street than the lobby of a museum, runs from Fifty-third to Fifty-fourth streets. After negotiating tickets and coats, an expectant and happy crowd ascends to the second floor and enters an enormous 110-foot high atrium, which the architect conceived as echoing the Abby Aldrich Rockefeller sculpture garden. Industrial-looking escalators carry visitors up and down through six floors of galleries, appropriately located in what is called the David and Peggy Rockefeller Building.

Few architectural critics loved the newly renovated MoMA. As *New York Times* art critic Holland Cotter wrote, "since its 2006 reopening, MoMA-bashing is the art world sport that Whitney-bashing was in the 1990s."[18] Critics point out the lack of coziness, the cold businesslike atmosphere, the large size, excessive height, and uniformity of the galleries, and the $850 million cost of the new building. Glenn Lowry and the curators of the museum's six major departments say that they listen to these criti-

A 2004 photograph of the Bauhaus staircase in the newly enlarged Museum of Modern Art in New York. (© The Museum of Modern Art/Licensed by SCALA/Art Resource, NY)

cisms seriously and feel that it will take time for the collections to adjust to their new space.[19]

Now, as earlier in the history of the museum, there is grumbling about the deaccession of certain works of art. In 1944, Stephen Clark had auctioned off a number of nineteenth-century works, many from the Bliss collection, resulting in the loss of Seurat's large sketch for the *Grande Jatte* and Van Gogh's *L'Arlésienne* going to the Met. In 1983, Marga Barr noted that Matisse's *L'Italienne*, which had hung in Nelson Rockefeller's living room and which he had given to MoMA, and a Picasso still life were now hanging in the Guggenheim, having been traded for a Kandinsky. "The present exchange," Marga wrote to David Rockefeller, "would infuriate Nelson and Alfred both: it's not only unscrupulous, it's financially obtuse—a unique Matisse, a brilliant Picasso were surrendered in order to obtain a not memorable Kandinsky with the excuse of completing a set."[20] One of Picasso's *Horta de Ebro* paintings, two De Chiricos, and a major drawing by Pollock were deaccessioned during Glenn Lowry's regime.

Gertrude Stein's view that a museum cannot own immense histori-
cal treasures and hold on to the improvisational frontier-like spirit that
animated its formative years is doubtlessly true. Progress always implies
compromise, but few art lovers would forego the chance to view the su-
perlative permanent collection, the world's largest and most inclusive col-
lection of modern art. The excitement of the crowd that each day clamors
for admission proves that the museum dreamt up by three society women
in 1929 has kept its magic.

THE JPMORGAN–CHASE CORPORATE ART COLLECTION

By 1955, Chase had swallowed fifty smaller banks and had merged with
the Bank of Manhattan, becoming one of the world's most powerful fi-
nancial institutions. It had outgrown its building at 18 Pine Street in New
York and needed to consolidate its operations, by then spread out among
nine separate locations in downtown Manhattan. Executive vice-president
of planning and development David Rockefeller was in charge of finding
new quarters.[21]

Downtown Manhattan was in dismal shape. Rotting piers, small shops,
marginal industry, and antiquated dwellings covered the tip of the island.
The vacancy rate was high, rents were low, and the population had shrunk
to four hundred thousand daytime workers and four thousand residents.
Construction of any type of new building had ceased with the Great De-
pression. Banks and other commercial enterprises were leaving the area,
either relocating to midtown Manhattan or crossing the river to New
Jersey.[22] David Rockefeller was inclined to have the bank remain in his-
toric Lower Manhattan, the site of New Amsterdam; of Federal Hall, where
George Washington was sworn in as president in 1789; of Senior's Standard
Oil Building; of the New York Stock Exchange; and of the nation's early
skyscrapers. Adhering to his father's cautionary approach, before proceed-
ing David had the project evaluated by experts, who responded favorably.

It would be difficult to assemble a larger parcel of real estate in Lower
Manhattan, but luck would have it that a major site adjoining Chase's

Pine Street property became available. After some string-pulling, the bank found itself the owner of a two-block parcel. To erect its new skyscraper, Chase Manhattan selected the firm of Skidmore, Owings, and Merrill and its star architect, Gordon Bunshaft, a follower of Mies van der Rohe and Le Corbusier. New York's building code had changed since Raymond Hood won praise for Rockefeller Center's principal skyscraper, in which setbacks had been a novel and highly desirable feature. Chase Manhattan would take advantage of the regulation that permitted the erection of buildings of any height, provided that they occupied only twenty-five percent of their lot. Bunshaft proposed a sixty-story rectangular building extended by five subterranean floors. Adhering to city regulations, the building would sit on a large plaza that allowed light and air to penetrate the famous canyons of Wall Street.

David Rockefeller's decision to locate Chase Manhattan's new headquarters in Lower Manhattan was crucial to the revival of the area. It was, however, not enough. At the suggestion of Robert Moses, he formed the Downtown Lower Manhattan Association (DLMA) in 1958. Its objectives were to "foster, promote and support: physical improvements, sound redevelopment and preservation of economic values, improvement of traffic and transportation," all while maintaining or adding to cultural historic sites and to educational and cultural institutions. It would take decades for some of the goals of the organization, such as the relocation of the Fulton Street Fish Market, to be accomplished.

The idea of creating a large trade center that would enable New York to compete for the leadership position in international commerce came up in 1959. The DLMA commissioned the development of a preliminary plan for a "world trade center" consisting of giant office buildings, a seventy-story hotel, an international trade mart, and an exhibition hall. Governor Nelson Rockefeller enthusiastically endorsed the costly project, and in 1970, the complex, whose centerpieces were two 110-floor towers, began rising on a sixteen-acre site on Manhattan's West Side.[23] As in the case of Lincoln Center, Albany contributed to the costly enterprise by signing a lease to rent two million of the ten million square feet of office space.

LIKE WALLACE HARRISON, Gordon Bunshaft believed in the interdependence of art and architecture. This was especially true of International-style buildings, whose no-frills character was relieved by art. His outlook resonated with David Rockefeller. Even before 1 Chase Manhattan Plaza was finished, Rockefeller laid the foundation of a corporate art collection, though he did not realize how large it would turn out to be.

Chase Manhattan was not the first corporation to form a large art collection. In modern America the honor of such a venture goes to the International Business Machines Corporation (IBM) and its president Thomas J. Watson. In 1939 he asked none other than Alfred Barr to help assemble nearly eighty paintings for exhibition at the 1939 World's Fair in Flushing Meadows. Barr happily obliged, and the relationship was the first example of the strong bonds MoMA established with powerful corporations. In 1940, *Think*, IBM's corporate magazine, invited Barr to contribute his views on art, and the following May he wrote somewhat condescendingly that though the public is interested in "the best, the finest, the strongest, the most beautiful [art], it can be slow to accept revolutionary works."[24]

Given his family background and his own art collecting activities, David Rockefeller was an expert by the time he decided to buy art for Chase. But being a team player, he appointed an Art Advisory Committee, which included representatives of many of the same institutions his father had relied on when forming Rockefeller Center's Art Committee, except that David's committee was clearly oriented toward modern and contemporary art. In addition to MoMA's Alfred Barr and Dorothy Miller, the committee included James John Sweeney of the Guggenheim, Robert B. Hale of the Metropolitan, Perry Rathbone of the Boston Museum of Fine Arts, Gordon Bunshaft, and a few members of the Chase Manhattan Bank itself. It was Barr, Miller, and Rockefeller himself who were largely responsible for selecting the art, not only for the building at Chase Manhattan Plaza but also for the bank's new midtown World Headquarters at 410 Park Avenue, which, in addition to banking, handled social functions.[25]

The art committee established a strict budget. Estimating that the cost per item would range between $100 and $1,000, the committee hoped to cap expenditures at $500,000. This low total required buying art from upcoming contemporary artists. More was to be spent on major works for public spaces.

At four- to six-week intervals the acquisition committee met to evaluate about 150 to 200 artworks that Dorothy Miller and others had selected. Vote was by secret ballot, using a scale of zero to three, with zero indicating total disinterest. The points were tallied, and a total of eleven meant the acquisition of the work under consideration. Given the massive number of paintings so purchased, the Rockefellers again had a major impact on the art market. The Chase Manhattan collection is amazingly fresh; it familiarized people with abstract art, and often made new converts. Dorothy Miller relates the story of a bank vice-president vehemently opposed to nonrepresentational art. By accident one evening, precisely such a work, by Jack Youngerman, was left standing in his office. The next morning the VP called Miller and, instead of exploding, said, "I'm crazy about that painting. I'd like to have it in my office."

Another such story concerns the large sculpture by Jason Seley welded from automobile fenders. The day it was installed in the lobby of 1 Chase Manhattan Plaza there was such an outcry that it was hastily removed. David Rockefeller acquired the work and for a year let it tour various U.S. museums. Upon its return, on a quiet weekend, it was reinstalled and has been beloved ever since.

Initially Chase Manhattan bought pictures to decorate its new buildings. The art at headquarters enchanted bank employees at its branch offices, and they asked to be included. Management then bought art for, first, its New York and later its international branches. In the catalogue published on the occasion of the fortieth anniversary of the collection, David Rockefeller recalled buying art in Ethiopia, Japan, and other places. By 1984 the bank owned nine thousand works.

The Chase Manhattan collection changed as it grew. To begin with, most of the art originated in New York, but as the international branches

became enthused about the project, the banks bought more regional art. Eventually the collection included an *Asmat Warrior Shield*; Native American blankets; a Peruvian embroidery of *Simón Bolívar on a Horse*; *The Juggler*, by Marino Marini; an African mask from the Ivory Coast; and a ceremonial gold-bead necklace and carved leaping goat carousel figure carved in Germantown, Pennsylvania.

IN ADDITION TO scores of relatively inexpensive items, Chase Manhattan also acquired major artworks for its reception areas and for outdoors. The first of these were destined for 410 Park Avenue. Bunshaft commissioned a large Calder mobile—a safe choice, in view of the artist's popularity. While visiting Sam Francis, a California Abstract Expressionist, in his studio, Dorothy Miller spotted an enormous 98-by-456-inch canvas. "What are you going to do with it?" she asked. "Oh, just roll it up, I guess," Francis answered. Chase Manhattan paid $16,000 for it, and it still embellishes the lounge of 410 Park Avenue.

The landscaping of the large plaza in front of the downtown headquarters—about the size of Piazza San Marco in Venice—was of major concern. For the well that provided daylight for the uppermost subterranean level of the bank, David Rockefeller approached Isamu Noguchi. The Japanese-American artist proposed a water garden variation on a traditional Japanese garden design. Noguchi viewed it as a seascape punctuated by rising elemental rocks. The artist himself fished six massive, free-form rocks from the Uji River in Japan and placed them on concentric patterns of four-inch-square, light gray paving stones, reminiscent of the patterns of the raked sand found in traditional Japanese gardens. In summer the "garden" is flooded with water, gushing from the old rocks; in winter it is dry and reminiscent of a moonscape. In either season, the sixty-foot-diameter pool is a small oasis in a severe urban environment.[26]

After a search of ten years, Gordon Bunshaft and David Rockefeller finally found the ideal sculpture for the main portion of the plaza: *Group of Four Trees*, a forty-two-foot-high epoxy-and-fiberglass work by the

The Sunken Garden, *designed by Isamu Noguchi, at 1 Chase Manhattan Plaza in New York.* (The Isamu Noguchi Foundation and Garden Museum, New York/Artists Rights Society (ARS) New York)

French artist Jean Dubuffet. The irregular shape of the sculpture contrasts with the vertical lines of the surrounding skyscrapers. Initially, some people at Chase objected to the sculpture, and to its high cost, even though David Rockefeller personally paid for it. Now it has become an integral part of Lower Manhattan's landscape, standing in front of the bank at what, in 2008, was renamed 1 David Rockefeller Plaza. Other successful site-specific commissions include an enormous David Flavin fluorescent light sculpture at the Metro Tech branch of the bank in Brooklyn, and Nam June Paik's *DNA Spring* for Chase's office in Seoul, Korea.[27]

The merger of smaller institutions into mega-banks that escalated during the second half of the twentieth century consolidated not only capital but sometimes also art. When the First National Bank of Chicago joined Chase in 2004, it was accompanied by 8,500 works of art, and by Lisa K. Erf, its art director.[28] Since then Erf has been in charge of the JPMorgan-Chase collection. She buys all the art herself, believing that the best art collections result from the vision and voice of a single individual. Since she is working for a bank, Erf takes the financial aspects of the collection into consideration. Like David Rockefeller, she buys pre-

dominantly "the art of our own time," which usually means acquiring undervalued art or works by emerging artists. The approach has been successful, and like most Rockefeller enterprises, the art has proved to be an extremely good investment, increasing in value from $22 million in 1967 to $506 million in 1982.[29] As David Rockefeller explained, like a museum, the collection has to renew itself to be alive.[30] Artworks are constantly added and deaccessioned.

Though no longer actively engaged in buying art, David Rockefeller is immensely proud of his initiative. In 2002, when asked by Cristina Carrillo de Albornoz what he considered to be the Rockefellers' major contribution to the world of art, he unhesitatingly cited MoMA, followed by the JPMorgan-Chase Collection.[31] By 2008 the bank's collection had become massive, numbering thirty thousand objects. Though acquired for the enjoyment of the bank's clients and employees, part of the collection is often loaned to major and minor museums throughout the world. During the past fifty years, artworks have traveled to large museums in Houston, Dubai, Istanbul, and Yokohama, and to small museums throughout the United States.

According to David Rockefeller, "Beauty is not, of course, a solution to the pressing problems of hunger, poverty and strife that plague the world today, and the love of beauty cannot and should never reduce one's sense of responsibility to one's fellow man . . . On the contrary, I believe that creative possibilities presented by beauty in art should inspire us to seek at least equally creative approaches towards achieving a harmonious society."[32] Both his parents would have concurred.

In Memoriam: The Michael C. Rockefeller Wing, and the Nelson A. Rockefeller Center in San Antonio, Texas

THE MICHAEL C. ROCKEFELLER WING

B Y ALL ACCOUNTS, New York's Metropolitan Museum of Art is America's leading museum. Yet when it opened its doors in 1872, an ordinary town house was large enough to shelter its activities. Eight years later it moved to its present site off Central Park. At first the museum occupied a smallish red brick building designed by Calvin Vaux. By 1917 the institution had sprouted its mammoth neoclassic Fifth Avenue wing fronted by a limestone façade that the *New York Evening Post* described as "one of the finest in the world, and the only building in recent years which approaches in dignity and grandeur that of the museums of the old world."[1]

Major elements of the grand façade survive, but during the 1980s the museum added two large glass pavilions attached to its north and south ends. The northern one houses the Temple of Dendur, Egypt's thank-you to America for helping it save monuments otherwise submerged by the dammed-up Nile following the construction of the Assouan Dam. The

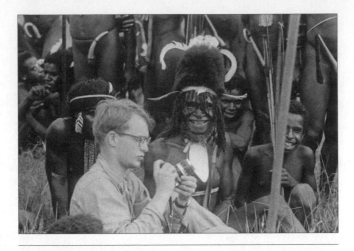

Michael Rockefeller in Asmat. (Courtesy of the Peabody Museum of
Archaeology and Ethnology, Harvard University.)

southern pavilion is the Michael C. Rockefeller Wing, housing the arts of
Africa, Oceania, and the Americas.

Until recently most of this so-called "primitive" art would have been
relegated to museums of ethnography or natural history.

The contents of this airy space differ markedly from the academic art
found elsewhere in the museum. Today's visitors, however, probably do
not experience the sense of shock and wonder that these unfamiliar ob-
jects elicited during the late nineteenth century, when they first arrived
in Europe.

The word *primitive* implies "unsophisticated," and hence has a some-
what negative connotation. The term has been widely, and often tran-
sitionally, used to describe certain types of art, most consistently that
created by certain native and tribal populations before their civilizations
became Westernized. Robert Goldwater, the founding director of New
York's Museum of Primitive Art, jokingly defined primitive art as "The
stuff that isn't in the Met."[2] For want of a short alternative, the term *primi-
tive* or *tribal* will be used throughout this chapter.

THE ROCKEFELLERS WERE unusually effective at bringing primitive art to the attention of the general public, though by the time Nelson arrived on the scene, others were starting to appreciate its beauty.

The non-Western objects that had arrived in Europe during the colonization of Africa and America were despised. Even then, however, there were exceptions. In 1520, after seeing the Mexican treasures Cortés had sent to Charles V, Germany's Albrecht Dürer wrote, "In all the days of my life, I have seen nothing which rejoiced my heart as much as these things—for I saw among them wondrous artful things and I wondered over the subtle genius of these men in strange countries."[3]

The art world became aware of non-Western art during the nineteenth century. The Impressionists and Postimpressionists had been devotees of Japanese art, including the prints so fervently collected by Abby Rockefeller. Their followers discovered African sculpture around 1900. The Aztec sculptures exhibited at the 1889 Paris Exhibition impressed Paul Gauguin, though he was even more taken with the art of French Polynesia.[4] Maurice de Vlaminck bought African figures in a Paris café for the price of a couple of drinks. André Derain and Jacob Epstein bought African art, some of which eventually migrated into Nelson's collection. The German Expressionists were partial to Oceanic art.

Picasso felt the protective powers and magic emanating from African fetishes and weapons when he visited the *Musée de L'Homme*, Paris's anthropological museum, in 1906. As he never tired of recounting, he experienced an epiphany there that inspired his *Les Demoiselles d'Avignon*, the world's most famous Cubist painting, now ensconced at MoMA. He described it as his "first canvas of exorcism."[5]

Gradually, collecting primitive art became popular in Europe and the U.S. American collectors, including John Quinn, Abby Rockefeller, and Walter C. and Mary Louise Arensberg, acquired some primitive art objects. In 1914, Alfred Stieglitz mounted America's first exhibition of African art.[6]

Nelson attributed his interest in these artifacts to his mother, who collected African sculptures along with everything else. In the 1930s, during his year-long round-the-world honeymoon trip, he bought several pieces of

tribal art of which he became inordinately fond. They included a wooden lute and a dagger, both made by the Batak tribe in Sumatra. Nelson intuitively responded to the art's "power . . . directness of expression and . . . beauty." His local host was unimpressed by the young man's enthusiasm, pointing out that missionaries had destroyed whatever good primitive art had previously been available.[7] Nelson's 1933 trip to Mexico dovetailed with his nascent interest in both primitive and folk art. Miguel Covarrubias, the Mexican painter, writer, and collector of pre-Columbian art, gave him a crash course in Olmec, Toltec, Mayan, and Aztec pre-Columbian art, and as expected, Nelson did some shopping. As he recalled, "I [started to see] art as widely varying expressions of individuals—individuals from all parts of the world and from all ages, with strong feelings and great creative capacities to express those feelings. No longer was my appreciation confined to classical forms of art as taught in our schools and shown in our great museums."[8]

When the Met elected Nelson to its Board of Trustees in 1931 he tried to persuade the museum to mount an exhibit of non-Western art. But the trustees were not interested. Rebuffed, he intensified his own activities. He soon found his ideal partner in René d'Harnoncourt. During the next thirty years the two, assisted by other experts, amassed an impressive collection of these objects.

When Nelson moved to Washington, art continued to be his primary form of relaxation. As René d'Harnoncourt told Francine du Plessix in 1965:

> Several times when he felt depressed I would fly [to Washington] for the night carrying a suitcase filled with small pre-Columbian sculptures, Peruvian gold objects and other little things to cheer him up. We would have dinner and have a wonderful time.
>
> During those Washington days, when he looked absolutely gray-green from overwork, his idea of a relaxing rest was to take a night plane with me to the West Coast, arrive at nine AM and carefully examine some 1000 pieces of primitive art, of which he would buy about

forty. He returned to Washington on the next night plane looking re-
freshed, rosy-cheeked and fit as after a vacation and I returned looking
gray-green. It is a big responsibility to distinguish the real from the
fake in the field of primitive sculpture. The problem of genuineness is
more difficult here than it is in any other art form.[9]

By 1957, Nelson's collection of primitive art had grown so large that he
felt it needed a museum of its own. That museum opened in New York
on February 20, 1957, at 15 West Fifty-fourth Street, in a large one-family
house owned by the Rockefellers, conveniently located across the street
from MoMA. Nelson put Robert Goldwater, professor of art at New York
University, in charge of the African collection; Douglas Newton curated
the art of Oceania; and Julie Jones, who arrived at the museum during the
early 1960s as a graduate student, became the pre-Columbian art expert.
The purpose of the museum, as stated by its founder, was to celebrate the
artistic achievements of the indigenous civilizations of Africa, Oceania,
and the Americas.

The new institution was unique in that its entire collection consisted
of non-Western art. Moreover, items for the collection were chosen because
of their aesthetic appeal rather than their ethnic provenance or historic
importance. Since the small size of the museum allowed it to exhibit only
a fraction of its permanent collection, it mounted special shows such as
Sculptures from the Pacific, Benin Bronzes, The Incas of Peru, and *African
Sculptures from the Museum's Collection.* By 1968, primitive art had gained
respectability. In January of that year, *ARTNews* wrote, "The Museum
of Primitive Art was born lucky, but it had the brains to push its luck,
becoming in the dozen years since its founding one of the few museums to
combine a passion for the past with a modern philosophy."[10]

MICHAEL AND HIS twin sister, Mary (later Mary Morgan), were Tod
and Nelson Rockefeller's youngest children. Fascinated by their father's
collecting activity, the twins watched enthralled whenever Nelson rear-

ranged his art. They also loved accompanying their father on his shopping expeditions, regardless of whether that meant rummaging through the basements of antique dealers in New York or going with him on trips to Africa or elsewhere.

Mary Morgan recalled that when her brother was eleven, about the time children are allowed to walk to school by themselves, it took Michael often a long time to arrive back home. He had discovered a small art gallery on Madison Avenue dealing in Old Masters, and thereafter regularly stopped by to discuss paintings with the owner.

Michael, like his father, was dyslexic, a condition that often endows people with a special visual sensitivity. Tod declared that both Nelson and Michael suffered from "arranger's disease," a need to move objects when they felt they would look better if ordered differently. Once, when the family was visiting a church in Africa, Michael marched up to the altar and rearranged the liturgical objects. When his mother chided him, he simply replied, "Mom, these objects simply did not look right."[11]

As an undergraduate, Michael went to Harvard and, like his father, toyed with the idea of majoring in architecture. Nelson vetoed that option and, setting himself up as an example, advised Michael to use art and collecting as an escape from the rigors of everyday life. Michael agreed, and his senior thesis at Harvard dealt with American banking reforms initiated by Senator Nelson Aldrich, his paternal great-grandfather. To encourage Michael's artistic interest, his father appointed him to the board of the Museum of Primitive Art when he was only seventeen years old.

Michael inherited Nelson's sense of adventure, too. When the Film Study Center of Harvard's Peabody Museum asked him to serve as their cameraman for a documentary about the Asmat, a tribe living in the Papua part of New Guinea, he accepted. Nelson was pleased. After the Peabody Museum finished shooting *The Sky Above, the Mud Below*, Michael stayed on, collecting Asmat artifacts for the Museum of Primitive Art.

Oceania is a vast geographic region encompassing the islands of the Central and South Pacific, traditionally subdivided into Polynesia, Melanesia, and Micronesia. Artistically there is some overlap among these

cultures, but before the arrival of European explorers, many enclaves developed their own individual styles. The region includes the Asmat, a term that refers to both the land and the people.

Throughout history the particularly inaccessible Asmat had deterred exploration. Captain Cook landed there in 1770, but native warriors rebuffed him. The Dutch established a colonial post in 1938, but abandoned it during World War II, and the region remained isolated until the 1950s. Thereafter, missionaries tried to convert the natives to Catholicism, and persuade them to desist from cannibalism and headhunting. In spite of these incursions, the population continued to rely on hunting and food gathering rather than agriculture. They were skilled wood carvers, and it was their artifacts, and the lumber in their forests, that attracted the outside world.

The Asmats are proud and fierce. Spirits govern their lives, and ancestor worship dominates their art. Men and women practice largely separate religious rites, those of the men taking place in special ceremonial houses (*yeu*), the largest structures of the community. One of the tribe's principal ceremonies concerns death, which, except in the case of the very old or the very young, is believed to be caused by malevolent spirits and must be avenged during a *bisj* ceremony.

For the ceremony the men of the village fell a mangrove tree, which, while being stripped of its bark, releases its blood red sap, thereby magnifying the sacrificial aspect of the ritual. Like a totem pole, the trunk of the upended mangrove is carved into a succession of stacked human figures, the deceased occupying the topmost position, a single root serving as his erect phallus.

Seymour Kurtz has written, "To the beat of war drums, the singing of songs, and a mock battle dance, the *bisj* pole is then raised in front of the ceremonial house. Within a few days the *bisj* is laid to rest in the sago forest ... The soft wood soon rots ... the spirit of the victim thus honored goes into the sago plant [the main food source of the Asmat] and thence into the people who eat sago."[12]

Michael Rockefeller's fascination with one of the world's last Stone Age cultures is evident from his letters and field notes:

I have just completed my first trip to the Asmat and am now sitting quietly on the boat back to civilization . . . The Asmat trip was equal to most of my wildest dreams . . .

The Asmat is filled with a kind of tragedy. For many of the villages have reached the point where they are beginning to doubt the worth of their own culture and crave things western. There is everywhere a depressing respect for the white man's shirt and pants, no matter how tattered and dirty.[13]

According to his brother Steven, it was during this 1961 trip that Michael considered devoting his life to anthropology rather than to taking care of Rockefeller business.[14] Upon his return home, he did not discuss the matter with his father, but instead prepared for a second, more extensive collecting trip to the Asmat. He packed an outboard motor to attach to a dugout canoe, and axes, knives, and other modern items to be traded for artifacts. Since the Asmat is so inaccessible, Michael and his Dutch companion, anthropologist René Wassing, planned to travel by boat along the coast and inland rivers.

The two men successfully collected shields, drums, sago pounders, ancestor figures, and other objects, which they stored at missionary stations located along their route. It would be difficult to ship these back to America, but as Mary Morgan recalled, "Father and Michael were impractical. They did not collect because they wanted to put 'it' someplace, they collected because it was beautiful, because it was meaningful."

In November, as Michael and René progressed along the mouth of the Eilanden River, a riptide developed. The canoes were overturned, the motor died, and the boats were swept out to sea. After a day at sea Michael decided to abandon the canoes and started to swim toward the twelve-mile-distant shore. A day later the Dutch air force rescued René, but Michael had vanished.[15]

As soon as they received the news of Michael's disappearance, Nelson Rockefeller and Mary Morgan flew to New Guinea and set out to search for him. As Mary recalled later, "Everything [among the Asmat] was unfamiliar:

their language, their looks, their lack of clothes." In spite of these cultural barriers, though, she felt that the people understood her pain, and shared it: "I realized at that moment why Michael was so in love with the Asmat people and also how close we are to people all over the world we know nothing about . . . that we basically have the same sensibilities. It made me able to go through that trip with another perspective than just loss."

Michael's treasures were brought back to New York, and in 1962, René d'Harnoncourt organized *The Art of the Asmat, New Guinea* exhibit in MoMA's garden. As Nelson Rockefeller recalled in 1978:

> There, the towering *bisj* poles, the beautifully decorated canoes and paddles, the warrior's shields and spears provided a tangible and impressive record of the life and creativity of one of the last great Stone Age civilizations . . .
>
> And thus we honor the memory of Michael, who, had he lived, would have been a leader today of the new generation in the arts.[16]

NELSON ROCKEFELLER KEPT searching for larger audiences to view the primitive art he was assembling, and in 1969 he finally persuaded the Met to mount a temporary exhibition consisting of one thousand objects from the collection of the Museum of Primitive Art. Mrs. Brooke Astor, a friend of the Rockefellers and a major supporter of the Met, saw a preview of the show and felt that the museum should acquire the pieces as part of its permanent holdings. Rockefeller assured Mrs. Astor that he would be willing to donate his collection. He pledged $2 million, and Mrs. Astor promised her financial support. The gift was announced at a celebratory dinner preceding the opening of the exhibition. The Met, it was agreed, would build a new wing named for Michael C. Rockefeller.[17]

In 1982 the Michael C. Rockefeller Wing opened its doors. In addition to the artworks, the Met had agreed to absorb the staff of the Museum of Primitive Art, and its specialized library. Thomas Hoving, the Met's great expansionist director, had spearheaded this offer. Under his stewardship

the museum had added the Robert Lehman Collection, located in its spe-
cial pavilion, and the glassed-in Sackler Wing, for the Temple of Dendur.
The primitive art was destined for another glassed-in enclosure, located at
the south end of the museum. The City of New York was balking at the
museum's encroachment on Central Park, and it took a while to obtain
the required permits. Mary Morgan worked hard at turning a paper con-
tract into a museum wing. Equal space was allocated to Africa, the Ameri-
cas, and Oceania. A psychotherapist by training, Mary Morgan, too, had
grown very close to the art, which to her was "more accessible in this wing
than almost anywhere else in the museum because it is so basic and deals
with so much kindness and with the feelings we all have."

THE WING IS subdivided into four sections, each featuring the art of a
vast geographic region: Africa, the Americas, and Oceania. Because primi-
tive art is often made from perishable material, surviving objects are of
recent origin, especially when compared to the vestiges of other ancient
civilizations.

The African section is filled with wooden ancestor figures; elaborate,
often scary masks; and headdresses. Even though these objects are famil-
iar to contemporary eyes, one can easily imagine how these powerful "ab-
stract" images affected artists at the turn of the twentieth century.

The Met's African collection consists mainly of ceremonial, intimate
objects. The masks and ancestor figures look constrained in their Lucite
cases. No wonder; they were meant to live in the open air and to partake
in celebrations and dances. Near the entrance to the African galleries is
a stately matron from Mali sitting on a high-backed chair. Her jewelry-
covered body and facial features are idealized. Her pointy, smooth breasts
proudly announce her gender, as does the child who clings to her middle.
The statue looks both contemporary and ancient.[18] Its closest neighbor is a
couple from Madagascar (seventeenth to eighteenth century) standing atop
a large post. Ancestor figures often come in pairs, the women and men of
equal size and importance.

The reliquary guardian head from Gabon was once owned by the sculptor Jacob Epstein, an early admirer of African art. (© The Metropolitan Museum of Art, New York/Art Resource, NY)

A reliquary guardian head from Gabon, made by the Fang people, is a prime example of the beauty, harmony, and power of African art. The minimalist eyebrows, eyes, and nose are balanced by elongated, extravagant ear ornaments. It is easy to see how the sparseness of the lines influenced Jacob Epstein's *Mother and Child* (1913) or Modigliani's *Head* (1915), both ensconced at MoMA.

More sophisticated, the art of Benin, a kingdom on Africa's western coast, includes nonperishable, finely cast dark brass heads, bas-reliefs, and ivory carvings commissioned by the kings, or *obas*. The museum's best-known Benin object is an ivory mask of queen mother Idia (mid-sixteenth century). A frieze of mudfish, a primitive amphibian said to have special powers, and of stylized Portuguese traders surrounds Idia's face. More typically, sculptures consist of ancestor heads wearing caps and chokers. A charming lion, from Nigeria (seventeenth to eighteenth century), bears an uncanny resemblance to those found in the Court of the Lions at the Alhambra Palace in Granada, Spain.

GOLD HAMMERED INTO gleaming vessels and objects for personal adorn-
ment are what captivated the Spanish Conquistadors as they reached South
America during the sixteenth century. A fraction of these gold objects, ar-
ranged in thirteen large cases, stops visitors in their tracks when they reach
the Jan Mitchell Treasury (named for the restaurateur–art collector), lo-
cated in the Michael C. Rockefeller Wing. Though the collection is named
for Mitchell, Alice K. Bache and Nelson A. Rockefeller contributed to it
equally. According to Julie Jones, the curator of the Michael D. Rockefeller
Wing, it is the world's most representative collection of pre-Columbian
gold because it includes examples from all regions of the ancient Americas:
Peru, Ecuador, Columbia, Panama, Costa Rica, and Mexico.[19]

Gold has a magic of its own. The Incas believed that, as the sun's rain,
it possessed spiritual and symbolic powers. The moon, on the other hand,
shed tears of silver. The Met's treasury is only a tiny fraction of the riches
that greeted the Spaniards, who were not actually interested in the beauty
of the objects and melted them down.

According to Jones, the first South American gold pieces date from 1500
BCE, when nuggets, sifted from riverbeds, were hammered into thin foil
and subsequently formed into objects. Casting processes were used later.
These ancient techniques came to an abrupt halt after the Spanish inva-
sion.[20] Most of the pre-Columbian gold objects were made for personal
adornment. There is great variety. Bats, turtles, frogs, crocodiles, double-
headed eagles, and other members of the animal kingdom decorate pen-
dants and nose and ear ornaments.

NELSON ROCKEFELLER AND René d'Harnoncourt minimized the
acquisition of North American native art because they felt that it was
amply represented in New York at the Museum of Natural History and
the Museum of the American Indian. Nevertheless, Nelson, the inveterate
shopper, owned a few choice pieces, and in 2007 the Met decided to enlarge
the space devoted to Native American art.

Native North American art was meant to beautify the world. The

blankets, clothing, and masks on display were used during ceremonies.[21] The objects illustrate the exquisite potting, weaving, carving, and embroidering skills of the native population. After the arrival of the Europeans, the Native Americans used their skills to make luxury items that were eagerly purchased by the new settlers.

OVER TEN THOUSAND miles separate the jungle-like mangrove swamps of the Pacific Islands and the glassed-in galleries of the Metropolitan. Yet even here, in its new environment, this strangely beautiful art creates a spiritual, almost religious atmosphere commanding respect. This is not surprising. Most of the objects created by the people residing on Oceania's twenty-five thousand individual islands are ceremonial, often representing ancestors and spirits who mediate between the supernatural and the human world.

About four hundred objects from various parts of Oceania are displayed in a huge, light-filled gallery and several smaller ones. The nine elegant Giacometti-like ancestor (*bisj*) poles steal the show. They are arranged along the outer wall of the gallery, the trees of Central Park and a bit of sky serving as a backdrop. The height of the poles—ranging from fifteen to twenty feet—contrasts with the horizontal length of the adjacent forty-eight-foot-long Asmat canoe. Carvings cover its prow and sides. Its crew would have numbered twenty standing men, each wielding a single upright oar. The sight of such a loaded craft might indeed have frightened off Captain Cook and other explorers.

An immense 80-by-30-foot ceiling consisting of 270 individual panels covers the center of the gallery, endowing it with a cathedral-like feeling. The panels, which used to cover the ceiling of a Kwoma ceremonial house, date from the 1970s. The master artists who created them applied a palette of blacks, browns, and beige paint to the barklike panels in ever-changing semi-naturalistic patterns. Equally powerful is a fourteen-foot-high gong from Melanesia, a humanoid effigy with tiny arms and hands and enormous saucer-like eyes surmounting a beaklike nose and mouth. The body of

the gong consists of a hollowed-out tree trunk, which when struck by mallets emits a loud sound, used for communication or as accompaniment to a dance. Many delicate smaller items are displayed in cabinets along the walls.

The Nelson A. Rockefeller Center for Latin American Art

On the last Wednesday in October 1978, Nelson Rockefeller phoned his older daughter, Ann Rockefeller Roberts, inviting her to accompany him to Mexico to celebrate the country's most colorful Indian feast day: the Día de los Muertos (the Day of the Dead, celebrated as All Saints Day elsewhere). Ann dropped her own plans and, two days later, joined her father. All of Nelson's children had loved the family's Mexican vacations—and a small voice in Ann's head was warning her that this might her father's last trip. As she recalled later, "It was an amazing weekend, both a mad buying spree and revisiting old times and old places."[22]

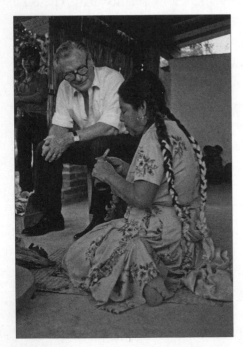

Nelson Rockefeller and Teodora Blanco in Mexico in 1978. (Annie O'Neill)

In 1977 a politically disappointed Nelson had retreated to multiple homes to write about his art collections. He had unpacked the crates that held the Mexican folk art and asked art photographer Lee Boltin to photograph its three thousand items. This was Nelson's most joyous collection, and no member of his family or staff had ever seen it in its entirety. To recapture his own enthusiasm, he had decided to revisit Oaxaca and recall the early days of his life-long Mexican love affair: "It was just forty-five years ago, in 1933, that I first went to Mexico and discovered the beauty and excitement of this unique land," he recalled in *Folk Treasures of Mexico*. This initial trip lasted three months. Francis Flynn Paine, who had introduced Abby to Diego Rivera, had planned their trip. In addition to Miguel Covarrubias and his dancer-wife, Rosa, the Rockefellers visited with Roberto Montenegro, another well-known Mexican painter and folk art expert, and Fred Davis, who, like Flynn, had played a key role in reviving Mexican crafts.[23] Nelson shopped without restraint and returned to the United States with twenty-seven cases of acquisitions.

As always, Nelson insisted on sharing his discoveries; in this case he wanted Latin American art to become part of the world's artistic alphabet. In 1940, soon after he had assumed MoMA's presidency, he had endowed an Inter-American Art Fund and arranged the aforementioned *Twenty Centuries of Mexican Art* exhibit (see chapter 11 of this book).

Nelson's love of Latin America had helped him enter politics. In spite of his crowded agenda he occasionally returned to Mexico, sometimes accompanied by his children. In 1934, after Junior had loosened the family purse strings, Nelson invested money in Creole Petroleum, the Venezuelan subsidiary of Standard Oil of New Jersey, thereby establishing a South American base and eventually building a spectacular hacienda at Monte Sacro in Venezuela.[24] His Mexican folk art collection had continued to grow haphazardly.

In 1968, Nelson accidentally discovered Annie O'Neill's folk art gallery in Manhattan. As she remembered, one evening a man knocked on the door of her closed shop, and she let him in. He looked around and started talking and buying. Annie realized that the art talk had miraculously re-

juvenated her tired, new client. The visit to Annie's shop prompted Nelson to organize a Mexican folk art show at the Museum of Primitive Art. He unpacked his collection at Pocantico Hills and dispatched O'Neill to Mexico to fill in the gaps. He asked Carl Fox, another folk art expert, to design the show at the museum and to write the catalogue.[25]

When Rockefeller returned to Mexico in 1978, accompanied by his daughter as well as by Annie O'Neill and Carl Fox, some of the great artists and potters he had encountered earlier were still "creating [ceramics] with the same vigor, insight, and sensitivity [as before]." They included Teodora Blanco, Doña Rosa, and members of the Aguilar family. Nelson shopped some more.

ANN ROCKEFELLER ROBERTS'S hunch had been right. Nelson Rockefeller died unexpectedly in January 1979, three months after this jubilant Mexican trip. Years earlier he had settled the future of most of his cherished possessions. Alfred Barr had selected works that would enhance MoMA's collections. The Museum of Primitive Art had morphed into the Michael C. Rockefeller Wing at the Metropolitan Museum of Art, and many other institutions had received smaller bequests. The Empire State Mall was finished, and Kykuit, with its interior galleries and spectacular outdoor sculpture garden, was ready to be handed over to the National Trust for Historic Preservation. However, no provision had been made for his Mexican folk art collection. It was about to be sold at auction or divided up among various family members when his daughter Ann Roberts bought it from the estate in its entirety. Then she set about finding it a home.[26]

It was Nelson's most personal, impulsively formed collection. During his 1978 trip, for example, he had bought a street vendor's entire supply of *milagros* (small offerings of gratitude). Many of Nelson's treasures were extremely delicate. Some of the ceramics were fragile because they had been fired at very low temperatures; other objects consisted of fabric, feathers, and even paper.

Ann Roberts appointed an advisory committee to help her find the

collection a permanent home. In 1985 she decided to donate the major part of the collection, about twenty-five hundred objects, to the San Antonio Museum of Art, or SAMA, and the remainder, about five hundred pieces, to the Mexican Museum in San Francisco, founded by her father's friends Miguel and Rosa Covarrubias.

As museums go, the one in San Antonio is rather young, though its parent organization started to assemble some artworks as far back as 1926. Because it is of such recent vintage, the institution is remarkably free of aesthetically indifferent clutter. By converting the historic Lone Star Brewery, erected between 1884 and 1904, into a modern museum, San Antonio was in the forefront of what would eventually become the building recycling movement.[27]

The yellow brick brewery still has a military appearance. The original structure included low-lying buildings and two towers connected by an astonishing floating bridge, from which one can see the skyscrapers of downtown San Antonio, the seventh largest U.S. city. Because it used to accommodate brewery stills, the structure has exceedingly high ceilings. The entrance, the so-called Great Hall, soars to the third floor. Directly in back of this hall is a low-lying gallery reached by a passageway covered by one of Dale Chihuly's magic glass concoctions. Galleries extending to the right and left are filled with excellent, comprehensive collections of Chinese, Japanese, Egyptian, Roman, Greek, Near Eastern/Oceanic, and European art.

More than half of Texas's population is Mexican, and San Antonio has a decidedly Mexican flavor. The stores are filled with colorful pottery; the food stands and outdoor cafés serve Mexican food. On November 1, the Día de los Muertos, the streets are filled with about five hundred altars, at which people celebrate the past and the present, the old country and the new, the living and the dead. Like the rest of Texas and its growing number of superior museums, SAMA has profited from the oil that gushes so liberally from the state's soil.

From the very beginning, San Antonio wanted its museum to serve its large Latino population. Robert K. Winn, a San Antonio resident, supported this goal. He, too, had assembled a major Mexican folk art collection, which

he intended to donate to SAMA. In addition he had also endowed a folk art curatorship at the museum. The new post came to the attention of Marion Oettinger, Jr., then teaching cultural anthropology at Cornell University. An ethnologist by training, Dr. Oettinger had gradually developed a special affinity for objects that fulfill utilitarian, decorative, and ceremonial functions.[28] In 1985, Oettinger became SAMA's curator of folk and Latin American art; in 2004 he would be appointed to the directorship of the museum.

Once the fate of Nelson's collection had been agreed upon, Oettinger went to examine it in Pocantico Hills. He recalled the thrill of seeing it for the first time, and he would spend the next year inventorying the items. Oettinger also completed the book dealing with the folk art collection that Nelson Rockefeller had started before his death. Both Lee Boltin, the photographer, and Annie O'Neill, the gallery owner, assisted.

The Rockefeller collection turned out to be special in many respects: its size, its inclusiveness, and its relative antiquity, including some items dating from the eighteenth and nineteenth centuries. Even though many of the objects had been bought impulsively, the collection nevertheless reflected the scholarship of Roberto Montenegro, Frances Flynn Paine, and Miguel and Rosa Covarrubias.

In 1991, twelve years after Nelson Rockefeller's death, the Metropolitan Museum of Art finally mounted *Thirty Centuries of Mexican Art*, a show that Nelson had spent years lobbying for. The exhibition had two other venues in the United States: in Los Angeles and at SAMA, which had fought hard for the honor and was a perfect host. The museum's effort had been worthwhile. During the seven weeks the show was in San Antonio it welcomed 270,000 visitors. The event increased the museum's visibility and reinforced its determination to strengthen its artistic link with Central and South America by establishing a Center for Latin American Art. It took some time to assemble the $11 million to build a major addition. From the beginning, it was clear that the center should be named for Nelson A. Rockefeller, even though several other donors had been extremely generous. As Oettinger recalled, Nelson had been fighting in the trenches for recognition of Latin American art at a

time when the U.S. art community was saying that "this stuff *que no tiene nada de valor, nada*" (was of no value, none). "Even in the 1930s," Oettinger continued, "the Met still turned away every gift of pre-Columbian art, [saying] *'que no es arte, nada'* ... On the other hand, when MoMA mounted its first Mexican exhibition, the museum published a bilingual catalogue. Who ever heard of such a thing in 1940?" Oettinger asked rhetorically. "That is the kind of thing we're celebrating and honoring here by naming the Center after him."

SAMA'S FOUR MEXICAN folk art galleries are roughly subdivided into general, ceremonial, utilitarian, and decorative objects. But this classification belittles the immense variety and playfulness of the material. Not all folk artists were equally gifted: some were highly skilled, while others used crude techniques.

Nelson's famous and often-illustrated crane is near the entrance. Its neck and body consist of an oddly shaped gourd that was hollowed out, dried, and lacquered by expert hands. The gray-green gold-flecked bird standing on long orange legs is even more graceful than it appears in pictures. "In the right hands folk art can be as great as fine art," says Marion Oettinger. The crane was collected by Nelson Rockefeller during his first Mexican trip, and has been widely exhibited, but now has become too fragile to travel.

Folk artists love to depict animals, with monkeys being a favorite. A large mama monkey wearing a colorful dress is accompanied by a smaller black pottery one huddled by her side. A large wooden bull and a smaller bear occupy the center of the gallery. Animal-, human-, and fantasy-faced masks are everywhere. Some are quite naturalistic, as is the bald Caucasian man wearing a white goatee. His near neighbor is a fierce-looking jaguar. Dating from the late nineteenth century, the mask consists of glass, painted wood, animal teeth, and boar bristles.

Enormous painted trunks fill another display case. An untutored eye could easily mistake the flower-adorned Mexican chests for Amish, or

Russian. Among the chests is a small, painted shoeshine box shaped like a small truck, inscribed "Expresso Bolivariano 747," which Marion Oettinger bought in 1983 from the man who made and used it on a Bogota street.

Excellent pottery, each type characteristic of a particular Mexican region, fills other cabinets. As in the case of a large utilitarian water jar, from Tonalá, Jalisco, made in 1925, the technique of making such pottery has barely changed since the seventeenth century. Jars from the Mezcala region are hand-molded using a pre-Columbian technique. The decorations, however, must have evolved with time, since the potters depict *charros* mounted on typical Western saddles. The museum used one of these charming cowboys as the logo of the folk art collection.

Humorous human figurines are also popular. One represents a devil, with horns, wings, and a tail wrapped around his leg, liberally imbibing from a bottle of wine. A pious couple holding a rosary and a Bible are presumably on their way to church. Teodora Blanco of Oaxaca, whose entire inventory Nelson bought during his final trip in 1978, made some of these statuettes. Whole cases are filled with exquisite textiles: woven, embroidered, and appliquéd.

Nelson A. Rockefeller's collection accounts for about 40 percent of the objects exhibited in the folk art galleries. The objects on display change periodically and represent only a small fraction of the immense Rockefeller collection lovingly cared for in storage.

One flight up from the folk art galleries are the mostly religious paintings and sculptures created during Latin America's colonial times. With its barrel-vaulted ceiling and subdued lighting, the space has the intimacy of a small, provincial church. Anonymous itinerant folk painters, influenced by the Baroque style of seventeenth- and eighteenth-century Spain, created the works. They are devoid of the extreme asceticism and expressions of grief characteristic of many religious works.

A large altarpiece, *The Retablo de María*, occupies the end of the gallery. It is extravagantly gilded and embossed with roses. In addition there are numerous smaller *retablos* painted on copper, canvas, or tin, often com-

missioned to thank a particular saint for a prayed-for intervention. These small gifts were placed on church or home altars. The saints, martyrs, virgins, angels, Roman soldiers, and even the crucified Christ shown in the small pictures are charming. Among the many examples, Oettinger singles out St. Francis embracing Christ on the cross "painted in rich colors with a sharply defined technique," and a small image of *El Niño de Atocha*, in which the young Christ, dressed as a pilgrim, is sitting on a small red chair.[29]

There are many parallels between Nelson's folk art in San Antonio and his mother's folk art in Williamsburg. Sometimes the links are amusing. San Antonio owns a guitar whose body consists of an armadillo shell; Williamsburg has a fiddle made from a tortoise shell. Both museums championed what Holger Cahill so eloquently called the Art of the Common Man. In creating their collections, both Abby and Nelson trusted their own judgment, and enjoyed buying neglected, inexpensive objects. Both gave a cheerful gift to their fellow Americans.

Smaller Gifts

I N ADDITION TO their major donations, the Rockefeller family gave art to other museums. Some, such as the Detroit Institute of Arts, or the College of William and Mary in Williamsburg, received a couple of art objects, while others received major contributions. This is the story of nine of them.

THE ARKANSAS ARTS CENTER

In 1954, Winthrop, the son who so far had not lived up to Rockefeller expectations, was on his way to Arkansas. His marriage to Barbara (Bobo) Sears was over, and the state's divorce laws were rather liberal. Being a Rockefeller, he found the move no financial hardship. He bought himself 927 acres of land atop Petit Jean Mountain, sixty-six miles west of Little Rock. He bought cattle, including a prize $31,500 Santa Gertrudis stud bull, conveniently named Rock. It was the bull, and not a Rockefeller, who lent his name to Winrock Farm. Eventually, six thousand head of cattle grazed contentedly on the ranch's thirty-four thousand acres of lush grassland.

After his divorce, Winthrop Rockefeller married Jeannette Edris. He also entered politics. During the 1950s, Arkansas was still part of the Deep South. It was strictly a one-party Democratic state, one sternly ruled by Governor Orval Faubus. Segregation and discrimination were the order of

the day, and the riots that accompanied the integration of the Little Rock public schools made history. Nevertheless, Winthrop, the great-grandson of abolitionists Harvey and Laura Spelman,[1] became a successful Arkansas politician. He was elected governor in 1966, the first Republican since the Civil War. Among other achievements, he reformed the Arkansas prison system and attracted technology and industry to the state.[2]

Winthrop would not have been Abby Rockefeller's son if he had ignored art. Little Rock had had a Fine Arts Club since 1914. Fourteen years later, the club morphed into the small Museum of Fine Arts, which hung twelve canvases on the fourth floor of the former Pulaski County Courthouse. In 1938 the embryonic museum moved to a small building in MacArthur Park. In 1957, Little Rock's Junior League and Mr. and Mrs. Winthrop Rockefeller came to the rescue. The Rockefellers insisted that the new institution serve the entire state of Arkansas. Five galleries, a theater, studio classrooms, sculpture courtyards, and an art library wrapped themselves around the old museum. The institution was renamed the Arkansas Arts Center (AAC).[3] The finances of the museum remained strained, but matching Rockefeller grants, made by the Rockefeller Brothers Fund, helped. Jeannette Rockefeller suggested that the museum hire a professional staff.

The Rockefeller family also donated art to the museum. In 1955, Abby (Babs) Rockefeller Mauzé gave it *Two Women*, painted in Paris in 1914 by the young Diego Rivera, then in his Cubist period. The work is one of AAC's treasures; its presence is often requested elsewhere, so it does a lot of traveling. Five years later David Rockefeller gave the museum Odilon Redon's mystical *Andromeda*, an equally impressive work also painted in Paris, in 1912. It, too, is often on the road.[4]

In spite of monetary infusions from the Rockefellers, AAC was almost on the point of closing when, in 1968, Townsend Wolfe became its director. His first task was to put the museum on a sound fiscal basis. Because they are relatively inexpensive, Wolfe acquired mostly drawings and other works on paper, and today the museum owns one of the best such collections in America. Laurance S. Rockefeller gave the museum a major gift of watercolors, etchings, drawings, and lithographs, by mostly French artists,

that he had inherited from his mother. Winthrop, too, passed some of his art inheritance to the museum, including eleven Chinese famille noire porcelain vases from Junior's fabulous collections, one of his spectacular Isfahan Polonaise silk-and-metallic-thread rugs, and George Romney's imposing portrait of *Lady Willoughby De Broke*. Charles Demuth's *A Bouquet*, a watercolor painted in 1928, descended from Abby. During the late 1990s, Wolfe undertook another major renovation, supported in large part by a grant from the Kresge Foundation. It enabled the AAC to become a very respectable institution, whose collection was valued at $22 million in 1999.

After Winthrop Rockefeller died in 1973, the AAC *Members' Bulletin* remembered how much he meant to the state, and the art museum.

> With his wonderful people-centered generosity, Winthrop Rocke-
> feller spent the monies he committed to art not on building a great
> personal collection, but on developing the Arts Center, and by doing
> so, he opened up the possibility for every person in this state to become
> sensitive to art . . .

The Frick Collection

Henry Clay Frick met John D. Rockefeller, Jr., in 1901, when they negotiated a deal concerning the Mesabi ironworks. Frick was impressed by the young man's earnestness, and the two established what Junior would describe as a "pleasant friendship." The men shared a love of art, especially Chinese porcelains. In 1913, Carrère and Hastings built an imposing mansion for Frick in New York City. To effectuate its eventual transformation into a public museum, Frick appointed a nine-member board of trustees that included Junior, and Frick's daughter, Helen Clay Frick, who had been much involved in forming the world-class art collection. To implement her father's wishes Helen had been left the major share of his fortune.[5]

Frick, a self-made entrepreneur, had always loved and collected art. Initially his purchases were modest, but after he had amassed his first million, he spent liberally. He bought carefully and, as attested by the collec-

Francesco Laurana, Beatrice of Aragon, *willed to the Frick Collection in New York by John D. Rockefeller, Jr.* (Courtesy of The Frick Collection, New York)

tion hanging in his mansion when he died in 1919, had excellent taste. The Fifth Avenue mansion remained a private home until the death of Frick's wife, Adelaide, in 1931.

In time, trouble between Helen Clay Frick and the other Frick museum trustees developed. It centered on the interpretation of her father's will and the enlargement of the collection. Insults were traded. Helen Frick called the Rockefellers cowbirds,[6] and Junior declared Helen unbalanced.

In spite of all this uproar, the architectural modifications progressed. Junior was appointed chairman of the building committee and went about his assignment with his usual thoroughness and zeal. John Russell Pope, later the architect of the National Gallery of Art in Washington, added galleries and a garden court, which includes a pool surrounded by plants and sculptures. The Frick opened to the public on December 16, 1935. Sixty years later, J. Carter Brown, director emeritus of the National Gallery of Art, declared it "one of the greatest private collections as well as one of the most-loved public institutions ever created on American soil."[7]

Helen was not mollified by the success of the building. The trustees continued to fight bitterly over what new works should be added to the 136 paintings left by Frick, Helen, feeling that since she had acquired art for the

collection since she was eight years old, she knew better than the trustees what was appropriate for her father's collection.

Helen Frick was particularly rankled by the fact that Junior planned to will the Frick eleven paintings and two sculptures. She feared that such donations would overwhelm the personal character of her father's beloved legacy, and that, in time, the Frick would become another Rockefeller institution. The dispute became so vehement that, in 1947, it went to court, which decided that the museum could accept the works. By then Junior had resigned his trusteeship and returned the $50,000 Frick had given to each trustee.

Eventually Junior changed his will and allowed his family the right to keep the works he had originally intended to leave to the Frick. The Rockefellers kept all of them except for *The Crucifixion*, by Piero della Francesca, and the busts of *Beatrice of Aragon*, by Francesco Laurana, and of a *Young Woman*, by Andrea del Verrocchio. Originally Junior had balked at the $1 million price tag of the two sculptures, but they had become much-beloved possessions, especially since it was felt that the features of the sculptures resembled those of the young Abby. Now the much-fought-over objects are often exhibited just off the serene garden court of the Frick; they delight visitors unaware of the previous disagreement.

HARVARD UNIVERSITY ART MUSEUMS

Harvard was always special to the Rockefellers, and in 1957, alumnus David established a professorship in Asian art in his mother's memory, a gift enlarged in 2007 to include an Asian art curatorship. In 2008, David Rockefeller pledged $100 million to his alma mater, specifying that $30 million be used for the renovation of the Fogg Museum, now part of the Harvard University Art Museums.

Abby had left the museum twenty-seven Persian miniatures. It was not surprising that these gems, whose intimate nature is so similar to the Japanese prints she had been collecting for decades, enthralled Mrs. Rockefeller. Persian miniature painting reached its height during the fifteenth and sixteenth centuries when the Ottoman Empire was at its apogee. The exquisite

illustrations, enhanced by Islamic calligraphy, clearly have a style of their own even though their European and Asian influences are apparent.

Created mostly as book illustrations, the works depict battles; hunting, camping, and domestic scenes; royal festivities; love stories; fables; bestiaries; and much more. Animals, especially graceful horses, played a major role. The images are highly decorative: strong primary colors and carefully defined areas filled with tile mosaics, rugs, plants, or calligraphy provide structure and delight the eye.

Abby Rockefeller purchased some of her Persian miniatures in Paris in 1924. They were so expensive that she pleaded with her husband to pay for them. As Abby's biographer reports, perhaps one day "her selections would displease him. But for now she was on safe terrain. Miniatures of theological origin, in flawless condition, encrusted with jewels, could cause him no discomfort."[8] Abby continued to acquire Persian miniatures in New York. In 1925 she enlarged her collection, buying a rare page from the *Manafi Al-Hayawan* (Description of Animals) manuscript from collector Dikran Kelekian in New York, and a *Man in a Fur Cap*, by Riza Abbasi, formerly in the possession of the Teheran court.[9]

In 1933, curator M. S. Dimand[10] included "splendid miniatures lent by Mrs. John D. Rockefeller, Jr.," in an exhibition at the Met. Dimand described the Persian artists as "great colorists capable of creating vivid contrasts as well as soft harmonious effects." In the show, Abby's miniatures shared the limelight with many supplied by mining magnate A. Chester Beatty, some of whose Impressionist masterpieces David Rockefeller was able to buy. The 1933 show also included Persian miniatures collected by Abby's friend Edward Forbes, the director of the Fogg Art Museum. It may very well have been this shared interest that prompted Abby to leave her paintings to Harvard.

Hood Museum of Art at Dartmouth College, Hanover, New Hampshire

When he decided to go to Dartmouth, Nelson may not have known how well the school fitted his artistic aspirations. The philosophy of the college

also suited the Rockefellers' principles of egalitarian education. In 1769, when the Reverend Eleazar Wheelock founded it, one of the school's goals was to provide "instruction of Youth of the Indian Tribes in this Land . . . and also of English Youth and any others."[11]

From the very beginning the college stressed art education. Its small collection included portraits by the leading American artists of the day: Ralph Earl, Thomas Sully, Joseph Steward, and Gilbert Stuart. Dartmouth, like several other older New England colleges, acquired Assyrian bas-reliefs from the Northwest Palace of Ashurnasirpal II. A British archaeologist helped alumnus Reverend Austin H. Wright, class of 1830, secure six panels for his alma mater.

Formal art education at Dartmouth began in 1890. Initially the courses dealt with the art of the Italian Renaissance and nineteenth-century Europe. Modern art arrived in 1928, with the almost concurrent construction of Carpenter Hall, which housed the art department studios and galleries, and the appointment of Churchill Lathrop. The young art historian was an inspired teacher and gifted gallery director. He exerted a major influence on Nelson Rockefeller, who in 1975 would give his alma mater *Guitar on a Table*, a seminal work by Picasso. Long before that, however, Nelson urged his mother to assemble a teaching collection and present it to the college.[12]

Mrs. Rockefeller, no doubt assisted by her friend and advisor Edith Halpert, carefully selected 117 highly diverse works, valued, according to the *New York Herald Tribune* of March 12, 1935, at $35,000. Upon its receipt, the school exhibited the collection in its entirety in Carpenter Hall, which remained Dartmouth's major exhibition hall until 1985, when alumnus Harvey P. Hood, a scion of a New England dairy fortune, donated money to erect a charming new museum.

Most valuable by far among the Rockefeller gifts was Thomas Eakins's *The Architect (Portrait of John Joseph Borie III)*. The collection includes Stuart Davis's *Statue Paris, 1928*; Charles Demuth's *Beach Study No. 3 Provincetown*; Marguerite Zorach's *Sixth Avenue "L"*; George Ault's *Roofs*; Stefan Hirsch's *Mauve Hat*; and many works of George O. "Pop" Hart. Most amusing among these contemporary American works is a caricature-like portrait of

Morris Ernst, by Peggy Bacon. In 1933, Ernst had successfully challenged the banning of James Joyce's *Ulysses* on grounds of obscenity. Abby had bought this pastel portrait of the liberal civil rights lawyer in 1934, at the First Municipal Art Exhibition held at Rockefeller Center and mostly organized by Edith Halpert. It had been daring of her to include such politically provocative art in the exhibition, since it followed, by a few weeks, the destruction of the unfinished Rivera mural in the lobby of 30 Rockefeller Plaza. A *New York Evening Post* headline duly noted Abby's purchase: "Radical Picture of Radical Bought at Art Show by—Yes, Mrs. Rockefeller, Jr."[13]

Dartmouth's most famous artwork, José Clemente Orozco's *The Epic of American Civilization*, is also Rockefeller-related.[14] The revival of mural painting dates from the 1930s, when both Diego Rivera and José Orozco worked in the United States. Though Rivera was better known, and Abby Rockefeller favored his coming to Dartmouth, the college's art department preferred Orozco and used a $500 study grant provided by the Rockefeller family to persuade him to come to the university, where he taught the fresco technique and painted a small mural. During that initial visit Orozco and his hosts started to dream about a much larger fresco cycle. A very enthusiastic Orozco proposed painting the myth of Quetzalcoatl and the creation of a new civilization in America. It took some time to obtain funding for the enormous project. In the end it cost Dartmouth about $10,000, very little when compared to the $21,000 Rivera received for the one ill-fated mural in Rockefeller Center, or the $20,000 and $60,000 John Singer Sargent and Pierre Puvis de Chavannes, respectively, collected from the Boston Public Library. Begun in 1932, the 150-foot-long Dartmouth mural is Orozco's most ambitious North American work, one that catapulted the institution into the forefront of the art world.

The *Epic* consists of twenty-three individual panels recounting the history of the Americas. It begins with an image of human migration and includes pictures of ancient human sacrifice; the arrival of the mystical, blue-eyed, white-clad Quetzalcoatl bearing the gift of agriculture; and his departure in a raft surrounded by rearing snakes. A small panel entitled *The Prophecy* depicts masked horses, and masked soldiers bearing a huge

cross. Crowds—pre- and post-colonization—are massed in larger panels; symbols, snakes, arrows, ancient totem poles, and modern machinery fill smaller ones. The fresco is both beautiful and terrifying. In the opinion of many critics, it is the greatest mural cycle in the United States.[15]

Junior, for one, did not agree. In 1933 he wrote to Abby, "While in Hanover I saw the murals of the other Mexican painter—Oresco or some such name. All I can say is that I am glad they are not on the walls of Rockefeller Center."[16]

Nelson remained devoted to his alma mater and even chaired its building committee. When the college was ready to build a performing arts complex, he suggested that Wallace Harrison design it. Even though the architect was deeply involved with Lincoln Center and its new opera house at the time, he accepted the commission for a nine-hundred-seat theater. Five arches, shielded by an overhanging roof, front Dartmouth's stunning white Hopkins Center. The architect told writer Victoria Newhouse that the building was inspired by Florence's fourteenth-century Loggia dei Lanzi. For years Harrison had struggled with the design of the Metropolitan Opera, and the Dartmouth building offered a proving ground.[17]

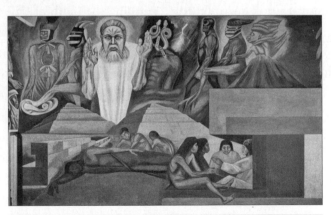

José Clemente Orozco, details from the mural series The Epic of American Civilization, *1932–34, Dartmouth College, Hanover, New Hampshire.* (Hood Museum of Art, Dartmouth College, Hanover, New Hampshire, commissioned by the Trustees of Dartmouth College)

Museum of Indian Arts and Culture

In 1926, Junior and Abby, accompanied by sons Laurance, Winthrop, and David, went once more to explore the American West. En route, they stopped in New Mexico, where Kenneth Chapman, an anthropologist and expert on Pueblo pottery, showed them the growing collection of the newly founded Indian Art Fund.[18]

Abby was enthralled, and insisted on visiting some of the artists in their pueblos. In San Ildefonso they met the word-famous Maria Martinez, who specialized in making polychrome pottery. In 1908, at the request of the Museum of New Mexico, Martinez had agreed to reinvent the technique of producing the shiny black-on-black pottery, shards of which had been unearthed near San Ildefonso. It took her ten years to achieve her goal. Junior and Abby bought several of Martinez's blackware pots, and young David spent three dollars on a small painted, buff-colored vessel. Chapman also introduced Abby to Pueblo painters and to the avant-garde artists of the Taos Art Colony.[19]

Shopping was part of every Rockefeller voyage. On this particular voyage Junior and Abby acquired Native American blankets, baskets, weavings, pottery, and other artifacts and had them shipped to Maine, where they formed the décor of their small "Rest House," which offered relief from the nearby 106-room Eyrie in Seal Harbor.[20]

Always ready to fund a cause he believed in, Junior contributed $200,000 to the nascent Laboratory of Anthropology in Santa Fe. Additional contributions were made until 1947. The primary goal of the institution was research and education, but from the very beginning, visitors could admire its growing collection of textiles, Navajo rugs, Kachina dolls, jewelry, and especially pottery. The small exhibition space of the Laboratory of Anthropology eventually became the Museum of Indian Arts and Culture, a branch of the Museum of New Mexico. It is a spectacular institution exploring all aspects of Native American culture. It owns more than ten thousand pots, a selection of which is on view in a special gallery. Only one of these, a Polacca polychrome handled bowl, is a gift of Peggy and David Rockefeller.

The Rockefellers, especially Laurance, collected Native American artifacts, but their interest in the American West had other major consequences. The beauty of Jackson Hole and the Grand Tetons in Wyoming particularly enthralled Junior. In 1926 he bought 33,562 acres that are now part of the spectacular Grand Teton National Park. Among the lands Junior purchased was the 1,106-acre JY dude ranch the family retained for 75 years as a much-beloved retreat. In 2001, Laurance Rockefeller donated it to the federal government for inclusion in the park.

DURING THE 1980S David Rockefeller became aware of the problems of the National Museum of the American Indian.[21] One of the foremost collections of Native American artifacts in the United States, when it was founded by George Gustav Heye the museum had been marooned in rather inadequate, inaccessible quarters in Washington Heights, New York, since 1917. Now, under the auspices of the Smithsonian Institution, the collection was to be housed in a new building on the Mall in Washington. There was a problem, though. According to Heye's will, the collection had to stay in New York City. Because of his involvement with Lower Manhattan, David Rockefeller was aware that a new use had to be found for the spectacular Alexander Hamilton U.S. Customs House located at 1 Bowling Green in Manhattan. Part of the Heye collection was, therefore, moved to the Customs House, where, administered by the Smithsonian, it delights visitors and satisfies the terms of Heye's will.

THE FRANCES LEHMAN LOEB ART CENTER
AT VASSAR COLLEGE

Matthew Vassar, a British-born American brewer, founded Vassar College in 1861 to provide women with a liberal education equal to that offered to men.

From its inception, Vassar attracted well-bred, liberal students. Bessie, the only one of Senior's daughters to attend college, went to Vassar during

the 1880s. Her father became a trustee of the college and donated Rocke-feller Hall. While visiting Bessie, Senior met William Rainey Harper, a Baptist minister and a Yale faculty member who often taught Sunday Bible class at Vassar. Senior was impressed by the young man and persuaded him to become the founding president of the University of Chicago.[22]

From the very first, music and art education were part of Vassar's core curriculum. An art gallery, to be filled with copies of famous European artworks, was to be the major component of the original design developed for the college by architect James Renwick. Instead of relying on copies of great European artworks, Matthew Vassar opted to buy the art collection assembled by Elias Lyman Magoon, a Baptist clergyman and member of the board. It included paintings of the Hudson River School, artworks sanctioned by the National Academy of Art, watercolors, prints, and some antiquities. Vassar paid $20,000—about $300,000 in 2009 dollars—for it.

Outstanding teachers have cared for the collection since its inception. Agnes Rindge, a student of Paul Sachs's famous museum school, arrived in 1923 and spent her entire career at Vassar. Through her, Alfred Barr, Henry Russell Hitchcock, Alexander Calder, and others involved in popularizing modern art would visit and teach at Vassar. Alumni and others enriched the burgeoning museum and turned it into an important center for modern art.[23]

Blanchette Ferry Hooker,[24] John 3rd's wife, attended Vassar, majoring in music. Blanchette showered her alma mater with gifts. In 1980, on the oc-casion of her class's fiftieth reunion, the Vassar Art Gallery mounted an ex-hibit of the nearly eighty works she had donated to the school, noting that "her gifts form the nucleus of the museum's contemporary art collection."

Blanchette's very personal gifts include paintings, sculpture, watercol-ors, and prints. The larger paintings reflect the donor's love of the New York School and other contemporary masters. Mark Rothko's *Number 18 (1948)*, one of the artist's seminal works, and Francis Bacon's *Study for Portrait I*, one of the British painter's *Pope* series, are world-famous, their presence being often requested by important shows. Other Rockefeller donations include Karel Appel's *Child and Beast II*, shown at MoMA in 1955; two white columns from Louise Nevelson's *Dawn's Wedding Feast*;

Matisse's twenty prints from his *Jazz* series; and a sculpture entitled *Junge Frau*, by Germany's Georg Kolbe.

Since 1993 the Vassar museum has been housed in the Frances Lehman Loeb Art Center, designed by the Argentinean architect César Pelli. Its red brick walls and steep roof harmonize with the older buildings of the campus. The most extraordinary architectural feature of the new art gallery is the entrance pavilion, and the corridor that links it to a small sculpture garden and the art department proper. The structures seem to be made entirely of glass, and they offer an enchanting view of the lawns and massive trees that dominate the campus. The name of Blanchette Rockefeller is embedded in the floor of the entrance—a gift from her family honoring the woman whom her class at Vassar described as "the most respected" and "the most perfect lady."

MAUNA KEA

Laurance S. Rockefeller inherited his father's concern for the environment. He enlarged Junior's gifts to the Grand Teton National Park and contributed to other parks, in the Caribbean and in Hawaii. During the 1950s, Laurance founded a series of environmentally sound, high-luxury resorts. Among these was Mauna Kea, located on a sandy bay on the lava-strewn coast of Hawaii's Big Island. The hotel, a continuous series of unadorned five-story concrete buildings, hugs the elevated shore, which is covered with an abundance of vegetation. Every room has a balcony with a view of the mountains, the ocean, the gardens, or the beach. Dining rooms, lounges, walkways, and other public spaces are wide open to the air, and the entire complex has an indoor-outdoor feeling.

The most spiritual of the Rockefeller brothers, Laurance majored in philosophy at Princeton, and though he became a venture capitalist, he continued to study religions, especially Buddhism. Mauna Kea gave him the opportunity to combine his reverence for nature with the Rockefeller building interest and the Aldriches' love of art. The resort houses about one hundred works of Asian and Oceanic art, and many guests describe it as a museum.

Seated Buddha, *India, seventh century.* (Courtesy
of Mauna Kea Beach Hotel, Hawaii)

Laurance Rockefeller felt that he could use the art he purchased for
Mauna Kea to "teach the West about the spirit and wisdom of the ancient
East."[25] He distributed the objects in the hotel and the outlying areas so
that visitors would encounter them often, thereby acquiring "an aware-
ness of, and an appreciation for, the traditions of the East."

The most visible is a Buddha from Nagapattinam, in southern India,
dating from the seventh century. Fittingly displayed at the foot of a *bodhi*, or
sacred fig tree, under which the Buddha achieved enlightenment, the statue
dominates the landscape. Other works fill the gardens, terraces, lounges,
and pavilions: the nineteenth-century *Crouching Goat*; an eighteenth- to
nineteenth-century Buddhist altar from Thailand; a nineteenth-century
pair of bronze koi (carp) from Japan; thirty-four carved and decorated

shields from Oceania; Abelam basketry masks; figural sculptures from New Guinea; and elaborately decorated canoe prows from Maori. Hawaii contributed contemporary art, including a wooden abstraction by Sam Ka'ai, an *'Iwa* (Frigatebird) by Edward Brownlee, and a collection of thirty quilts designed by Meali'i Kalama.

Marsh-Billings-Rockefeller Mansion

Museums are often born accidentally, and so it was with the Marsh-Billings-Rockefeller Mansion (the MBR Mansion) and its art collection in Woodstock, Vermont. Its story is a tale of three different prominent, financially comfortable men and their families. All had a great love for America, its beauty and natural resources, and all became staunch environmentalists and conservationists.

Born in 1801, the future U.S. senator George Perkins Marsh remained deeply attached to the lush green of his family's Woodstock farm and home. Today Marsh is remembered as America's first environmentalist. In 1864 he wrote *Man and Nature*, in which he presaged that human activity "brought the earth to a desolation almost as complete as that of the moon." In 1861, President Abraham Lincoln appointed Marsh as the first U.S. minister to Italy. It is there, far from his beloved Vermont, that he died in 1882.

Enter Frederick Billings. Born in Vermont in 1823, as a young man Billings joined the California gold rush. He, however, derived his riches from his law practice, real estate developments, and investment in the Northern Pacific Railroad. Always civic-minded, he participated in the founding of the College of California, suggesting that it be named Berkeley, after a seventeenth-century Irish philosopher. He also lobbied for the establishment of national parks in California, Wyoming, and Montana.

In 1861, Billings returned east. After his marriage to Julia Parmly of New York, the couple divided their time between New York City and Woodstock. In 1869, Billings bought George Perkins Marsh's old farm, including its stately Federal-style home, which he promptly remodeled and enlarged into a fashionable Stick-style mansion. Like Marsh before

him, Billings was shocked by the denuded Vermont landscape. He and his heirs bought up many failing farms and started reforesting the surrounding hillsides with Norway spruce, Scots pine, European larch, and many native species of trees. According to the U.S. National Park Service it is the country's oldest managed forest. Twenty years after the first remodeling, Billings once more revamped his house. This time he opted for a splendid Victorian brick building painted in subdued colors.

After Frederick Billings died, Julia Billings and their three daughters, Elizabeth, Mary, and Laura, lovingly cared for the family mansion. Elizabeth married John French, and in 1934 their daughter Mary married Laurance Rockefeller. Eventually the Marsh-Billings mansion descended to the couple, and they used it each year from July 1 to August 15, their wedding anniversary, which they celebrated in Woodstock in grand style. Thereafter, the family departed to Laurance's favorite residence, the JY Ranch in Wyoming.[26]

Laurance, endowed with Rockefeller perfectionist genes, not only took on the house, but also turned Woodstock into an idyllic New England village. He carefully restored the mansion, preserving its Victorian character. Marsh's original farm could not have ended up in better hands.[27]

The house sits on a hill and has an expansive, unobstructed "Rockefeller view" of its surroundings. The Rockefellers sandblasted it, and the fresh-looking orange-colored brick exterior is trimmed with white woodwork. The rooms are exceedingly large; the forty-by-fifteen-foot parlor is filled with comfortable sofas and armchairs; a grand piano stands at one end. A Tiffany stained-glass window featuring a lute, grapes, and, atypically, a Shakespeare quotation, surmounts it.

The Victorian decorating principle "if much is good, more is better" fits the decoration of the MBR Mansion, a good example of the private museums assembled by the upper middle class during the second part of the nineteenth century.

The Parmlys, Mary Rockefeller's grandparents, had been art-minded. Young Julia and her mother, Anna Maria Parmly, embarked on a lengthy European grand tour in 1854. Julia's diary records visits to museums and sites in Rome, Florence, Dresden, and Vienna. Once she married Freder-

ick Billings, Julia and her husband started to assemble two art collections: one for their New York house at 279 Madison Avenue, the other for their country estate.

In forming their Vermont collection, the Billings adhered to the teachings of John Ruskin, the English philosopher and art historian, who worshipped nature and favored idealized landscapes. Indeed, by far the best paintings in the Billings collection are Hudson River School landscapes. Genre works that told easily interpreted stories, "Orientalist" works conveying the mysteries of foreign lands, marine paintings, and family portraits were also acquired. Frederick Billings bought most of his art from the artists themselves, from the National Academy of Design, or from reputable artist associations and dealers.

About fifty artworks are on view throughout the MBR Mansion. As befits art displayed in a private house, the works are small. There are four by Albert Bierstadt; three (*Cathedral Rock, Yosemite; Cliff House and Bay of San Francisco*; and *Scenery in the Grand Tetons*) bought by the Billingses; and *The Matterhorn*, added by the Rockefellers. Of these, *Cathedral Rock, Yosemite* occupies a place of honor. Small as it is, the work honors Yosemite's dramatic cliffs, colored pink by the setting sun. A flower-strewn meadow occupies the foreground and a foliated tree is silhouetted against the rocks. *Cliff House* depicts a dramatically illuminated wild ocean crashing against the rocks of San Francisco Bay.

Mary French Rockefeller, Laurance's wife, died in 1997, and her husband proceeded to donate his Vermont estate and the JY Ranch to the U.S. Park Service. Like Kykuit and Bassett Hall, the two other Rockefeller house-museums, the MBR Mansion, which celebrated its 140th birthday in 2009, looks lived-in, as if Laurance Rockefeller had just stepped out for a cup of coffee.[28]

THE WENDELL GILLEY MUSEUM

In 1927, Wendell Gilley entered his family's plumbing business in Southwest Harbor, Maine, fixing oil burners, laying pipes, installing toilets,

and welding tanks for boats. He loved the outdoors, especially the great variety of birds that populated the woods, lakes, and the ever-present ocean. Gilley hunted ducks and other game birds, and was so taken with their beauty that he learned to stuff them. In 1930, on a visit to Boston's Museum of Natural History, he came across the miniature bird carvings of A. Elmer Crowell. Upon his return to Maine, Gilley carved a miniature mallard duck. Pleased with his efforts, he persevered. Carrol (Sargent) Tyson, a well-known Maine landscape and bird painter, taught him how to paint his carvings. Tourists started buying Gilley's birds, and eventually the work came to the attention of a buyer from Abercrombie and Fitch, a fancy New York department store specializing in outdoor wear.

By the time he was fifty-two, Wendell had to decide whether to go on plumbing or become a full-time bird carver. He chose the latter. Wendell and Addie, his wife, opened a little "bird shop" in their home, and it became a popular attraction for tourists, would-be carvers, and friends. The Gilleys sometimes hosted a hundred or so visitors in the course of a summer day. Wendell made a reasonable living, but he was worried about Addie should he die. Perhaps, he wondered, he could open a small museum in Southwest Harbor and charge admission.[29] Gilley shared these thoughts with Nelson's son Steven.

"My interest in bird carving," Steven Rockefeller recalled in 2006, "was linked to Father's interest in folk art, but also reflects my interest in birds, the natural environment, and more realistic forms of art."[30] When Gilley talked to him about his dreams of a museum, Steven asked, "What are we going to put in the museum?" It turned out that Wendell's wife, Addie, had saved 110 of her husband's best carvings in the basement of their home. And that's how the museum started. At first Gilley, Steven, and architect Roc Caivano examined the possibility of remodeling an existing Southwest Harbor house into a museum. To tempt Steven, Caivano also created a model for a small contemporary museum. Steven had inherited Nelson's taste for modern architecture and when he saw the elegant plans for the structure, he opted for financing a new building.

Unless you know what you are looking for you might very well over-

look the Wendell Gilley Museum. It occupies a handsome, modern clapboard building sitting on a corner lot on Main Street. Built in 1980, it is hardly larger than its neighbors. An enormous multi-trunk pine hides its entrance, and visitors might be tempted to remain seated on the comfortable bench in its front yard and commune with a pair of whooping cranes sculpted by Walter T. Matia.

According to Nina Gormley, the museum's founding executive director, the Wendell Gilley is one of the few museums in the world whose permanent collection is almost entirely devoted to carved wooden birds. But what birds! Upon entering the museum, visitors are confronted by a life-size bald eagle, its wings in takeoff position. It casts a double shadow on the partition that separates it from the largest gallery of the museum. The eagle was David Rockefeller's gift to his brother Nelson when he concluded his term as vice-president of the United States. Steven acquired it from his father's estate.

Gilley's birds overflow the galleries. There is a flock of Canada geese, a large osprey, a bald eagle about to devour its prey, two Belted kingfishers, and a great blue heron. One cabinet is occupied by wooden ducks. There are flocks of colorful puffins, elegant cormorants, and lots of wise-looking owls sporting the most amazing beaks. The Gilley could not be a Maine bird museum without loons "swimming about" with young nestled on their backs.

Each summer the Gilley museum organizes a new show. As a sentimental as well as an artistic gesture, Steven Rockefeller requested that in 1999 the museum mount *Birds and Flowers: Hiroshige Woodblock Prints.* In many ways the show was a tribute to his grandparents and the Asian art that filled their homes. Steven approached RISD, to which his grandmother had donated the bulk of her collection, and asked for ten to fifteen prints. "RISD never lets that collection go anywhere," Steven recalled, "and negotiations took two years." But the ultimately successful effort was worth it. The exhibition was a remarkable feat for the small museum, and a memorable tribute to Abby Aldrich Rockefeller by her grandson.

Kykuit: On a Clear Day You Can See Forever

S ENIOR LOVED LAND and the outdoors, and in 1893, when the
center of his business shifted from Cleveland to New York, he looked
for country property. Before the family actually moved to New York,
he spent his weekends at the country home of his brother William, his
associate at Standard Oil. The latter had built a mansion in Tarrytown,
a small village settled by the Dutch around 1645. Like many of the es-
tates built by New York aristocrats around 1900, William's château-like
Rockwood abutted the Hudson. Senior, however, wanted land and a view.
Assisted by eighteen-year-old Junior, he explored a hill named Kykuit—
Dutch for "lookout"—surrounded by streams and woodlands. A distance
of two miles separated it from the river, but the land was elevated and
offered a panoramic view of the Hudson and its surroundings. Senior
bought it and gradually increased his holdings to about 3,600 acres.[1]

The view from Kykuit is much as it was more than one hundred years
ago when Senior bought the site. Far below is the shimmering Hudson,
which, eons ago, cut its bed between steep hills. Here, as it crosses under
the Tappan Zee, it is extra wide. On its far shore New York's rocky Pali-
sades cliffs border the river. Thanks to Rockefeller money, the view may
even be more spectacular now than in the past. Instead of farmland,
houses, and the detritus of ordinary life, there are only treetops. Depend-

ing on the season of the year, the palette is tinted in browns, greens, yellows, and oranges. Senior was adamant about protecting his views and bought up and relocated any human habitations and even a railroad that interfered. According to grandson David Rockefeller, he bought the entire village of neighboring Eastview for $700,000 in 1929 and leveled its forty-two houses. Later, when Junior and his son Laurance noticed that buildings were encroaching on the top of the Palisades, they bought that land and gave it to the Palisades Interstate Park.

Chronologically, Kykuit is the oldest of the Rockefeller residences described in this account, and its story should have opened this book. However, since the mansion epitomizes the glory days of the Rockefellers, it is a fitting conclusion. Senior used Kykuit until his death in 1937, Junior occupied it until 1960, and Nelson took possession in 1962. From the day Nelson moved in, he realized that he was the last Rockefeller who could afford to live in the mansion, and from the very beginning he prepared it for its future as a house-museum. As with so many other Rockefeller possessions, Kykuit and its gardens and art collections are now accessible to the public.

SEVERAL OLDER HOUSES existed on the property when Senior acquired it. He used one of them, the Parsons-Wentworth House, whenever the family visited the estate. From the very beginning, Senior considered building a home on Kykuit, and he leveled the top of the hill and even built a foundation. He also planned the general orientation of the house and of its major rooms so that they would face west, taking maximum advantage of the view. For a variety of reasons, the building project was abandoned for thirteen years, though Senior continued to improve the land. He and his staff felled some trees and planted others, moved earth and rocks, built bridges, and honeycombed the woods with fifty miles of carriage roads, bridle paths, and hiking trails. Senior, by then an avid golfer, also built a two-way, nine-hole golf course on the slope of the hill below his still nonexistent mansion.

In 1902 the Parsons-Wentworth House burned to the ground. Senior would have been content to erect another modest abode, but his son felt otherwise. Stung by criticism in the press that his father was exhibiting pride by choosing to live so modestly, Junior persuaded the older man to let him and Abby construct a more fitting domicile for America's richest citizen. After some resistance, Senior agreed, his only stipulation being that his son would not involve his ailing mother in any decision. Architects Delano and Aldrich, the latter a distant relation, developed plans for an elegant but low-key villa. William Welles Bosworth, who would become Junior's favorite architect, started to design the gardens; Ogden Codman, Jr., one of America's most fashionable decorators, was in charge of the interior.[2]

Ground for the house was broken in 1906, and two years later Cettie and Senior moved in. Soon they discovered that the chimneys did not draw properly and regurgitated smoke; the elevator was too noisy; the guest rooms were too small; Cettie's flushing toilet reverberated in the

Kykuit, layout of the gardens. (Library of Congress, Prints and Photographs Division, Historic American Buildings Survey, (HABS NY,60-POHI))

parlor; the roof leaked; and the din from the service entrance, located directly below Senior's bedroom, disturbed him. It was decided that a major revamping, directed by Bosworth, was in order. The architect's ideas, inspired by Hampton Court, Hadrian's Villa, and British mansions, were grand, and Senior was forever grumbling at the extensive cost overruns. The roof was raised, the rooms were refigured, and a tunnel connecting the road directly to the service door eliminated unwanted noise. The façade was redone in an extravagant Beaux-Arts style, and the forecourt was modified to match the home's grandeur.

Both Junior and his architect had a great liking for then-fashionable Greek and Roman mythology, whose pagan culture certainly was at variance with the family's Baptist faith. A copy of the ten-foot-high *Oceanus and the Three Rivers* fountain Giambologna sculpted in Florence in 1576 became the focal point of the forecourt. The powerful god of the ocean, assisted by deities representing the Nile, the Ganges, and the Euphrates, tops the fountain.

Fully grown great elms, trucked in from elsewhere, used to tower over the four-story mansion. After their demise, Nelson planted wisteria vines to soften the façade of the house. Two giant torchères, capped by orange Tiffany Favrile glass globes, light the walkway to the house. Sculptor François-Michel-Louis Tonetti filled the pediment with figures of Demeter, the Greek goddess of the earth, and Apollo, the sun god. The pinnacle of the roof is crowned with a giant eagle, and flower-filled vases held up by putti occupy other parts of the roofline. Two Ming Dynasty lions crouch near the door. The entrance portico also accommodates sculptures by Constantin Brancusi, Alberto Giacometti, and Fritz Wotruba.

CETTIE WAS A semi-invalid when she and Senior moved into the rebuilt Kykuit. After she died, he enjoyed being the lord of the manor, playing golf, inspecting the land, showing off the vistas, and entertaining his numerous grandchildren at Sunday dinners. He established a small farm whose produce he considered so superior that he had it shipped to his

other residences. His birthday on July 8 was always celebrated in grand style. In one of her letters to John 3rd, Abby described the morning's photo session with all participants being arranged in "every combination possible." There was organ music during the dinner party for twenty-four guests. Afterward, at Nelson's request, Radio City's chief tenor sang popular songs on what Abby called the Piazza. David Rockefeller, of whom Senior was especially fond, remembered his grandfather parceling out five-dollar gold pieces to everyone present.[3]

After Senior's death in 1937, Abby and Junior moved into Kykuit, making it more homelike and rearranging some of the bedrooms so that they would be suitable for family visits. Abby, respectful of the way the house had been during her in-laws' occupancy, decorated only her second-floor sitting room to her own taste.

At first there were overnight stays by children and grandchildren, collectively called "the Cousins," the term used to describe the fourth generation of Rockefellers. Soon most everyone had weekend houses of their own in Pocantico Hills, and visits became more structured. Still all the Cousins have very fond memories of the mansion, which Laurance dubbed the "Winter Palace."[4]

After Junior's death, and with his own siblings' consent, Nelson moved into Kykuit. Though he had rationalized that, as governor of New York State he needed the mansion to entertain dignitaries, he turned it into a child-friendly environment.[5] Nelson Aldrich, Jr., and Mark Fitler, Nelson and Happy's young sons, played baseball and raced their cars around the staid old house. Nelson added modern art to his grandfather's traditional setting. "He had taken this eclectic approach [to] decorating . . . believing that truly beautiful things can live comfortably with any other beautiful things, regardless of period and style," writes his daughter Ann.[6]

FROM THE VERY first, Kykuit was to be like an elegantly restrained English manor house. Two small rooms flank the entrance hall. The northern one was Senior's and then Junior's office, and finally Nelson's

television room. The Music Room, formerly housing the organ, occupies the central part of the ground floor, inspired by the Ashburnham House in London. With its elliptical opening to the floor above, it was Ogden Codman's grandest gesture.[7] Nelson removed the nonfunctioning organ and replaced it with an enlarged copy of Joan Miró's *Hirondelle Amour*, the original of which he had given to the Museum of Modern Art in 1976. Distributed throughout the house are some of Junior's beloved Chinese porcelains. A portrait of Abby's father, Senator Nelson W. Aldrich, by Anders Zorn, hangs on the west wall; Senior's portrait by John Singer Sargent is in the dining room. Always concerned with his father's reputation, Junior had involved himself in making sure that Senior wore an appropriate suit when the portrait was painted in Florida. In 1905, while visiting Kykuit, Sargent made a watercolor sketch of the Oceanus Fountain, which is now displayed in the entrance hall.

In the dining room a table set for twelve is a reminder of the many Sunday family dinners given by Senior and Junior. The fancy accoutrements—glass Epergne, Meissen figures, marble-topped side tables, glass chandeliers and sconces—illustrate the serious nature of formal dinners. Next to the dining room, Nelson had glass cabinets constructed displaying place settings for the many sets of antique porcelain dinnerware he enjoyed using.

Afternoon tea was often served in the so-called Alcove Room. In front of the window stands the Rockefellers' famous Tang Dynasty bodhisattva. Nelson paired it with Adele Herter's portrait of Abby. The juxtaposition reminded him of his mother's "artistic acquisitiveness, directed in particular towards sculpture."[8]

The Alcove Room faces west, its windows framing the river as if a member of the Hudson River School had painted it. The simply furnished master bedroom, one flight up, offers a still better view. A frail-looking Eliza, Senior's mother, peers out of a frame wearing a bonnet and modest jewelry. The adjoining bathroom is splendid, especially when one remembers that it was built a hundred years ago. Today it must be the only such space in the world sporting original prints by Cézanne, Bonnard, and Degas.

When Nelson moved into Kykuit he asked Philip Johnson to transform the home's underground passages into five cheery art galleries for the display of about a hundred different artworks. Like the rest of the house, the space was available to his young children, and a comfortable couch, armchairs, and tables indicate that this was an informal environment. The first gallery is directly under the Music Room and holds a black-and-white painting by Robert Motherwell, a mobile by Alexander Calder, and a large cabinet with carefully arranged glass bottles that Nelson, Nelson, Jr., and Mark found on the estate. The two long galleries are filled with some of Nelson's favorite artworks, mostly dating from the 1960s and '70s. There is a delightful Louise Nevelson construction made out of Lucite and a very cheerful Calder gouache, and Andy Warhol's silk screens of a serious Nelson and a smiling Happy. Most remarkable are the tapestries based on favorite paintings by Picasso. After he acquired the *Guernica* tapestry, Nelson asked Mme J. de la Baume Dürrbach to weave seventeen other tapestries, all based on major paintings by Picasso. The painter, Nelson's favorite artist, checked the cartoons and the colors, and it took the weaver from 1958 to 1975 to complete the job. Twelve of the tapestries, including those based on *Night Fishing at Antibes*, *Harlequin*, *Pitcher and Bowl of Fruit*, and *Three Musicians*, are now at Kykuit. Alexander Calder contributed three colorful abstract tapestries.

KYKUIT WAS CONCEIVED as an indoor-outdoor summer home. Its terraces and gardens have always been grander, and more beloved, than the house itself. They are considered Welles Bosworth's finest legacy. Charles Platt's *Italian Gardens*, published in 1894, and Edith Wharton's *Italian Villas and Their Gardens* were sources of inspiration. The Rockefeller site, atop a truncated steep hill, necessitated the terracing typical of Mediterranean gardens. Bosworth was also influenced by the vistas of the Hudson River School painters, his Beaux-Arts training, the stylized nature of Japanese gardens, and the more naturalistic approach popular in England. In the end, the design, carefully integrated with the architecture of the man-

sion, consisted of a series of formal gardens that gradually morphed into the rolling landscape of lawns and trees.

The steepness of the land and the complexity of the design make the organization of the gardens confusing. Bosworth divided the terrain encircling the house into a series of small environments separated by walls, plantings or other architectural devices. The "rooms" are "furnished" with sculptures, topiary bushes, fountains, pools, and pergolas. Bosworth was mindful of long vistas terminated by focal points, of light and shade, of secluded areas and open spaces, of bird song and running water, of scent and color. Most of all, he took advantage of the site's spectacular panoramas.

Bosworth's fundamental layout, which takes account of the daily movement of the sun around the house, has not changed much during the past century. The Forecourt and Oceanus Fountain are in the east. Both are high above the next level, reached by imposing double stairs. The Morning Garden, with its teahouse, to the left of the forecourt, also faces east. The Brook Garden turns the southeast corner. The Inner Garden runs along the large terrace on the southern side of the house. Three terraces, the Linden Allée, the former Orange Tree Terrace, and the Swimming Pool Terrace, border it on the west. A formal Rose Garden occupies the north. Highlights, such as the Temple of Aphrodite, a grotto, and overlooks, provide additional delights.

Statuary always played an important role in Kykuit's outdoor décor. To begin with, those on display there consisted of the one hundred or so classical works chosen by Junior and his architect. These have mellowed during the past century and most are now covered with lichen, which adds to their old-fashioned charm. When he took over, Nelson added his stellar seventy-piece twentieth-century sculpture collection and, with the help of René d'Harnoncourt, had it installed on the terraces, in the manicured gardens, on the open lawns, and amid the giant trees. The intermingling of classical and modern art works surprisingly well, and attests to Nelson's innate talent at what Tod Rockefeller so long ago called "arranger's disease."

———

BACK WHEN IT had a Pompeian motif, the teahouse and its surroundings, were much beloved by Junior's mother, Cettie Spelman Rockefeller. To the delight of his two young sons, Nelson Rockefeller turned it into an ice-cream parlor. The Morning Garden, whose pool is peopled by sculptures of small sea creatures and a faun, fronts it. The bottom of the shallow pool consists of striated marble, giving the illusion of wafting waves. Rufus Evans sculpted the two large bronze swans at the head of the pool. According to Arnaldo Ugarte, Kykuit's sculpture conservator, the swans were cast at the Roman bronze foundry in Queens, which a quarter of a century later cast and gilded Rockefeller Center's *Prometheus*. The gilding on Kykuit's swans has long since vanished.

Once upon a time the adjacent lawn, now occupied by Picasso's *Bathers*, was a tennis court. The arrangement of the *Bathers* turned out to be René d'Harnoncourt's last job. Originally Picasso had assembled the six figures from driftwood he found on the beach near his studio in France. Cast in bronze, the group was sent to Canada to be exhibited at the Montreal World's Fair in 1967, where Nelson acquired them. After much deliberation and consultation with the artist, d'Harnoncourt made a final sketch of how they should be displayed at Kykuit. However, before he could finalize the display on site, he was run over and killed by a car while watching birds near his Long Island home.[9]

A gurgling stream traverses the Brook Garden to the southeast of the house. A study for Isamu Noguchi's *Black Sun*, which fronts Seattle's Asian Art Museum, sits on a pedestal near the rock-lined rivulet, where it contrasts nicely with a Japanese lantern dating from Senior's time. Three other small versions of Noguchi's *Sun* are part of the Empire State Collection, demonstrating, as that collection's curator, David Anderson, observed, that Rockefeller was shaping the Albany and the Pocantico Hills collections at the same time.

Nelson peopled the Inner Garden and the South Porch with splendid sculptures dating from the mid-1900s. Aristide Maillol's *Bather Putting Up Her Hair* looks as if she's just emerged from a dip in the waters. One of Gaston Lachaise's corpulent nudes stands on tippy-toes. There are two sets

of paired women by Elie Nadelman, a version of which, much enlarged, greets spectators at the New York State Theater at Lincoln Center. Another Nadelman, *Circus Woman I*, who is examining her foot, occupies the center of the South Porch.[10]

On its southwest corner the small, round Aphrodite temple, a typical Beaux-Arts feature, serves as an outpost of the formal part of the estate. At one time, the purchase of its occupant, the goddess accompanied by a dolphin, was considered to be Junior's biggest artistic coup. He had been led to believe that it was an original statue of Aphrodite by Praxiteles, but it turned out to be an ancient copy by a very skilled sculptor. Before it was moved to Pocantico Hills the statue was exhibited at the National Arts Club in New York City, where it created quite a stir.[11]

Near the classical temple, Janet Scudder's charming flute-playing *Pan*, god of the woodlands, one of Junior's choices, guards the approach to a remarkable grotto-like chamber. Italian stalactite, used as ballast on ships, is embedded between roughhewn columns made from rocks dug up on the estate itself. The central column of the chamber serves as the foundation for the temple of Venus. The ceiling of the octagonal room consists of bisque-colored brick laid in a special herringbone pattern invented by Rafael Guastavino, whose work was popular in 1900. Other examples of his remarkable style can still be seen at New York's old Customs House and in Grand Central Station's Oyster Bar.

The Orange Tree Terrace, on the west side of the house, offers a commanding view of the three old swimming pools, Senior's golf course, vast lawns, and the gigantic Tudor-style playhouse completed in 1927 by Duncan Candler. The orange trees are long gone, and today classic and modern works vie for attention. Karl Bitter's *Goose Girl*, dating from 1914, occupies a small grotto made from Italian stalactite in the center of the terrace.

Many of Nelson's largest sculptures are on the lawns abutting the house to the north and east. They are silhouetted against a still-pristine landscape. Way in the distance an occasional high building encroaches on Senior's view. Carol K. Uht, Nelson's longtime art curator, describes

the infinite care that went into the emplacement of the individual works at Kykuit. The large pieces were moved into place during the winter of 1961–1962 when they could easily be slid over the snow covering the ground. During the spring the displays were finalized. A massive couple by Gaston Lachaise was sunk into the ground so that it did not look like a tomb effigy. Henry Moore's *Knife Edge, Two Piece*—a large version of a 1962 work—rests on a platform under the Rose Garden. Nelson painstakingly directed a helicopter as to where to place its two components. At the time, the operation played havoc with David Rockefeller's golf game and resulted in a temporary rift between the brothers.

Upon closer inspection, one sees that a family of giraffes craning their necks is actually Alexander Calder's *Large Spiny*. At Nelson's request, the sculptor made a large version of a smaller stabile dating from 1944. *Large Spiny* is the only piece of sculpture specifically commissioned for Kykuit. The original, small *Spiny* now belongs to MoMA. Marino Marini's *Horse* (1966), standing on its spindly legs, is at ease in its pasture. *Atmosphere and*

Henry Moore's Knife Edge, Two Piece, *at Kykuit, is an enlarged 1965–66 version of a 1962 sculpture.* (Mick Hales for Historic Hudson Valley/www.hudsonvalley.org)

Environment (1967), a large construction by Louise Nevelson, is tucked near a hedge, and there is Gaston Lachaise's *Man* (1930–35), a change from his usual robust women.

Given the steep grade of the terrain, the lawn with these sculptures is below the level of the house and of the carefully tended rose garden, a favorite of Abby Rockefeller's, which at its upper end is edged by an old-fashioned pergola. Its Corinthian columns and serious-looking busts of Roman senators perfectly contrast with Max Bill's *Triangular Surface in Space*, so placed that it is silhouetted against a framed slice of the Hudson.

Three of George Barnard's sculptures are located at the foot of the double stairs descending from the forecourt. During the early decades of the twentieth century, Barnard was one of America's best-known sculptors. In 1915 the Rockefellers commissioned male and female nudes from the artist. *The Hewer* portrays a muscular youth fashioning an oar from a piece of wood. Its companion, *The Rising Woman*, is in the process of standing up from a crouching position. Junior was very pleased with these, and commissioned *Adam and Eve*, an even larger work, illustrating woman's creation from man's rib. The sculptor caused Junior much grief, though, since he adhered neither to his schedule nor to the agreed-upon fee. In addition, there were arguments over the configuration of Adam's male attributes: the artist favored anatomical correctness; Junior insisted on modesty. In the end, a cloud shields Adam's penis.[12]

Hidden from view on the north side of the house is the entrance to the Japanese garden. Inspired by two world's fairs—Philadelphia in 1876 and Chicago in 1893—Japanese gardens arrived in America around 1900. Bosworth included one among Kykuit's many outdoor diversions. The soul of a Japanese garden is the distillation of a meticulously shaped randomness; its purpose is communion with nature, tranquility, and meditation. Small and intimate, Japanese gardens rely on the careful juxtaposition of trees, plants, grasses, water, and stones.

At Kykuit, a brook winds its way through the Japanese garden, sometimes widening into a pond, sometimes gathering into a waterfall, sometimes becoming shallow enough to be forded by stepping stones. There

are bridges, one arched, as in Monet's garden in Giverny. Paths, surfaced in stone, tile, or bark, wind their way past carefully clipped trees. Some of the trees are over a hundred years old and by now look like giant bonsai. In spring, the garden is abloom with irises, daffodils, and Japanese cherry trees. The leaves of an extensive bamboo grove rustle in the wind, and large black rocks stand in the middle of carefully combed sand in the dry Meditation Garden. An authentic teahouse with sliding walls stands at one end of the garden.

NELSON AND HAPPY lived at Kykuit for seventeen years. Then Nelson and John 3rd died within six months of each other. Before their deaths, the control over the tense relations these two brothers had maintained since childhood began to crack. The gulf in their political and social out- looks had widened as they aged. As governor of New York, Nelson's views had moved to the right, while John 3rd had become what brother David called a "Parlor Pink."[13] During the last decade of their lives, John 3rd and Nelson, for example, fought bitterly over the millions the Rockefeller Brothers Fund donated to various causes. Arguments developed over how to pay for the increasingly complex family office and over the transfer of autonomy to the Cousin generation. In addition to these problems the four remaining brothers were concerned with the fate of the Pocantico Hills property, subdivided into "the Park"—Kykuit and the 250 acres sur- rounding it—which Nelson had succeeded in declaring a national land- mark, and 2,000 acres of "open space," which they intended to give to New York State for a park. The terms for such a transfer—which included a $5 million gift—had to be clearly spelled out in each of the brothers' wills, but John 3rd died before he had incorporated this provision into his. A livid Nelson changed his will and left his share of "the Park," the area surrounding the mansion, to the National Trust for Historic Preserva- tion, and willed his share of the open land destined for New York State to Happy. It took Laurance and David Rockefeller, the surviving broth- ers, millions of dollars and fifteen years of red tape to right matters, but

today Pocantico Hills, including the land on which Rockwood, William Rockefeller's former property, stood, is part of the Rockefeller State Park, and the National Trust owns Kykuit. The Rockefeller Brothers Fund manages all aspects of the property's administration, and during the spring, summer, and fall visitors can view the luxurious lifestyle enjoyed there by three generations of Rockefellers.

THE UNION CHURCH OF POCANTICO HILLS

In November 1921, exactly six years before he laid the cornerstone of Riverside Church, Junior helped the small Pocantico Hills community build a new church. The two edifices were built on Rockefeller-owned land; both have towers and magnificent carillons dedicated to Laura Celeste Rockefeller, and both have magnificent stained-glass windows.

It was Nelson who thought of commemorating his mother with a rose window designed by Henri Matisse. Alfred Barr was entrusted with the negotiations with the ailing eighty-four-year-old Fauve master, now mostly confined to his bed. Matisse first refused because he could not visit the site and get a feeling for its ambiance. Barr sent him a great deal of supporting material and managed to change the master's mind. Using his paper cut-out technique, he designed the window and, on October 28, 1954, reported that he was "happy to note that this second precise outline reveals a far greater beauty of form than the preceding scheme . . . In order not to disturb in any way the spirit of this Protestant chapel I have avoided any symbols of any kind." Matisse explained that it was imperative that the glass be executed in Paris "by the master glazier who is trained to respect my designs because each compartment calls for sections in different glass."[14]

Three days later, on November 1, Matisse sent another letter to Barr saying that he had happily concluded his work. When he died on November 3, the maquette for the window was found tacked to the wall of his bedroom, and his atelier translated the design into reality. The delicately shaped translucent glass petals are surrounded by yellow glass, which are in turn encircled by free-form shapes of magical blue-green glass.

After Junior's death in 1960, his six children were searching for a way to honor their father. By chance, David and Peggy Rockefeller saw the stained-glass windows Marc Chagall had made for the Hadassah–Hebrew University Medical Center synagogue in Jerusalem while they were exhibited in Paris. The rest of the family needed a bit of convincing, feeling that Chagall's "strongly modernistic and highly mystical style might be inappropriate for Father," but in the end everyone agreed to commission Chagall.[15]

In his work, Chagall had often used religious and biblical themes. During the 1950s, he and Charles Marq, his associate, had developed a new technique for making stained-glass windows. The painter's exuberant style and vibrant colors were ideally suited for this medium, and Chagall windows now grace major synagogues, churches, and institutions throughout the world.

The search for an appropriate theme for a man determined to "do good" with the enormous fortune he had inherited turned up the *Parable of the Good Samaritan*. The intense blues, yellows, reds, and greens of the work are a stunning contemporary version of Junior's beloved medieval stained-glass windows.

The two spectacular works of art made the remaining windows of the Union Chapel look shabby. In the end, with the approval of the congregation, the Rockefellers asked Chagall to replace all eight remaining windows. Nelson's son Steven, a Ph.D. in religion, thoughtfully researched the themes for the series.[16] The figures of the prophets, including Jeremiah, Ezekiel, Daniel, Joel, and the crucified Christ, fill the windows, each tinted in a harmony of wondrous blues, greens, yellows, and purples.[17]

Three of the smaller windows are dedicated to the memory of Rockefellers: David's wife Peggy, Nelson, and his son Michael. There are two other Rockefeller commemorations: a memorial tablet to Senior placed there by his children, grandchildren, and great-grandchildren on the hundredth anniversary of his birth, and a new organ dedicated by David Rockefeller to the memory of his brother Laurance.

On a sunny day, light filters through the stained glass, transforming

the nave into an artistic masterpiece. Outside, majestic trees dwarf the small chapel so reminiscent of an English country church; its walls occasionally reverberate with great music. Most often, however, there is solitude and silence. The sanctuary is both modest and exquisite; it is a perfect memorial for a family that at once cherished and resented the riches and glare that oil had cast upon them.

Acknowledgments

America's Medicis would not exist were it not for the many people who assisted me during its conception, development, and birth.

I want to thank the Rockefeller Archive, which for decades has collected and organized millions of documents pertaining to the Rockefeller family and their associates. Particular thanks go to my archivist—now assistant director—Robert Battaly—and to photo archivist Michele Hiltzik.

I am grateful to the many people who took time to talk to me about the Rockefellers and the institutions associated with the family. They include Dennis Anderson, curator of the Nelson A. Rockefeller Empire State Collection; Deborah Del Gais of the Museum of the Rhode Island School of Design; Nina Gormley of the Wendell Gilley Museum; Janet Houghton of the Marsh-Billings-Rockefeller Mansion in Woodstock, Vermont; Julie Jones of the Metropolitan Museum of Art; Barbara MacAdam of the Hood Museum in Hanover, New Hampshire; Marion Ottinger, Jr. of the San Antonio Museum of Art; John A. Larson and Emily Teeter of the Oriental Institute of the University of Chicago; and Arnaldo Ugarte of the Rockefeller Brothers Fund. Particular thanks also go to Mary R. Morgan, Ann Roberts Rockefeller, and Steven C. Rockefeller, who took the time to talk about their father and brother.

I want to thank the many writers and scholars who examined the life

of the Rockefellers before me; without their spadework, I would not have been able to build this book. Though I delved into many of the two hundred books written about the family, I am particularly indebted to Mary Ellen Chase, Ron Chernow, Raymond B. Fosdick, John Ensor Harr and Peter J. Johnson, Bernice Kert, Daniel Okrent, Cary Reich, and Christine Roussel. Special thanks are also due to Cynthia Altman and Lindsay Pollock, whose writings helped in many ways to enrich my tale. Pertinent information was also derived from the autobiographical and other writing of various scions of the Rockefeller family: David Rockefeller, Anne Rockefeller Roberts, Mary Louise Pierson and Nelson Rockefeller. The often-magnificent books published by or about the institutions that now shelter the treasures donated by the Rockefeller family also proved to be a rich source of information. Appreciation is also due to the individuals who helped me obtain the many illustrations that enliven this book. I would like to single out Jennifer Belt of Art Resources, New York, and Rob Schweitzer of Historic Hudson Valley, Sleepy Hollow, New York.

Any writer owes a debt of gratitude to libraries and their librarians. The following proved particularly useful: The James Watson Library of the Metropolitan Museum of Art; the newly refurbished library of the Museum of Modern Art; and as always, the New York Public Library and the Southwest Harbor Library in Maine.

Immense thanks go to a great number of people who went over portions of the manuscript, helped tame recalcitrant computers and software problems or straightened out bibliographic references or endnotes. These include Joseph Ahern, Stephanie Ford, John C. Gordon, Peter J. Johnson, Judy H. Loebl, Deborah Morse, Jessica Smith, Susanne Spandich, and Melissa Solomon. I also owe a huge thank you to my lifelong friends Olga and Serge Blumenfeld; by offering food and lodging in their art-filled home, they turned the long days and weeks of hunting at the Archive into a pleasure.

Very special thanks go to my agent Regina Ryan, whose enthusiasm for the project and wise counsel helped me overcome hurdles and to the editors at Smithsonian Books: T. J. Kelleher, who bought the book, and

William B. Strachan and Kathryn Whitenight, who saw to its completion. Elisabeth Dyssegaard, editor extraordinaire, deserves the largest share of my gratitude, for going over each chapter several times and suggesting major rearrangements, which turned this complicated story into a coherent whole. My thanks also go to Jenna Dolan, who came to my rescue, when it turned out that the manuscript did not meet the electronic formatting required by the publisher. She also polished the text, bibliography, notes, checked facts, names, and dates. Even though each one of my helpmates picked up actual errors and/or unfortunate phrasing, any inaccuracy or omission is strictly the responsibility of the author.

Last but not least I want to thank my family, who not only offered love and comfort, but who contributed in various practical ways. My fresh-from-college granddaughter Naomi Gordon-Loebl saw me through the end stages of this project. And last but by no means least, I want to thank my husband, Ernest M. Loebl, who read numerous drafts and sustained me during this arduous task.

During the four years I spent "with" them, the Rockefeller clan, whose story is partially told in this book, lost their remoteness and began to feel almost like family. I became proud of their accomplishments, annoyed at their shortcomings, amused by their foibles, and most of all grateful that they devoted some of their wealth and talents to enrich the art treasures of the world.

Bibliography

Anderson, Dennis, R. *The Governor Nelson A. Rockefeller Empire State Plaza Art Collection and Plaza Memorials*. New York: Rizzoli, 2002.

Asia Society. *A Passion for Asia: The Rockefeller Legacy*. New York: Asia Society, 2006.

Balfour, Alan. *Rockefeller Center: Architecture as Theater*. New York: McGraw-Hill, 1978.

Barnet, Peter, and Nancy Y. Wu. *The Cloisters: Medieval Art and Architecture*. New York: Metropolitan Museum of Art; New Haven, Conn.: Yale University Press, 2005.

Barr, Alfred H., Jr. *Picasso: Fifty Years of His Art*. New York: Museum of Modern Art, 1946.

_____. *What Is Modern Painting?* 9th ed. New York: Museum of Modern Art, 1988.

Bass, Jacquelynn, et al. *Treasures of the Hood Museum of Art, Dartmouth College*. New York: Hudson Hills Press, 1985.

Bayless, Stephanie, et al. *Sketch of the History of the Arkansas Art Museum*. Master's thesis, University of Arkansas at Little Rock, July 2007.

Behrman, S. N. *Duveen*. New York: Random House, 1952.

Berman, Avis. *Rebels on Eighth Street: Juliana Force and the Whitney Museum of Art*. New York: Atheneum, 1990.

Biddle, Flora Miller. *The Whitney Women and the Museum They Made: A Family Memoir*. New York: Arcade, 1999.

Blackford, Bland, Burke Davis, and Patricia A. Hurdle. *Bassett Hall: The Williamsburg Home of Mr. and Mrs. John D. Rockefeller, Jr.* Williamsburg, Va.: Colonial Williamsburg Foundation, 1984.

Boltin, Lee. *The Nelson A. Rockefeller Collection Masterpieces of Modern Art*. New York: Hudson Hills Press, 1981.

Breasted, Charles. *Pioneer to the Past: The Story of James Henry Breasted, Archaeologist*. New York: Charles Scribner's Sons, 1943.

Breasted, James H. *Ancient Times: A History of the Early World: An Introduction to the Study of Ancient History and the Career of Early Man.* Boston: Ginn and Company, 1916.

Brimo, René. *L'Évolution du goût aux Etats Unis d'après l'histoire des collections.* Paris: J. Fortune, 1938.

Burgard, Timothy Anglin, Daniell Cornell et al., eds. *Masterworks of American Painting at the De Young.* San Francisco, Calif.: Fine Arts Museum of San Francisco, 2005.

Burt, Nathaniel. *Palaces for the People: A Social History of the American Art Museum.* Boston: Little, Brown, 1977.

Cahill, Holger E. et al. *Masters of Popular Painting: Modern Primitives of Europe and America.* New York: Museum of Modern Art, 1938.

Casey, Elizabeth Temple. *The Lucy Truman Aldrich Collection of European Porcelain Figures of the Eighteenth Century.* Providence: Museum of Art, Rhode Island School of Design, 1965.

Chase, Mary Ellen. *Abby Aldrich Rockefeller.* New York: Macmillan Company, 1950.

Chassé, Patrick. *The Abby Aldrich Rockefeller Garden: A Visitor's Guide.* Seal Harbor, Maine: D. and P. Rockefeller, 1990.

Chernow, Ron. *Titan: The Life of John D. Rockefeller, Sr.* New York: Random House, 1998.

Collier, Peter, and David Horowitz. *The Rockefellers: An American Dynasty.* New York: Holt, Rinehart and Winston, 1976.

Conforti, Michael et al. *The Clark Brothers Collect: Impressionist and Early Modern Paintings.* Williamstown, Mass: Sterling and France Clark Art Institute, 2006.

Crowell, Merle. *The Last Rivet: The Story of Rockefeller Center, a City Within a City, as Told at the Ceremony in Which John D. Rockefeller, Jr., Drove the Last Rivet of the Last Building, November 1, 1939.* New York: Columbia University Press, 1940.

Dimont, Max I. *Jews, God and History.* 2nd ed. New York: New American Library, 1994.

Dorr, George B. *The Story of Acadia National Park: The Complete Memoir of the Man Who Made It All Possible, George B. Dorr the Father of Acadia.* Bar Harbor, Maine: Acadia Publishing Company, 1985.

Duberman, Martin. *The Worlds of Lincoln Kirstein.* New York: Alfred A. Knopf, 2007.

Empire State Plaza Art Commission. *The Empire State Collection: Art for the Public.* New York: Empire State Plaza Art Commission in association with Harry N. Abrams, 1987.

Ernst, Joseph. *Dear Father/Dear Son: Correspondence of John D. Rockefeller and John D. Rockefeller, Jr.* New York: Fordham University Press, 1994.

Fosdick, Raymond B. *John D. Rockefeller, Jr.: A Portrait.* New York: Harper, 1956.

Fowles, Edward. *Memories of Duveen Brothers.* London: Times Books, 1976.

Francisco, Charles. *Radio City Music Hall: An Affectionate History of the World's Greatest Theater.* New York: Dutton, 1979.

Furst, Peter T., and Jill Leslie McKeever Furst. *North American Indian Art.* New York: Rizzoli, 1982.

Gervasi, Frank. *The Real Rockefeller.* New York: Atheneum Publishers, 1964.

Goldberger, Paul. *The Skyscraper.* New York: Alfred A. Knopf, 1981.

Goodyear, A. Conger. *The Museum of Modern Art: The First Ten Years.* New York: 1943.

Hanks, David A. *Donald Deskey: Decorative Designs and Interiors.* New York: Dutton, 1987.

Harr, John Ensor, and Peter J. Johnson. *The Rockefeller Century.* New York: Scribner, 1988.

_____. *The Rockefeller Conscience: An American Family in Public and Private.* New York: Maxwell Macmillan International, 1991.

Haskell, Barbara. *The American Century: Art and Culture 1900–1950.* New York: Whitney Museum of American Art in association with W.W. Norton, 1999.

Hay, Susan H., Iwao Nagasaki, et al., eds. *Patterns and Poetry: Nō Robes from the Lucy Truman Aldrich Collection at the Museum of Art, Rhode Island School of Design.* Providence: Rhode Island School of Design, 1992.

Ibrahim, Fawzi. *West Meets East: The Story of the Rockefeller Museum.* Jerusalem: Israel Museum, 2006.

Ilan, Ornit, Duby Tal, and Moni Haramati. *Image and Artifact: Treasures of the Rockefeller Museum.* Jerusalem: Israel Museum, 2000.

Jacobs, Jane. *The Death and Life of Great American Cities.* New York: Random House, 1961.

Johnson, Paul. *Art: A New History.* New York: HarperCollins, 2003.

Joyce, Henry. *Tour of Kykuit: The House and Gardens of the Rockefeller Family.* Tarrytown, N.Y.: Historical Hudson Valley Press, 1994.

JPMorgan-Chase Collection. *Art at Work: Forty Years of the JP Morgan Chase Collection,* 1999.

Kantor, Sybil Gordon. *Alfred H. Barr, Jr. and the Intellectual Origins of the Museum of Modern Art.* Cambridge, Mass.: MIT Press, 2002.

Kennedy, William. *O Albany!* New York: Viking, 1983.

Kert, Bernice. *Abby Aldrich Rockefeller: The Woman in the Family.* New York: Random House, 1993.

Knoedler, M. and Co. *The Rise of the Art World in America: Knoedler at 150.* New York, Knoedler and Co., 1996.

Kramer, Michael S., and Sam Roberts. *"I Never Wanted to be Vice-President of Anything!": An Investigative Biography of Nelson Rockefeller.* New York: Basic Books, 1976.

Krinsky, Carol Herselle. *Rockefeller Center.* New York: Oxford University Press, 1978.

Kuhn, Walter. *The Story of the Armory Show.* New York, 1938.

Leidy, Denise Patry. *Treasures of Asian Art.* New York: Asia Society Galleries, 1994.

Lewis, Arnold, James Turner, and Steven McQuillin. *The Opulent Interiors of the Gilded Age.* New York: Dover, 1987.

Lincoln Center for the Performing Arts. *Painting and Sculpture at Lincoln Center.* New York: Lincoln Center for the Performing Arts, 1992.

Lipman, Jean, and Alice Winchester. *The Flowering of American Folk Art, 1776–1876.* New York: Viking Press, in cooperation with the Whitney Museum of American Art, 1974.

Loebl, Suzanne. *America's Art Museums.* New York: W.W. Norton, 2002.

Loth, David Goldsmith. *The City Within a City: The Romance of Rockefeller Center.* New York: William Morrow, 1966.

Lowe, David Garrod. *Art Deco New York.* New York: Watson-Guptill Publications, 2004.

Lynes, Russell. *The Tastemakers.* New York: Harper, 1954.

_____. *Good Old Modern.* New York: Atheneum, 1973.

MacAdam, Barbara J. *Marks of Distinction: Two Hundred Years of American Drawings and Watercolors from the Hood Museum of Art.* New York: Hudson Hills Press, 2005.

_____. *American Art at Dartmouth: Highlights from the Hood Museum of Art.* Hanover, N.H.: Hood Museum of Art, Dartmouth College; University Press of New England, 2007.

McBride, Henry. *The Flow of Art: Essays and Criticisms.* Ed. Daniel Catton Rich. New Haven, Conn.: Yale University Press, 1997.

Manchester, William. *A Rockefeller Family Portrait, from John D. to Nelson.* Boston: Little, Brown, 1959.

Marquis, Alice Goldfarb. *Alfred H. Barr, Jr.: Missionary for the Modern.* Chicago: Contemporary Books, 1989.

Mazlich, Anne, ed. *The Charles Tracy Diaries.* Bar Harbor, Maine: Acadia Publishing Company, 1997.

Miller, Dorothy C., ed. *The Nelson A. Rockefeller Collection: Masterpieces of Modern Art.* New York: Hudson Hills Press, 1981.

Miller, Robert Moats. *Harry Emerson Fosdick: Preacher, Pastor, Prophet.* New York: Oxford University Press, 1985.

Morris, Joe Alex. *Nelson Rockefeller: A Biography.* New York: Harper, 1960.

Museum of Primitive Art. *The Asmat, The Michael C. Rockefeller Expeditions:* New York: The Museum of Primitive Art, 1961.

Newhouse, Victoria. *Wallace K. Harrison, Architect.* New York: Rizzoli, 1989.

Newton, Douglas. *The Nelson A. Rockefeller Collections: Masterpieces of Primitive Art.* New York: Alfred A. Knopf, 1978.

Noguchi, Isamu. *A Sculptor's World.* New York: Harper and Row, 1968.

Oettinger, Marion, Jr., *Folk Treasures of Mexico: The Nelson A. Rockefeller Art Collection.* New York: Harry N. Abrams, 1990.

Okrent, Daniel. *Great Fortune: The Epic of Rockefeller Center.* New York: Viking, 2003.

The Oriental Institute. *John D. Rockefeller, Jr., Centenary Exhibition: A Productive Collaboration 1919–1935.* Chicago: University of Chicago, 1974.

Ostergard, Derek E. *George Nakashima: Full Circle.* New York: Weidenfeld & Nicolson, 1989.

Perlman, Bernard B. *The Lives, Loves, and Art of Arthur B. Davies.* Albany, N.Y.: State University of New York Press, 1998.

Persico, Joseph E. *The Imperial Rockefeller: A Biography of Nelson A. Rockefeller.* New York: Simon and Schuster, 1982.

Phillips, Lisa. *The American Century: Art and Culture, 1950–2000.* New York: Whitney Museum of American Art, 1999.

Pierson, Mary Louise, Ann Rockefeller Roberts, and Cynthia Altman. *The Rockefeller Family Home: Kykuit.* New York: Abbeville Press, 1998.

Pollock, Lindsay. *The Girl with the Gallery: Edith Gregor Halpert and the Making of the Modern Art Market.* New York: Public Affairs, 2006.

Quimby, Ian M. G., and Scott T. Swank, eds., *Perspectives on American Folk Art.* A Winterthur Book. New York: W.W. Norton, 1980.

Reich, Cary. *The Life of Nelson A. Rockefeller: Worlds to Conquer, 1908–1958.* New York: Doubleday, 1996.

Riverside Church. *The Riverside Church in the City of New York.* New York: Riverside Church, 1978, revised 2002.

Rochfort, Desmond, *Mexican Muralists: Orozco, Rivera, Siqueiros.* San Francisco, Calif.: Chronicle Books, 1998.

Rockefeller, Abby A. *Abby Aldrich Rockefeller's Letters to Her Sister Lucy.* New York: John D. Rockefeller, Jr., 1957.

Rockefeller, David. *Memoirs.* New York: Random House, 2002.

_____. *Union Church at Pocantico Hills,* pamphlets for visitors.

Rockefeller, David, Peggy Rockefeller, Monroe Wheeler, Margaret Potter, et al. *The David and Peggy Rockefeller Collection, Volumes I–IV, 1984–1993.* New York: published privately, 1984–1993.

Rorimer, James J. *The Cloisters: The Building and the Collection of Mediaeval Art in Fort Tryon Park.* New York: Metropolitan Museum of Art, 1946.

Rose, Bernice, and William S. Lieberman. *Marc Chagall: Studies of the Windows at Pocantico Hills,* catalogue. New York: Museum of Modern Art, 1978.

Roseberry, Cecil R. *Capitol Story.* Albany: State of New York, 1964.

Roussel, Christine. *The Art of Rockefeller Center.* New York: W.W. Norton, 2006.

Rumford, Beatrix T. "Uncommon Art of the Common People: A Review of Trends in the Collecting and Exhibiting of American Folk Art." In Ian M. G. Quimby and Scott T. Swank, eds. *Perspectives on American Folk Art.* New York: W.W. Norton, 1980, pp. 13–53.

Rumford, Beatrix T., and Carolyn J. Weekley. *Treasures of American Folk Art from the Abby Aldrich Rockefeller Art Center.* Boston: Little, Brown and Company, in association with the Colonial Williamsburg Foundation, 1989.

Russell, John Malcolm. *From Nineveh to New York.* New Haven, Conn.: Yale University Press, 1997.

Saarinen, Aline. *The Proud Possessors.* New York: Random House, 1958.

Sanger, Martha Frick Symington. *Henry Clay Frick: An Intimate Portrait.* New York: Abbeville Press, 1998.

Schnee, Alix S. *John Cotton Dana, Holger Cahill, and Dorothy C. Miller: Three Art Educators.* Ph.D. diss. UMI Dissertation Services, Rutgers University, 1987.

Severinghaus, J. Walter, et al. *Art at Work: The Chase Manhattan Collection.* New York: E.P. Dutton, in association with the International Archive of Art, 1984.

Simpson, Marc. *The Rockefeller Collection of American Art.* New York: Fine Arts Museums of San Francisco; Harry N. Abrams, 1994.

Stasz, Clarice. *The Rockefeller Women.* New York: St. Martin's Press, 1995

Sterne, Margaret. *The Passionate Eye: The Life of William R. Valentiner.* Detroit, Mich.: Wayne University Press, 1980.

Tansey, Richard G., and Fred S. Kleiner *Gardener's Art Through the Ages.* Fort Worth, Texas: Harcourt Brace College Publishers, 1996.

Tarbell, Ida. *History of Standard Oil.* New York: Macmillan, 1904.

Tomkins, Calvin. *Merchants and Masterpieces.* New York: Henry Holt, 1989.

Walker, John. *Self-Portrait with Donors.* Boston: Little Brown, 1974.

Weber, Nicholas Fox. *The Clarks of Cooperstown: Their Singer Sewing Machine Fortune, Their Great and Influential Art Collections, Their Forty-Year Feud.* New York: Alfred A. Knopf, 2007.

Winks, Robert W. *Laurance S. Rockefeller: Catalyst for Conservation.* Washington, D.C.: Island Press, 1997.

Wolfe, Bertram D. *The Fabulous Life of Diego Rivera.* New York: Stein and Day, 1963.

Wye, Deborah. *Artists and Prints, Masterworks from the Museum of Modern Art.* New York: Museum of Modern Art, 2004.

Young, Edgar B. *Lincoln Center: The Building of an Institution.* New York: New York University Press, 1980.

Zilczer, Judith. *"The Noble Buyer": John Quinn, Patron of the Avant-Garde.* Washington, D.C.: Smithsonian Institution Press, 1978.

Zorach, William. *Art Is My Life.* Cleveland, Ohio: World Publishing Company, 1967.

EXHIBITION CATALOGUES

Masterpieces from the David and Peggy Rockefeller Collection: Manet to Picasso. New York: Museum of Modern Art, 1994.

Abbreviations

AAR Abby Aldrich Rockefeller
ACG A. Conger Goodyear
AHB Alfred H. Barr
BHR Blanchette Hooker Rockefeller
DR David Rockefeller
JDR, Jr. John D. Rockefeller, Jr., Junior
JDR, Sr. John D. Rockefeller, Sr., Senior
JDR, 3rd John D. Rockefeller, 3rd, John 3rd
LTA Lucy Truman Rockefeller
Met The Metropolitan Museum of Art
MMA The Metropolitan Museum of Art
MoMA The Museum of Modern Art
NAR Nelson Aldrich Rockefeller
RAC Rockefeller Archive Center
RFA Rockefeller Family Archives
RISD Museum of the Rhode Island School of Design
B=box
F=file

The Rockefeller Archive Center at 15 Dayton Road in Sleepy Hollow, New York, 10509, is the principal repository of Rockefeller-related documents. It is referred to as RFA (Rockefeller Family Archives) throughout the notes.

Notes

INTRODUCTION

1. Ron Chernow, *Titan: The Life of John D. Rockefeller, Sr.*, New York: Random House, 1998.

2. Aline Saarinen, *The Proud Possessors*, New York: Random House, 1958, 366.

3. Quoted in Bernice Kert, *Abby Aldrich Rockefeller: The Woman in the Family*, New York: Random House, 1993, 474.

4. Frank Crowninshield, "Art, and Mr. Rockefeller," *Vogue*, August 1, 1938.

1 PREAMBLE: AN IMPERIAL NEST

1. Kert, *Abby Aldrich Rockefeller*, 54.

2. Junior to Senior, 6/2/1911, F 264 B 34 Se JDR Sr. Papers, Rockefeller Archives Center, Rockefeller Family Archives, Sleepy Hollow, New York (hereafter RFA).

3. Raymond B. Fosdick, *John D. Rockefeller, Jr.: A Portrait*, New York: Harper, 1956, 336.

4. S. N. Behrman, *Duveen*, New York: Vintage Books, 1952; Edward Fowles, *Memories of Duveen Brothers*, London: Times Books, 1976.

5. S. N. Behrman, "Duveen," *The New Yorker*, Sept. 1951, 35.

6. Fosdick, *John D. Rockefeller, Jr.*, 334.

7. Junior to Senior, 4/13/1915, F 1339 B 134 Homes, RG2 RFA.

8. Fong Chow, "Symbolism in Chinese Porcelain: The Rockefeller Bequest," *MMA Bulletin* 21, no. 1 (1962): 12–24.

9. Saarinen, *Proud Possessors*, 344–95.

10. Maurice S. Dimand, "A Gift of Persian Silk Rugs," *Metropolitan Museum of Art Bulletin* 5 (1951): 142–44.

11. Duveen's enormous bills are stored in Box 133, Homes, RG2 RFA.

12. Edouard Larcade, letter excerpt, 1/9/1924, F 174 B 17 AAR Papers RG2, RFA.

13. Edouard Larcade, *The Hunt of the Unicorn: A Set of Six French Gothic Tapestries*, bro-
 chure, F 1350 B 136 RG III 21, RFA.

14. The *Moorish Smoking Room* of the Worsham/Rockefeller House is on view at the Brook-
 lyn Museum. The master bedroom and the dressing room are displayed at the Museum
 of the City of New York.

15. T. Hobby to Junior, 1/29/37, F 134 B 136 Homes RG2, RFA.

16. Mark Dion, *Project 82: Rescue Archaeology*, published in conjunction with the exhibi-
 tion, New York: MoMA, 2005.

2 TO THE GLORY OF GOD

1. Chernow, *Titan*, 4–51.

2. Ibid., 92.

3. Kert, *Abby Aldrich Rockefeller*, 54.

4. Fosdick, *John D. Rockefeller, Jr.*, 26.

5. AAR to NAR, F 65 B 5 AAR Correspondence, RG2, RFA.

6. John E. Harr and Peter J. Johnson, *The Rockefeller Century*, New York: Scribner, 36.

7. Fosdick, *John D. Rockefeller, Jr.*, 31.

8. Junior to W. R. Harper in Centenary Exhibition: University of Chicago, pamphlet, The
 Oriental Institute, December 1974.

9. Chernow, *Titan*, 348.

10. Harr and Johnson, *Rockefeller Century*, 45.

11. Philip S. Fonen, *A Curriculum of United States Labor History for Teachers*, www.kentlaw.
 edu/ilhs/curricul.htm (accessed 10/16/08).

12. Harr and Johnson, *Rockefeller Century*, 18.

13. Ida Tarbell, *History of Standard Oil*, New York: Macmillan, 1904.

14. Kert, *Abby Aldrich Rockefeller*, 151.

15. Fosdick, *John D. Rockefeller, Jr.*, 163.

16. John E. Harr and Peter J. Johnson, *The Rockefeller Conscience: An American Family in
 Public and Private*, New York: Maxwell Macmillan International, 1991, 382.

17. Personal Speeches, RG2, RFA. F 264 B 5

18. Robert Moats Miller, *Harry Emerson Fosdick: Preacher, Pastor, Prophet*, New York: Oxford
 University Press, 1985, 156.

19. Fosdick, *John D. Rockefeller, Jr.*, 221.

20. Miller, *Harry Emerson Fosdick*, 162.

21. Fosdick, *John D. Rockefeller, Jr.*, 327.

22. Helen Gardner, *Gardner's Art Through the Ages*, Fort Worth, Texas: Harcourt Brace Col-
 lege Publishers, 1996, chap. 13.

23. Jerry Koffler, *Freeing the Angels from the Stone: A Guide to Piccirilli Sculptures in New York City*, New York: Calandra Italian American Institute, 2008.

24. Christine Roussel, *The Art of Rockefeller Center*, New York: W.W. Norton, 2006, 18, 214.

25. Riverside Church, B 80 F 629 RG2 Religious Interests, RFA.

26. Junior to Collens, Pelton, 5/5/1930, F 630 B 80, Religious Interests, RG2, RFA.

27. Junior, Celebratory Dinner F 659, B 82 F Religious Interests, RG2, RFA.

28. Miller, *Harry Emerson Fosdick*, 212.

29. Testimonial Dinner for JDR Jr. 2/6/1931, F 658 B 82 F Religious Interests, RG2, RFA.

30. Fosdick, *John D. Rockefeller, Jr.*, 220.

31. Riverside Church, *The Riverside Church in the City of New York*, New York: The Riverside Church, 1978, revised 2002, 29.

32. Junior to W. W. Bosworth, 12/29/29, F 629 B 80 Religious Interests, RG2, RFA.

33. Eidlitz to Junior, 2/24/1933, F 557 B 72 Religious Interests, RG2, RFA.

34. Walter A. Taylor, "A Criticism of the Riverside Church, New York," *American Architect* CXXXIX, no. 2596 (June 1931): 32–33, 68–70.

35. Charles Crane, "Why We Made It Gothic," *American Architect* CXXXX, no. 2597 (July 1931): 26–27, 122–23.

3 A PASSION FOR ASIA

1. Kert, *Abby Aldrich Rockefeller*, 13 18.

2. Mary Ellen Chase, *Abby Aldrich Rockefeller*, New York: Macmillan Company, 1950, 13.

3. Ibid., 4.

4. AAR, Diary entries 1892, F 139 B 11 AAR Personal RG2, RFA.

5. AAR to John 3rd, NAR, and LR, Feb. 1923, quoted in Kert, *Abby Aldrich Rockefeller*, 208.

6. Russell Lynes, *Good Old Modern*, New York: Atheneum, 1973, 108.

7. Susan H. Hay, ed., *Patterns and Poetry: Nō Robes from the Lucy Truman Aldrich Collection*, Providence: Rhode Island School of Design, 1992, 15.

8. Chase, *Abby Aldrich Rockefeller*, 12.

9. Ibid., 33.

10. AAR to John 3rd, F 275 B 30, John 3rd Papers RG5, RFA.

11. Kert, *Abby Aldrich Rockefeller*, 186.

12. Anne Mazlich, ed., *The Charles Tracy Diaries*, Bar Harbor, Maine: Acadia Publishing Company, 1997.

13. George B. Dorr, *The Story of Acadia National Park: The Complete Memoir of the Man Who Made It All Possible*, Bar Harbor, Maine: Acadia Publishing Company, 1985.

14. Patricia C. Willis, "Ernest Fenollosa: Scholar and Source," www.library.yale.edu/beinecke/orient/fenell.htm; Paul Johnson, *Art: A New History*, New York: HarperCollins, 2003, 468–94.

15. Manik Sandrasagra, "Going Against the Stream: The Relevance of Ananda Coomaraswamy in the Twenty-first Century," Aug. 21, 1999, at the Indian Cultural Centre, Colombo, Sri Lanka, www.kataragama.org/centers/akc/_oraton99.html; B. Srinivasa Rao "Dr. Ananda K. Coomaraswamy," www.astro.uni.torun.pl/-kb/rishikul/coomaraswamy.html.

16. Hay, *Patterns and Poetry*, 14.

17. Kert, *Abby Aldrich Rockefeller*, 243.

18. LTA to AAR, Miyako Hotel, Kyoto, 5/12/1919, F 6 B 1 AAR Personal Correspondence, RG2, RFA.

19. LTA to AAR, 7/18/1919, F 6 B 1 AAR Personal Correspondence, RG2, RFA.

20. LTA to AAR from Grand Hotel Ltd., Yokohama, 8/24/1919, F 6 B 1 AAR Personal Correspondence, RG2, RFA.

21. Kert, *Abby Aldrich Rockefeller*, 191.

22. David Rockefeller, in *A Passion for Asia: The Rockefeller Legacy*. New York: Asia Society, 2006, 38.

23. AAR to John 3rd, F 275, B 30 RG5, RFA.

24. David Rockefeller, in *A Passion for Asia*, 2006, 38.

25. AAR to LTA, 14/8/1920, cited in Kert, *Abby Aldrich Rockefeller*, 185.

26. AAR to LTA, 7/26/1922, in Kert, *Abby Aldrich Rockefeller*, 74.

27. David Rockefeller, Peggy Rockefeller, Monroe Wheeler, and Margaret Potter, *The David and Peggy Rockefeller Collection*, New York: published privately, Vol III, 1993, 11.

28. Junior to Yamanaka and Company, 6/16/1924, cited in Asia Society, *A Passion for Asia*, p. 118.

29. Mary Louise Pierson, Ann Rockefeller Roberts, and Cynthia Altman, *The Rockefeller Family Home, Kykuit*, New York: Abbeville Press, 1998, 78.

30. Gifts to the Metropolitan Museum of Art, F 173 B 16 Art collections, AAR Papers, RG2, RFA.

31. Rockefeller, Rockefeller, Wheeler, and Potter, *David and Peggy Rockefeller Collection*, Vol III, 1993, 11.

32. Patrick Chassé, *The Abby Aldrich Rockefeller Garden: A Visitors' Guide*, Seal Harbor, Maine: David and Peggy Rockefeller, 1990; Beatrix Farrand, "Autobiography," *Reef Point Gardens Bulletin*, No.17, Reef Point, Bar Harbor, Maine, 1959.

33. AAR to LTA, 10/12/1926, in *Abby Aldrich Rockefeller's Letters to Her Sister Lucy*, New York: John D. Rockefeller, Jr., 1957.

34. Chassé, *Abby Aldrich Rockefeller Garden*, 20.

35. Beatrix Farrand to Junior, 10/26/1928, B 73 F 752 Homes, RG2, RFA.

36. Beatrix Farrand to Junior, 4/10/1929, F 749 B 73 Homes, RG2, RFA.

37. Rockefeller, Rockefeller, Wheeler, and Potter, *David and Peggy Rockefeller Collection*, Vol III, p. 25.

38. David Rockefeller, foreword, in Chassé, *Abby Aldrich Rockefeller Garden*, 3.

39. Junior to Beatrix Farrand, 7/18/1949, F 750 B 73 Homes, RG2, RFA.

40. Rockefeller, Rockefeller, Wheeler, and Potter, *David and Peggy Rockefeller Collection*, Vol III, p. 25.

41. Jan Fontein and Olive Bragazzi, Sculptures in the Abby Aldrich Rockefeller Garden, Sept. 1969, F 1005 B 29, Homes, Junior Papers, RG2, RFA.

42. LTA to Junior, 10/18/1948, cited in Hay, *Patterns and Poetry*, p. 25.

43. Johnson, *Art*, see note 14.

44. Japanese Prints, F 208 B 20 AAR Papers, RG2, RFA.

45. *Feathers, Flowers, Talons, and Fangs*, Rhode Island School of Design, exhibit bulletin, no. 26 (Spring 2004).

46. "Japanese Prints," *Philadelphia Museum Bulletin* 42, no. 211 (Nov. 1946): 3–5.

47. Gifts to NAR AAR Art Collections, AAR Papers F 200 B 20 RG2, RFA.

48. Hay, *Patterns and Poetry*, 23.

49. Rockefeller, Rockefeller, Wheeler, and Potter, *David and Peggy Rockefeller Collection*, Vol IV.

50. William H. Edwards, in Elizabeth Temple Casey, *The Lucy Truman Aldrich Collection of European Porcelain Figures of the Eighteenth Century*, Providence: Museum of Art, Rhode Island School of Design, 1965, 22.

4 BRIDGING THE PAST AND THE PRESENT: THE ORIENTAL INSTITUTE, THE CAIRO MUSEUM, THE METROPOLITAN MUSEUM'S ASSYRIAN SCULPTURES, AND THE ROCKEFELLER ARCHAEOLOGICAL MUSEUM, JERUSALEM

1. John D. Rockefeller, Jr., *Centenary Exhibition: A Productive Collaboration 1919–1935*, exhibit bulletin, University of Chicago, Oriental Institute, December 1974.

2. James Breasted, *The Oriental Institute*, Chicago: University of Chicago Press, 1933.

3. Charles Breasted, *Pioneer to the Past: The Story of James Henry Breasted, Archeologist*, New York: Charles Scribner's Sons, 1943; Leonard Aronson, producer, *Breaking Ground: The Story of the Oriental Institute / Pioneer to the Past: The Life and Times of James Henry Breasted*, WTTW11: 2004, DVD.

4. See Breasted, *Pioneer to the Past*; Map, John D. Rockefeller, Jr., *Centenary Exhibition*, 22.

5. Frances Breasted to Junior, 12/11/1919, Rockefeller, *Centenary Exhibition*, 11.

6. Breasted, *Pioneer to the Past*.

7. James Breasted to AAR, 2/23/1926, F 29 B 2 AAR Papers RG2, RFA.

8. James Breasted to Junior, 9/25/1931, F 802 B 111 Educational Interests, RFA.

9. Karen L. Wilson, *In the Beginning*, DVD, 2006, www.oi.uchicago.edu.

10. Musée du Louvre, exhibition label, viewed 2007.

11. See Wilson, *In the Beginning*.

12. James Breasted to Raymond Fosdick, 5/15/1925, F 824 B 112 Educational Interests, RG2, RFA.

13. Junior to "Dear Children," 2/6/1929, F 378 B 42, JDR Jr., Personal Papers, RG2, RFA.

14. Junior to "Children, one and all," 2/16/1929, F 378 B 42 SE II, JDR Jr., Personal Papers, RG2, RFA.

15. Junior to Senior, 2/26/1929, F 378 B 42 SE II JDR Jr., Personal Papers, RG2, RFA.

16. The Cairo Museum, F 210 B 258 Cultural Interests, RG2, RFA.

17. James Breasted to Raymond Fosdick, 2/26/1925, F 210 B25 Cultural Interests, RG2, RFA.

18. John Malcolm Russell, *From Nineveh to New York*, New Haven, Conn.: Yale University Press, 1997.

19. Junior to C. Edward Wells, 1/13/1930, F 281 B 28 Cultural Interests, RG2, RFA.

20. James J. Rorimer, *Museum of Modern Art Bulletin* XVIII, no. 8 (April 1960): 241.

21. Max I. Dimont, *Jews, God and History*, 2nd ed., New York: New American Library, 1994.

22. Ilan, Tal, and Haramati, *Image and Artifact*, 9.

23. Ibrahim, *West Meets East*, 8.

24. Junior to Raymond Fosdick, 12/16/1926, F 211 B 25 Cultural Interests, RG2, RFA.

25. Junior to James Breasted, 12/24/1926, F211 B25 Cultural Interests, RG2, RFA.

26. Ibrahim, *West Meets East*, 18.

27. Junior to H. E. Field Marshal Lord Plummer, 10/11/1927, F 263 B 25 Cultural Interests, RG2, RFA.

28. Ibrahim, *West Meets East*, 22.

29. Ibid., 8.

30. Ibid., 11.

31. The description of the objects is derived from Ilan, Tal, and Haramati, *Image and Artifact*.

32. "A Museum in Jerusalem," *The Boston Transcript*, Nov. 18, 1927.

33. Breasted, *Pioneer to the Past*.

34. Ibrahim, *West Meets East*, 27–28.

35. James G. McDonald to John 3rd, 4/21/1949, F 264 B 26, Cultural Interests, RG2, RAC.

36. James L. Kelso, "The Palestine Archaeological Museum," *Archaeology* (Summer 1950): 66–67.

5 ROCKEFELLER CENTER

The history of Rockefeller Center has been told so often and so well that it is difficult to assign exact references. The author wishes to thank all those who have so eloquently told the story before her.

1. Alan Balfour, *Rockefeller Center: Architecture as Theater*, New York: McGraw-Hill, 1978.

2. John D. Rockefeller, Jr., in Merle Crowell, *The Last Rivet: The Story of Rockefeller Center, a*

City Within a City, as Told at the Ceremony in Which John D. Rockefeller, Jr., Drove the Last Rivet of the Last Building, November 1, 1939, New York: Columbia University Press, 1940.

3. David Garrod Lowe, *Art Deco New York*, New York: Watson-Guptill Publications, 2004, 7.

4. Daniel Okrent, *Great Fortune: The Epic of Rockefeller Center*. New York: Viking, 2003, 4

5. Fosdick, *John D. Rockefeller, Jr.*, 263–66.

6. Ibid.

7. John 3rd to AAR and Junior, F223, B 29 John 3rd Papers, RFA.

8. Harr and Johnson, *Rockefeller Century*, New York: Scribner, 1988, chap. 12: "Loomis Days," 246–47.

9. Ibid, chapter 13: "The College Man," 268.

10. NAR, "The Constitution of the Fifth Grade," F 163 B 4 AAR Correspondence, RG2, RFA.

11. Cary Reich, *The Life of Nelson Rockefeller: Worlds to Conquer, 1908–1958*, New York: Doubleday, 1996, 66.

12. Ibid., 67.

13. NAR to Junior, quoted in a letter Junior wrote to Senior from Egypt on 2/26/1929, F 378 B 42 RG2, JDR Jr. Correspondence, RFA.

14. David Rockefeller, *Memoirs*, New York: Random House, 2002, 35.

15. NAR to Junior (undated) 1928, F 63 B 4 Correspondence, AAR Papers, RG2, RFA.

16. NAR to AAR, 3/21/1933, quoted in Reich, *Life of Nelson Aldrich Rockefeller*, 114.

17. Kert, *Abby Aldrich Rockefeller*, 290. Interview with Blanchette Rockefeller on March 19, 1986.

18. Kert, *Abby Aldrich Rockefeller*, 369.

19. Okrent, *Great Fortune*, 60.

20. Frank Gervasi, *The Real Rockefeller*, New York: Atheneum Publishers, 1964, 64.

21. Lowe, *Art Deco*, 167.

22. Fosdick, *John D. Rockefeller, Jr.*, 268.

23. Okrent, *Great Fortune*, 287.

24. Letter of Mrs. Hirsch to Carol Uht, Sept. 29, 1977, in Rockefeller, Rockefeller, Wheeler, and Potter, *David and Peggy Rockefeller Collection*, Vol. II, 117.

25. NAR, Introduction in Lee Boltin, *The Nelson A. Rockefeller Masterpieces of Modern Art*, New York: Hudson Hill Press, 1981.

26. Newhouse, *Wallace K. Harrison*, 46.

27. Okrent, *Great Fortune*, 158.

28. Balfour, *Rockefeller Center*, 19–21.

29. Ibid., 42.

30. Junior, F 692 B 92 2 C, Correspondence, RFA.

31. Lowe, *Art Deco*, 173.

32. Hartley Burr Alexander, www.capitol.org/goodteam/alex.html, accessed 10/16/08.

33. Hartley Burr Alexander, Rockefeller City—Thematic Synopsis, May 1932, RFA 2C, B 93, F 704, RFA

34. Balfour, *Rockefeller Center*, 139.

35. Advisory Art Committee, F 70 B 93 III 2 C RFA.

36. Balfour, *Rockefeller Center*, 137–91.

37. Roussel, *The Art of Rockefeller Center*, 89–91.

38. Ibid., 150.

39. Rockefeller Memorial Chapel, www.nationmaster.com/encyclopedia/RockefellerChapel, accessed 7/3/2009.

40. Okrent, *Great Fortune*, 374.

41. Junior to John Todd, F 704 B 93 OMR, III, 2 C, Business Interests, RFA.

42. Junior to John A. Todd, R., 9/19/1933, F 581 B 78 RG 2C RFA.

43. Junior to Welles Bosworth, 1/1/1921, F 1041 B 140, 2H RFA.

44. David Goldsmith Loth, *The City Within the City: The Romance of Rockefeller Center*, New York: W. Morrow, 1966.

45. Okrent, *Great Fortune*, 299.

46. Roussel, *The Art of Rockefeller Center*, 282.

47. Ibid., 150.

48. Balfour, *Rockefeller Center*, 150.

49. Kert, *Abby Aldrich Rockefeller*, 350.

50. David Rockefeller, *Memoirs*, 58–59.

51. Reich, *Life of Nelson Rockefeller*, 105.

52. Desmond Rochfort, *Mexican Muralists: Orozco, Rivera, Siqueiros*, San Francisco: Chronicle Books, 1998, 126–30, 225.

53. Suzanne Loebl, *America's Art Museums: A Traveler's Guide to Great Collections Large and Small*, New York: W.W. Norton, 2002, 235.

54. For correspondence see Diego Rivera, Box 95, 1 B I Rockefeller Center, RFA.

55. Junior to Robert Hood, 10/12/1932, F705 B 94 Business Interests, RG2, RFA.

56. Diego Rivera to AAR, 11/5/1932, Cultural Interests, RG2 B 95 B 1 RFA.

57. Bertram D. Wolfe, *The Fabulous Life of Diego Rivera*, New York: Stein and Day, 1963; Lucienne Bloch, "On Location with Diego Rivera," *Art in America* 74, no. 2 (February 1986): 102–22.

58. Kert, *Abby Aldrich Rockefeller*; Okrent, *Great Fortune*; Reich, *Life of Nelson Rockefeller*.

59. NAR to Diego Rivera, 5/4/1933, RFA B 95, B I RFA.

60. Rochfort, *Mexican Muralist*, 133.

61. Balfour, *Rockefeller Center*, 150.

62. Helen Worden, "Five Characters," *New York World-Telegram*, April 20, 1943, in Okrent, *Great Fortune*, 320.

63. John Matturri, "Unreeled Presence: The Film Screen as Altar," 1988, personal website of John Matturri, www.home.earthlink.net/~jmatturr/altar.html.

64. Charles Francisco, *Radio City Music Hall: An Affectionate History of the World's Greatest Theater*, New York: Dutton, 1979, 8.

65. Lindsay Pollock, *The Girl with the Gallery: Edith Gregor Halpert and the Making of the Modern Art Market*, New York: Public Affairs, 2006, 157–67.

66. Ibid.

67. Ibid.

68. Crowell, *The Last Rivet*.

69. Peter Collier and David Horowitz, *The Rockefellers: An American Dynasty*, New York: Holt, Rinehart and Winston, 1976, 611.

70. Fosdick, *John D. Rockefeller, Jr.*, 266.

71. Okrent, *Great Fortune*, 376.

72. Ibid., 384.

73. Balfour, *Rockefeller Center*, 215.

74. Jane Jacobs, *The Death and Life of Great American Cities*, New York: Random House, 1961, 163.

75. Paul Goldberger, *The Skyscraper*, New York: Alfred A. Knopf, 1981, 101.

6 MOTHER'S MUSEUM: MOMA, 1929–39

1. Fosdick, *John D. Rockefeller, Jr.*, 329.

2. Richard G. Tansey and Fred S. Kleiner, *Gardener's Art Through the Ages*, 10th Ed., Fort Worth, Texas: Harcourt Brace College Publishers, 1996, 985.

3. Saarinen, *The Proud Possessors*.

4. Walt Kuhn, *The Story of the Armory Show*, New York: 1938.

5. Judith Zilczer, *"The Noble Buyer": John Quinn, Patron of the Avant-Garde*, Washington, D.C.: Smithsonian Institution Press, 1980.

6. Pollock, *Girl with the Gallery*, 32.

7. Flora Miller, *The Whitney Women and the Museum They Made: A Family Memoir*, New York: Arcade, 1999, 42.

8. Suzanne Loebl, *America's Art Museums: A Traveler's Guide to Great Collections Large and Small*, New York: W.W. Norton, 2002, 117.

9. Ibid., 131.

10. Michael Conforti et al., *The Clark Brothers Collect Impressionism and Early Modern Paintings*, Williamstown, Mass.: Sterling and Frances Clark Art Institute, 2006.

11. Margaret Sterne, *The Passionate Eye of William R. Valentiner*, Detroit, Mich.: Wayne University Press, 1980, 111, 128.

12. Kert, *Abby Aldrich Rockefeller*, 218.

13. Sterne, *Passionate Eye*, 152.

14. AAR to WRV, F 74 B 5 RG2 AAR Papers, RG2, RFA.

15. Sterne, *Passionate Eye*, 161.

16. AAR to WRV, 8/28/1930 F 74 B 5 RG2 AAR Papers, RFA.

17. Kert, *Abby Aldrich Rockefeller*, 253.

18. "53rd Street Patron," *Time*, Jan. 27, 1936.

19. Kert, *Abby Aldrich Rockefeller*, 220.

20. Henry McBride, *The Flow of Art: Essays and Criticism*, New Haven, Conn.: Yale University Press, 1997, 25.

21. Pollock, *Girl with the Gallery*, 84.

22. Edith Gregor Halpert, interviewed by Harlan Phillips, April 4, 1962, Jan. 20, 1965, Oral History Project, Smithsonian Archives of American Art, www.aaa.si.edu/collections/collection/halper65.htm.

23. Pollock, *Girl with the Gallery*, 126.

24. NAR to AAR, 1/2/1928, AAR Box 12, RFA, cited in Reich, *Life of Nelson Rockefeller*.

25. AAR to NAR, 1/7/1928, B 12 RG2, RAF.

26. Kert, *Abby Aldrich Rockefeller*, 290; Joe Alex Morris, *Nelson Rockefeller: A Biography*, New York: Harper, 1960, 73.

27. Reich, *Life of Nelson Rockefeller*, 64.

28. Kert, *Abby Aldrich Rockefeller*, 291.

29. Martin Duberman, *The Worlds of Lincoln Kirstein*. New York: Alfred A. Knopf, 2007, 12.

30. Ibid., 62.

31. John Walker, *Self-Portrait with Donors*, Boston: Little, Brown, 1974, 22–27.

32. Pollock, *Girl with the Gallery*, 149.

33. Marquis, *Alfred H. Barr, Jr.*, 45.

34. Duberman, *Worlds of Lincoln Kirstein*, 372.

35. Exhibition label, William Steig Retrospective at the Jewish Museum, New York, 2006–2007.

36. Pollock, *Girl with the Gallery*, 175–76.

37. AAR to NAR, 1/10/1931, F 63 B 4 AAR Correspondence, RG2, RFA.

38. Kert, *Abby Aldrich Rockefeller*, 300.

39. Ibid., 252.

40. Frank Crowninshield, "Art and Mr. Rockefeller," 84–85.

41. Helen Appleton Read, "Modern Art: The Collection of Mrs. John D. Rockefeller, Jr.," *Vogue*, April 1, 1931, 79.

42. Kert, *Abby Aldrich Rockefeller*, 309.

43. Ibid., 269.

44. Randall Suffolk, *Arthur B. Davies: Dweller on the Threshold,* exhibition catalogue, Glens Falls, N.Y.: The Hyde Collection Art Museum, 2001; Bernard B. Perlman, *The Lives, Loves, and Art of Arthur B. Davies,* Albany: State University of New York Press, 1998.

45. Rona Roob, "A Noble Legacy," *Art in America,* November 2003, 73–83.

46. Kert, *Abby Aldrich Rockefeller,* 271.

47. AAR to Arthur David Davies, 12/18/1928, F 27 B 2 AAR Papers RG2, RFA. The mural AAR commissioned from Davies for International House depicted a group of nudes. Eventually these were said to have offended certain foreign students, and the work was retired. The mural is now at the Munson-Williams-Proctor Art Institute Museum, in Utica, New York, the painter's hometown. Note that this institution also mounted a celebration of the Armory Show in 1963.

48. Henry McBride, *The New York Sun,* Dec. 22, 1928.

49. Kert, *Abby Aldrich Rockefeller,* 268.

50. Conger Goodyear, *The Museum of Modern Art: The First Ten Years,* New York: 1943, 14.

51. Lynes, *Good Old Modern,* 8.

52. Kert, *Abby Aldrich Rockefeller,* 281.

53. Marquis, *Alfred H. Barr, Jr.,* 63.

54. Kantor, *Alfred H. Barr, Jr.,* 16.

55. Marquis, *Alfred H. Barr, Jr.,* 37.

56. Ibid., 43.

57. Lynes, *Good Old Modern,* 59.

58. *New York Evening World,* Sept. 7, 1929, quoted in Lynes, *Good Old Modern,* 34, 55.

59. Lynes, *Good Old Modern,* 61.

60. Saarinen, *Proud Possessors,* 366.

61. Mural painting underwent a major revival during the 1920s and '30s. Both Lynes, *Good Old Modern* (98–101), and Reich, *Life of Nelson Rockefeller* (102–105), report extensively on MoMA's 1932 mural exhibition; Marquis, *Alfred H. Barr, Jr.,* 94.

62. Marquis, *Alfred H. Barr, Jr.,* 95.

63. Goodyear, *MoMA: First Ten Years,* 29.

64. Rona Roob, "Rockefeller Vision and the Making of the Museum of Modern Art," *Research Reports from the RAC,* 1997, 1–5.

65. Reich, *Life of Nelson Rockefeller,* 124.

66. Rona Roob, "A Noble Legacy," 73–83.

67. Conforti et. al., *The Clark Brothers Collect,* 168.

68. Lynes, *Good Old Modern,* 240.

69. Alfred H. Barr, "A Gift of Paintings from a Trustee," *MoMA Bulletin* 8, no. 4 (May–June 1941).

70. AHB to AAR, 12/6/1935, F 104 B 8, RG2, RFA.

71. Lynes, *Good Old Modern,* 301–23.

72. Ibid., 84–90.

73. Ibid., 95.

74. Marquis, *Alfred H. Barr, Jr.*, 175.

75. Kert, *Abby Aldrich Rockefeller*, 287, 335.

76. "The 53rd Street Patron," *Time*, January 27, 1936, 28–29.

77. Rockefeller, Rockefeller, Wheeler, and Potter, *David and Peggy Rockefeller Collection*, Vol. II, 54.

78. Alfred H. Barr, *What Is Modern Painting?* 9th ed., New York: Museum of Modern Art, 1988.

79. Alix S. Schnee, *John Cotton Dana, Holger Cahill, and Dorothy Miller: Three Art Educators*, Ph.D. diss., UMI Dissertation Services, 1987, 24–36.

80. Ibid., 154.

81. Ibid.

82. *Exhibition of American Paintings and Sculpture*, authored by Holger Cahill, Newark Museum, 1944, 9–68.

83. Schnee, *Dana, Cahill, Miller*, 84–112.

84. Kert, *Abby Aldrich Rockefeller*, 376.

85. Alfred H. Barr, *Art in Our Time*, exhibit catalogue, New York: Museum of Modern Art, 1939.

86. McBride, Henry, *The New York Sun*, May 13, 1939.

87. Kert, *Abby Aldrich Rockefeller*, 413.

88. Conger Goodyear, Tenth Anniversary, *MoMA Bulletin* 6 (May–June 1939).

89. Franklin D. Roosevelt, "A Citadel of Freedom," Radio address, May 10, 1939, reprinted in the *New York Times*, May 11, 1939.

90. Kert, *Abby Aldrich Rockefeller*, 418.

7 THE CLOISTERS

1. Fosdick, *John D. Rockefeller, Jr.*, 336.

2. Nicholas Fox Weber, *The Clarks of Cooperstown: Their Singer Sewing Machine Fortune, Their Great and Influential Art Collections, Their Forty-Year Feud*, New York: Alfred A. Knopf, 2007, 57–60, 79.

3. Joseph Breck, *The Cloisters: A Brief Guide*, vol. 21, New York: Metropolitan Museum of Art, 1926, 166–77; Calvin Tomkins, *Merchants and Masterpieces*, New York: Henry Holt, 1989, 246.

4. Sabine Tischer, "Medievalism in American Culture: The Cloisters," *Research Reports from the RAC*, 1996, 1–3.

5. Tomkins, *Merchants and Masterpieces*, 253.

6. Ibid., 246.

7. James J. Rorimer, *The Cloisters*, 2nd ed., New York: Metropolitan Museum of Art, 1946.

8. Tomkins, *Merchants and Masterpieces*, 249.

9. Breck, *The Cloisters*, 166–77.

10. Fosdick, *A Portrait*, 325.

11. Junior to Charles Collens, 2/5/1931, F 318 B 31 Cultural Interests, RG2, RFA.

12. Tomkins, *Merchants and Masterpieces*, 253–61.

13. Charles Collens to Junior, 4/13/1931, F 318 B 31 Cultural Interests, RG2, RFA.

14. Ibid.

15. Charles Collens's report on his European trip, F 318 B 31 Cultural Interests, RG2, RFA.

16. Tomkins, *Merchants and Masterpieces*, 258.

17. Rorimer, *The Cloisters*, 31.

18. Rorimer, "The Opening of The Cloisters," *Metropolitan Museum of Art Bulletin* 33, no. 4 (1938): 90–97.

19. Junior to Joseph Breck, Jr., 4/25/1930, F 282 B 28 Cultural Interests, RG2, RFA.

20. Rorimer, *The Cloisters*, 11.

21. James Rorimer, "XIII Century Statues of Kings Clovis and Clothar at the Cloisters," *Metropolitan Museum of Art Bulletin* 35 (1940): 122–26.

22. Rorimer to Junior, 4/30/1940, F 297 B 29 Cultural Interests, RG2, RFA.

23. W. H. Forsyth, "Doorway from Moutiers-Saint-Jean," *Metropolitan Museum of Art Journal* 13 (1978): 33–74.

24. James J. Rorimer, "The Virgin from the Strasbourg Cathedral," *Metropolitan Museum of Art Bulletin* 7 (1946): 220–27.

25. Peter Barnet and Nancy Y. Wu, *The Cloisters: Medieval Art and Architecture*, New York: Metropolitan Museum of Art, 2005, 87.

26. Conforti et al., *The Clark Brothers Collect*, 126.

27. Fosdick, *John D. Rockefeller, Jr.*, 339.

28. Fosdick, *John D. Rockefeller, Jr.*, 342; James J. Rorimer, "Recent Accessions at The Cloisters," *Metropolitan Museum of Art Bulletin* 36 (1941): 106–7.

29. Fosdick, *John D. Rockefeller, Jr.*, 343.

30. James. J. Rorimer, "The King Arthur Tapestry," *Metropolitan Museum of Art Bulletin* 28, no. 3 (1933): 48–50.

31. Saarinen, *Proud Possessors*, 355.

32. James J. Rorimer, "The Apse from San Martin at Fuentidueña," *Metropolitan Museum of Art Bulletin* 19 (1961): 265–66.

33. Barnet and Wu, *The Cloisters*, 39.

34. Tomkins, *Merchants and Masterpieces*, 346; Barnet and Wu, *The Cloisters*, 52–53.

35. "Antioch Chalice," in Heilbrunn Timeline of Art History, Metropolitan Museum of Art website, 2006, accessed at www.metmuseum.org/toah/ho/06/waa/ho_50.4.htm.

36. George Grey Barnard to Junior, 5/30/1936, F 30 B 32 Cultural Interests, RG2, RFA.

37. Junior, "Remarks at the Opening of The Cloisters," 5/10/1938, F 494 B 56 JDR Jr. Personal, RG2, RFA.

38. Tomkins, *Merchants and Masterpieces*, 261.

39. James Rorimer to Junior, 12/29/1943. B32 Cultural Interests RG2, RFA.

40. Tomkins, *Merchants and Masterpieces*, 245.

8 COLONIAL WILLIAMSBURG AND THE ABBY ALDRICH ROCKEFELLER MUSEUM OF AMERICAN FOLK ART

1. Fosdick, *John D. Rockefeller, Jr.*, 272–301.

2. Kert, *Abby Aldrich Rockefeller*, 391.

3. Pollock, Lindsay, *Girl with the Gallery*, 51.

4. Beatrix T. Rumford, "Uncommon Art of the Common People: A Review of Trends in the Collecting and Exhibiting of American Folk Art," in Ian M. G. Quimby and Scott T. Swank, eds., *Perspectives on American Folk Art*, New York: W.W. Norton and Company, 1980, 13–53.

5. Ibid., 21.

6. Kert, *Abby Aldrich Rockefeller*, 106.

7. Ibid., 324.

8. Winthrop Rockefeller, in Rumford and Weekley, *Treasures of American Folk Art*, 8.

9. Rumford, "Uncommon Art," 25.

10. EGH to AAR, 2/11/1933, F 1340, B 154, Cultural Interests, RG2, RFA.

11. Rumford and Weekley, *Treasures of American Folk Art*, 11.

12. Kert, *Abby Aldrich Rockefeller*, 323.

13. Rumford, "Uncommon Art," 19.

14. Pollock, *Girl with the Gallery*, 132.

15. Holger E. Cahill, et al., *Masters of Popular Painting: Modern Primitives of Europe and America*, exhibition catalogue, Newark Museum, 11/4/1930–2/1/1931.

16. Holger E. Cahill, *American Folk Sculpture*, catalogue to the exhibition, Newark Museum, 10/20/1931–1/31/1932.

17. AAR to NAR, 7/16/1932, F 63 B 4 Se I RG 2 AAR correspondence RFA.

18. Holger E. Cahill, *The Art of the Common Man in America, 1750–1900*, Catalogue to the Exhibition, Museum of Modern Art, New York, 1932.

19. Junior to Kenneth Chorley, 1/16/1935, Colonial Williamsburg Archives, quoted in Rumford, "Uncommon Art," 39.

20. Rumford and Weekley, *Treasures of American Folk Art*, 11.

21. Kenneth Chorley to Junior, 3/18/1957, F 1338 B 153 Cultural Interests, RG2, RFA.

22. Kenneth Chorley to Junior, 3/21/1957, F 1343 B 154 Cultural Interests, RG2, RFA.

23. Colonial Williamsburg Foundation, press release, January 2007; *Abby Aldrich Rockefeller Folk Art Museum, 1957–2007*, booklet commemorating the opening of the new museum, Colonial Williamsburg Foundation, Feb. 3, 2007.

24. Kert, *Abby Aldrich Rockefeller*, 393.

25. Bland Blackford, Burke Davis, and Patricia A. Hurdle, *Bassett Hall: The Williamsburg Home of Mr. and Mrs. John D. Rockefeller, Jr.*, Williamsburg, Va.: Colonial Williamsburg Foundation, 1984.

26. AAR to LTA, 6/8/1935, quoted in ibid., 38.

27. AAR to Stuart Aldrich, 10/23/1936, in Blackford, Davis, and Hurdle, *Williamsburg Home*, 33.

28. Marc Simpson, *The Rockefeller Collection of American Art*, New York: Harry N. Abrams, 1994, 298.

29. Fosdick, *John D. Rockefeller, Jr.*, 429.

30. AAR to LTA, 11/2/1945, in Blackford, Davis, and Hurdle, *Williamsburg Home*, frontispiece.

31. Raymond B. Fosdick in Blackford, Davis, and Hurdle, *Williamsburg Home*, 12.

9 MOMA UNDER NELSON A. ROCKEFELLER'S STEWARDSHIP, 1939–69

1. John Loring, "Nelson Rockefeller's Fifth Avenue Apartment," *Architectural Digest*, April 2001, 102.

2. AAR to NAR, 7/6/1935, F 63 B 4, AAR Papers, RG2, RFA.

3. Newhouse, *Wallace K. Harrison, Architect*, 1989, 99.

4. Steven C. Rockefeller, private communication.

5. Suzanne Loebl, personal recollection.

6. Saarinen, *Proud Possessors*, 384.

7. NAR, interview with Holger Cahill, radio broadcast, 10/28/1939, F 1512 B 152 Personal Papers, RG4, RFA.

8. Francine du Plessix, "Anatomy of a Collector," *Art in America* 53 (April 1965): 27–46.

9. Lynes, *Good Old Modern*, 218–19.

10. PBS, *Treasures of the World* series, *Guernica: Testimony of War*, www.pbs.org/treasuresof theworld/guernica/gm.html, accessed 7/1/2009.

11. Aline Saarinen, television broadcast interview with Nelson Rockefeller, 1/19/1964, F 67 B 13 RG III 4A NAR Personal Activities Se Collectors RFA.

12. *Italian Masters*, exhibition catalogue, Jan.–March 1940, New York: Museum of Modern Art; Lynes, *Good Old Modern*, 227–29.

13. Lynes, *Good Old Modern*, 222–24.

14. Frank Crowninshield, "New York Goes Mexican," *Vogue*, June 1940, 38.

15. MoMA, label of Clemente Orozco painting *Dive Bomber and Tank*.

16. David Rockefeller, pamphlet, Union Church at Pocantico Hills.

17. AHB to AAR, 9/22/1941, cited in Kert, *Abby Aldrich Rockefeller*, 449.

18. Marquis, *Alfred H. Barr*, 190–92.

19. Chase, *Abby Aldrich Rockefeller*, 142–47.

20. Kert, *Abby Aldrich Rockefeller*, 450.

21. Marquis, *Alfred H. Barr, Jr.*, 177–78.

22. Lynes, *Good Old Modern*, 305; Marquis, *Alfred H. Barr*, 118.

23. Chase, *Abby Aldrich Rockefeller*, 138.

24. Lynes, *Good Old Modern*, 241.

25. Weber, *The Clarks of Cooperstown*, 334, 345–46. With authors taking sides, the firing of Alfred Barr by Steven Clark is widely discussed in biographies dealing with the lives of the principals. See Marquis, *Alfred H. Barr*, 198, and Conforti et al., *The Clark Brothers Collect*, 169.

26. Kert, *Abby Aldrich Rockefeller*, 450–54.

27. Weber, *The Clarks of Cooperstown*, 362; Lyons, *Good Old Modern*, 245, 314.

28. William S. Lieberman, *René d'Harnoncourt*, biographical account, F 1323 B 135 RG 4L RFA.

29. Lynes, *Good Old Modern*, 267–70.

30. Marquis, *Alfred H. Barr*, 224.

31. David Rockefeller, *Memoirs*, 180.

32. Harry E. Fosdick, *Memorial Service for Mrs. John D. Rockefeller, Jr.*, Riverside Church, 5/23/1948, F 307 b 34 RG 2 Se VI AAR Papers, RFA.

33. "Mrs. John D. Rockefeller, Jr., 1874–1948," *Museum of Modern Art Bulletin* 15, no. 3 (1948): 23.

34. Fosdick, *John D. Rockefeller, Jr.*, 180.

35. AHB to NAR, 5/29/1948, F 1527 B 153 Projects, RG 4 NAR Personal RFA.

36. "The Abby Aldrich Rockefeller Print Room, Master Prints from the Collection," *Museum of Modern Art Bulletin* 16, no. 4 (1949).

37. Deborah Wye, *Artists and Prints: Masterworks from the Museum of Modern Art*, New York: Museum of Modern Art, 2004.

38. Kert, *Abby Aldrich Rockefeller*, 474.

39. Ibid., 475.

40. du Plessix, "Anatomy of a Collector," 27–47.

41. Ibid.

42. Monroe Wheeler to NAR, 11/1/54, F 1253 B 128 Personal Projects, RG4, RFA.

43. John Canaday, "Governor Gives Museum a Matisse," *New York Times*, Nov. 14, 1963.

44. AHB to NAR, 4/9/1963, F 1251 B 128 Personal Project RG4, RFA.

45. Grace Glueck, "3 Museums to Show Rockefeller Art," *New York Times*, April 30, 1969.

46. Alfred Barr, selection of paintings from the Nelson A. Rockefeller Collection, F 320 B 39, NAR Personal Projects, RG4, RFA.

47. Hilton Kramer. "Governor to Give Art to the Modern," *New York Times,* May 27, 1969.

48. Nelson Rockefeller, introduction, in Boltin, *Nelson A. Rockefeller Collection*, 19.

49. Mrs. Donald Straus, "The Junior Council," *Metropolitan Museum of Art Bulletin* 21, no. 2 (1953/54): 54.

50. Harr and Johnson, *Rockefeller Century*, 335–53.

51. Saarinen, *Proud Possessors*, 369.

52. Harr and Johnson, *Rockefeller Conscience*, 228–30.

53. Lynes, *Good Old Modern*, 385.

54. Ibid.

55. Ibid., 378.

56. Blanchette Rockefeller interview with Paul Cummings for the Smithsonian's Archives in American Art, 6/30/1970 and 8/19/1970, F 116 B 16 RG 53 BHR Paper RFA.

57. It was the manner in which the museum raised its funds that so angered Steven Clark that he curtailed his involvement with MoMA.

58. Marquis, *Alfred H. Barr*, 334.

59. Ibid., 335–37.

60. Ibid., 343.

61. Ibid., 357.

62. Alfred H. Barr, Memorial Service, F 410 B 53 Series 4 RG 53 MoMA BHR, RFA.

10 A MODEST MAN ASSUMES HIS BIRTHRIGHT: THE ASIA SOCIETY AND LINCOLN CENTER

1. Asia Society, *A Passion for Asia: The Rockefeller Legacy,* New York: Hudson Hills Press, 2006.

2. Michele Hiltzig, "Asia Society Fiftieth Anniversary Exhibit," *Rockefeller Archive Center Newsletter* (Spring 2006): 16.

3. Derek, E. Ostergard, *George Nakashima Full Circle*, New York: Weidenfeld and Nicholson, 1989.

4. Kert, *Abby Aldrich Rockefeller*, 154.

5. AAR to John 3rd, 10/24/1921, F 275 B 30 RG5 RFA.

6. Harr and Johnson, *Rockefeller Century*, 411.

7. Ibid., 419.

8. Sherman Lee, "A Personal Recollection," in D. P. Leidy, *Treasures of Asian Art*, New York: The Asia Society Galleries, 1994, 15–21.

9. Harr and Johnson, *Rockefeller Conscience*, chap. 16.

10. Blanchette Rockefeller interview with Paul Cummings, Smithsonian's Archives of American Art, tape recording, 7/30/1970 and 8/19/1970, F 116, B 16 RG 53 BHR Papers RFA.

11. Lee, "Leidy," 17.

12. Leidy, *Treasures of Asian Art*, 48.

13. John 3rd to George Ball, chairman, Asia Society, 1/31/1974, F 123 B 125 RG 53 BHR Papers RFA.

14. Edgar B. Young, *Lincoln Center: The Building of an Institution*, New York: New York University Press, 1980, 302.

15. Newhouse, *Wallace K. Harrison*, chaps. 16–18.

16. Harr and Johnson, *Rockefeller Conscience*, 120.

17. Murielle Vautrin, "Nelson Rockefeller and the Promotion of Culture in New York City," *Research Reports from the Rockefeller Archive Center*, 1997, RAC.

18. Julia L. Foulkes, "Lincoln Center, the Rockefellers, and New York City," *Research Reports from the Rockefeller Archive Center*, Fall 2005, RAC.

19. Joseph E. Persico, *The Imperial Rockefeller: A Biography of Nelson A. Rockefeller*, New York: Simon and Schuster, 1982, 90.

20. Jacobs, *Death and Life of Great American Cities*.

21. Program of groundbreaking ceremony, F 276 B 36 RG 53 Lincoln Center, RG53, RFA.

22. The information concerning the thirty-two major artworks distributed throughout Lincoln Center is based on the publication *Painting and Sculpture at Lincoln Center*, published by Lincoln Center, approximately 1965.

23. Randy Kennedy, "Max Abramovitz, 96, Architect of Avery Fisher Hall Dies," *New York Times*, Sept. 15, 2004.

24. John Canaday quoted in Young, *Lincoln Center*, 208.

25. Newhouse, *Wallace K. Harrison*, 198.

26. Ibid., 220.

27. Marc Chagall to NAR, 1/8/1946, F 1244 B 28 Personal Projects, RG4, RFA.

28. Robert Moses to Wallace Harrison, 7/1/1965, F 631 B 73 RG4 Lincoln Center Opera House, RG4, RFA.

29. John V. Lindsay, "Tribute to John D. Rockefeller III," *Congressional Record*, April 9, 1964, Proceedings and Debates of the Eighty-eighth Congress, Second Session, Thursday, April 9, 1964, Washington, D.C.: Government Printing Office.

30. Harr and Johnson, *Rockefeller Conscience*, 157.

11 THE ROCKEFELLER COLLECTION AT THE FINE ARTS MUSEUMS OF SAN FRANCISCO

1. Martha Hutson, "An Interview with John D. Rockefeller 3rd," *American Art Review* 3, no. 4, July–August 1976.

2. Marc Simpson, *The Rockefeller Collection of American Art at the Fine Arts Museums of San Francisco*, New York: Harry N. Abrams, 1994. The introductory chapter, "A Source of Pleasure and Satisfaction," gives an excellent account of the formation of the collection and of the close relationship between Mr. and Mrs. John D. Rockefeller 3rd and Edward P. Richardson as based on the correspondence between the principals.

3. Harr and Johnson, *Rockefeller Conscience*, 256.

4. Simpson, *Rockefeller Collection*, 16.

5. E. P. Richardson to John 3rd, 12/31/1964, quoted in Simpson, *Rockefeller Collection*, 6.

6. E.P. Richardson to John 3rd, 1/23/1967, and 9/1/1970, quoted in Simpson, *Rockefeller Collection*, 17.

7. E. P. Richardson to John 3rd, 10/14/1965, quoted in Simpson, *Rockefeller Collection*, 27.

8. Timothy Anglin Burgard, "Ben Shahn, Ohio Magic: The Mystery and Melancholy of a Street," in Timothy Anglin Burgard, with Daniell Cornell et al., eds., *Masterworks of American Painting at the de Young*, San Francisco: Fine Arts Museums of San Francisco, 2005, 377.

9. Simpson, *Rockefeller Collection*, 27.

10. John 3rd to Ian M. White, 8/18/70, quoted in Simpson, *Rockefeller Collection*, 25.

11. Hutson, "An Interview with John D. Rockefeller 3rd."

12. Simpson, *Rockefeller Collection*, 201–02.

13. Ibid., 222.

14. Horace Pippin, "How I Paint," in Holger Cahill et al., *Masters of Popular Painting: Modern Primitives of Europe and America*. Exh. Cat. (New York: The Museum of Modern Art, 1938), 125–26, quoted in Simpson, *Rockefeller Collection*, 300–01.

15. Loebl, *America's Art Museums*, 301.

16. Emily Genauer, *New York Post*, Sept. 18, 1976, quoted in Simpson, *Rockefeller Collection*, 32.

17. Simpson, *Rockefeller Collection*, 35.

18. Harry S. Parker III, foreword and acknowledgements, in Burgard et al., eds., *American Paintings at the de Young*, vii.

19. In Memoriam, John 3rd, F 242 B 32 BHR Papers RG53, RFA.

20. In Memoriam, BHR, 1992 F 250 B33 BHR Papers, RG53, RFA.

21. "Rockefeller Creates $80 Million Alzheimer's Research Venture," *Discover: The Real West Virginia Foundation*, newsletter, 4 (2000): 1–2.

12 THE NELSON A. ROCKEFELLER EMPIRE STATE MALL

1. Reich, *Life of Nelson A. Rockefeller*, 768.

2. Persico, *Imperial Rockefeller*, 1982.

3. du Plessix, "Anatomy of a Collector," 27–47.

4. Nelson Rockefeller, "The Arts and the Quality of Life," *The Saturday Evening Post*, Summer 1971.

5. William Kennedy, *O Albany! An Urban Tapestry*, New York: Viking Penguin, 1983, 304–24.

6. C. R. Roseberry, *Capitol Story*, Albany: State of New York, 1982.

7. Fifty years earlier, the three hundredth anniversary of Hudson's voyage had occasioned the Metropolitan Museum's first blockbuster exhibition, ushering in an appreciation of the American-made furniture so dear to Abby Aldrich Rockefeller.

8. Empire State Plaza Art Commission, *The Empire State Collection: Art for the Public*, New York: Empire State Plaza Art Commission in association with Harry N. Abrams, 1987, 13.

9. Nelson Rockefeller, quoted in Acoustiguide. The Acoustiguide Tour is published by the Empire State Plaza and Acoustiguide Corporation, 2004, www.acoustiguide.com.

10. Kennedy, *O Albany!*, 307.

11. Roseberry, *Capitol Story*, 131.

12. Newhouse, *Wallace K. Harrison*, 265.

13. Roseberry, *Capital Story*, 134.

14. Happy Rockefeller, in Acoustiguide Tour.

15. Barbara K., interview with the author, 9/14/2009.

16. Roseberry, *Capitol Story*, 140.

17. Nelson A. Rockefeller, "Cornerstone Ceremony South Mall," 6/21/1965, F 1305 B 32 NAR Speeches, Series 33 RFA.

18. Happy Rockefeller, Acoustiguide.

19. Lena Williams, "The Footlights Begin to Lend a Glow to 'Egg,'" *New York Times*, Jan. 18, 1981.

20. Persico, *Imperial Rockefeller*, 47–48.

21. Paul Goldberger, "Built with Vision, Money and Hubris," *New York Times*, Jan. 10, 1982.

22. Carol Herselle Krinsky, "St. Petersburg-on-the-Hudson: The Albany Mall," in Moshe Barash and Lucy Freeman Sandler, eds., *Art, the Ape of Nature: Studies in Honor of H. W. Janson*, New York: Harry N. Abrams, 1981, 772.

23. Krinsky, quoted in Kennedy, *O Albany!*, 305.

24. Lo Faber, "Rocky's Last Erection: The Architectural, Economic, and Urban Planning Fiasco that is the Albany Mall." April 25, 2005. http://www.lofarber.com/Albany/es saymaking/html (viewed April 22, 2010).

25. Kennedy, *O Albany!*, 6.

26. Irving Sandler, introduction to Empire State Art Plaza Commission, *Empire State Collection*, 14.

27. Dennis R. Anderson, personal communication, 9/14/2008.

28. Dennis R. Anderson, Acoustiguide.

29. Persico, *Imperial Rockefeller*, 219.

30. Ibid.

31. Author interviews with Albany residents, Summer 2009.

32. Kennedy, *O Albany!*, 321–23.

33. Kert, *Abby Aldrich Rockefeller*; interview with Blanchette Rockefeller 3/19/1986, 290.

34. Nelson A. Rockefeller Memorial Service, February 1979, Riverside Church B4 F 47 NAR Speeches—Post VP RG4, RFA.

13 DAVID ROCKEFELLER: THE MUSEUM OF MODERN ART AND THE JPMORGAN–CHASE CORPORATE ART COLLECTION

1. Calvin Tomkins, "Talk of the Town," *The New Yorker*, May 30, 2005.

2. James T. Soby, "Recent Acquisitions of the Museum of Modern Art, New York," *The Studio*, Dec. 1954, 161–70.

3. David Rockefeller, *Memoirs*, New York: Random House, 2002, 443–50.

4. Cristina Carrillo de Albornoz, "David Rockefeller on Art," *Connoisseur's Guide: The Art Newspaper*, www.forbes.com/2003/03/05/cx_0305conn.html, accessed 7/2/2009.

5. Information pertaining to the artworks collected by David and Peggy Rockefeller is derived from both the catalogue to their collection and that published by MoMA (see note 7 for this chapter).

6. David Rockefeller, *Memoirs*, 446.

7. *Masterpieces from the David and Peggy Rockefeller Collection: Manet to Picasso*, published in conjunction with the exhibition of the same name, June 9 to Sept. 6, 1994, New York: Museum of Modern Art, 1994.

8. Grace Glueck, "Gertrude Stein's Art Collection Is Sought for Modern Museum," *New York Times*, Oct. 14, 1968.

9. *Masterpieces from the David and Peggy Rockefeller Collection*, 56.

10. Ibid., 60.

11. Rockefeller, Rockefeller, Wheeler, and Potter, *David and Peggy Rockefeller Collection*, Vol. I.

12. Marga Barr to DR, 3/13/83, RFA, F 410 B 53 MoMA BHR Papers S 4 RFA.

13. Rockefeller, Rockefeller, Wheeler, and Potter, *David and Peggy Rockefeller Collection*, Vol. II, 65.

14. Carol Vogel, "High Hopes for a Rothko Painting at Auction," *New York Times*, March 22, 2007.

15. Rockefeller, Rockefeller, Wheeler, and Potter, *David and Peggy Rockefeller Collection*, Vol. I, introduction.

16. David Rockefeller, *Memoirs*, 455–62.

17. Tomkins, "I Remember MoMA," *The New Yorker*, Sept. 25, 2006, 127–35.

18. Holland Cotter, "MoMA Plunge," *New York Times*, July 27, 2007.

19. Tomkins, "I Remember MoMA," 127–35.

20. Marga Barr to DR, 3/13/83, RFA, F 410 B 53 MoMA BHR Papers S 4 RFA.

21. David Rockefeller, *Memoirs*, chaps. 15 and 26.

22. Robert Battaly, The Downtown–Lower Manhattan Association: Rockefeller Archive Center Newsletter, Spring 2002, 19-22, Spring 2008. Also available online by putting in author and Research Reports from the Rockefeller Archive Center.

23. Darwin H. Stapleton, "Current Events and History," Research Report from the RAC (Fall/Winter 2001). Also available online by putting in author and Research Reports from the Rockefeller Archive Center.

24. Patrick Pacheco, "America's Best Corporate Art Collections," *Arts and Antiques* (Jan. 1996): 33–41; Marquis, *Alfred H. Barr*, 193.

25. Dorothy Miller, in *Art at Work: The Chase Manhattan Collection*, New York: E.P. Dutton, 1984, 23.

26. Isamu Noguchi, *A Sculptor's World*, New York: Harper and Row, 1968.

27. JPMorgan-Chase, *Art at Work*, privately published circa 2000, 315.

28. Louise Nicholson, "An Art Gallery for the Office," *Apollo* magazine, Jan. 7, 2008, www.apollo-magazine.com /features/43455 /an-art-gallery-for-the-office html, accessed 7/2/2009.

29. Rockefeller, Rockefeller, Wheeler, and Potter, *David and Peggy Rockefeller Collection*, Vol I.

30. Cristina Carrillo de Albornoz, "David Rockefeller on Art," *Connoisseur's Guide: The Art Newspaper*, http://www.forbes.com/2003/03/05/cx0305conn.html.

31. Ibid.

32. David Rockefeller, introduction to the forty-fifth anniversary booklet entitled *JPMorgan Chase Collection*, 2004.

14 IN MEMORIAM: THE MICHAEL C. ROCKEFELLER WING, AND THE NELSON A. ROCKEFELLER CENTER IN SAN ANTONIO, TEXAS

1. Tomkins, *Merchants and Masterpieces*, 87.

2. M. J. Weber, "The Rockefeller Wing: How A Great Museum Saw the Light," *Connoisseur*, March 1982, 85.

3. Douglas Newton, *The Nelson Rockefeller Collection: Masterpieces of Primitive Art, Metropolitan Museum of Art*, New York: Alfred A. Knopf, 1978, 27–47.

4. Paul Johnson, *Art: A New History*, New York: HarperCollins, 2003, 685.

5. André Malraux, foreword in Newton, *Masterpieces of Primitive Art*, 15.

6. Newton, *Masterpieces of Primitive Art*, 27–47.

7. Nelson A. Rockefeller in Newton, *Masterpieces of Primitive Art*, 19–25.

8. Ibid., 20.

9. du Plessix, "Anatomy of a Collector," 27–47.

10. "Museum of Primitive Art," special issue of *ARTNews*, January 1968.

11. All quotes by Mary R. Morgan are from an interview with the author on 3/8/2007, and from a telecast entitled *Merchants and Masterpieces* made by the Educational Broadcasting Corporation on the occasion of the Metropolitan Museum of Art's 125th anniversary celebration. Telecast produced by Suzanne Bauman and Carolyn Neipris, 1989.

12. Seymour Kurtz, "Asmat: The People," *Museum News* 41, no. 3 (1962): 11–14.

13. *The Asmat: The Michael Rockefeller Expeditions*, catalogue, Museum of Primitive Art, New York, 1967. Foreword by Robert Goldwater.

14. Collier and Horowitz, *The Rockefellers*, 531.

15. Nelson A. Rockefeller, in Newton, *Masterpieces of Primitive Art*, 11–12.

16. Ibid., 13.

17. NAR and the Metropolitan Museum of Art, Agreements, August 15, 1969, F 1665 B 164 RG4 NAR Personal Papers, RFA.

18. Information partially derived from the labels affixed to the artworks at the Metropolitan Museum of Art.

19. Julie Jones, private communication, March 1, 2007.

20. Julie Jones and Heidi King, *Bulletin of the Metropolitan Museum of Art* 59 (Spring 2002).

21. Peter T. Furst and Jill L. M. Furst, *North American Indian Art*, New York: Rizzoli, 1982.

22. Ann Rockefeller Roberts, preface in Oettinger, *Folk Treasures of Mexico*, 21–23.

23. Nelson A. Rockefeller, foreword in Oettinger, *Folk Treasures of Mexico*, 13–19.

24. Reich, *Life of Nelson A. Rockefeller*, 167.

25. Oettinger, *Treasures of Mexico*, 56.

26. Rick Lyman, "From Mexican Soil to Museum Sanctum," *New York Times*, Oct. 20, 1998.

27. Loebl, *America's Art Museums*, 392–95.

28. Marion Oettinger, Jr., personal communication, 3/27/2007.

29. Comments about the artworks are based on Oettinger, *Treasures of Mexico*.

15 SMALLER GIFTS

1. Chernow, *Titan*, 90.

2. "Winthrop Rockefeller: The Arkansas Traveler," *Time*, Dec. 2, 1966.

3. Stephanie Bayless, et al., "Sketch of the History of the Arkansas Art Museum," master's thesis, University of Arkansas at Little Rock, July 2007; Loebl, *America's Art Museums*, 52.

4. Thom Hall, registrar of the Arkansas Arts Center, personal communication, April 2008.

5. Fosdick, *John D. Rockefeller, Jr.*, 345.

6. Martha Frick Symington Sanger, *Henry Clay Frick: An Intimate Portrait*, New York: Abbeville Press Publishers, 1998, 485–538.

7. J. Carter Brown, prepublication comment for Sanger, *Henry Clay Frick*.

8. Kert, *Abby Aldrich Rockefeller*, 214.

9. Harvard (Fogg), F 172, 173, B 16 Gifts to Museums, AAR Papers, RG2, RFA.

10. M. S. Dimand, *A Guide to an Exhibition of Islamic Miniature Paintings*, Oct. 9, 1933, to Jan. 7, 1934, New York: Metropolitan Museum of Art, 1933.

11. http://www.dartmouth.edu/home/abouthistory. (accessed April 20, 2010)

12. Barbara J. MacAdam, *Marks of Distinction: Two Hundred Years of American Drawings and Watercolors from the Hood Museum of Art*, New York and Manchester: Hudson Hills Press, 2005, 168; Ibid.

13. Jacquelynn Bass et al., *Treasures of the Hood Museum of Art*, New York: Hudson Hills Press, in association with the Hood Museum of Art, Dartmouth College, 1985, 17, 140–41.

14. Barbara J. MacAdam, *American Art at Darmouth: Highlights from the Hood Museum of Art*, Hanover and London: University Press of New England, 2007.

15. *Orozco at Dartmouth, The Epic of American Civilization*, Hood Museum of Art, Dartmouth College, 2007. Pamphlet.

16. Daniel Okrent, Junior to Abby, May 19, 1933, cited in his *Great Fortune*, 311.

17. Victoria Newhouse, interview with Wallace Harrison, March 17, 1981, in *Wallace K. Harrison*, 210–12.

18. Bunny McBride, curator's essay, "Journeys West," *The David and Peggy Rockefeller American Indian Art Collection*, August 31, 2007–June 15, 2008, Abbe Museum, Bar Harbor, Maine. Catalogue to the exhibition.

19. Fosdick, *John D. Rockefeller, Jr.*, 306–15.

20. Kert, *Abby Aldrich Rockefeller*, 232.

21. Loebl, *America's Art Museums*, 260–62.

22. Chernow, *Titan*, 304.

23. The Frances Lehman Loeb Art Center, Vassar College: *The History and the Collection*, Munich, Berlin, London, and New York: Prestel Publishing, 2007.

24. Blanchette Rockefeller, www.Vencyclopedia.vassar.edu/index.php; Friends of the Vassar Art Gallery, *Blanchette Hooker Rockefeller, Gifts to the Gallery 1952–1980* 6, no. 2 (Spring 1981).

25. Don Aanavi, *The Art of Mauna Kea: Asian and Oceanic Art at Mauna Kea Beach Hotel*, Honolulu: East West Center, 1980.

26. *Marsh-Billings-Rockefeller: National Historical Park*, brochure, Vermont, U.S. National Park Service.

27. Robert L. McGrath, *Art and the American Conservation Movement: Marsh-Billings-Rockefeller National Historic Park*. National Park Service, U.S. Department of the Interior, Boston, 2001. McGrath based much of his information on the research of Janet Houghton, curator of the mansion.

28. Janet Houghton, interview with author, March 28, 2008.

29. Richard V. Adams *Gilley: Portrait of a Bird Carver*, DVD, Wendell Gilley Museum, Southwest Harbor, Maine, 1981.

30. Steven C. Rockefeller, interview with author, 10/28/2006.

16 KYKUIT: ON A CLEAR DAY YOU CAN SEE FOREVER

1. Mary Louise Pierson, Anne Roberts, and Cynthia Altman: *The Rockefeller Family Home: Kykuit*, New York: Abbeville Press, 1998, introduction, 9–51.

2. Fosdick, *John D. Rockefeller, Jr.*, 196.

3. Pierson, Roberts, and Altman, *Kykuit*, 21.

4. Kert, *Abby Aldrich Rockefeller,* 387–88.

5. Ray Robinson and Morris Warman, "A Pleasant Day with the Rockefellers," *Good Housekeeping,* no. 2, 66, February 1968, 71–73, 186.

6. Pierson, Roberts, and Altman, *Kykuit,* 30.

7. Henry Joyce, *Tour of Kykuit: The House and Gardens of the Rockefeller Family,* New York: Historic Hudson Valley Press, 1994, 16.

8. Ibid., 24.

9. Carol K. Uht to Mordechai Ohmer, 11/6/1970, F 1323 B 135 series III L RG NAR Personal, RAC.

10. Cynthia Altman, in Pierson, Roberts, and Altman, *Kykuit,* 176.

11. "Statue of Aphrodite May Be a Praxiteles," *New York Times,* Feb. 19, 1905.

12. Frederick C. Moffat, *Re-Membering Adam*: The Henry Francis du Pont Winterthur Museum, Winterthur Portfolio 35, no. 1 (2000): 54–80.

13. David Rockefeller, *Memoirs,* 339.

14. Henri Matisse to Alfred Barr, 10/28/1954, and 11/1/1954, F 1714, B 156 RG4 A, RFA.

15. David Rockefeller, *Memoirs,* 186.

16. Steven Rockefeller, Memo re Chagall Windows, F 1720 B 156 RG4 A, RFA.

17. Bernice Rose and William S. Lieberman, *Marc Chagall, Studies of the Windows at Pocantico Hills,* exhibition catalogue, New York: MoMA, 1978.

Index

Pocantico Hills, New York, 4, 23, 49, 92, 137, 201, 351; Fieldwood Farm, 226, 258, 267, 269–70; Hudson Pines, 290; Nelson Rockefeller retreat, 208, 280, 287, 322, 324; playhouse, 43; teahouse, 50, 238; transfer to New York State as park, 359–60. *See also* Kykuit; Union Church

Pollock, Jackson, 223, 227, 281, 299

Pollock, Lindsay, 137, 191

Pope, John Russell, 170, 331

Postimpressionism, 127, 135, 144, 221, 293, 309

Potter, Margaret, 290

Prendergast, Maurice, 130, 134, 135

Princeton University, 92, 147, 340

Puvis de Chavannes, Pierre, 335

Quinn, John, 128, 129–31, 134, 144, 155, 309

Radio City Music Hall, 118–21; *Acts of Vaudeville* (Chambellan), 119; art used in, 118–21, 189; *Crouching Panther* (Billings), 120; design and construction, 118–19; Deskey and, 118, 119, 120, 140; *Eve* (Lux), 120; *Goose Girl* (Laurent), 120; Grand Lounge, 120; *The History of Cosmetics* (Gorden), 120; *Men Without Women* (Davis), 120; *Quest for the Fountain of Eternal Youth* (Winter), 119; *Spirit of Dance* (Zorach), 120; wallpaper (*Nicotine*), 119

Rathbone, Perry, 302

RCA (Radio Corporation of America), 102, 121; Rockefeller Center RCA building, 101, 102, 104, 105, 116–17, 121

Read, Helen Appleton, 142

Redon, Odilon, 130, 143, 152, 163, 329

Reed, Reuben Law, *195*, 199

Reeves, Ruth, 119

Reich, Cary, 112, 271

Reinhard, Andrew, 99

Reinhard and Hofmeister, 98

Rembrandt, 185–86

Renaissance art, 5–6

Renior, Pierre-Auguste, 143, 162, 292

Renwick, James, 106, 339

Revlon Foundation, 248

Rhode Island School of Design (RISD), 46, 59, 60: Abby Rockefeller's Japanese prints, *47*, 47, 56–57, 59, 234, 346; Lucy Aldrich and, 56–57, 59; Lucy Truman Aldrich Porcelain Gallery, 60; Lucy Truman Aldrich Textile Collection, 59, 234

Richardson, Charles, 147

Richardson, Edgar Preston, 260–63

Rindge, Agnes, 339

Ritchie, Andrew, 246

Rivera, Diego, 111–16, 148, 155, 221, 223, 289, 290, 321, 329, 335

Riverside Church, xi, 26–35, *29*, 170; Blanchette Rockefeller, memorial service, 269–70; dedication, 32; Epstein sculpture, 33; Gothic style, 27, 35; John 3rd's memorial service, 268–69; John 3rd's wedding at, 92–93; *Madonna and Child* (Epstein), 33; Nelson Rockefeller, Memorial Service, 285–86; opening services, 32; organ and carillon, 30–31; stained-glass windows, 29–30, 33–34; stone and wood carvings, 28–29, *30*; testimonial dinner for Junior, 31–32; west portal, *30*

ein and, 140; marriage to Happy
Murphy, 271; marriage to Tod, 93,
96, 206, 208; memorial service,
285–86; on Met's Board of Trustees,
209, 310; MoMA and, 96, 138, 151–
52, 153, 155, *162*, 164, 209, 223–26,
269, 294; mother and, 19, 95–96,
133, 137–38, 140, 141, 194, 206,
223; Municipal Arts Exhibition
and, 140; Municpal Art Committee,
243–44; Museum of Primitive Art,
xiv, 224, 308, 311, 312, 322; Nelson
A. Rockefeller Empire State Mall,
Albany, 271–86; Philip Johnson as
and, 227; Pocantico Hills retreat,
208, 280, 287; relationship with
children, 207, 311–12, 320, 345,
353; residences in Washington,
Albany, and Venezuela, 208; Rock-
efeller Center and, 96, 98, 117, 123,
209; shopping, love of, xii, 321, 322;
Tang Dynasty bodhisattva and, 51;
Union Church, Pocantico Hills,
360–61; as vice president, 283
Rockefeller, Nelson: art works and
collections, 8, 96, 206–7, 208–9,
222–26, 246, 280, 310–11, *320*;
Abstract Expressionism and, 207;
art advisors, 217–18; art collec-
tion, Albany, 271–72; art curator
for, 210, 272, 356; art for Albany
Mall, 280–83; bequests of art, 322;
d'Harnoncourt and, 217–18; do-
nates *Dance* to MoMA, 224; gallery
at Seal Harbor, 207; Japanese prints
inherited, 57; Kykuit sculpture
garden, 218, 354–58; Kykuit
underground gallery collection,
353; *L'Italienne* (Matisse), 207, 299;

La Poésie (Matisse), 207; *Le Chant
des Voyelles* (Lipchitz), 252; Léger
mural, 207; Mexican art, 210, 217,
320, 320–27; Miró oil, 223; Nadel-
man art work, 192, 207, 223, 250;
Native American art, 318; *Odal-
isque* (Matisse), 223; non-Western
art, 210, 217, 309–10; Picasso given
to Dartmouth, 334; Picasso prints,
295, 318; *View of Collioure and the
Sea* (Matisse), 207; Wendell Gilley
sculpture, 346
Rockefeller, Nelson Aldrich, Jr., 271,
351, 353
Rockefeller, Peggy McGrath, 54, 55
249, 290, *291*, 361. *See also* Rock-
efeller, David and Peggy: art works
and collections
Rockefeller, Rodman C. (Roddy), 206
Rockefeller, Steven C., 207, 208, 234,
268, 314, 361; Wendell Gilley
Museum and, 194, 345–46
Rockefeller, William, 347
Rockefeller, William Avery (Big Bill),
15
Rockefeller, Winthrop, 41, *43*, *97*, 190,
286, 328, 330, 337; Arkansas Art
Center and, 329–30; as governor of
Arskansas, 328–30; *View of Central
Park* (Sheeler), 158
Rockefeller Archaeological Museum,
Jerusalem, xiii, 67, 75–86, *80*; arti-
facts from three faiths at, 83; bas-
reliefs by Eric Gill, 80; design and
construction, 78–80, 81; *Image and
Artifact* exhibit, 81; Megiddo ivories
at, 68, *82*, 82–83; tiles by Ohanes-
sian, 80–81; treasures of, 82–84
Rockefeller Archives, 4